W9-CLO-775

THE VISION OF LANDSCAPE

IN RENAISSANCE ITALY

PUBLISHED FOR THE DEPARTMENT OF
ART AND ARCHAEOLOGY, PRINCETON UNIVERSITY

THE VISION
OF LANDSCAPE
IN RENAISSANCE
ITALY

BY A. RICHARD TURNER

PRINCETON, NEW JERSEY

PRINCETON UNIVERSITY PRESS

Published by Princeton University Press, Princeton and London

L. C. Card 66-11977
ISBN 0-691-00307-6 (paperback edn.)
ISBN 0-691-03849-X (hardcover edn.)

First Princeton Paperback Edition, 1974
Second Hardcover Printing, 1974

Publication of this book has been aided
by the Publication Committee of the Department of
Art and Archaeology of Princeton University

Printed in the United States of America
by Princeton University Press

TO MY MOTHER AND FATHER

PREFACE

THESE ten collected essays are intended to introduce the nonspecialist to landscape in Italian Renaissance paintings. More critical and appreciative in approach than historical, they make no claim to touch upon all the important painters of the age, and omit certain problems of interest primarily to the art historian. My one hope is that through verbal descriptions and comparisons new visual experiences may be opened to those who are sympathetic to Italian painting.

I first turned to this subject on a Fulbright to Italy in 1955-56, and continued research in a 1959 Ph.D. dissertation at Princeton University. Since then my work has been supported generously by the Spears Fund of the Princeton Department of Art and Archaeology, the Princeton University Research Fund, and a grant for 1963-64 from the American Council of Learned Societies.

These essays were written in Florence at Villa I Tatti during 1963-64, where I was a Fellow of the Harvard Center for Italian Renaissance Studies. I remember with gratitude the association with the staff and fellow students at I Tatti, and especially thank Kenneth Murdock and Lauro Martines for their generous and refreshingly un-art historical encouragement. Also, my thanks to the staffs of the Kunsthistorisches Institut, the Biblioteca Nazionale, the Gabinetto dei disegni degli Uffizi, and the Soprintendenza alle gallerie di Firenze.

In a book as general as this it is impossible to acknowledge fully one's debts. I have decided to minimize scholarly apparatus, so that references to standard monographs, museum catalogues, and Vasari are given only if there is a compelling reason. The footnotes indicate specific references and additional information where it may be of use to advanced students.

Quotations are reprinted by permission from the following publishers. From Harvard University Press, Loeb Classical Library: Ovid, *Fasti,* trans. J. G. Frazer, London/ New York, 1931; Vitruvius, *De architectura,* 1, trans. F. Granger, London/ New York, 1931. From Oxford University Press: J. P. Richter, ed., *The Literary Works of Leonardo da Vinci,* New York, 1939. From Penguin Books, Ltd., G. R. Kay, ed., *The Penguin Book of Italian Verse,* Harmondsworth, 1958.

Numerous persons have been especially helpful to me over the past years. My teachers and colleagues at Princeton have all offered advice at one time or another, particularly Rensselaer W. Lee, who kindly read the manuscript; John R. Martin; and the late George Rowley. The late Gertrude Coor and Michelangelo Muraro made many suggestions. Thanks to Miss Fredericka Oldach of the Marquand Library, and to Miss Gloria Ramakus and Mrs. Frank Scott, who prepared the manuscript.

To three my warmest thanks: to Harriet Anderson of Princeton University Press for penetrating suggestions about both style and content; to David R. Coffin, *il mio maestro*, who in friendship has cheerfully put up with themes and variations of this book for seven years; and to Jane, who with unfailing humor has kept my thoughts in perspective and the family in order.

Princeton, New Jersey
September 7, 1965

Baltimore, Walters Art Gallery: 118, 119
Berlin-Dahlem, Staatliche Museen, Gemäldegalerie: 82, 83
Bologna, Biblioteca universitaria: 102, 103
Bologna, Foto Villani: 127, 128, 133, 135, 136
Budapest, Museum of Fine Arts: 106
Darmstadt, Hessisches Landesmuseum: 116
Florence, Foto Alinari: 1, 3, 4, 6, 7, 8, 9, 12, 13, 14, 15, 18, 19, 20, 22,
 32, 33, 34, 39, 42, 46, 50, 58, 88, 89, 90, 91, 114, 122, 138, 139, 140
 Alinari-Anderson: 38, 59, 61, 72, 73, 93, 94, 104, 110
 Alinari-Brogi: 17
 Alinari-Fiorentini: 45, 47, 48, 49, 52, 53, 56, 57, 67, 78, 79, 84, 151
 Soprintendenza alle gallerie, Gabinetto fotografico: 16, 68, 69, 70,
 76, 77, 80, 86, 111, 121, 156, 158
Hartford, Wadsworth Atheneum: 99
Leningrad, Hermitage: 81
London, British Museum: 71, 129 (Reproduced by courtesy of the
 Trustees)
 National Gallery: 2, 30, 31, 40, 41, 43, 44, 62, 74, 97, 105, 113 (Re-
 produced by courtesy of the Trustees)
Madrid, Prado: 63
Modena, Foto Orlandini: 101
Moscow, Pushkin Museum of Fine Arts: 92
New York, Frick Collection: 11, 35, 36, 37
 Kress Foundation: 98
 Metropolitan Museum of Art: 27, 28 (Gift of Robert Gordon
 1875), 54
 Parke-Bernet Galleries: 100
Oxford, Ashmolean Museum: 5, 29
Paris, Caisse nationale, Archives photographiques: 21, 25, 65, 66, 75,
 131, 132
Princeton, University Art Museum: 130
Rome; Gabinetto fotografico nazionale: 95, 107, 108, 109, 117, 141,
 142, 143, 144, 145, 146
 Istituto centrale del restauro: 10
Urbino, Soprintendenza alle Marche: 147, 148
Vatican City, Monumenti, musei e gallerie ponteficie, Archivio foto-
 grafico: 112, 115, 123, 124, 125, 126, 137
Venice, A.F.I.: 64
 I. Brass: 87
 Foto Giacomelli: 149, 150, 152, 153, 155, 157
Vienna, Albertina: 55, 60, 120, 134, 154
 Kunsthistorisches Museum: 85, 96
Windsor, Windsor Castle (By gracious permission of Her Majesty
 Queen Elizabeth II): 23, 24, 26

CONTENTS

LIST OF ILLUSTRATIONS

LIST OF ILLUSTRATIONS

xvi

THE VISION OF LANDSCAPE

IN RENAISSANCE ITALY

I ✦ INTRODUCTION

THE rolling hills and limpid clarity of Piero della Francesca's allegories, the fresh hour of dawn in Giovanni Bellini's *Gethsemane,* Leonardo's acutely observed view of the Arno Valley—these are among the first great landscapes of Italian painting. Only around 1470 does the Renaissance artist fully appreciate the expressive possibilities of landscape within a painting. He seeks a unity between figures and the illusionistic world in which they dwell, and by this union suggests a compelling mood. At times this mood had been caught before, but first with a Leonardo and a Bellini does it become the essence of landscape painting.

Mood born of the union of figures and landscape is the subject of these essays. Renaissance landscape, whatever its particular form, exists to serve mankind. Its fields and groves are carefully groomed and only rarely give way to wild ravines, spectacular vistas, or deserted places. This domesticated world gives sustenance to the physical needs and spiritual yearnings of the men who inhabit it. In the broadest sense the landscape is humanized.

Before a painting is an expression of a mood, or even a pictorial symbol, it is the solution to problems of pictorial structure. And when a painting includes an important passage of landscape, these problems assume a special character. The nature of these problems as they existed five centuries ago can be suggested briefly here.

Today we might define a painting as a two-dimensional surface upon which lines and colors have been laid in a planned relationship. In the fifteenth century a painting probably would have been described as a window through which the beholder glimpses a view of the world, a fiction calculated to be a reasonable counterfeit of that which the eye experiences in everyday life. Such in essence was the thought of Leon Battista Alberti, that remarkable humanist and architect who in 1435 published his *De Pictura.*[1] This little book, composed in the spirit of friendship for the leading Florentine artists of the day, is a judicious blend of mathematics, classical erudition, and simple common sense. He tells us

[1] Quotations are from L. B. Alberti, *On Painting,* tr. and annot. by John R. Spencer, New Haven, 1956.

that "the painter is concerned solely with what can be seen," and that his central business is to paint objects so that "they appear in relief and seem to have mass." If the artist was asked to provide an illusion of tangibility and space, based upon observation, these were but means to the end that "movements of the soul are made known by movements of the body." For Alberti the artist's proper subject is the *istoria*, that subject matter in which men's noble passions are communicated through an edifying narrative subject. The picture surface is indeed a window through which the world is seen, but in this world figures will occupy the center stage, and their setting, and hence landscape, will be subordinate.

Alberti, then, asks that the painter strive for naturalism if by that term is meant simply that the painter grounds his art in the imitation of natural appearances. But Alberti's precepts are theory, and in any age theory stands in tenuous relation to artistic practice. So in Italy of the Quattrocento Pisanello's small panel of the *Vision of Saint Eustace* is at a far remove from Masaccio's *Tribute Money* (Figs. 2 & 3), yet both might be described as naturalistic. In caricatured form the comparison suggests a problem that every landscapist must resolve: how is he to reconcile fidelity to detail with the breadth and generalization needed to create a convincing illusionistic effect.

Pisanello offers us a delightful fairy tale, the story of a hunter who comes upon a stag with the crucified Christ between its antlers. The panel seems a swatch snipped from a tapestry, for it is gaily decorative, a gathering of flat cut-outs applied to a somber background. Objects are scattered at random, and those which are to be understood as deep in space are placed at the top of the panel. Lilliputian trees sprout from the flower-sprinkled turf, and a coiled scroll is the clue to the decorative aesthetic of the picture. There is no sky, and without it the eye does not seek depth, but is content instead to roam the colored patterns of a carpet.

Naturalism will not do as a label to describe this painting, at least not until one examines its individual parts. Only then comes the discovery that Pisanello's art is based upon strenuous observation. Whether studied from nature or north Italian pattern books, the greyhound above the scroll presupposes a competent understanding of anatomy. The bones and ligaments of the hindquar-

4

ters are precisely drawn, and equally close attention is given to the hare, the deer, and even the small crucifix. Most of the details in the panel are credible counterfeits of nature when seen out of context. The coherency of the picture is based upon an additive process, where each observed part contributes to the pattern of the whole. Pisanello's is a fractional naturalism, directed at the individual manifestations of God's creation. He loved each created being as had the sculptors of the foliated capitals on the cathedrals before him. Neither they nor Pisanello desired to create an illusionistic environment which would deceive the eye or mind.

If Pisanello's picture belongs to the Gothic past, Masaccio's *Tribute Money* is the font of the new. Following the lead of the great Donatello, the young painter posed pictorial problems which were to find response for many decades after his death. His fresco is a place of grave import where bodies are stately, and faces solemnly impassive. Christ indicates to Peter the miraculous source from which the coin will be taken, while the apostles stand in a quiet semicircle. These forms are monumental and sculptural, economically described lest their power be diminished.

The environment that Masaccio provides for this heroic race complements their noble demeanor. A building rendered in linear perspective at once defines the foreground space and leads the eye into the distance, where lies a strange, primordial landscape. Beyond sparse and ravaged trees rise the distant mountains, naked spurs of rock that reach to the sky. This land is desiccated. Fires long ago laid it bare, and torrents from the mountains have swept away the last vestiges of organic matter. Through aerial perspective—the observation that distant objects lose definition and become gray—Masaccio has suggested the measureless extensions of mountain vistas.

Unlike Pisanello's panel, the individual parts of Masaccio's composition are not counterfeits of nature, for they are too simplified. The word naturalism as applied to his art must differ in meaning from its use in connection with Pisanello. It will refer to Masaccio's creation of a coherent illusionistic whole where space is rationally defined, where light and atmosphere fill that space, and where detail is sacrificed in the interests of generalization. Precisely this desire for illusionistic coherency breaks with Gothic naturalism.

5

These two pictures suggest the conflict which may trouble the landscapist. While in love with detail, with the leaf of a tree or the plumage of a bird, he must realize that the description of illusionistic space is the essence of his art, and to achieve it successfully he must subordinate detail to the whole. Usually the Renaissance artist was able to reach some sort of compromise between the vision of a Pisanello and that of a Masaccio. Unlike his predecessors, he regarded the evocation of illusionistic space as his primary task, and usually this space was defined by the newly developed convention of linear perspective. The limitations and possibilities of linear perspective intrigued the Florentines for more than a century, and shaped their view of landscape painting.

For the Renaissance artist space was simply the void that separates objects from one another. In his painting he sought to suggest the measurable distance between objects, and so developed a system of illusionistic space where each object is related to the viewing point of the beholder, and in scale with every other object in the painting. Linear perspective provided this consistent method, and by 1435 it was fully understood in both practice and theory.

The relationship between linear perspective and landscape painting is problematic, for perspective depends for its effect upon a number of straight lines which converge upon a vanishing point. Obviously these straight lines are rarely found in nature, but are the attributes of artifacts. So, for instance, an ideal cityscape of the later fifteenth century embodies the very essence of space built upon the assumptions of one-point perspective (Fig. 4). But landscape as we observe it in nature is habitually irregular, a veil of atmosphere, a series of overlapping horizontal strips which fade towards the horizon. A mind thoroughly imbued with the methods of linear perspective would be not only ill-equipped to create the illusion of landscape space, but might even need to unlearn the precise and artificial limitations imposed by perspective.

Two paintings, one by Paolo Uccello and the other by Domenico Ghirlandaio, suggest in different ways the Florentine faith in linear perspective, even in matters of landscape painting (Figs. 5 & 6). Uccello's hunting party is brilliant splotches of red and blue, tawny arabesques of greyhounds which arch across the forest floor. Action is frozen within firm pattern, and by the sys-

tematic structuring of space. A spatial avenue opens in the center of the panel, while rows of trees fan out on either side, a rigid scaffolding that supports a foliated roof. All seems pattern, until one notices that the trees follow orthogonals that converge upon a central vanishing point. Lest the point go unnoticed, Uccello has arranged fallen logs that serve as secondary lines of recession. Such is the quaint ordering of space in this untypical picture where Gothic tapestry and Renaissance pictorial science meet for the last time.

Domenico Ghirlandaio's happy visual journalism suggests a subtler problem. His *Adoration of the Magi* reveals the artist's highly competent if contrived workmanship. Once beyond the richly anecdotal foreground one's eye passes up a river valley. Hills dip to the water's edge, and minute details of a distant town are recorded soberly. Ghirlandaio's fascination with the motif of a view up a river valley has been explained at times as a sign of the artist's devotion to his native Arno Valley. Perhaps a more prosaic explanation is in order, for a river valley offers the closest approximation in nature to the artificial conditions of one point perspective. A flat ground plane can be established, banks converge, and objects diminish in size in orderly fashion. So the mechanics of illusionistic representation may well have determined the type of landscape which the artist decided to represent.

Linear perspective, then, is a limited tool in the hands of the landscapist. It may well be, and usually is, the assumption which lies behind his treatment of space, but in practice it is only implied. More basic means must be used: overlapping tongues of land, curved guiding lines, color relationships, aerial perspective, varying intensities of light. Perhaps it is no accident that landscape did not first bloom in Florence, the city that in so many other respects led the way.

A satisfactory construction of space is the first task of the landscapist, but hardly his only one. A space defined by perspective remains a sterile artifact if not enlivened by atmosphere and light. Masaccio had understood this, and in the *Tribute Money* developed the rudiments of atmospheric perspective. But it was not for him to paint a landscape saturated with sunlight. This experience engaged Gentile da Fabriano in the delightful predella of his 1423 *Adoration of the Magi* (Fig. 7). The sun is still low

in the sky, and its soft light touches the tops of the hills, and the pastel walls of the far-off cities. Wispy clouds float above the hills, a transparent mist in the morning air. Yet this light falls in no logical way, nor do shadows lie across the land. It is a poetic make-believe, not least of all because the sun is a button of gold, worked in raised relief. Even as the artist would use the magnificence of tooled gold to suggest the glory of Christ and his mother, so the sun, the nourisher of life, could best be evoked by material opulence.

By the 1440's Florentine artists had deeply probed the problems of representing light though the historical genesis of this concern is largely lost along with the beginnings of Domenico Veneziano and Piero della Francesca. These names have distracted attention from that considerable innovator of the thirties, Fra Angelico. One of his more ambitious altarpieces is the San Marco *Deposition*, from which a detail shows the terrain painted as if carved by a knife from porous rock, and then smoothly rounded until the pores disappear (Fig. 8). The buildings are cut from soft wood, joined with the simplest of planes, and then painted in a naive and happy juxtaposition of pastels and darks. The lucid simplicity of this world appeals to the sensibility of our own century. The landscape is unreal, but also supra-real. A flood of brilliant light moves across the land, reflected with Mediterranean intensity from stuccoed walls, and intermittently absorbed into deep, cool shadows. Piero della Francesca's luminous landscapes done thirty years later are but the subtle culmination of Fra Angelico's essays in light (Fig. 1).

Such are a few of the formal preoccupations of the Renaissance landscapist, immediately in the wake of the artistic revolution initiated by Donatello, Brunelleschi and Masaccio. Having considered them, one happens upon a simple but largely unanswerable question: why did the artist choose to paint landscape at all? To seek an answer one should look back of 1400 to those great Sienese who had explored landscape during the previous century. Their formal solutions were radically different from a Leonardo or a Bellini, yet the reasons why they turned to landscape are shared with the generations that followed.

In medieval art landscape elements were symbols whose usual function was to clarify the narrative rather than to create an illu-

sion of space. This is their function in a mosaic of the *Entry into Jerusalem*, in the Cappella Palatina at Palermo (Fig. 9). The artist confines himself to the smallest number of elements of setting required for a lucid narration. The road upon which Christ rides is covered by palm fronds. The terrain is undescribed, but for the schematized indication of an outcrop of rock, and a city gate whose architectural complexities are reduced to a flat, conventionalized formula. No object is drawn from nature, and since relationships of scale are meant to indicate the relative importance of objects rather than their position in space, we accept the landscape as a footnote to the narrative rather than as an illusionistic environment which contains figures.

Out of this same Byzantine tradition emerges a distinguished innovator towards 1300, Duccio di Buoninsegna. The narrative panels from his *Maestà* are the work of one imbued with an exquisite sense of line and pattern, and a deep respect for traditional Christian subject matter. He, too, did an *Entry into Jerusalem,* iconographically similar to the Palermo mosaic, but in feeling a world apart (Fig. 10). Seen against its immediate heritage, Duccio's panel stands out as an unprecedented attempt at an illusionistic rendition of space. The artist has not only sought plausible scale relationships, but has delighted in elaborate spatial complexities. While the mosaicist keeps all the elements of his design parallel to the picture plane, Duccio bends his path back into space, turns it under the city gate, and then prolongs this arc by means of receding buildings. He loves the genre detail of the crowds that lean over the wall, the children who playfully bear palms, and combines this common touch with spatial conceits, such as the trick of pulling us through the gate to look at a face which peers out of a window. One might argue that this illusionism is not consistently thought out, but the "errors" are of execution rather than intent. Duccio would have us understand that Christ's entry into Jerusalem was a historical event which took place at a precise spot at a given moment, and his illusionism encourages us in the belief that we are there.

A historical event: the phrase suggests why Duccio sought to evoke a plausible illusionistic environment. Only when the artist conceived the scene as an event once experienced by real people, who rejoiced and sorrowed long ago, would he try to provide this

9

people with an illusionistic realm which corresponds to his own. Though all but impossible to prove, one suspects that the rise of an illusionistic art is related to the shift from a view of history as the implacable unfolding of the Divine Will to a view which imaginatively relives the emotions and actions of past generations.

The probable justness of this generalization is confirmed by a second panel from the *Maestà,* the *Temptation of Christ,* today in the Frick Collection (Fig. 11). Christ, attended by two angels, gracefully resists the temptations of a hairy and wizened Devil. The figures stand on top of a world built of papier-mâché mountains and brightly colored toy cities. The faithful rendering of such details as the paving blocks and roof tiles only serve to emphasize the improbable appearance of the whole. In its denial of logical relationships of scale this world assumes the qualities of a dream.

The way that Duccio saw the world in a given painting depended upon the idea that he was illustrating. While in the *Entry* he saw a historical event, to be couched in purely human terms, the *Temptation* represented for him a transcendent spiritual truth, a vision of Good and Evil whose essence could not be communicated through the banal observations of normal human vision. By conscious choice Duccio places the transcendent idea in the context of a symbolic landscape, while in the *Entry* the historical truth of the Incarnation led him to adhere to the visual facts of daily human existence. In so doing the Sienese painter shares the outlook of his great Florentine contemporary, Dante. The *altissimo poeta* offers us landscapes and psychological situations which are intensely seen, yet they remain fragments of reality, imbedded within the over-all abstract structure of his poem.

The beginnings of landscape painting are intimately tied to human events and ideas. A Duccio does not seek illusionism solely out of a new love for nature, but because the subject matter calls for a realistic setting. To be sure, the appearance of landscape is one more sign of the humanization of art, humanization in the Franciscan sense of a warm and tender response to God's creation. When history is vicariously relived, then Jerusalem becomes Siena, the city of the Virgin. But this should not distract one from the fact that early examples of landscape painting usually occur

in a context where the subject matter explicitly calls for a natural setting. Such, for instance, is the panoramic, denuded land which stretches behind Simone Martini's Guidoriccio da Fogliano (Fig. 12). This barren badland is enlivened by two towns, which we learn from a contemporary document are Montemassi and Sassoforte. These villages had been captured for Siena through the agency of her condottiere, and this event is appropriately portrayed in the heart of the Palazzo Pubblico. We admire the rider who is emblazoned in heraldic flatness against the landscape, but the same document fails to mention him. Evidently the mural commemorates more than a feat of arms; through landscape it boasts about the possessions of Siena, and this, quite simply, is the reason why the landscape is represented with such prominence.

Ambrogio Lorenzetti's *Good Government in the Country* is by far the most precocious landscape of the fourteenth century (Fig. 13). For the first time in Italian painting an artist has clothed bare rock with soil, and planted upon it trees and crops. And for the first time the suggestion of great distances has been achieved. Either as a spatial structure or a record of genre detail the fresco is unparalleled in its age. Though the fresco seems a fantasy, those who have traveled the road southeast from Siena to Asciano will realize that Ambrogio has captured the essential character of a corner of Tuscany. One's thoughts before this fresco quickly turn to Ambrogio's remarkable grasp of form and his sympathetic response to nature.

Yet this entirely proper response to the fresco is likely to make one overlook the very practical considerations which brought it into being. Ambrogio's task was to fresco the Sala della Pace in the Palazzo Pubblico in Siena, his subject an Allegory of Good and Bad Government. This decoration is divided into two distinct parts, the hieratic, symbolic presentation of the idea of government, and the more concrete visualization of the fruits of proper and improper government in city and country, represented respectively as cityscapes and landscapes. Lorenzetti's problem was to give tangible expression to the Idea of Good Government in the Country, and to accomplish this he sought to create a landscape which would be visually convincing, the real manifestation of an abstract idea. Therefore human activity in relation to the

land is the essential quality of the landscape. Elegant city folk ride out to enjoy the salubrious effects of the country, while peasants walk to town to dispose of their animals and crops. We glimpse varied activities; reaping in the fields, tilling of the soil, hunting in the country. In the distance the painter shows us properly cultivated hillsides, where the rules of sound agricultural practice have been observed. In microcosm this detail focuses the essential meaning of the fresco, the presentation of a well-governed land where both human needs and pleasures are satisfied.

Thus far I have suggested that a painted landscape is first of all a problem in pictorial structure, and then that the renewed interest in landscape painting in the fourteenth century was closely bound to a desire to elaborate rather specific concepts. Moreover, these conclusions should have validity outside the chronological limits of the period that we are considering. The critic should always consider the structure of the picture before him, and ask why the artist chose to paint landscape. But amidst all this rationalization an essential intuition ruffles the argument. We wonder if in an increasingly secular world the artist may have turned to nature out of direct and uncomplicated love for her many joys. How, indeed, could the artist's love of the world about him not be a significant factor in the rise of landscape painting?

How, indeed. The question is an embarrassment, for we cannot readily ascertain the motivations of those long since passed to the grave. And reading the sonnets of a Petrarch, where all locks are blond, all rivulets fresh and clear, all fields clothed in blossoms, we are painfully aware that an artist's feeling for natural beauty is readily masked by the conventions of his art. But read the entire oeuvre of Petrarch, and contemplate the landscapes of Lorenzetti, and you will have no doubts concerning the genuine sensitiveness of these men to the world about them. In *Good Government in the Country*, Ambrogio sees the Sienese countryside as an object of civic pride, just as Petrarch in his metric epistle *Ad Luchinium Vicecomiteur* could look upon his native Italy as a fecund and happy fatherland. But both men also responded spontaneously to the beauty about them. Only thus is explained Am-

brogio's searching eye, or Petrarch's sensitive description of his ascent of Mont Ventoux.

The heart has its reasons, but they inevitably are encased either in words or the conventions of pictorial representation. One suspects that a love, usually religious in the widest sense, has animated the great landscape artist in every age. And from that love springs the desire not merely to describe a topography, but to capture a mood. In few places was this more true than in Florence of the 1460's, where artists different in temperament and style celebrated the topography of the Arno Valley.

Alesso Baldovinetti's *Adoration of the Child*, done in the early 1460's, is in the forecourt of the Annunziata (Fig. 14). A glance tells us that this is the valley of the Arno, with the steep advance guard of the Apennines rising from the plain. Perhaps it is a view from Florence towards Sesto Fiorentino, with distant Prato barely in sight, but the idea strains credulity. No matter, for the appearance is just right for the broad valley of the Arno below Florence. The counterfeit of observed facts is no more convincing than it had been in Fra Angelico. Rather it is the whole that works, the sense of vastness imparted by the meandering river, the trees and buildings which grow ever smaller in the distance, and the mountains whose very lack of definition suggests an imposing stature. The high bird's-eye view favored by Baldovinetti was a common spatial solution at the time. Figures are placed upon a plateau, which drops away to the broad landscape below. The solution, already adopted about 1430 by Masolino in his frescoes at San Clemente, has obvious advantages. An interesting and varied background is made possible, while the sky, that feature the Italians were always hesitant to paint, is minimized. More important, this particular spatial solution sidesteps the crucial problem of how to effect a successful transition from the foreground to the deeper space of the picture. Baldovinetti's landscape is fine topography, for without dull-minded, close description it suggests the essential character of a place and gives the observer the pleasing sensation of recognition.

Baldovinetti's vision was shared by Antonio Pollaiuolo, and if we still possessed those canvases of the Labors of Hercules, done for the Palazzo Medici in 1460, we would probably see that he was a pioneer in this sort of landscape. Paintings like the small

Hercules panels in Florence, the battered *Hercules and Deinira* at Yale, and the London *Martyrdom of Saint Sebastian* reveal Pollaiuolo's topographical passion. He describes more closely than Baldovinetti, but in this very particularization something is lost. Pollaiuolo's exactitude complements the taut and brittle contours of muscle and tendon of his figures.

A different sort of topography is not scrupulously naturalistic, but nonetheless it succeeds in capturing the mood of a particular place. How true of that jewel of the Florentine fresco art, the little chapel in the Palazzo Medici, done by Benozzo Gozzoli in 1459 (Fig. 15). Festive decoration, reminiscent of tapestry, the fresco describes with pomp and magnificence the journey of the Magi to the Christchild's crib, represented in the panel by Fra Filippo Lippi which originally adorned the altar. Benozzo's frescoes are rich in stylizations, trees built upon formulae, tautly curved streams and roads, the bright and nervous heaping of one improbability on top of another. Yet the custodian today will enthusiastically point out the portraits of the Eastern Emperor, the Medici, and many Medici buildings in the vicinity of Florence. This visual delight, then, would represent the great of Florence, and the look of the hilly topography that girdles her walls. A dispassionate examination of both the fresco and the facts of history dispels most of these alleged identifications, but the basic truth of the guidebook legends remains. In the retinue of the kings appear unquestioned portraits, including the labeled image of the artist himself. Decoratively the room is a *cassone* panel extended to four walls, and in meaning is a mammoth *sacra rappresentazione*. Revered Christian pageantry is acted out by the leading members of contemporary society and it was only natural that the holy town of Bethlehem should be imagined as Florentine Tuscany.

If it should be asked just what it is that the critic of landscape seeks, the questions might be: Does he discuss painted landscapes in reference to the actual topography which is supposed to have inspired them? Or conversely, does he look upon a painted landscape purely as a formal structure? The questions are troublesome, for we know that of all men artists are among the most sensitive to natural beauties, but since Oscar Wilde we also know that Nature copies Art. It would be a mistake to imagine that

these views are mutually exclusive, for in the meeting of formal means and the objective suggestions of topography is born the mood of most Renaissance landscape painting.

Mood, which flees definition like the shadow pursued, is the critic's proper quarry. As I suggested at the outset, the self-conscious cultivation of mood in landscape dates from the emergence of Leonardo and Giovanni Bellini as independent personalities. The course of the following essays is of necessity directed by evocation and suggestion rather than by demonstration. These pages speak above all of things which may be seen, and are offered for whatever help verbal description may afford in pointing the way to essentially visual experiences. In this, as in so much of life, the demonstrable is not of central importance.

II ✧ LEONARDO DA VINCI

D AY of Holy Mary of the Snow, August 5, 1473." With these words Leonardo inscribed a carefully studied ink drawing of a river landscape, a precious bequest from his twenty-first year (Fig. 16).[1] The artist stands at the edge of a precipice, and gazes across a river valley. Below him the earth drops away into a deep gorge, a gnarled and rugged topography, sketched in thick, heavy strokes. Clumps of trees cling to perilous footholds, while here and there bare rock thrusts from the soil. The eye passes with relief from the ravine to a domesticated river bottom. Slow waters meander through the trees, and beyond fields recede in orderly patterns to the distant hills. A breeze blows upon the hilltop above, but over the valley the air hangs light and still.

It is a drawing done in exhilaration; home is in the valley, where the doings of life transpire. A fortified villa tops a bluff, placed so that it may at once be defended and catch the gently stirring airs. But Leonardo has climbed higher, putting a difficult path behind him. He halts at a *bella vista,* breathing in the freshness of summer. The spurs he has mounted are stroked in decisively, perhaps as a memory of expended effort. The summit lies further on, still to be experienced; it is indicated with the simplest of lines. A pause on an August day, a *festa*: in honor of the Madonna of the Snow Leonardo has laid aside serious work and made a visual entry in his private diary.

To see a landscape in nature and to record it graphically are disparate activities. Blank paper, ink, and a writing instrument await an informing intelligence. The artist will transform his observations of nature, for the artistic conventions that he knows by rote will always to some extent obtrude on what he sees. Leonardo saw as few have before or since. Nothing in the drawing is described closely, yet the master's graphic shorthand presupposes a fine-honed awareness. Thin tree trunks rise on the left, their light foliage indicated by rapid, curved lines. They are saplings that bend resiliently before the wind. Leonardo has

[1] On Leonardo's landscapes, see L. Goldscheider, *Leonardo da Vinci: Landscapes and Plants*, London, 1952. Contains a useful bibliographical note, to which add G. Castelfranco, *Il paesaggio di Leonardo*, Milan, 1953.

sketched quite another grove beneath the castle. Compact, rounded trees hug the hill, the sturdy and unyielding form of the olive. Shorthand notations, to be sure, but they are firmly anchored in visual experience rather than convention. The separation of soil and underlying rock also has interested Leonardo. Along the edge of the ravine rounded earth meets the faceted planes of bedrock. To the right the land slopes downward, bearing the trees with it, and caps the eroded indentations of a cliff. Leonardo's fascination with the relation of surface to core begins here.

These details are interesting, yet their depiction was secondary to Leonardo. He had an empty piece of paper before him, and the task at hand was to evoke a convincing illusion of space. He used as the major idea the flow of space from a confined hollow into a vast expanse. Several devices direct the eye towards the ravine. The right side of the sheet is out of focus; one's eye slips across it to the heavier lines that define the gorge. Because the gorge plunges out of sight, the temptation to peer over the edge is irresistible. Once the edge is gained, the eye follows a serpentine line out to the buildings on the bluff. This land mass is but a stage wing which is matched on the other side of the ravine. So a massive stone barrier is breached, and the eye passes to the freedom of the space and light below. It is an imperfectly executed concept. The castle tilts upward at an odd angle, countering the illusion of space, and the right side of the ravine is closely grained with meaningless horizontal and vertical strokes of the pen. Perhaps a waterfall was intended, or an outcrop tentatively explored. But the passage has been too closely worked, becoming flat and unreadable. Such hesitancies only point up the brilliance of the over-all idea.

Once beyond the cliffs, the eye moves easily across the plain. Large areas of the paper are left white, as if glowing with sunlight. Lines become fragile and broken, softly evoking a mountain ridge, a tilled field. Blunted and fuzzed hooks of the pen form the shapes of trees. Such are Leonardo's means of describing the atmosphere that hovers between him and the objects he depicts. But he has fretted. Atmosphere must not threaten to dissolve the pictorial structure. So he has decided as a last minute thought to lay in lines that converge in perspective. Ostensibly

the rows of cultivated fields, they assert the angle and solidarity of the ground plane. Little matter if the fields seen to the right and left of the castle seem at different levels whereas in fact one is behind the other; the effect is largely persuasive. Leonardo has fabricated his space, and managed to fill it with light and atmosphere.

So far I have made an assumption, that the drawing is done from nature. There is no way to prove that this is so, but these quick lines have all the quality of a spontaneous reaction to a living model. For a millennium artists had copied art rather than nature, and had chosen not to look at nature with a fresh eye. Leonardo for the first time reveals that calm observation in the face of complex visual facts that will mark the rest of his career. Yet not even Leonardo cared to depart wholly from convention, and it should be stressed that the 1473 drawing is also quite traditional. The artist's viewpoint is from raised ground, overlooking a flat plain. As we have seen, this sort of an arrangement had found brilliant treatment in the hands of Antonio Pollaiuolo and Alesso Baldovinetti when Leonardo was still a boy. Leonardo has taken the old formula and developed it, grafting on the results of fresh observation. If Leonardo's drawing weds innovation with a traditional scheme, it is still a milestone. Rarely had landscape been represented earlier for its own sake, and the idea is remarkable for a young artist.

Still the drawing is a drawing, and not a painting. As such it is a private and direct means of expression, a medium for speculation and experimentation. Here the artist will attempt things that he would not think of offering to his public in a painting. A painting, after all, is Art, and as such governed by tradition and custom. Small wonder that while Leonardo drew complex landscape studies, in his pictures they remain in the background. And it is to these backgrounds that we are led, for Leonardo's haunting lands of blue rock provoke many thoughts about landscape as an art. We may wonder what purpose they serve in the paintings as a whole, and what relation they bear to that more empirical drive evident in the master's drawings.

A glance at Leonardo's earliest paintings reveals that for him landscape will not be topographic in intent, but a means of evocation. That famous background of Verrocchio's *Baptism* is

one of the first examples by Leonardo's hand (Fig. 17). Already landscape is deeply felt as a condition of light and atmosphere. The brush has moved quickly, sketching a loose vision of those elements that will fascinate Leonardo for the rest of his life, rock and water. A river winds through a valley, its course tumbling downward over low waterfalls. The river bottom opens on either side, soon to rise in jagged pinnacles on the right. It is the same raw material as the 1473 drawing, but the topography in the painting is more fanciful, and becomes ephemeral in the shifting haze. At the same time, or perhaps even earlier, Leonardo painted the *Annunciation*, now in the Uffizi (Fig. 18). It is a peculiarly uneven picture, with its half understood perspective and overly described foreground. The happiest part is the landscape, framed by the dark silhouettes of cypresses, which grow beyond the *hortus conclusus*. One looks up an estuary dotted with ships, and flanked by a city lying off to one side. Beyond, great peaks rise up into a misty sky, icy blue stalagmites whose sides are too precipitous to scale. These mountains touch the sky, and the receding ones gradually melt away into a diaphanous blend with the atmosphere, so that finally the two cannot be distinguished. They cast an air of suggestive unreality over the more mundane harbor town below. As yet these snatches of landscape play no vital role in Leonardo's pictures, and we savour them in isolation. But they do show that from the beginning landscape in a drawing will be one thing for Leonardo, and landscape in a painting quite another. These little vignettes well prophesy the imaginative and enigmatic landscapes to come.

It compels little attention at first, that murky altarpiece that hangs near the *Mona Lisa*. If one approaches it on a cloudy day, when the Grande Galerie of the Louvre is steeped in gray, Leonardo's *Virgin of the Rocks* is a somber, twilight place (Figs. 19 & 20). Should the sun break through and its light fill the hall, one's impression is altered only in degree. The picture remains a study in quiet browns and grays, tinged with olive, and only the hues of the garments bloom with greater intensity. Granted that the centuries have smoked the picture, even after imagining away the grime one must see a faintly illumined atmosphere, completely appropriate to the cool half-light of the chapel where the picture once hung.

19

Historically the picture is a prime document. It is one of the few finished pictures by Leonardo left to us. It also stands as a watershed in fifteenth century painting. One instinctively feels a little uncomfortable before the panel, and soon realizes that his discomfort is born of a pictorial tension. The resolution in the picture between the general and particular is strangely un-achieved. Leonardo has arranged his figures in a broad-based triangle, set close to the picture plane. It is an unequivocally lucid idea, and what it meant to the high noon of Italian painting can be seen by looking a few years ahead to Raphael. But the differ-ences between Raphael and Leonardo are profound. In Raphael the tensions are gone, because he has eliminated what Leonardo would not, the searching and precise rendition of detail, and has bathed the scene in the unambiguous light of full day. In Leo-nardo we feel the pull between the omnivorous naturalist and the artist who seeks broad simplifications. The blunt curiosity of the earlier Renaissance seems mixed with the self-conscious distillations of the new century.

Leonardo's mother and child are placed in no ordinary land-scape. Put beside them Ghirlandaio's *Adoration* (Fig. 6), and we compare the bland and obvious to an unfulfilled restlessness. For the familiar scenes of Tuscan life Leonardo has substituted a primordial realm of naked rock. It is as if he had ascended Masaccio's desolate mountains, and come upon those "caverns measureless to man" that lie behind the dawn of human history. Before the figures darkness cloaks a pool or an abyss, a void that we are unable to cross. To the rear saw-toothed forms rise from the bedrock, their sharp profiles cutting the vaporous mist that floats above the river. This stark land supports a few plants, de-scribed by Leonardo with scrupulous accuracy. They survive but do not flourish in a place of perpetual twilight. This light lends the picture its peculiar ineffableness. It touches all, modeling the flesh with morbid softness, plunging shadowed areas into dark-ness. With finality Leonardo has dismissed the blond enameled luster of earlier fifteenth century painting, and suggested that total clarity conforms neither to visual nor imaginative experi-ence.

This lunar geology (so celebrated by Pater) and the light that shrouds it are the evocative agents, but Leonardo's arrangement

of the landscape intensifies the eeriness of his silent world. In the 1473 drawing he had breached a hill in order to suggest depth: here the idea of things seen through things is highly developed, not simply to create space, but as a positive expressive idea. One peers through pierced apertures at serrated ridges in the distance. These are gloomy rocks, dark and barely defined; one with hesitant wonder asks what might lie beyond. There is an ominous note, for the edged roof of stone hangs in precarious balance, threatening at any moment to fall and seal the group in an exitless cavern. Leonardo has moved far from the objective experience of the 1473 drawing.

This cavernous setting, seemingly estranged from the subject matter, can probably be explained specifically by reference to medieval biblical exegesis.[2] More generally, Leonardo seems to suggest that the coming of grace is the culminating event in a world very old, a world where growth and decay of both the organic and the inorganic co-exist in an eternal rhythm. A spiritual mystery is conceived as inseparable from the process of time itself. Whatever the iconographical meaning of the landscape, no patron or literary source suggested its final appearance. The vision is Leonardo's own, and this is what is of high interest. One ponders the particular blend of observation and imagination that resulted in such a picture.

One wonders in short how Leonardo responded to nature. It is a question that cannot be answered, but is certainly worth posing. For a moment we may broaden the question, and inquire how generally men in our culture respond to nature. Perhaps the difference between naturalist and biologist will help us here, a difference eloquently explained by William Morton Wheeler some years ago:

> The naturalist is mentally oriented toward and controlled by objective, concrete reality, and probably because his senses are highly developed, is powerfully affected by the aesthetic appeal of natural objects. He is little interested in and may even be quite blind to abstract or theoretical considerations, and is therefore inclined to say with Goethe: Grau ,Freund, ist alle Theorie,/Und grün des Lebens ewig goldener Baum.

[2] D. W. Robertson, Jr., "In Foraminibus Petrae: A Note on Leonardo's 'Virgin of the Rocks,' " *Renaissance News*, VII (1954, Autumn), pp. 92-95.

The biologist *sensu stricto*, on the other hand, is oriented towards and dominated by ideas, and rather terrified by or oppressed by the intricate hurly-burly of the concrete, sensuous reality, and its multiform and multicolored manifestations. He . . . obtains his esthetic satisfaction from all kinds of analytical procedures and the cold desiccated beauty of logical and mathematical demonstration. His will to power takes the form of experimentation and the controlling of phenomena by capturing them in a net of abstract formulas and laws. . . .[3]

How might this apply to Leonardo? We realize that the attitude of the biologist as Professor Wheeler describes it was only being born in the sixteenth century. But the temperament to nourish it was in many men, the mind of the theorizer as against that of the empiricist. Our problem, then, is roughly this: we wish to know whether Leonardo's response to nature was direct and aesthetic, or whether he sought principles behind the things that he examined.

Objections arise. When a painter lavishes attention upon a landscape, he must be moved aesthetically by a love for real things. He paints, suggesting that we, too, may find these things beautiful. It would seem simple—the landscape painter is perforce a naturalist. Quite right, provided that we treat only of the landscape painter. Our subject, though, is Leonardo, a man for whom painting was but one among many activities. Doubtless these other activities strongly colored his approach to painting. So our problem is really two-fold: Leonardo's attitude in general towards nature, and his attitude as an artist. Perhaps they coincide or are very different.

The "intricate hurly-burly of the concrete" was Leonardo's love. His corpus of drawings and writings leaves no doubt of this. At heart he was Professor Wheeler's naturalist, a man in love with things. But it cannot be left at that. A look at two drawings will be helpful, one a study of flowers, the other of a mountain range (Figs. 22 & 23). Exquisite studies such as the sheet of flowers are a necessary prelude to what we see in the *Virgin of the Rocks*. Usually drawings are a means to an end, which is the finished

[3] Quoted from the ever fascinating anthology, *The Practical Cogitator*, ed. C. P. Curtis, Jr. and F. Greenslet, Boston, 1945, pp. 207-8.

painting, but with Leonardo one feels that the paintings are ulti-
mately a by-product of his activity as a draughtsman. Like all the
artists of his day he made preparatory drawings, but much of
his work was done independently of his paintings, in pursuit of
themes that never left his mind. With whatever intent the
flowers were drawn, they exist independently as records of ob-
served facts (Fig. 22). Examining the seemingly insignificant,
the drawing clarifies the life and strength that paradoxically
reside in frail-looking structures. And who would deny that these
recorded facts are transfigured through love? The sheet is com-
posed with a sensitive feeling for curve and counter-curve, the
flowers pleasingly spaced. Fine lines of shading model the petals
in light and dark, and then continue outward to provide a back-
ground against which the plants may breathe and flourish. One
senses instantly a keen eye and vibrant aesthetic sensibility work-
ing hand in hand. Whether one regards the drawing as the
product of a naturalist, or an artist, is of little matter: in both
cases love springs first from the apprehension of beauty.

But let us take care. It would be easy to forget Leonardo the
scientist, and to replace him with Leonardo the liberator of caged
birds, the lover of all God's creation. The small sketch of an
alpine range may serve as a warning (Fig. 23). These mountains
are towering in monumentality, an effect achieved by the sug-
gestion of thick cloud banks that drift through the lower valleys.
All is seen from an immense distance. The faceted peaks are
sketched with care to reveal the light that plays across their crys-
talline slopes, their profiles gently blurred by the haze. The artist
seems alone and detached from the world. And what is to be
made of this sketch—is it a record of the artist's awe before the
overwhelming spectacle of nature? Perhaps, but Leonardo's words
would suggest otherwise:

> I say that the blueness we see in the atmosphere is not in-
> trinsic color, but is caused by warm vapour evaporated in
> minute and insensible atoms on which the solar rays fall,
> rendering them luminous against the infinite darkness of the
> fiery sphere which lies beyond and includes it. And this
> may be seen, as I saw it, by anyone going up Monboso, a
> peak of the Alps which divides France from Italy. The base

23

of this mountain gives birth to the four rivers which flow in four different directions through the whole of Europe. And no mountain has its base at so great a height as this, which lifts itself above the clouds; and snow seldom falls there, but only hail in the summer, when the clouds are highest. And this hail lies [unmelted] there, so if it were not for the rarity of the clouds there rising and falling, which does not happen twice in a life-time, an enormous mass of ice would be piled up there by the hail, and in the middle of July I found it very considerable. There I saw above me the dark sky, and the sun as it fell on the mountain was far brighter here than in the plains below, because a smaller extent of the atmosphere lay between the summit of the mountain and the sun. Again as an illustration of the color of the atmosphere I will mention the smoke of old and dry wood, which, as it comes out of a chimney, appears to turn very blue, when seen between the eye and the dark distance. . . . (Richter, I, 300)[4]

There is no historical justification for linking these words to the drawing except a similarity in date, but it is likely that such a drawing and such words issued from a common experience. Leonardo begins by describing, but we soon realize that cause and effect move him, that he has posed the child's question as to why the sky is blue. His description completed, he confirms his point by reference to another experience. While at times Leonardo is moved solely by the beauty of nature, at others his drawings seek the principles lying behind the things observed. Often his motives cannot be separated, for emotional response and intellectual inquiry are bound together. The will to understand through analysis and formulation of principles was strong in Leonardo. Had he been born later, we would possibly recognize the biologist in him more clearly.

The objects treated in so many of Leonardo's drawings are here in the *Virgin of the Rocks*: plants, rocks and water, water which nourishes the one and destroys the other. But it is an eerie and mood-laden setting very different from the sketches. We are prompted to ask what it means, and how it was born in Leo-

[4] J. P. Richter, *The Literary Works of Leonardo da Vinci*, 2 vols., London, 1939.

nardo's mind. We wonder above all whether such a vision can issue from experience, or whether it is a glorious phantom of the imagination.

Leonardo's faith in experience is clearly expressed throughout his writings:

They say that knowledge born of experience is mechanical, but that born and consummated in the mind is scientific, while knowledge born of science and culminating in manual work is semi-mechanical. But it seems to me that all sciences are vain and full of errors that are not born of experience, mother of all certainty, and that are not tested by experience, that is to say, that do not at their origin, middle, or end pass through any of the five senses. (Richter, 1, 6)

Leonardo's idea of the nature of painting as an activity is in full accord with this:

If you despise painting, which is the sole imitator of all visible works of nature, you certainly will be despising a subtle invention which brings philosophy and subtle speculation to bear on the nature of all forms—sea and land, plants and animals, grasses and flowers—which are enveloped in light and shade. Truly painting is a science, the true-born child of nature. For painting is born of nature; to be more correct we should call it the grandchild of nature, since all visible things were brought forth by nature and these, her children, have given birth to painting. Therefore we may justly speak of it as the grandchild of nature and as related to God. (Richter, 1, 13)

Yet these coolly reasoned propositions stem ultimately from Leonardo's warm response to natural things. This is how he defends the first among the arts:

What induces you, oh man, to depart from your home in town, to leave parents and friends, and to go to the countryside over mountains and valleys, if not the beauty of the world of nature which, on considering, you can only enjoy through the sense of sight; and as the poet in this also wants to compete with the painter, why do you not take the poet's description of such landscapes and stay at home without exposing

25

yourself to the excessive heat of the sun? Would that not be more expedient and less fatiguing, since you could stay in a cool place without moving about and exposing yourself to illness? But your soul could not enjoy the pleasures that come to it through the eyes, the windows of its habitation, it could not receive the reflections of bright places, it could not see the shady valleys watered by the play of meandering rivers, it could not see the many flowers which with their various colours compose harmonies for the eyes, nor all the other things which may present themselves to the eye. (Richter, I, 27)

Leonardo's purpose here is to vaunt painting at the expense of poetry, but his words issue as much from the heart as from the mind.

Love of nature, belief in painting as a means of recording experience; it still will not do. Leonardo's *Virgin of the Rocks* passes beyond these into the far reaches of the imagination. Leonardo rarely discusses the imagination, yet it ran strongly within him. It was he, after all, who suggested that landscapes might be conjured up by contemplating the stains upon a wall.

The genesis of the haunting landscape in Leonardo's altarpiece will never be known, but it would be strange if it did not begin in experience, and then mature in the imagination. Leonardo's whereabouts during much of the 1470's is unknown, but it seems possible that these were years of wandering which took him the length of the peninsula. He appears to have visited the island of Sicily, and there to have explored the slopes of Etna. An account of such an expedition is startlingly similar to the setting in the *Virgin of the Rocks*:

Unable to resist my eager desire and wanting to see the great multitude of various and strange shapes made by formative nature, and having wandered some distance among gloomy rocks, I came to the entrance of a great cavern, in front of which I stood some time, astonished and unaware of such a thing. Bending my back into an arch I rested my tired hand on my knee and held my right hand over my downcast and contracted eyebrows: often bending first one way and then the other, to see whether I could discover any-

thing inside, and this being forbidden by the deep darkness within, and after having remained there for some time, two contrary emotions arose in me, fear and desire—fear of the threatening dark cavern, desire to see whether there were any marvellous things within it. . . . (Richter, II, 1339)

In this way the *Virgin of the Rocks* may have been born.[5] The appeal was in the first moment to experience, but over the years— the *Virgin of the Rocks, Mona Lisa*, the Louvre *Virgin and Saint Anne*—the experience became a recurrent dream. "Why does the eye see a thing more clearly in dreams than with the imagination awake?" The question is to the point, and it is Leonardo's own (Richter, II, 1144).

The meaning of the *Virgin of the Rocks* remains a mystery. In the spread between topography and poetry, Leonardo the painter is a poet supreme. His art suggests nothing obvious, and we should be content that the mood of his landscapes be undefined. But a final question remains, the least answerable of all. Many of Leonardo's drawings seek more than appearances. Do his painted landscapes search for something beyond evocative mood, and is this search bound up in any way with the empirical side of his activities?

At about 1500 and a little after are dated the famous *Mona Lisa* and a red chalk drawing of a storm in the Alps (Figs. 21, 25, 26). The comparison is purely visual, for once again there is no demonstrable historical link between the two. But how alike they are, and on second look, how different. Both are conceived from a high viewpoint, as was Leonardo's wont. In neither does he indicate a measurable distance from our eye to the first sight of earth at the foot of the picture. Not only is the land seen from on high, but it is an expansive vista on a heroic scale, carved from the raw rock of young mountains, and softened by a layer of atmosphere.

These things noticed, differences abound. The drawing is a probability: somewhere, at some time, the eye might have seen this. The gently rolling foothills, steep peaks, the compressed rolls of clouds—none of these try our experience. The buildings and

[5] The association between painting and written passage was suggested by Charles De Tolnay.

ordered trees that dot the valley floor characterize a land that is in-habited, in fact civilized.

Behind Mona Lisa looms another world. There is the winding road and a stone bridge spanning a stream, but these are forlorn signs of man's presence in a barren landscape. Beyond the valley earth color gives way to steel blue. A high plateau rises on the right, but plunges drastically downward to the left so that the land seems out of joint. The rocks are shrouded, and melt towards a horizonless distance. Glacial in its icy damp, this is a forbidden land where like Leonardo before the cave, one stands in wonder, but dares not go on.

Differences between the two works feed our speculation. In the drawing we may see simply the record of a spectacular view. Or, and I am inclined to this, it may show Leonardo's growing in-terest in process, in the nature of change. Behind Mona Lisa the landscape is a vivid image from Leonardo's recurring dream, evoking a mood that comments upon the enigmatic figure. One wonders what common bond might unite the two works.

To look more carefully at the mountain drawing is to see that the storm is the real subject matter. One's eye catches the area where the chalk has pressed down hardest. It is no mere vague notation, but an economical description of the movement of wind and rain during a mountain storm. Rain plummets straight down-ward from a central cloud mass, while a rush of air warps water against the mountain sides. The circular motion that Leonardo had used in the 1473 drawing to indicate windblown trees here expands to become the churning turbulence of an electrical storm. Less and less is Leonardo content to record stationary fact; the process of movement and change now increasingly fascinates him.

> When the air is condensed to rain it would produce a vacuum if the rest of the air did not prevent this by filling its place, as it does with a violent rush; and this is the wind which rises in the summer, accompanied by heavy rain. (Richter, 1, 480)

This would serve as a fine explanatory caption for the thunder-storm drawing.

The motivation for many such investigations is concisely given by Leonardo:

In nature there is no effect without cause; once the cause is understood there is no need to test it by experience. (Richter, II, 1148B)

Western culture was surely born when men first realized that their experiences might be rationally explained, that there might be unity behind the variety of experiences. The idea was the Greeks', but no one before him had seen as Leonardo saw, nor had made sight a prerequisite to speculation. If read correctly, Leonardo's words and sketches reveal his importance as a thinker, not simply as an eye.

But what of landscape in his paintings, in particular, in the *Mona Lisa*? For Leonardo, as for all great artists, the landscape was a vehicle to convey mood—but was it more than that?

For Giorgio Vasari, born a few years after the portrait was painted, she was simply a marvel of art. He lovingly describes her bright and moist eyes, the tints of flesh and lips, the miracle of paint become incarnate. He gives no hint that an enigma is hidden in this marvel of art. Of course Vasari never saw the painting, in 1550 long since passed to France. His lines were inspired by copies and the words of others, but they are surely an accurate reflection of the reputation the painting enjoyed as a miracle of naturalism. The flaccid hands, the inscrutable smile, the vaporous landscape—of all this we have no mention. For Vasari, the often sensitive critic, the mystery of the *Mona Lisa* had no meaning because it did not exist.

Exist it did for another man, Walter Pater, who nearly a century ago impressed forever the enigma upon the consciousness of the West: "The presence that rose thus so strangely beside the waters, is expressive of what in the ways of a thousand years men had come to desire."[6] Like some inebriating incense, Pater's heady passage wafts back into the memory. We remember his omniscient Mona Lisa, "older than the rocks among which she sits," a diver in deep seas who keeps their fallen day about her, at once Leda and Saint Anne, and like the vampire, many times dead. We may find Pater's words extravagant, unfounded, a blatant tour de force.

[6] Walter Pater, *The Renaissance*, London, 1888, pp. 129-30.

But they are also unforgettably beautiful, a critical flight which, Phoenix-like, becomes a new and original work of art.

And there, for better or for worse, lies the power of criticism. We have no choice in the matter; Pater's words have become an inextricable part of Leonardo's lady, and having read them, we can never again see her in quite the same way. She has become precious, omniscient, ambiguous. Though these qualities may have issued more from a neurotically refined sensibility in an ill-lit Victorian study than from Leonardo's brush, they cannot be expunged from our critical consciousness.

Though let it be said that mid-twentieth century democracy has tried its best. Mona Lisa, Italian by birth and Gallic by adoption, traveled to America. She has become one of us, a somewhat eccentric but acceptable neighbor.

It is not a question whether Vasari, Pater, the American public or anyone else is "right," for the meaning of any picture lies in the dialogue between it and a beholder at a given moment. Yet one wonders whether there are not observable qualities in the painting itself which vindicate the very basis of Pater's critical flight. There would seem to be, and in abundance. The slightly asymmetrical smile has provoked the most comment, but it is only one, and not the most important, peculiarity of the painting. How acceptable it is compared to those flaccid and pneumatic hands, loathsome to touch but charged with potential power. Or consider the eyes which smile in accord with the thin lips, but whose gaze avoids ours. There is none of that warmth of recognition which we feel while before Raphael's *Baldassare Castiglione,* a portrait based upon the *Mona Lisa* and near her in the Louvre. Or again the "fallen day" of Leonardo's chiaroscuro must suggest the accidental rather than the normative, and the strange asymmetry of the entire face leaves us in doubt about the position of the head. All these qualities are more intuited than explicitly apprehended, and so produce a heightened effect of restlessness and unresolved tensions.

Our digression has been purposeful, for *Mona Lisa* is a total picture, and no aspect of it stands scrutiny in isolation. The picture is full of formal ambiguities, but it is the relation of the sitter and the eerie geology behind her which is most evocative. It is the landscape both of the earlier *Virgin of the Rocks* and of the later

Madonna and Saint Anne. Reasonably we should conclude that Leonardo's fantasy world of sharp escarpments and flowing waters is unchanging, and not profoundly related to the various figures placed before it. Perhaps just the reverse is true, that for Leonardo the narrative subject matter was of lesser interest than his constant concern, the appearance, structure, and functioning of the earth itself. Facts of the Christian story and mysteries of a human soul were vital interests in so far as they were parts of the cosmic system.

Seen in this light, in *Mona Lisa* is the complement to the primordial world of the cave. Its riddle is hers, and in both lies buried the life pulse of the universe. As artistic form, cave and lady suggest the ineffable through calculated ambiguities and unresolved tensions. Leonardo's essential belief in the oneness of man and the world, in the life forces which flow through both, appears in his words on the relation of the Microcosm and Macrocosm:

> By the ancients man has been called the world in miniature; and certainly this name is well bestowed, because, inasmuch as man is composed of earth, water, air, and fire, his body resembles that of the earth; and as man has in him bones, the supports and framework of his flesh, the world has its rocks, the supports of the earth; as man has in him a pool of blood in which the lungs rise and fall in breathing, so the body of the earth has its ocean tide which likewise rises and falls every six hours, as if the world had breathed; as in that pool of blood veins have their origin, which ramify all over the human body, so likewise the ocean sea fills the body of the earth with infinite springs of water. The body of the earth lacks sinews, and this is because the sinews are made expressly for movements and, the world being perpetually stable, no movement takes place, and, no movement taking place, muscles are not necessary. But in all other points they are much alike. (Richter, II, 929)

Strange words. They testify to old and quaint beliefs untested by experience. When Leonardo sought to comprehend the ultimate riddle, his sensory data failed him. He fell back upon tradition for an all-encompassing scheme, groping instinctively for

some principle of coherence. We need not think that he believed in it literally; rather it was a metaphor for his intuition. *Mona Lisa* stands as a symbol of that intuition. In the uncontrollable forces of a mountain storm, and in that lady's soul Leonardo found the oneness of things.[7]

So Mona Lisa wears a number of faces. She is the naturalistic product of an acute vision, as Vasari saw her. And for Pater, she is the symbol of omnipotence and omniscience, "the embodiment of the old fancy, the symbol of the modern idea." The reading of the picture will shift through the years, but it is doubtful that either Vasari's uncomplicated adulation or Pater's vision will ever again do. Somewhere between the two extremes must lie the truth, though it will never be accurately circumscribed. This is the truth of Leonardo the thinker, whose ideas metamorphose in paint under the touch of poetry. The creator of *Mona Lisa,* to quote a later poet, belongs to that breed of intellect "forever voyaging through strange seas of thought alone."

From what has been said so far it becomes clear that the art of landscape painting is only secondarily the imitation of a scene from nature, if it is that at all. The topographical aspect of a painting is often striking, but the creation of an illusion of three-dimensional space upon a two-dimensional surface is the painter's first concern. Leonardo loved the variety of objects around him, and his drawings show that he was capable of transcribing them with unrelenting accuracy. But in a painting his goal was always artistic plausibility, not a mere counterfeiting of what the eye sees. Further, for Leonardo and for many after him, the poetic aspect of a landscape was far more important than its topographical verisimilitude. His essential modernity as a landscapist is the discovery of mood as the content of landscape. Any attempt to talk seriously about landscape in a painting must find the slippery word "mood" an inescapable starting point. In short, in its aim

[7] Leonardo in his landscapes was concerned with the flux behind appearances. The idea is neither new nor demonstrable, and would require a volume of judicious argument before it would pass beyond the realm of generalization. Scholars have endowed Leonardo with every possible sort of mind. He has been seen as a profound philosophic intelligence, an untutored practical genius, and almost every shade of intellect between the two. A lucid introduction to this vast problem and literature is Eugenio Garin's essay, "La cultura fiorentina," in *Medioevo e Rinascimento*, Bari, 1961.

(the evocation of a mood) and in its means (the creation of an illusionistic space) landscape is a branch of painting with its own problems and rules. To speak of it in terms of the imitation of nature is to miss the point, but to consider it as more of the emotions than of the intellect, and hence like in quality to man's reaction to natural beauty, is to begin aright. Only then will we perceive how the artist's intellect has operated in order to achieve his evocative results.

A puzzling question remains. Why did not Leonardo go the whole way, and paint landscape as a thing in itself? He possessed the qualifications of a landscapist in abundance. He had a keen feeling for appearances, and was able to transcribe them down to the smallest details. More important, he had pondered thoroughly the problem of how to create illusionistic space. That the moods of nature appealed to him is certain, and it was mood that he cultivated in his backgrounds. Finally, Leonardo's own writings eloquently support the activity of landscape painting:

> If the painter wishes to see beauties that charm him it lies in his power to create them, and if he wishes to see monstrosities that are frightful, buffoonish, or ridiculous, or pitiable, he can be lord and creator thereof; and if he wishes to produce inhabited regions or deserts, or dark and cool retreats from the heat, or warm places for cold weather, he can do so. If he wants valleys likewise if he wants from high mountain tops to unfold a great plain extending down to the sea's horizon, he is lord to do so; and likewise if from low plains he wishes to see high mountains, or from high mountains low plains and the seashore. In fact, whatever exists in the universe, in essence, in appearance, in the imagination, the painter has first in mind and then in his hands; and these are of such excellence that they are able to represent a proportioned and harmonious view of the whole that can be seen simultaneously, at one glance, just as things in nature. (Richter, I, 19)

Could a manifesto be more broad-ranging, or boast more for the painter? What Pico claimed for man's free will, Leonardo claimed for the painter: no task is beyond him who reaches for the heavens. Though he possessed the skill of a landscapist, Leo-

nardo never did a pure landscape painting, nor is there any reason to suppose that the idea ever entered his mind. This apparent anomaly between theory and practice vanishes on reflection.

Landscape as an end in itself did not exist as an idea in fifteenth century Italy. It was neither censured nor condoned; as a genre of painting it simply had not been born. Christian subjects, portraiture, mythology; these the patron demanded and got. Landscape first became a specialized genre in the north of Europe, and the paintings of these northerners were exported to Italy where they were received with growing enthusiasm after 1500.

Surely, though, it is men as well as the impersonal course of events that determine history. Had Leonardo been moved to paint landscape for its own sake, he would have done so. No man relied less upon precedent. But he was not so moved, and the reasons are not far to seek.

First, we must not be deluded by the fallacy of awareness. By this I mean the school of thought that argues that at a certain point man became poignantly aware of the landscape around him, and so began to paint it. As we have already seen, it is one thing to feel the beauties of nature and quite another to convert this feeling into some sort of artistic expression. So Leonardo may have looked on the world with love, but it did not occur to him to broaden the range of permissible subject matter accepted by his age.

Further, Leonardo's words quoted above, so clearly a carte blanche for the landscapist, must be explained. In context, Leonardo is arguing the superiority of painting over sculpture. He writes that the painter may represent not only man but also man's environment, an impossibility for the sculptor. Leonardo does not propose new horizons for the painter but simply says how very much wider are the limits of his art than is generally supposed. He does not suggest that all these wondrous things be painted for their own sake, only that they are available to support and adorn the proper concern of the artist, the study of man.

A man paints landscape because he loves nature, or because his patrons demand it of him. The latter demand did not exist for Leonardo, and the former was sublimated outside the art of painting. Leonardo's cravings as a naturalist seem to have been fulfilled by countless drawings, and his more theoretical specula-

tions were satisfied by drawings and the written word. His re-actions were spontaneous, and so expressed in a spontaneous me-dium, drawing. Painting is arduous work. What remains in Leo-nardo's pictures that is uncomplicatedly direct is the attention given flowers, grasses, pebbles on the ground. But the major in-tellectual effort he put into a picture is but remotely connected with the love of natural things. That intellectual effort was pic-ture-making, and for Leonardo and his age picture-making was the presentation of the actions and emotions of men. From the melancholic image of Ginevra de' Benci to the sickening path-ological Saint John, Leonardo sought the humors of the human soul. All else was accessory to this central concern.

But there is a profounder reason why Leonardo never became a landscape painter. His final years are marked by a disenchant-ment with appearances and with static fact. His intellect turned in upon itself, and art could no longer satisfy him. Vasari tells us that the years in Rome after 1513 were spent largely on philos-ophy and alchemy, in the construction of strange flying animals, in the mixing of varnishes for pictures that were never painted. Dilatory dreams enchanted the aging master, by now a venerable eccentric in a busy court.

A series of drawings and brief writings from these years form what we might call Leonardo's "concluding unscientific post-script." These are the visions that describe the end of the world in flood. Leonardo's eschatological speculations burned brightly in his mind's eye. At times his words sound like a detached em-pirical observation, so clearly did he read his own imagination:

> Let the dark and gloomy air be seen buffetted by the rush
> of contrary winds and dense from the continued rain mingled
> with hail and bearing hither and thither an infinite number
> of branches torn from trees and mixed with numberless
> leaves. All round may be seen venerable trees, uprooted and
> stripped by the fury of the winds; and fragments of moun-
> tains, already scoured bare by torrents, falling into those tor-
> rents and choking their valleys till the swollen rivers over-
> flow and submerge the wide lands and their inhabitants.
> Again, you might have seen on many of the hilltops terrified
> animals of different kinds, collected together and subdued

35

to tameness, in company with men and women who had
fled with their children. The waters which covered the fields
with their waves were in great part strewn with tables, bed-
steads, boats and various other contrivances made from neces-
sity and fear of death, on which were men and women with
their children amid sounds of lamentation and weeping, ter-
rified by the fury of the winds which with their tempestuous
violence rolled the waters under and over and about the
bodies of the drowned. Nor was there any object lighter than
the water which was not covered with a variety of animals
which, having come to a truce, stood together in a frightened
crowd—among them wolves, foxes, snakes and others—flee-
ing from death. And all the waters dashing on their shores
seemed to be beating them with the blows of drowned bodies,
blows which killed those in whom any life remained. . . . Ah!
what dreadful noises were heard in the dark air rent by the
fury of thunder and lightnings it flashed forth, which darted
from the clouds dealing ruin and striking all that opposed
its course. . . . Huge branches of great oaks loaded with men
were seen borne through the air by the impetuous fury of the
winds. How many were the boats upset, some entire, and
some broken in pieces, with people on them laboring to
escape with gestures and actions of grief foretelling a fearful
death. Others, with gestures of despair, took their own lives,
hopeless of being able to endure such suffering; and of these
some flung themselves from lofty rocks, others strangled
themselves with their own hands, others seized their own
children and violently slew them at a blow; some wounded
and killed themselves with their own weapons; others, fall-
ing on their knees, recommended themselves to God. . . .
Already the birds had begun to settle on man and other
animals, finding no land uncovered which was not occupied
by living beings, and already had famine, the minister of
death, taken the lives of the greater number of the animals,
when the dead bodies, now fermented, were leaving the
depths of the waters and rising to the top. Among the buf-
fetting waves, where they were beating one against the other,
and, as balls full of air, rebounded from the point of con-
cussion, these found a resting place on the bodies of the dead.

And above these judgments, the air was seen covered with
dark clouds, riven by the forked flashes of the raging bolts
of heaven, lighting up on all sides the depth of the gloom.
(Richter, I, 608)

Why do I call this a "concluding unscientific postscript"? Be-
cause the strange subject bespeaks anxieties harbored in Leo-
nardo's consciousness, the nightmare of final judgment. Because
Leonardo had seen all, recorded all, and now left it behind, his
empirical mind shifted wholly into the limitlessness of the imag-
ination where it was free to envision the chaos of doom.

In one of the more beautiful of the deluge drawings (Fig. 24),
a velvet line undulates in a supple rhythm, seeming to describe
the thin tresses of a woman's hair. So subtle is the spacing on the
sheet and the variety of linear motion that it is some time before
it occurs to us to seek subject matter. Only then is the paradox
discovered that supreme delicacy has become a vehicle descriptive
of cataclysmic destruction. To the left clumps of trees are violently
uprooted by tight whirlpools of lashed water, and on the right
caught up in the onslaught of the waves. Tongues of water,
measured in tons, churn out from a heavy cloud above. The
identity of all things is swallowed in a relentless return to chaos.

Leonardo's speculations had carried him beyond *mimesis*, be-
yond any desire to evoke the moods of landscape. Rocks, foliage,
and water had fascinated him all his life, and now at the end they
become the chief actors in a spectacle of destruction. These draw-
ings were the culmination of the drive to investigate motion, the
life process in which death alone is the final moment. Leonardo's
quest, come to a climax in the shadow of such untroubled souls
as Leo X and Raphael, had taken him out of his profession as a
painter and out of the discourse of his age.

Now you see that the hope and desire of returning to the
first state of chaos is like the moth to the light, and that the
man who with constant longing awaits with joy each new
springtime, each new summer, each new month and new
year—deeming that the things he longs for are ever too late in
coming—does not perceive that he is longing for his own
destruction. But this desire is the very quintessence, the spirit

37

of the elements, which finding itself imprisoned with the soul is ever longing to return from the human body to its giver. And you must know that this same longing is that quintessence, inseparable from nature, and that man is the image of the world. (Richter, II, 1162)

For "paradise," whoever would wish to define it narrowly, means nothing other than a most pleasant garden, abundant with all pleasing and delightful things, of trees, apples, flowers, vivid running waters, song of birds, and in effect all the amenities dreamed of by the heart of man; and by this one can affirm that paradise was where there was a beautiful woman, for here was a copy of every amenity and sweetness, that a kind heart might desire.

THESE lines are by Lorenzo il Magnifico, a part of a commentary upon his sonnets.[1] The passage captures in microcosm much of the later fifteenth century feeling for nature. Time and again we find ourselves in a meadow laced with meandering brooks, where flowers dot the grassy glades. Trees extend their cool shadows across the landscape, and as a lovely apparition appears a lithe lady, her blond tresses garlanded with flowers.

This imaginary landscape belongs to the world of letters; its props and stylizations are the traditional imagery of the *locus amoenus*, the pleasant place. One may argue that this is the dominant vision of landscape in later fifteenth century Florence because in these years literature rather than the visual arts conveys the main streams of thought.

Like most interesting ideas, so this one is debatable, but doubtless partly true. Much of what needs to be said about the early Renaissance is evoked through such names as Donatello, Masaccio, and Brunelleschi, for theirs was a public and heroic art, direct in its message. By the end of the century their forceful clarity disappears. In its place one finds the exquisite sensitivities of a Botticelli, the private eccentricities of a Piero di Cosimo. To grasp the core of this culture, one should read the poetry of Lorenzo and Poliziano, the pseudo-philosophy of Ficino, the prophetic words of Savonarola. Seen as complementary to literature, the visual arts gain in meaning: to oversimplify the case, a visual and

[1] Lorenzo de' Medici, *Opere*, ed. by A. Simioni, Bari, 1939, 1, p. 42. All quotes from Lorenzo's poetry are from this edition, though I have given exact reference below only to the most important.

empirical Renaissance had evolved into a largely literary and esoteric one.

Perhaps this is why Leonardo da Vinci left Florence in 1482, not to return for two decades. The literary climate may have been profoundly distasteful to the man who believed experience the measure of all things. As his letter to Lodovico il Moro would suggest, he perhaps sought patronage where his practical genius could find broader expression. So he moved from the verbal elegance of Lorenzo's circle to the tough-minded atmosphere of ducal Milan.[2]

Whatever the reasons for his move, landscape painting evolved without following the suggestions of Leonardo's earliest pictures. The desire for a topographical landscape, so strong in the sixties and seventies, gave way to a series of set conventions. In a history of landscape morphology, I might trace these conventions, and underscore the great importance of events such as the decoration of the Sistine Chapel in 1481-1482, and the arrival of Hugo van der Goes' *Portinari Altarpiece* in Florence. Further I would stress the quality of Perugino's landscape, that disarming simplicity where great spaces are bathed in a dust-free atmosphere, and where objects are precisely defined in a world of limpid clarity.

But the morphology I shall leave until another time and Perugino to the memorable pages of Bernard Berenson. Instead we shall concentrate upon one of the most tantalizing of Renaissance painters, Piero di Cosimo.[3] So individual is he that the author of a recent handbook of Italian painting has relegated him to an appendix, apparently perplexed by this bizarre personality. However, Piero's landscape art surely makes him a cen-

[2] Leonardo may have left Florence not only because he found the intellectual climate distasteful, but because he discovered that the conditions of patronage in Florence were not so generous as we are inclined to suppose. On this, A. Chastel, *Art et humanisme à Florence au temps de Laurent le Magnifique*, Paris, 1961, p. 15.

[3] The stylistic development of Piero and the iconography of many of his pictures remain problematic. As yet there is no satisfying monograph. The latest treatment of his art is by Luigi Grassi, in a *dispensa* for the University of Rome: *Piero di Cosimo e il problema della conversione al Cinquecento nella pittura fiorentina ed emiliana*, Rome, 1963. Lists earlier bibliography, including the good article by F. Zeri, "Rivedendo Piero di Cosimo," *Paragone*, IX, 115 (1959), pp. 36-50.

tral figure in his age. He was one of the first to paint pictures which might reasonably be called landscape paintings, and through these landscapes he sought to convey definite ideas about the life of man in a younger stage of history. Though Piero seems unique, we shall find that his art bears comparison to the sensibilities and conceits of Florentine literature. In him there is violence but also compassionate tenderness, and in depth of feeling he is almost unique in his time.

Though documented facts are few, Piero the man lives vividly in the biographical portrait offered by Giorgio Vasari. Part of Vasari's knowledge of Piero's life may have been deduced shrewdly from paintings, one of which was in the Aretine's own collection. He tells us that Piero served his apprenticeship in the shops of the popular but uninspired Cosimo Rosselli, and this suggests that Piero early acquired the usual bag of pictorial tricks but otherwise had no special education. The painter lived out his life in Florence, patronized by those solid businessmen who were the foundation of Florentine stability. It would seem a dull and uneventful existence, but Vasari leaves no doubts concerning the great rarity of Piero's imagination. He tells us that as an apprentice Piero already was considered a peculiar and abstracted fellow. The artist shunned people, and became a recluse who rarely wandered from his own house. Working in filth, he would fortify himself with hardboiled eggs, which he prepared in batches of fifty. His windows must have been sealed tight, for the crying of babies, the sound of church bells, and clamor of singing friars all revolted him. But these eccentricities go forgiven, for Piero was wrapped up in his own capricious and extravagant imagination. He built castles in the air, and contemplated sputum spattered upon a wall, drawing from it the visions of fantastic cities and extraordinary landscapes. This imagination, drawn to the unusual and bizarre, was devoted especially to the plants and creatures of nature. Piero allowed his yard to grow wild, feeling that nature should be her own mistress, and kept a sketchbook full of drawings of animals. With the passing years the artist grew ever more eccentric, until he seemed an unbearable individual. His strange existence ended long after he had become an anachronism in his own time.

Vasari's account is fascinating reading: *se non è vero, è ben*

trovato. We are introduced to a solitary soul guided by an un-bridled imagination, a man unlikely to indulge in conventional forms and iconography. Attempts to find precise meanings for his pictures may miss the mark, for he dreamed dreams, and they richly colored his work.

Piero's vision of landscapes crystallizes in two panels in the Metropolitan Museum, the *Hunt* and the *Return from the Hunt* (Figs. 27 & 28).[4] This is no hunt for sport, as is celebrated in the poetry of Lorenzo de' Medici, but an unsettling vision of the brutal dawn of human existence. The *Hunt* depicts ruthless vio-lence broken forth within a hybrid community. Animal battles animal, as teeth lacerate flesh and gouge out eyes. Repulsive men and hirsute satyrs stalk the woods, bludgeoning the beasts into insensibility. Rough skins clothe their bodies, and their faces are masked in primordial bewilderment. Here and there death has already come, to a dog turned turtle on the left, to a human corpse on the right, ligaments locked in *rigor mortis* and flesh drained of color.

The occasion for this massacre is a flaming forest fire, which flashes from the woods in a spew of sparks and smoke. Its flames drive every beast before them into the path of the waiting hunters. The conflagration is the terrifying principal fact of the picture, spreading as it does from the center, its bright yellow and orange flames leaping from the somber shades of brown and green that describe the landscape. No pleasant picture, this: we are shown man before he became human, asserting his superior intelligence in a manner little better than bestial.

The companion painting, *Return from the Hunt,* is less violent only because the killing is now out of sight. Hunters in crudely-hewn boats bring the game back to their waiting women. The forest still burns across the bay, and animals swim out from shore in order to escape the dual calamity wrought by man and nature. In the distance other boats move forward beneath a pall of smoke to take up the slaughter on the far shore. This somber and sooty

[4] I am indebted in general and in detail to Erwin Panofsky's fine study, "The Early History of Man in Two Cycles of Paintings by Piero di Cosimo," *Studies in Iconology,* New York, 1962 (first published in 1939). My pages speculate upon some of the less tangible aspects of this subject matter, and also attempt to point out the paradoxical contrast between the brutal and lyric in Piero's work.

panel is brutal, but we glimpse the hesitant beginnings of civilized human relationships.

To this pair of panels we may add a third, probably related to them originally, for it is similar in theme, format and style. This is *Forest Fire,* in the Ashmolean Museum (Fig. 29). Once again the leading idea of the picture is a conflagration. It glows fiercely midst a thick grove of trees, driving birds and animals from the wood. Flocks of birds speckle the sky, while beasts swim a stream and lope swiftly across the meadows. No hunters await these creatures, only a shepherd who walks towards his cottage in the background. His folk gesticulate excitedly towards the fanning flames while once out of the forest the beasts seem to forget their peril, and wander aimlessly about the landscape. Human activity plays a small part in this clearing, and instead we are fascinated by a menagerie, both domesticated and wild. Hawks, bears, lions—all manner of animals wander forth. What in the Metropolitan panels had been a frightful slaughter is here almost a child's delight. The air is bright, and the smoke is dispersed quickly as it rises from the wood. This fire burst forth in the full light of day seems bereft of ominous possibilities until one notices that some of these beasts are hybrids born of the union of animals and men.

In these panels Piero came as close as anyone in his age to the creation of what we call a landscape painting. None of these panels would seem to be explained by an exact narrative text, and in the *Forest Fire* man has all but disappeared, leaving the relation of animals to natural phenomena as the proper subject of the painting. A freak of nature, a forest fire, governs activity in this world. In the *Hunt* man is not even clearly separable from surrounding nature, for we find animal, man, and strange hybrids of the two, all equally children of the wooded hills, all responding to the instinctive dictates of survival.

Piero's world of landscape is a carefully reasoned artifice. One is immediately aware of an object, a stump or a tree, directly on the picture plane. This offers the eye something to see around and past, a gauge to measure space. Once into the foreground the eye is stopped at either end of the composition, and funneled towards the principal spatial device of the picture, which in the *Hunt* and the *Forest Fire* is virtually identical. In the near middle distance

two stage wings, a hill or a copse of trees, block the view and direct the eye towards the center of the panel. One's eye is then drawn back to a central mass, the forest in which the fire rages. From here, the line of vision is forced to shoot off towards the horizon on two diverging tangents. This spatial formula, a development of experiments made earlier in the Sistine Chapel, had attractive advantages. By minimizing the sky, Piero could create a color pattern that would function as fine decoration, an important consideration for a set of panels made to adorn a room. But within this pattern Piero might also elaborate an intricate structure in depth which leads the eye through carefully worked avenues of space.

One is struck by the thought that some of the blunt force of these panels is a question of form as well as subject matter. Barren trees are etched in hard outline, as are the edges of hillocks and silhouettes—outline that offers a heightened sense of pattern. Color strengthens this pattern and silhouette, for with frank lack of subtlety it describes circumscribed shapes. On first seeing the *Forest Fire,* one feels the dominant color scheme of green, brown, and sky blue which serves as a ground for such defined color spots as the flying birds seen against the sky on the right, and the buff and gray animals in the foreground.

These three panels suggest the paradox that permeates much of Piero's work. We are confronted with a compelling combination of the sinister and the disarmingly naive. Fire threatens to destroy the balance of nature, and man wanders about the landscape as King of the animals but little better than an animal himself. This world of flame, soot, and death is presented in clear and forceful imagery, so that the least thought of the nostalgic or delicate is throttled within us. But on the other hand, who can really believe the fine ox which stands open-mouthed before the forest fire, or the abstract pattern of birds which fills the sky? They belong to the world of the very young, where toys are carved from soft wood and then lacquered brightly. Ultimately Piero is the beneficiary of that gay fantastic, Paolo Uccello.[5]

[5] It would be interesting to see those lost paintings of animal combats which Uccello did for the Palazzo Medici, a general idea of which can be deduced from contemporary engravings. They probably conveyed brutal violence through almost naively simplified forms, the very quality of Piero's panels. For the

Piero's highly imaginative vision is presented with unfaltering clarity. This mind dwelt upon images from the early life of mankind, and saw there brutality and unrelieved hardship. One can only speculate on the manner of man who conceived these pictures, but there seems little question that he was widely read. In the Roman writers he would have found accounts of the customs and rites of primitive men, and passages such as Ovid's description of the Arcadians probably would have fired his imagination:

> The Arcadians are said to have possessed their land before the birth of Jove, and that folk is older than the moon. Their life was like that of beasts, unprofitably spent; artless as yet and raw was the common herd. Leaves did they use for houses, herbs for corn: water scooped up in two hollows of the hands to them was nectar. No bull panted under the weight of the bent ploughshare: no land was under the dominion of the husbandman: there was as yet no use for horses, every man carried his own weight: the sheep went clothed in its own wool. Under the open sky they lived and went about naked, inured to heavy showers and rainy winds. Even to this day the unclad ministers recall the memory of the olden custom and attest what comforts the ancients knew. (Ovid, *Fasti*, II, 284ff., Loeb ed.)

Ovid was but one of many ancient authors consulted by Piero, at times through modern intermediaries such as Boccaccio. From Lucretius he might have derived the idea of hybrid beings as the offspring of man and beast, and from more than one author the image of the forest fire. Vitruvius and Pliny, Lucretius and Diodorus Siculus—all describe a terrifying forest fire whose ultimate legacy was the domestication of man. Before the fire man fled, but then returned and felt the warming power of the flames. So fire was recognized as a useful as well as a destructive force, and its powers were harnessed by man. With this new power came the advent of speech and the establishment of communal life. Vitruvius gives a full account of this somewhat quaint idea:

lost Uccellos and engravings related to them: J. Pope-Hennessy, *Paolo Uccello*, London, 1950, p. 172.

Men, in the old way, were born like animals in forests and
caves and woods, and passed their life feeding on the food of
the fields. Meanwhile, once upon a time, in a certain place,
trees, thickly crowded, tossed by storms and winds and rub-
bing their branches together, kindled a fire. Terrified by the
raging flame, those who were about the place were put to
flight. Afterwards when the thing was quieted down, ap-
proaching nearer they perceived that the advantage was great
for their bodies from the heat of the fire. They added fuel,
and thus keeping it up, they brought others; and pointing it
out by signs they showed what advantages they had from it.
In this concourse of mankind, when sounds were variously
uttered by the breath, by daily custom they fixed words as
they chanced to come. Then, indicating things more fre-
quently and by habit, they came by chance to speak accord-
ing to the event, and so they generated conversation with one
another. Therefore, because of the discovery of fire, there
arose at the beginning, concourse among men, deliberation
and a life in common. Many came together into one place,
having from nature this boon beyond other animals, that
they should walk, not with head down, but upright, and
should look upon the magnificence of the world and the stars.
They also easily handled with their hands and fingers what-
ever they wished. Hence after thus meeting together, they
began, some to make shelters of leaves, some to dig caves
under the hills, some to make of mud and wattles places for
shelter, imitating the nests of swallows and their methods of
building. Then observing the houses of others and adding to
their ideas new things from day to day, they produced better
kinds of huts. (Vitruvius, *De architectura,* II, I, Loeb ed.)

Such passages stirred Piero's imagination, but one may well
wonder whether he was simply an erudite intellectual who pic-
torially elaborated theories of early man, or rather was a quaint
pedant whose findings flowered in his imagination. Following
the mood of Vasari's life, I prefer the latter explanation. Piero
was surely learned, and a basic theme entranced him, the life of
primitive man. However, one must hesitate to seek method in
the madness, for it is essentially the madness that characterizes
Piero.

These three panels quite surely once belonged together, probably in the house of the silk merchant Francesco del Pugliese. Vasari describes pictures that he saw disposed about a room there, pictures with small figures, and filled with a variety of fantastic things: animals, shacks, implements, and other fantasies. Vasari was struck by their imaginative nature, and suggested that they partook of the quality of fable. This room would have presented a vision of a world new born, calculated to be a decorative delight. It is unlikely that paintings of a different size and clearly different style were ever associated with these oblong panels, so the Pugliese room remains a pictorial fancy without strict iconography, an imaginative collection of men and beasts prey to a fire that disrupts their lives.[6]

The mind that conceived the decoration of this room was a paradox. It carefully sought archaeological fact, but also mused with fantastic abandon. Many of its reactions were at heart aesthetic. A forest fire, according to the ancients, might explain man's escape from the Stone Age, but for a Renaissance artist it was an enchanting artistic opportunity. We may stress the basically poetic frame of mind with which Piero approached his sources. He looked and read intently, but the impressions he received can hardly have been narrowly iconographical. Rather they confirmed his own feelings, and were a catalyst for his imagination. Possibly Piero perused a manuscript of Lorenzo de' Medici's *Selve d'amore*. If so, he would have found there aesthetically pleasing images. He would have discovered an animal menagerie like the one he was to paint, although it existed in a different context. He could have read here of the Golden Age (*Selve*, II,

[6] If the New York and Oxford panels are not part of a larger cycle of pictures (Panofsky suggests that they are), then perhaps they can be interpreted more freely than they have been. Panofsky would associate them with canvases in Hartford and Ottawa, both of which represent stories of Vulcan. The five pictures taken together would depict the rise of man from his primitive beginnings *ante Vulcanum* (New York and Oxford) to a higher state *sub Vulcano* (Hartford and Ottawa). That the two groups might have once belonged together is suggested to Panofsky by similarities of "style, period, aesthetic attitude" (p. 56). These similarities are not clear to me, and I feel that the discrepancy in format, dimensions and materials further clouds the possibility that all five pictures once belonged together. Panofsky cautiously suggests that the New York and Oxford panels might have adorned an antechamber, while the two canvases hung in the adjacent *salone*, an ingenious but improbable solution to undeniable difficulties.

47

86ff.) where the wolf and the bear played peacefully with the grazing flocks, where the hare and the hound rested together in a thicket. The dove, the falcon, and the crane lived in quiet, while the merlin rejoiced to hear the lilting song of the lark rise to the sky. Even the lion and the tiger possessed the gentleness of the rabbit, and multi-hued birds perched cheerfully on the shoulders of man. The theme of the peaceful co-existence of the animals was ancient in origin, and Lorenzo picked it up in a spirit of ebullient cataloguing. For Lorenzo this peaceable kingdom shattered when fire came to the world from out its sphere, upsetting the balance of the elements. Possibly Piero was able to fix upon the ideas and verbal imagery of a Lorenzo, lifting them from their context and allowing them to grow in his fertile imagination. Such is the way of artists who seek the suggestive thought rather than the reasoned argument.

A reading of the *Selve* would have offered Piero additional imagery. In an expansive analogy the first part of the poem develops the parallel of love unbound to a raging forest fire (*Selve,* I, 5-8):

When a gentle breeze breathes with sweet rule, the flowers bow to earth, and joking with them the breeze turns about, sometimes binding them, now loosening, now binding again. It fertilizes the crops; it rises and falls and becomes wrathful at the grass awaiting the scythe; sweet sound the young branch utters, and not a flower falls to earth.

But, if Aeolus frees from the cave fierce and violent winds, not only the green branches break, but whole aged pines fall to earth: the infuriated sea menaces the miserable wood of the pointed prow, and seems to despair; the air of dense clouds assumes a veil; so mourns earth, sea and sky.

A small spark, from flint struck, nourished in leaves and small dried branches, flames up; and, lashed by the swift wind, burns the twig, shoots and sticks, then near to the thick and dense forest it ignites stone oak and the old and tall oaks: cruel enemy of the wood fulfills its ire: smoke, sparks and strange cries fill the air.

Shaded homes, sweet nests, and tall and ancient woodland folds go up in flames; nor will any beast trust the wood but

48

terrified by the flames takes flight; various roars and cries fill the sky: the sound terrifies the opaque valley. The imprudent shepherd, who has fled the fire, weeps, stupefied and disheartened.[7]

The mood of these lines is that of Piero's pictures. The same sort of imagery haunts both men, and springs to life from the somewhat dry descriptions of the ancient authors. In each case the poetic fabric of the work is far more important than any narrowly iconographical considerations. In Piero that fabric is woven rough, of fiber unyielding in strength. It is here that he differs from Lorenzo, for in Piero the improbable visions have an astounding presence. Simplicity easily becomes naiveté, but in Piero we consider the possibility and then dismiss it. His images are too evocatively strange to permit such an interpretation. Over his work hangs a feeling of the odd and awkward, not the bungling of a quaint primitive, but the calculated seriousness of an eccentric visionary.

Such is Piero's landscape of Early Man, a sharply focused vision of a violent world. But within him there dwelt a feeling for the tender and pathetic which found expression in landscape. The paradoxical juxtaposition of the tender and violent is nowhere better seen than in the *Battle of the Lapiths and Centaurs* (Fig. 30).

The wedding feast has disintegrated into bestial violence. Every manner of combat swirls across the landscape, stretching back to minute figures silhouetted in the distance. Contorted bodies struggle in primitive, hand-to-hand combat. Piero has read his Ovid with relish, for the Roman elaborated this tale in over thee hundred gory lines. (*Metamorphoses,* XII, 210ff., Loeb ed.) Ovid paints (for most pictorial he is) an endless series of smashed skulls, sputum mixed with blood and teeth, singed hair, and charred flesh. Piero has taken this all in, and translated it into varied contortions of the body. Grizzly details are played down, and the nauseating eliminated. With fine taste spilled blood is replaced by struggle itself.

In the midst of brutal battle appears a moment of poignant tenderness. This moment is in fact the central image of the panel, a quiet hub midst swirling violence. The mortally wounded Cyl-

[7] Lorenzo de' Medici, *op.cit.*, I, pp. 244-45.

larus is embraced by his beloved Hylonome, who bestows a kiss upon him. (*Metamorphoses,* XII, 393ff., Loeb ed.). There is something haunting in the way that Piero renders their bodies. The faces are homely, with their faun-like ears and snub noses. These creatures, who are neither man nor beast, are given pathetically awkward limbs. Cyllarus' right wrist folds into the ground with rubbery limpness, and Hylonome's arm is emaciated and stunted. Death comes to a creature for whom we would have felt pity even in the prime of his life. Such is Piero's emotional range: alongside the love of violence resides a deep feeling for the tender and pathetic. He exemplifies a paradox we have all known, the temperament which glorifies the rough and ready, and yet at the next moment can be almost embarrassingly sentimental.

This tender streak in Piero flowers in one of his finest pictures, an unidentified scene formerly called the *Death of Procris* in the National Gallery, London (Fig. 31).[8] The mood has changed from stone age mayhem to a quiet lyricism. A young maiden lies dead upon a flowery meadow, seeming to be asleep, until we notice the fatal wound in her throat. The satyr who discovered her, fallen face downward, has gently lifted her shoulder and looks at her face with restrained compassion, his hand still resting lightly upon her shoulder. A large brown dog waits at her feet. He sits in stoic calm, baffled by this unusual occurrence in the normal rhythm of daily life. His fellow beasts play upon a beach shared with aquatic birds, and beyond spread the smooth waters of a tidal estuary that reaches away to blue hills on the farthest shore.

The figure of the maiden lies upon the grass, young but pitiably awkward. Her breasts are small small and firm, but the abdomen sags loosely. The outline of her left side undulates like a ridge of hills, suggesting that the figure floats lightly above the plants. The paradox of the beautiful and the awkward poignantly sets the mood of the picture.

The panel is one of Piero's most subtle essays in composition. The maiden is flanked by the satyr on one side, and the dog on the other. Their backs arch over the body, forming living parentheses that enclose the scene of death. The curved form of the

[8] M. Davies, *National Gallery Catalogues: The Earlier Italian Schools,* London, 1961, p. 421.

girl's hip and leg are echoed where grass meets beach, and the serpentine path from the grass to the water's edge picks up the curve of the dog's tail. By such devices Piero gives the picture a sense of rhythmic consonance. The space opens freely over the water, and seems to stretch endlessly away, a silent complement to the figure group.

It is a quiet picture, an image for contemplation. Piero's color has a limpid clarity far different from the forest fire panels. The maiden's hips are draped with a scarlet cloth, cast over a diaphanous garment. We are drawn to her immediately, for she lies between the dusky-skinned satyr and the brown dog. Her death is cradled in a carpet of life, a thick mat of light green grass which is sprinkled with small red and white flowers. At each edge of the panel grow flowering shrubs, their olive leaves interspersed with purple blooms. They stand as a floral offering to young beauty. From the tan beach onward all is a light blue, water, hills and sky being but variants on the same clear color. These hues offer a simplicity and freshness that seem to alleviate the tragedy of the moment.

Once again the general and the particular are disarmingly combined. Unreal figures are joined to scrupulously observed flora and fauna, but there is no tension in this apparent anomaly, for the whole is more than the sum of the parts. The vision is simple and pure, couched in touching awkwardness. Those tiny flowers and blades of grass, sought out one by one, coalesce in a dream-like reality that is vividly present, but which in waking hours never can be.

The subject of the picture remains an enigma. It has usually been believed to represent the dead Procris. According to Ovid (*Metamorphoses,* vii, 796ff., Loeb ed.), Procris and her husband Cephalus had a tempestuous marriage. Yet all seemed well when Procris presented her husband with gifts of divine power, the dog Lailaps who always found his quarry, and a remarkable spear which never missed its mark. Still Procris suspected her mate of infidelity and followed him one day on the hunt. At a certain moment Cephalus heard rustling in a thicket, and hurled his spear. Rushing to retrieve the kill, he found with horror the dying Procris, who had been spying on him from behind a bush.

Piero's picture fits this text badly. Cephalus, who by Ovid's

account should hold the dying girl in his arms, is nowhere to be seen. Instead a satyr gently turns her body in order to look upon the face. He seems almost a chance passer-by, as does the impassive dog. No spear lies upon the ground, and the girl has not been struck in the chest, as Ovid describes it. It is, then, the combination of a dead maiden and a watching dog that suggested the myth of Procris. Perhaps Piero's interpretation is a most personal one, an idyll that adheres but loosely to Ovid's text, a mood piece akin to the non-narrative content of the *Forest Fire*. Or again, it is more likely that we look at some fable whose literary source has escaped notice. Whatever the precise meaning of the picture, its more general meaning to Piero is sensed instantly.

We look at the poignancy of early death in a springtime world. It has taken a young woman, but the loss is noticed only in one small corner of a serene landscape. Satyr and hound contemplate the unusual sight, but without overt emotion. They seem to understand that this is in the natural order of events. Behind, bird and beast play beneath still skies, and the peace of midday lies over the land.

Life and death exist in a natural relationship, for the girl's dead body is cradled softly in the luxuriant grass. The spirit is that of Ovid's *Metamorphoses,* where the fallen dead find perennial renewal in the flowers of spring. The question of death is posed somewhat in the abstract, in all its irony and wistfulness. Though the withering of life is inevitable, for Piero it is fraught with an exquisite sadness. It is a fact to be accepted with a quiet tear.

In the gentle mood of this picture Piero has left far behind the strenuous exertions of the forest fire panels. The quietude of the painting, with its wistful overtones, places it in relation to a painter such as Botticelli, and to the Laurentian poets. The ephemeral quality of human beauty, and the intimations of mortality run as a plaintive refrain through the poems of Lorenzo and his circle. For instance, the theme is clear at the close of Lorenzo's *Corinto,* an eclogue on the love of the shepherd Corinto for the nymph Galatea:

Autumn comes, and the mature, sweet apples are harvested; and the good weather flown, flowers and fruits and leaves

finally fall to earth. Gather the rose, oh nymph, while the weather is yet fair.[9]

The theme recurs, in Lorenzo, in the even finer poetry of Angelo Poliziano. Always it touches the fragility of human beauty, the need to savor the brief hour of flowering. The thought finds eloquent summation in Lorenzo's famous lines:

How beautiful is youth, that so swiftly flies away; who would be happy, be so now for of the morrow there is no certainty.[10]

It is a fitting epitaph for a young maiden, dead among the flowers of a sun-filled world.

The aging Piero di Cosimo exercised a less extravagant fantasy, and the violence was gone from him. His *Perseus and Andromeda* is a charming fairy tale, bathed in warm lights and softened surfaces (Fig. 32). A great dragon lolls in a gray-green sea, his weight rolling transparent waves onto the shore at Andromeda's feet. He is ferocious, but no more than the crowd upon the near shore. Their faces and limbs, mollified by light, show that Piero has been to school with Leonardo, at last returned to Florence. The green sea is embraced by the soft tans of the retreating shore, whose hills are crowned by trees and precariously perched buildings. In the distance a silvery mountain rises, its soft profile a kid-gloved fist, and the brilliantly garbed Perseus skips with the ease of Peter Pan across a cerulean sky. The old man had his quiet dreams, and lived upon them at the end. They must have seemed a bit quaint to others, but for Piero this can hardly have mattered. He continued to paint in solitude until one day, as Vasari writes, he was found dead at the foot of his stairs.

Piero the landscapist is difficult to assess in the context of his age, for he strikes one as a unique temperament. In the forest fire panels we are presented a vision of primordial man, of the relation of man and nature in an age lost in time. This is not the vision of a happier world, but a hard-bitten imagery of violence. In the so-called *Procris* the idea would seem no longer to

[9] Lorenzo de' Medici, *op.cit.*, I, p. 312.
[10] *Quant' è bella giovinezza* --: Lorenzo's most famous lines are from the Canzona di Bacco. Lorenzo de' Medici, *op.cit.*, II, p. 249.

be historical, but a tender image which finds in nature an evocative analogy for human feelings about the fragility and impermanence of life.

If one compares Piero the landscapist to his fellow painters, no broad correspondence is to be found, except on the most basic level of the morphology of landscape forms. Rather, as I have suggested, in meaning the painter bears comparison to both classical and Renaissance writers. The writers were not without a sharp eye for naturalist detail, as for example Lorenzo il Magnifico in his *Partridge Hunt* (*Uccellagione di starne*). With vibrant originality the poet gives us a morning dedicated to the chase, describing the burst of dawn on the mountain peaks, the crystalline purity of the morning air. Or again, in his *L'Ambra* he can paint an unforgettable scene of a winter landscape, where dried twigs snap underfoot, and the fir branches bend down with snow.

Both painter and poet reveal an acute eye, which fastens with love upon the details of sensuous experiences. But in each man this observation is at the service of a grander concept. In a Lorenzo or a Poliziano it frequently evokes a land of eternal spring: ". . . a golden age, an earthly paradise, and there the first century renews itself." (Lorenzo, *Selve d'amore,* II, 122)

In this world dwells a beautiful woman:

> Your flowing locks bound about a sprig, I would see your white foot dancing across the sward, kicking at the wind. Then tired you would rest beneath an oak: I would gather various flowers in the meadow, and shower them upon your face; laughing, you would bring forth others of a thousand colors and scents, where the first had been picked. How many garlands I should make upon your beautiful golden locks, with boughs and flowers twined! You would conquer their every beauty. (Lorenzo, *Corinto,* 64-75)

This woman is an apparition from the classical world, but she is also Petrarch's Laura, and Dante's Matilda of the *paradiso terrestre* (Purgatorio, XXVIII):

> a solitary lady, singing as she went, and gathering flower after flower with which her entire path was painted.

54

This is a land of multi-colored flowers, where garlanded maidens wend their way in the cool forest shade, and sweet perfumes are wafted through the sheltering branches. In its delicate awkwardness Piero's so-called *Procris* belongs to this world where exquisite beauty is poignantly seized in a passing moment. But the picture is an exception, for Piero's images of primitive man would seem to deny the very existence of this poetic realm. Where the poets had found a pure simplicity, Piero found only violent bestiality.

In order to savor this contrast, one need only remember that Botticelli is the painter of these poets and that the *Primavera* is the picture which suggests best their vision of landscape (Fig. 33). Everyone recalls that perfect painting which hangs in the Uffizi. Elongated figures, clad in gauzes and thin stuffs, float lightly above a bed of flowered greenery. Their forms are described in exquisitely supple line, guided by a finely educated hand. Figures with no real corporeal substance become outlined patterns of white, pastels and quiet reds, suspended effortlessly before the cool shade. Fruits and flowers are picked out with fond care, then scattered wide in an unreal world of tapestry-like flatness. It is a vision of Poliziano's *Realm of Venus* (*Stanze per la Giostra*), but poetically it is no less Dante's *paradiso terrestre*. The picture is a paradise, where born of a humane mind Cythera and the Mount of Purgatory meet.

One can only imagine Piero's distaste and probable lack of comprehension before this picture. His forest fire panels suggest that such an elegant realm can never have been, that man emerged from his animal beginnings only with cruelty and violence. Piero's landscape, then, would be called a historical landscape. It attempts to depict the state of the world as it was when mankind began. He did research for these panels, and discovered with joy ancient theories about the origins of man as a social being. Then with dispassionate deliberation he recorded his results pictorially.

Somehow this sort of an explanation will not do. We are speaking of a misanthropic eccentric, a man constantly attracted to the marvellous and bizarre. Piero's portrayal of man's beginnings is grim, and one wonders whether he felt that the human race had progressed towards a significantly higher station. Is it possible

55

that these images of fire and death are not so much history as a comment upon that strange constant which is human nature? If we are to believe this, then we must imagine a man of not more than forty years already infected by the cynicism and anguish of old age, the sort of crisis that troubled a Donatello, a Poggio, or above all the old Michelangelo.

If these paintings are outpourings of venom upon Piero's fellow men, then they must mark a brief interlude, and an almost unconscious attitude. Piero's concern with the life of early man seems to spread over his whole career, and the pictures of his old age are amongst his most serene and happy. I would speculate, then, that Piero the eccentric scholar-landscapist was motivated by a rare curiosity and a rich imagination rather than by any direct desire to comment on the Florence of his day. For this recluse history offered an escape from his own society but in his choice of subject matter he perhaps also comments with resigned cynicism upon the innate animalism of man.

Near the end of Piero's life a great exile penned an unfinished poem. This was *L'Asino* (*The Ass*) of Niccolò Machiavelli. In it Machiavelli proposes to masquerade as an animal, in which guise he may bite and kick the other beasts about him. The poem marries this biting satire to plain fun, the *terza rima* at times mocking Dante, so much so that Machiavelli's Beatrice gladly submits to his amorous desires. At the end of the poem a true creature of Circe speaks his credo:

> No other animal is found that has a more fragile life, more will to live, more confused fear or greater rage. One pig gives not another sorrow, nor does the deer; only men kill, crucify and despoil one another. Think now how you wish me to become again a human, I being relieved of all the miseries I bore as a man. If any amongst men appears exalted, happy and joyous, do not truly believe him, for I live more happily in this mud, where without thoughts I bathe and roll.[11]

We shall never know whether the old Piero had occasion to read these words, eyes lighting with wry amusement.

[11] Niccolò Machiavelli, *Opere*, ed. by A. Panella, i, Milan, 1938, p. 849.

IV ❖ GIOVANNI BELLINI

VENICE remains a living memory, perhaps the most suggestive in Italy. Even today the city is formed by colors dancing in roiled waters, changing patterns brought by clouds blown across the lagoon. A long walk and a little imagination recaptures her as she has always been. One may pass by San Marco and the Palazzo Ducale, opulent reliquaries of tourism. Go instead to the Rialto and its markets, where the push and confusion of commerce has changed but slightly. Better, wind back through byways and canals to Sant'Alvise and the Madonna dell'Orto, those churches on the periphery that overlook the islands to the north. Here are unruffled canals, buildings where a Gothic arch has survived change, unexpected vistas. Quietly the sun plays on countless stones, and cats sleep on the warmed surfaces.

Venice is rich in imagery for the landscape painter, and some great ones have flourished there. This was already true in the Renaissance. A historical account of the painting of landscape during those years would require a large book. Figures such as Gentile Bellini and Vittore Carpaccio would be central to such an account, for their work adorned the *scuole,* those enlightened religious confraternities which provided some of the finest opportunities for painters. In the *scuole* Venice was portrayed as she appeared; the excitement of the Canal Grande at the Rialto Bridge, laundry hung from poles to dry, characteristic chimneys reaching into a streaked sky (Fig. 34). Venice had her topographers even then, and their work is rich in social implications that never have been studied properly. The most public manifestation of landscape painting in Renaissance Venice was such cityscapes as this, rendered with a simple joy in appearances.

The cityscape might be a starting point for a book on Venetian landscape. But other things to discuss would be legion; the fresh eye of Lorenzo Lotto, the topographical surprises and formal innovations of a Cima da Conegliano, to name only two. But before long, one would turn his attention to that imposing figure, Giovanni Bellini, and to his brilliant pupil, Giorgione.

These two men seem to me to lie at the heart of the matter, and since this is not a history of landscape painting, I shall write

57

of them only. As landscapists both left the Venetian scene for the mainland, and explored those fields and villages where the blue hills rise in the distance. This was not a landscape to reproduce, but the raw material out of which might arise a mood. Evocation is the business of these two painters. Both of them attempt to fuse figures and landscape, and the goal of this fusion is contemplation, and at times, enchanted reverie. Giovanni Bellini and Giorgione are two of the profoundest contemplatives of western art. It is to this idea that the following two essays speak.

In the years before Giovanni Bellini, landscape was usually but an ornamental addition to the narrative subject of a painting. Formally and expressively the landscape was rarely more than a secondary part of the composition. In Bellini's pictures the figures remain the central facts of the composition and its narrative meaning. Yet beyond narrative any fine picture possesses a mood which gives it a distinctive character. A Bellini is fairly steeped in mood, and where landscape is present, the mood assumes a special quality.

For Giovanni Bellini this quality had a religious value. If we forget for a moment that his pictures are largely Christian in subject, and instead try to examine them with a naive eye and mind, we shall be struck by their innate religiosity. One feels in his pictures that the spiritually significant emanates from a simple love of objects observed. Through familiarity with things known the artist would join his spirit to the unknown.

This quality of Giovanni's work is hard to describe, though it may arise for a pair of reasons. One is the particular character of the artist's feeling for nature, the other the sensitive manner in which he relates figures to landscape. With love he examines the smallest details of nature, not in profusion, but in selective isolation. He will take a stone, a flower, a blade of grass, and into this microcosm pour his love for all creation. So he captures the essence of our sensuous love for the multitude of things about us. His is a pristine love, controlled but utterly uncalculated. We cannot help surrender to it, for as westerners we follow as a matter of faith intuition born of empirical fact.

And so we remember Bellini, harbinger of the western artist's love affair with things observed. There were others, and earlier, who transcribed fact with greater precision. Bellini stands apart

in his selectivity, in his ability to glorify the apparently insignificant. The prose of a Jan van Eyck in his hands becomes an exquisitely wrought poetry. Unglutted by rich detail, the eye is free to move slowly about the painting, shifting from passage to passage. In this slow wandering the spirit is given over to contemplation. So the commonplace is distilled to reveal the quintessential.

Bellini's conception of the relation between figures and landscape deepens the contemplative sense of his pictures. Figures are at rest, silent objects that find their natural place within the landscape. In the greatest of his pictures with landscape—the *Saint Francis,* the *Gethsemane,* the *Madonna in the Meadow*—the sense of religious silence is overwhelming. Because figures are still, because there is no statement in a major key, our sensibilities are given over to the suggestiveness of space and light, to the subtle innuendos which are the stuff of landscape painting.

This is the mood of the protagonists of the pictures. Typically they are at prayer, in adoration, transfigured amid familiar surroundings. One feels that they breathe in sympathetic accord with the grasses and shrubs, that Bellini's Christianity is founded upon a broader pantheistic base. But such an idea leads into speculations that would be out of place here. For the moment we see Giovanni's joyously optimistic outlook upon a mysterious universe, and may probe his art by turning from generalities to specific paintings. Nowhere is the essence of Bellini more apparent than in the *Saint Francis,* in the Frick Collection (Figs. 35, 36, 37). It will pay us to have a thorough look at this major work of Giovanni's early maturity.

The frank colors of the *Saint Francis* sing out in the mahogany velvet surroundings of the Frick Collection. The subject matter is a quiet moment, intimately comprehended. Yet in size the painting is much bigger than one might expect from a reproduction. This combination of private feeling with large format commands our prompt attention.

The scene is one of exaltation. In whatever way we understand the exact nature of Saint Francis' posture, we know that his spirit expands out of all personal confines, giving itself over to the morning air. It is the morning of a friendly landscape, a place of town walls, of a proud castle, and carefully tended hillsides.

Saint Francis' exaltation is not the hermit's tortured isolation, but joyous emotion in a domesticated world. He is far from La Verna, the rugged site of the stigmatization, and has ascended instead to that Venetian hinterland where the green fields and neat rows of plane trees give way to the more irregular configurations of the Dolomitic foothills. This is Bellini's world as a landscapist, those cultivated lands to the west of Venice where centuries of care have yielded a stable union between the works of man and nature. He will explore no other region, seeming to find here the full expression of his feeling for nature.[1]

Before this painting one feels satisfied, for it is aesthetically resolved. One lingers over details, the plants at the feet of Saint Francis, the lovingly painted leaves upon his trellis, the small bird that awaits a drop of water from the drain tile. At the same time there are pleasingly unbusy areas of paint, buffers between pockets of rich detail. Giovanni sees with a microscopic vision, but records with a fine instinct for moderation. In him the always dangerous conflict between generalization and searching detail has happily dissolved.

His color is clear and frank, now soft, now with an enamel-like glow. He plays upon two basic colors, the earth shades of the saint's robe and the town, and the cool blue-gray of the rocks. These warm and cool areas work delicately one against another, here moving to the azure of the sky, there to the quiet green of the foliage. While technically subordinate to the drawing beneath it, the color has a life of its own. Coloristically Bellini is a precursor of those later Venetians who will allow the brushstroke an autonomous existence, and he understands well that ultimately a painting must stand or fall on the quality of its color.

Color is indivisibly bound to light, and in this fusion lies the magic of the *Saint Francis*. The saint stands full face before the morning sun, his drab garment aglow under its rays. His back is in deep shadow, and casts a somber path towards the darkened cave. Clouds, hilltops, and buildings are all immersed in this light, which searches out forms precisely, but not to the point of brutal definition. Only a suggestion of haze hangs over the most distant

[1] The Venetian hinterland is surely Bellini's landscape world, though he will not infrequently make specific topographical references to other places, not so much through landscape forms as through recognizable architecture.

hills, emphasizing the limpid clarity of atmosphere within the valley. Bellini's air, as almost always, has a crisp nip to it, the slightly crystalline quality of sudden clearing after a heavy rain.

Color sense, the feeling for light, for the right relation between details and the demands of a unified whole—these are a few of the qualities that contribute to the success of the picture. But beyond these there is another characteristic which we slowly comprehend, Bellini's refined and elegant sense for pictorial structure. One feels his love of the right angle, how the breaks in the rocks above the saint's head are scrupulously ordered, how the treatment of architecture goes beyond description to achieve a simple relationship of plane surfaces. Upon his right angles he will subtly impose a triangle, the slope of rock to the left of Saint Francis' chest. With a feeling for rhythmic repeat he then echoes this form in the distant hills.

The space of the picture is achieved only secondarily by means of linear perspective, as in the foreground trellis, or the few zigzag lines of the land which lead back to the town. Rather the picture is built in space much as our eye normally experiences landscape in fact, by a series of overlapping parallel planes. The foreground is defined by the rocky bluff, near middle distance by the dark band extending across the picture from the shepherd and his flock. Then in orderly progression the distant architecture and hills retreat towards an unseen horizon. In this way a finite space is neatly described, an ample and unambiguous vessel to contain the figures. The space has all the marks of a thoughtfully wrought artifact.

Artifact is a carefully chosen word. In Bellini's landscape each detail has been considered, and its creation subjected to the scrutiny of an orderly mind. The saint's lectern is built of clean, evenly planed boards, the joints sure, the angles calculated, and the nails precisely driven. It is a humble object, but nonetheless the product of a proud craftsman. In other parts of the picture this precise attitude is unflagging in its rigor. The trellis is built from straight shafts, possessing a slender grace and sense of proportion that is almost architectural. Moving from it to a natural object, Giovanni cannot help humanizing even the accidents of nature. The entrance to the cave is crowned by a lintel, supported by regularly-hewn blocks which have slipped out of posi-

tion. So it is throughout the picture; nature has been constantly corrected, not with the abstract severity of a Poussin, but with a respectful love at all times rooted in fact.

For this reason we feel the intimate connection between nature and human activity in Bellini's work. His nature is humanized, or, his human activity is endowed with a natural simplicity. In the *Saint Francis* everything works to enrich this relationship. A fellowship exists between the saint, the rabbit who peers out of his burrow, the heron, the simple donkey. Creatures all, they share a communal life in the spirit of the *Fioretti*. In the world that these creatures occupy there is no longer a clear distinction between things made by God and those made by man. A small garden wall ends at the water jug which stands behind the saint. It sweeps back in a gentle arc to the bedrock behind, yet where does the wall end and the rock begin? The far end is an accidental juxtaposition of fractured stones, the fabricated part inexplicably eroded to offer a rabbit a home.

These are a few of the qualities that make the painting. We stand before a domesticated land where the ordinary is somehow important, and the insignificant touched with dignity. Each object is wrought with love, and all things are combined in a spirit of simple clarity. Initially attracted by a certain naiveté in details, we are then intellectually satisfied by the refined sophistication with which simple emotions are presented.

Although one may speak of the mood of a painting, this cannot be done intelligently without first knowing something of the subject matter.[2] The saint before us is surely Francis; he wears the humble garb of his order, and bears the marks of the Stigmata on his hands. This climactic moment of the saint's life was the pre-

[2] Since my essay was written there has appeared an interesting study by Millard Meiss, "Giovanni Bellini's *Saint Francis*," in *Saggi e memorie di storia dell'arte-3*, Venice, 1963. This has reappeared in a slightly altered form as a book: Millard Meiss, *Giovanni Bellini's "Saint Francis" in the Frick Collection*, Princeton, 1964. Both Professor Meiss and I find the essence of Bellini's genius as a religious painter in his quest to convey the miraculous and supernatural in natural terms, notably through light. For Meiss, the picture is a Stigmatization, and for me, following earlier suggestions, Saint Francis singing his canticle to the rising sun. Meiss cheerfully admits the tentativeness of his suggestion, and I shall do likewise for mine. I urge the reader to acquaint himself with Professor Meiss' argument. While appreciating its many sensitive observations, I feel it to be basically mistaken for reasons too lengthy to develop here.

ferred subject for three centuries of Franciscan artists, and was usually presented in a conventional form: the saint was shown kneeling upon one knee, his hands raised and palms turned upward, rays descending from a seraph upon the miraculous wounds. This is hardly the attitude of Francis in the Frick painting, yet the predella of the Pesaro altarpiece, done somewhat earlier, shows that Giovanni was perfectly aware of the traditional iconography. But this same predella panel shows an interesting trait; the artist has minimized the supernatural apparatus within the picture, and it is only by the saint's kneeling posture that we immediately identify the scene. One wonders whether this distaste for supernatural *impedimenta* may not have been carried further in the Frick picture, so that all that is left of the traditional iconography of the Stigmata are the outstretched arms. The picture would still be a Stigmata, but with the sun itself a substitute for the more conventional form of divine intervention. The idea is an exciting one. Bellini would have conceived the supernatural in wholly natural terms, and identified sunlight with Godhead itself.

Anything is possible in a man who might make such a daring innovation. But as with all such puzzling images, we should go back and look at the picture with a naive eye. The wounds of Francis are minimized, and are only visible upon his outstretched hands. Looking closely at the left hand, one sees that the mark of the Stigmata is actually in shadow, which may shake our confidence in the idea of stigmatization by light. At first glance the saint would seem stupefied in the face of divine revelation, but another possibility suggests itself. Francis stands with firmly planted feet, his head drawn back and chest swelled outward. His mouth is open, and his arms hang loosely, hands cupped in silent expressiveness. It would seem to me that this is the stance of a singer whose lungs have expanded, and who sings forth with graven face. Thus the religious silence of the picture would find a solemn musical accompaniment.

If this is right, one wonders what may be the sentiment of Francis' song. He addresses his words to the warm light of the morning sun as his fellow creatures quietly listen. The land reverberates with a hymn to joy while the shadows are yet long and folk still sleep. The fervent outpouring of a saint who praises

the beneficent light of the Maker may well be the disarmingly simple message of the painting.

The idea is profoundly Franciscan, whether by design or unconscious affinity. Neither Bellini nor Francis valued nature for its picturesqueness, nor as a pleasant place in which to shed earthly cares. Rather nature was relished by them in all its plainness, in its most commonplace details. Individual things were loved, for in them glowed the munificence of the Creator.

The parallel between painter and saint can be carried further in a suggestive comparison. One of the earliest famous pieces of Italian literature is the beautiful *Canticle of Created Things,* by Francis himself. It is interesting to reread it with Bellini's picture at hand:

Lord, most high, almighty, good, yours are the praises, the glory, and the honor, and every blessing. To you alone, most high, do they fittingly belong, and no man is worthy to mention you.

Be praised, my Lord, with all your creatures, especially master brother sun, who brings day, and you give us light through him. And he is fair and radiant with a great shining—he draws his meaning, most high, from you.

Be praised, my Lord, for sister moon and the stars, in heaven you have made them clear and precious and lovely.

Be praised, my Lord, for brother wind and for the air, cloudy and fair and in all weathers—by which you give sustenance to your creatures.

Be praised, my Lord, for sister water, who is very useful and humble and rare and chaste.

Be praised, my Lord, for brother fire, by whom you illuminate the night, and he is comely and joyful and vigorous and strong.

Be praised, my Lord, for sister our mother earth who maintains and governs us and puts forth different fruits with colored flowers and grass.

Be praised, my Lord, for those who forgive because of your love and bear infirmities and trials; blessed are those who will bear in peace, for by you, most high, they will be crowned.

Be praised, my Lord, for sister our bodily death, from which no living man can escape; woe to those who die in mortal sin; blessed are those whom it will find living by your most holy wishes, for the second death will do them no harm.

Praise and bless my Lord and give thanks to him and serve him with great humility.[3]

If this is not the actual text of Bellini's picture, then it is poetry that might well accompany it. Like the painting, it is a hymn of praise, addressed first of all to the sun. And like the painting, it celebrates even the smallest grasses and flowers of creation. Both contain an admonition concerning death, for such is the meaning of the skull upon Francis' lectern. Perhaps the proper title of the picture is *Saint Francis Singing the Canticle of Created Things*; if not, this at least describes its essential spirit.

However one interprets the scene, the striking originality of Bellini's religious sentiment is inescapable. We find no appeal to the supernatural, none of the graphic or angelic paraphernalia which are the usual crutches of the artist who depicts Christian subjects. A spiritual experience, whatever be its exact definition, is understood in wholly natural terms. Man appears as simple man, divinity as a flood of sunlight which bathes all creation.

To sanctify the observed, to suggest the supernatural by means of the natural—such is the essence of Bellini's art, both as landscapist and Christian painter. This is true not only of the *Saint Francis,* but of all Giovanni's religious paintings. One of these is in Naples, painted a few years after the *Saint Francis,* in the early 1480's (Fig. 38).[4] Its subject is visionary and transcendental, and its deeper meaning differs little from the *Saint Francis.*

[3] For the text and translation: *Penguin Book of Italian Verse,* ed. George Kay, Harmondsworth, 1958, pp. 1-2. For the circumstances of its composition: Paul Sabatier, *Vie de S. François d'Assise,* Paris, 1897, pp. 348-53.

[4] I am aware that the chronology of Bellini's works is problematic but do not feel a discussion is needed in the context of this essay. I consider the *Pesaro Altarpiece,* the *Saint Francis* and the Naples *Transfiguration* to be painted in that order. The Uffizi *Allegory* should be around 1490, in spite of the temptation to push it towards 1500.

Once again we are in a world where the air is pure, cleansed of dust by the gentle breezes from the hills. The light is subdued, but touches all, sculpting the land in clear relief. Detail and broad pattern blend happily. At the bottom of the painting sunburnt grass curls over the fractured strata of rock, lines of cleavage are etched with deliberation, and the prismatic junction of warm tans and shadowed grays is geologically true. These precise facts are accurate, yet simplified, bathed in the all-embracing veil of light. In broad design the earth rolls into the distance, the little hillocks interlocking in lozenge and triangular shapes that unite in a quiltwork pattern of greens and browns. Pattern it remains, for nowhere is the generalizing effect of light and color sacrificed to searching detail.

The subject is the Transfiguration. The figures are disposed in a hieratic symmetry that recalls the bloodless world of the Byzantine icon. But the resemblance is superficial, for these men are very much alive, engrossed in a fleeting miracle. One immediately feels the solemnity of the moment, but as in the *Saint Francis,* Bellini gives no overtly supernatural symbols to guide the spectator. Those angels, the bundles of celestial rays, the clouds underfoot; all the trademarks of the supernatural have been done away with. The formal arrangement of the figures announces the profound importance of this gathering, but beyond this it is the light that signifies divine presence. A strong glow emanates from Christ's robe, the raiment of shining white described in the scriptures. This light plays round the figure, and one realizes slowly that rationally it should come from an outside source. The light falls upon Christ's right side, while his left hand is shadowed in a dark silvery-gray. Yet the robe does glow from within; never has celestial radiance been so strongly suggested by the simple play of silvers and whites. Part of the secret of this emanation is that it is set against warmish colors—lavenders, pinks, salmons, greens, browns. From this frame of color issues the miraculous coolness of Christ's robe.

Once again the probable and the miraculous meet. Light is both a mysterious emanation and a rationally explicable phenomenon. The modeling of the figures suggests that it comes from an outside source, yet the principal figures cast no shadows, and the brilliance of Christ's robe fails to touch the ground about

him. The sun is directly above the head of Christ, but covered for the moment by the passing cloud from which God speaks. Clouds fringed in pink drop weak shafts of sunlight to the hills below. It is as if for an instant the natural light of the world had been lowered in deference to a miraculous event.

Still another seemingly accidental feature of the topography underscores the supernatural climate of the moment. The figures are a scant few yards from us, their presence strengthened by Christ's uplifted hands, and his compelling, impassive gaze. Yet for all this immediacy we can go no closer, for the world of the miracle is cut off from our own. A fence rises before the vision, and behind this barrier a gorge of unknown depth drops from sight. A mere chance of nature, but by that chance we are denied final access to the presence of a mystery.

This painting is the clear and neat world of the *Saint Francis* revisited, where clouds of fluffy white drift slowly across the blue hills of a peaceful land. A miracle transpires midst the setting of daily life, so much a part of the landscape that it might almost pass unnoticed. Looking at both paintings side by side, one is struck by the common denominator of complete simplicity, of the momentous revealed by means of the insignificant. And above all, one senses an exquisite feeling for light which sets Bellini apart. It conveys both significant religious meaning and unusual aesthetic delight.

The *Saint Francis* and the *Transfiguration* represent the mature outlook of a fifty-year-old man. We could leave Bellini now, and still possess much of what we should know of this remarkable artist. Much, but not all. The genesis of a bold vision is always interesting to trace, and this is especially true in Bellini's career, which evolved late and with deliberation. His accomplishment stands in relief when compared to the master from whom he learned much of his art, Andrea Mantegna.

Bellini's early contact with Mantegna came in Padua, where the young Andrea had artistically come of age in the Ovetari Chapel. It was in this university town that the Bellini family settled at mid-century, a time fecund for a young and impressionable artist such as Giovanni Bellini. The great Donatello was at work in the Santo, and through Mantegna the lesson the sculptor had to offer painters was made clear. Mantegna's brittle and

crackling draperies derive from the example of bronze sculpture such as Donatello was then making, and the Paduan's fascination with perspective doubtless has this same Florentine source. These innovations were eagerly absorbed by Bellini from Mantegna, and gradually transformed into a new art. This process was indeed slow, for Giovanni's "youthful" works must be placed about his thirtieth year, and most of his early essays do not reveal the signs of a remarkable talent.

His first great picture is the *Gethsemane,* probably painted before 1465 (Fig. 40). It would seem to depend upon a somewhat earlier version of the same subject by Mantegna, a picture which by rare chance hangs together with Bellini's in the London National Gallery (Fig. 41).[5] There can be no better comparison to see how Bellini's manner evolves from Mantegna's, nor to judge the profounder meaning of the Venetian's art.

Mantegna's picture is clear, enameled brilliance. Its colors convey no subtle undertones, but instead underscore the firm incisiveness of a draughtsman's conception. There is a crisp aridity to this geological conception. Sharp lines describe each turn of architecture or landscape, and the whole seems immersed in an airless void, a place of utter clarity where as if by vacuum pump the air with its multitudinous particles has been drawn off. A bright light rakes the land, but its coolness does little to soften the incised folds of drapery, nor the razor-sharp fractures of the inhospitable escarpments. The painting is a crystallized abstraction, whose unreality is reinforced by the compressed space of the picture. Mantegna's landscape is built from a series of convex rock formations that overlap one another. One's eye is pulled around these masses by densely grouped parallel lines, the lines of a city wall on a hill, or the packed stratifications of an outcrop of rock. The path back into space between these hills is usually etched by an unswervingly rigid curved line, such as a road or a wall. Forms loom up one over the other, and there is no common plane of ground to which they can be related. These forms are far from the realm of normal experience, places of precarious balance and ambiguous scale relationships. The painting is an

[5] It is generally agreed that Mantegna's version is first. M. Davies, *National Gallery Catalogues: The Earlier Italian School,* London, 1961, p. 59.

imaginative world, but wrought from the hardest rock where each detail is seen with merciless acuity.

So absorbing is this geological vision that one almost forgets that it is the setting for a human drama. A brightly garbed Christ prays upon his knees, and before him a cloud of cherubim display the instruments of the passion, as if some sort of suspended sculptural group. Below Christ sleep the apostles, coarse and spiritless in their unattractive slumber. The actors are all present, but the performance lacks life. Like the landscape, the protagonists of the picture are frozen, having little meaning beyond their simple physical presence. The relationship between figures and landscape is mainly a question of form, of a community of brittle line and taut angularities. Beyond this no intimate connection exists, no sympathy between the mood of nature and the spiritual moment of man. Mantegna works with a curious precision, tenacious in his assault upon formal problems. The sensitivity towards living things is gone in him, and he cares not to probe the minds of his figures. Like Paolo Uccello, his appeal to us lies largely in the realm of pure forms.

One can only speculate as to what Giovanni Bellini thought of his brother-in-law's art during the 1460's. What is sure is that confronted with this picture, Giovanni created a remarkable variation upon the theme. The general relationship of one painting to the other is evident—Christ kneels in each picture upon a similar geological *prie-dieu*, the apostles sleep behind him, and in middle distance Judas approaches with the soldiers. There are strong stylistic affinities in the crisp handling of draperies, the wiry treatment of hair, the tautly curved line as a device to lead the eye back into space. But once these affinities have been noticed (and they might be elaborated further), it is apparent that what is significant are the differences.

The hour is the dawning of a new day. This is both biblically correct and aesthetically the primary fact of the picture. Christ is seen against a shadowed valley which lies below the cloud-streaked blue of an early morning sky. He might be little noticed, but for the silhouette of his head and praying hands against the band of a pink and white aurora. The point of greatest emotion, where courage is taken in a moment of anguish, corresponds to the daily return of warmth and light to a darkened world. The

gray clouds are touched with pink upon their under sides, signaling the awakening that fills the picture. Light slips over the distant hill to paint the village on its crest a creamy buff, and the deep browns and greens of the valley floor here and there brighten under the first rays of light. One's strongest impression of the painting is this sense of light and warmth gradually emerging from darkness. The natural hour of dawning fuses with a transcendental state of the spirit, and through light Bellini sets himself apart from his exemplar.

Interestingly, Bellini's Christ still wears the gold-striated robe of the Byzantine manner, but in no way is the artist's use of light to be equated with the timeless, spaceless glow of a Byzantine mosaic. His light denotes specifics—a place, a time of day, a condition of atmosphere. Its effectiveness depends upon our acceptance of it as a plausible, sensuous fact. Acceptance is quick because Bellini has created an ample space where the light may diffuse slowly over the logically related forms of the landscape. In the lower left corner he has painted a brittle outcrop of rock which arcs back into space, described by rigid lines. In isolation this detail could well come from a Mantegna, and would seem to prefigure the spatial structure of the whole painting. Yet clearly it does not. The tight arcs and close-packed land masses of Mantegna have surrendered to a broader conception. The curved lines are still there—a picket fence to the right, the lines of the plain which lies beyond—but it is fair to say that they are now secondary means of achieving space, vestigial remains of Mantegna's formula. More important is the broad ground plane that serves as a unified foundation for the varied topography. It is crisscrossed by paths, a stream bed, and some streaks of arid earth. On either side of this river bottom the hills rise gradually to frame the picture, already suggesting the parallel disposition of topography that will later characterize Bellini's structure of space. So a shallow bowl is formed, an arena where the effects of a quiet miracle may reverberate, and subtleties of light may find full life. Light and space are intimately fused, wholly dependent upon one another.

Compared to Mantegna, Bellini's picture is everywhere softened. Brittle and fractured rocks become a more mollified geology. Mantegna's unyieldingly hard *prie-dieu* is replaced by a rock which

seems smoothed into the form of a large cushion. Out in the valley the rock cliffs have been reduced in number, and their texture is less igneous. Mantegna loved the abstract forms of barren rock, but even at an early date his brother-in-law will clothe rock with soil, and plant the soil with grasses. The very softness of the clouds is somehow transferred to the land itself, when the harsh contrasts of midday are still hours away. Bellini is aware of the textures of the breathing earth. We may walk his landscapes and feel the springiness of the soil underfoot.

The scheme, in which color is important, plays reds and blues against the somber colors of early morning. Above is a pink and white streaked dawn which is born in the full blueness of retreating night. As a complement to this Bellini clothes Christ in blue, while pinks, salmons, and reds dominate in the apostles' garb. So earth and sky harmonize in sonorous variations on red and blue. The setting for this is a quiet mixture of tans, deep olives, green-grays. The whole has a toned-down subtlety unknown to Mantegna.

Not only is Bellini's painting an aesthetically pleasing whole, but it also appeals to us as a reasonable facsimile of what an observer might actually experience of shapes, colors and spaces in a river valley at sunrise. No small part of this illusion of reality is Bellini's refusal to allow significant supernatural intervention in his pictures, a characteristic so strongly developed by the 1480's. Mantegna's Christ is an overly large, dominant figure who prays before a raft of cherubim; Bellini's Christ, while still large, kneels before one small figure whose dull silver color makes him hardly noticeable. This insubstantial apparition is a lone cherub who holds a chalice, an inconspicuous but effective abbreviation of Mantegna's crowd of children. It is the sole concession that the artist will make to the supernatural character of the moment, and it is eloquently sufficient.

Once again the miraculous is clothed in perfectly natural terms. The world is still asleep, and the landscape breathes slowly in empathy with the slumbering apostles. The first light of day falls here and there upon the landscape, and with it stirs the activity of men, who approach in the background to take the Redeemer. In light lives the miracle, for the dawn is at once a natural event, and a burst of spiritual radiance from the head of Christ. As

surely as the day shall come, so shall his beseeching be answered.

The painting gives us Bellini's art a decade and a half before the *Saint Francis,* and as is so often true with a great artist, the early work bears the seeds of the mature years. From the first the artist casts out conventional signs and symbols of super-natural presence, and instead makes the supernatural a reasonable emanation of the natural. Almost from the beginning his chief tool is light, the primary source of the painting's expressiveness. In the *Gethsemane* the light is not fully what it will be later. It does not as yet cast a completely unified atmosphere over the picture. Here and there a sharp line or hard passage still recalls the legacy of Mantegna. One could point out that the lighting is hardly logical, but its expressive intent is as clear as it ever will be. As yet Bellini has not fully learned to create space by masses parallel to the picture plane, but ample space is there, and the way to the future is simply a question of refinements.

Lest the above lines characterize the *Gethsemane* as a tentative picture, or a prelude to greater things, I must stress the innovat-ing quality of the painting, and its complete coherence as an aesthetic expression. It is, as has been remarked long ago, the first great landscape of Italian art. To say this is to reveal a healthy bias, that a great landscape must possess a powerful mood, and that this mood must comment significantly upon a human longing. The *Gethsemane* does this, and Giovanni painted no finer picture in the fifty years that remained to him.

Questions of qualitative judgment aside, Bellini's art under-went considerable change in the 1470's, a time when the basic formal premises of his art were refined. It is questionable whether this refinement followed any neat and logical course, and to what extent this course was of Giovanni's sole making. These problems are for the specialized historian, but it will help us to look at one obviously crucial step on the way to the *Saint Francis.* This is the important Pesaro altarpiece, painted about 1475. Here Bellini's full mastery of light is revealed for the first time.

Because of its somewhat peripheral location, this painting is not sufficiently known. Only its pinnacle, the fine *Lamentation* in the Vatican, is on a well-traveled road. This fragment alone tells what has happened to Bellini's art. The light is full and bril-liant, the natural light of the sun. It both models the forms and

vcils their surfaces, blurring any detail that might be too dry or particularized. The texture has the richness of oil, but without any disagreeable slippery qualities.

Bellini further pursues landscape problems in this altarpiece, in the main panel, and more particularly in the predella panels below. This is but one more example of a recurring phenomenon, the tendency of artists to use the predella as a place for new experiments. In this most inconspicuous part of the altarpiece they were least bound by iconographical conventions, and first tried those innovations which only later would find their way to the main panel of the painting.

The *Adoration of the Child* is probably the most successful of these small panels (Fig. 39). One senses quickly the absolute rightness of tonal relationships, and the exhilarating light that fills the picture. Light and a free technique combine in an atmosphere that submerges detail. Atmosphere, more easily achieved in a panel of this small size, has an all-pervasiveness that is lacking in the rougher-edged *Gethsemane*. Moreover, the spatial structure now seems more cohesive. The curved line that recedes into depth remains, but it has gone languid in its meandering course. It is no longer a structural artifice, but serves as the course of a stream. Spatially it is subordinate to another device, the series of parallel planes, or stage wings, that move back into the picture. The foreground is demarcated by the shed and hillock with the figures. From here one moves back to a tree-covered tongue of land on the left, thence to a bluff, finally to the hills which close off the space in the background. For the first time this simple and fundamental method of building space is thoroughly thought through, and so Bellini becomes the fountainhead of a tradition of seeing landscape that will lead through the Venetians to an ultimate culmination in Claude and Poussin.

A finer sense of compositional balance accompanies this new sureness of spatial structure. Elements that function in depth also work in a pleasing two-dimensional pattern. So the large tree on the left is necessary both to indicate recession and to balance the weight of the shed on the right. From this time onward Bellini will achieve a resolution of surface and depth as a matter of course.

The artist has also worked to eliminate uncertainties of scale.

In the *Gethsemane* there is some awkwardness in the placement of the four figures, and in the ambiguous size of Christ. In the predella these inconsistencies have been resolved. One feels the proper size of Mary and Joseph in relation to the rest of the picture. The spatial transitions are constructed suavely, and at no point are scale relationships puzzling. From this point of view there is a great gulf between the *Adoration* and Mantegna's *Gethsemane*.

Everything considered, the predella reveals a new cohesiveness and economy of means in Bellini's art. All parts of the picture function in some positive pictorial way, and no passages are hesitant. Bellini's neat and precise temperament begins to show itself in his selectivity, in the love of parallels and right-angle relationships which are the essence of the pictorial structure. It is not much of an exaggeration to say that the *Saint Francis* and the *Transfiguration* are but this little panel blown up to a larger size and made more complex. Put another way, Bellini's maturity as a landscape painter dates from the predella of the Pesaro altarpiece.

If we look once again at the *Saint Francis* and the *Transfiguration,* we can see in them clearly the *Gethsemane* of fifteen years earlier come to formal maturity. From the beginning Bellini sought a convincing spatial structure, a truthful play of light, a fusion of detail and generality. From this he built a quiet place of contemplation, where the winds of the spirit whisper softly across the land. Before these pictures one feels himself in the presence of something complete, as before a Raphael Madonna, where no further exploration in the same direction seems possible. Partially this is true. However, the artist still had significant elaborations to make on his ideas after the 1480's. Two further paintings will give some idea of this new dimension.

Bellini's *Allegory of Justice and Mercy* was painted around 1490, probably on commission from an ecclesiastical patron (Fig. 42). In it the artist shows an amazing ability to convert a highly verbal concept garbed in dry symbolism into purely pictorial terms, a visual concept with its own peculiar magic. The subject is a high medieval allegory, and as a recent convincing study has shown, a proper title for the picture would be *Allegory of*

Justice and Mercy.[6] The painting is then allegorical in intent, a presentation of symbols and personifications rather than narrative. A woman on the left has no feet, because the demands of the written allegory decree it. Bellini supplies an image of surrealistic suggestiveness. So it goes throughout the picture; each part is explicable verbally, yet what would be dry reading is visually most evocative.

The picture is, and surely always was, unintelligible in subject without an erudite explanation. So we approach it as an essay in landscape, as a self-contained reality, content that its precise meaning remain an enigma. One suspects Bellini himself had mixed feelings towards the allotted subject. As a man of his age he would have fulfilled to the letter the requirements of a precise iconographic scheme, but as an artistic sensibility he must have realized that allegory is but a blunt tool to reveal an intangible mystery. It is this mystery which fascinated him, so while giving us the allegorical meaning he also transcended it, offering a poem whose essence is enigma and ambiguity. The painting is a paradox. While medieval in subject, it is most modern in its ineffable evocativeness.

Formally the painting carries forward the principles of the earlier pictures, the parallel spatial structure founded upon a well-defined ground plane, the play of diffused sunlight, a harmonious color scheme (here the interaction of tans and blues), an economical attitude towards the rendition of detail. Expressively, though, it is quite new, and somewhat disturbing. An eerie silence hangs over this strange gathering. The figures exist in psychological isolation; in prayer, in contemplation, at rest. Their lethargic actions are motivated by the improbable scene of children who play with fruits plucked from a potted plant. This can have no narrative meaning, and is puzzling until one remembers fully the archetypal meaning of the tree in man's fall from grace and his redemption. Even then the enigma is not resolved, for a perusal of the individual figures only serves to deepen one's perplexity. Saint Sebastian stands erect with his hands bound behind his back, his body pierced by arrows. He

[6] Philipp Verdier, "L'Allegoria della misericordia e della giustizia di Giambellino agli Uffizi," *Atti dell'Istituto di scienze, lettere ed arti* [Venice], cxi (1953), pp. 97-116.

is in the traditional pose of martyrdom, but is bound to nothing, and suffers not one whit. Released from bondage and pain, he calmly contemplates the scene before him. A balding man behind the rail stares open-mouthed at his sword. He is immediately recognizable as Paul, but a Paul unknown to us before. Does he ponder the blade of his weapon, the use to which it should be put, or does he simply stare blankly into space? And how strange the columnar figure to the left, dark shawl over a light blue robe, floating without anchor above the neatly tiled floor. Beyond the terrace a centaur rests in the shade of a wall, and a Negro contemplates in a secluded corner. Why? The texts tell, but visually the juxtaposition of improbables is simply compounded.

The strangeness of the picture lies in more than the detached contemplation of the protagonists, or the improbable relationships between them, for the landscape is one of the most silent ever painted. Nothing is heard, and the air hangs still and pure above the motionless mirror of water. The lake throws back reflections without shimmer or ripple, an artifact rather than a part of nature. Indeed it seems a world in miniature, a landscape too simplified, seen in too perfect a light to have any real existence in time or place. The spectator thinks it rationally constructed; the foreground stage is laid out according to the best rules of linear perspective, the tiled floor giving a sure sense of scale to the figures. But he is deceived. The eye wanders past the open door, and slips silently across glassy waters to the hills and buildings of the background. The cerebral dictates of line give way to the softened suggestiveness of muted colors.

I have stressed that Bellini's landscape is a place of contemplation, where nothing moves and nothing happens. This contemplation belongs to the protagonists of the pictures themselves, and is imparted to the spectator who looks at the painting. Through landscape one's soul is quieted, and in quietude may come a sense of empathy with the spiritual state of the figures within the landscape. And it is here that the *Allegory of Justice and Mercy* remains an enigma, whose ambiguities are not solved by knowledge of the subject matter. Though we know better, it is almost as if contemplation as a state of the spirit, and silence as the fertile condition which brings it forth, are the subject of

the picture. In leaving this painting one cannot help think ahead to the second of the great Venetian contemplatives, Giorgione. Like Giorgione, Bellini has cast a spell that transcends the particular meaning of the subject matter, a spell that can be defined only as visual poetry. In the face of the usual attempts to stress the differences between the two masters, it is well to remember this picture: in it the poetry of Giorgione's art is prophetically prefigured at a time when the master from Castelfranco was but thirteen or fourteen years old. The aging Bellini could yet show a young boy the stuff that dreams are made of.

Some ten years later Bellini painted one of his finest madonnas, the London *Madonna in the Meadow* (Figs. 43 & 44). Seated upon the grass, Mary prays over her sleeping son. It is a tender and intimate moment, but as an image it is pictorially monumental. The figures form a stable triangle that nearly fills the height of the panel, and whose bulk is brought close to the surface of the picture. The paradox of intimacy in monumentality is immensely effective, for an ageless subject is suddenly seen in a new light, and so with the freshness of a first encounter.

Iconographically the image is a Madonna of Humility, a traditional type which shows the Virgin seated upon the ground, often with bare feet, the humble guardian of her child. Never, though, had the subject been interpreted in quite this way. Mary's body rises from the flower-sprinkled sward, seeming to issue naturally from the earth itself. Her presence in this domesticated landscape is not explained by scripture, but goes beyond the text to express a more personal article of faith. The child is cradled by an earth mother who rests lightly on the springy cushion of the soil, and the sleep of her child suggests a quiet communion with the unseen.

Figures and landscape seem separated, but in truth are closely joined. There is a new softness and smoothness in the modeling of both flesh and draperies, qualities which carry over into the landscape behind. The artist moves towards a greater generalization, confining descriptive detail to the pebbled ground and the grass upon which Mary sits. The unity of the painting coalesces through a subtle play of colors. Mary wears a bright blue robe over a garment of rose, her head veiled in silvery-gray. These colors come forward from the grays and tans of the landscape,

and assure that we shall first contemplate the mother and child. Soon, however, the coloristic consonance between figures and landscape becomes as important. The flesh of Mary and the Christ child is a pure, creamy white, tones delicately picked up in the chalky tints of the buildings behind. The blue of Mary's robe plays against the cerulean sky, which pales as it drops towards the horizon to become a white complement to her veil.

The season is autumn; there is a coolness in the light that suggests the departure of warm and sultry days, and the vegetation is sparse upon the land. Soft cumulus clouds still drift across the sky, but their pleasantness is denied by the stark outlines of naked trees, harbingers of death, as is the bird of carrion upon the branch. Trees like this will be painted later by Pieter Brueghel, when the land is locked in deepest winter. The structure of the landscape suggests further a note of austerity. Bellini had always sought a precise and economical organization in his pictures, but never quite to the degree seen in this painting. Everything is kept parallel to the surface of the picture—the disposition of the Virgin and Child, the figure with an ox, the fences, trees, and town behind. All the forms are conceived in clear, planar relationships, and the meeting of lines is guided by the right angle and triangle. A photographic detail of the landscape to the right makes clearer than any amount of description the ordered severity of Bellini's art at this time (Fig. 44). The picture is cool, and sufficiently abstracted to invite detached contemplation.

The passing of summer alludes suggestively to the sacrificial death of the sleeping babe. Mary, with lowered eyes and solemn expression, prays in the intimation of what shall befall. The mood is evoked by sleep, and in the quietude of the moment mother and child are united. Bellini, accurate describer of the outer world, here harmonizes that world with a touching moment of the spirit. We are hushed in the presence of something within.

At the time this painting was done Bellini still had fifteen years to live, and were we to attempt a complete account of his landscapes, there would be other pictures to discuss, notably the *maestoso finale* that is the Santa Corona *Baptism*. But we may stop here and look back, for by 1500 Giovanni Bellini had made his important pronouncements as a landscapist. The feeling for

nature in his paintings is bound to the religious sentiment, and must lead us ultimately to speculate upon the artist's religious outlook.

I suggested at the outset that Bellini's art might seem to reveal a pantheistic point of view, for in his paintings even the smallest detail seems presented with reverential respect. But this possibility must be put aside. Bellini is still a figure painter, and the sacred images that he presents are mostly traditional in meaning. His beautiful landscapes are but backgrounds for Madonnas, Christs, and saints. As backgrounds, however, their function is more than decorative, for the landscape is humanized. By this I mean that its forms and light are not arbitrary, but directed specifically to an enlargement of the spiritual meaning of the figures. Bellini's Christ kneels upon a smoothed rock, his head wreathed in the hope of a new dawn. Or again, the radiance of full day is the spiritual emanation of a raiment of shining white. Saint Francis dwells in a world everywhere touched by the hand of man, and man and beast share equally in its fruits. Time and again one finds that Bellini's interpretations are fully Christian and traditional, and that his vision of landscape serves to enrich these traditional meanings.

To substitute the adjective nominalistic for pantheistic would be closer to the mark, but still not just. There is no doubt of Bellini's empiricism, of his profound love for things. He can describe the smallest blade of grass to perfection. Yet the variety of things he depicts is narrowly prescribed; pebbles, twigs, plants, and flowers. His love is directed toward a few objects, and there is no hint of a voracious appetite for promiscuous description. Paradoxically, Bellini develops stock conventions out of observation, a trait that is quite clear if one compares the paintings after 1485 to the *Saint Francis*. It is not, in the last analysis, his rendition of detail that we find remarkable, but his ability to fuse these details into a believable whole by means of light.

One must ponder just what this fascination with light meant to Bellini. From the outset he certainly realized its potential as a means of enhancing traditional Christian meanings. Did it, however, mean more to him? The role of light as the central core of mysticism is too well known to warrant review here, yet it should be mentioned, for light in association with a work of

Christian art has rarely failed to find an interpretation grounded in mystical writings. The case could be made for Bellini as a mystic, and texts adduced to support the supposition. Nor would it need to stop there. One could further dabble in the realm of the Neoplatonists, for whom Saint Francis' sun had become a more complex analogy for the Creator and his beneficence. Such juxtapositions could be made, tantalizing and unverifiable. But no matter how judicious and artful the presentation, such associations between the written word and the visual image always stop short of satisfaction. Ultimately we are thrown back on our own assumptions, for we must inquire into the nature of the temperament and mentality of the artist under consideration. We can prove that two men talked, but it is only supposition as to what was said. Likewise we may show that an artist owned a particular book though this does not mean that he read it, or if he did, we still do not know what it meant to him.

So with Bellini we ponder his mind and temperament. Since little is known of his personal life or habits, any sort of answer must be deduced from his works. This is risky, but there is no choice. His work reveals Giovanni as a painter's painter, a fine intellect who allowed feelings to be the ultimate judge in any artistic problem. He was too much an artist to indulge in philosophy (which is at the furthest remove from anything sensuously real), or to warp his formal pursuits to the service of a philosophical idea. His art is thoughtful and highly disciplined, betraying none of the fitful and unstable moods of a mystic. It is attractive to think of him as a high intelligence, warmly humane, with a genius for the manipulation of paint. The fascination with light came early to him, perhaps out of his own searchings, perhaps out of the tradition of Domenico Veneziano and Piero della Francesca. Be this as it may, he realized soon the relation between this formal concern and the needs of religious art. I look first for the explanation of Bellini's light to his needs and aspirations as a painter, and only then to his humane sensibility as a Christian.

Bellini could be called a modern in his awareness that landscape can be a powerful tool of religious expressiveness. For a moment we might consider this modernity. In the seventeenth century many landscapes have undoubted religious (though not neces-

sarily specifically Christian) overtones. And with the failure of
traditional Christian iconography during the nineteenth century,
a painter such as Caspar David Friedrich found in landscape an
alternative outlet for religious expression, a Vincent Van Gogh
the salve for a tormented spirit. Yet to see Bellini as in any sense
a harbinger of these later developments is surely an error. The
leitmotif of landscape painting from the seventeenth century
onward is man's relation to the unknown, not just the undefined
mystery of a Christian God, but a coldly impersonal mystery of
physical extension. Like Pascal, the landscape painter will stand
in awe before the ungraspable prospects of infinity, now lyric,
now frightened at what he sees. Bellini, however, paints a small
corner of the universe, a finite world whose limitlessness rests
solely in the boundlessness of God's love. He stands not in awe
or fear, but in familiarity, like Saint Francis a friend to every
particle of creation. His conception, then, is hardly modern, for
it is untouched by that loss of innocence which the next century
was to bring.

Above all, Bellini's landscape loses its meaning if its relation
to the figures before it is not taken into account. In this union
is achieved the sense of contemplation that is the essence of his
Christian expression. We are asked to pause for a moment, and
to think upon fundamentals. Bellini is but one artist among many
in the west at this moment who strove for this religious quietude.
We may think of Michelangelo's *Pietà* in Saint Peter's, of Hans
Memling, Perugino, of the détente sculptors in France. Giovanni
shares their goals, yet he takes a special place in our hearts, for in
him is most deeply expressed that humble attitude toward the
miracle of nature which touches the fund of our common ex-
perience.

V ✧ GIORGIO DA CASTELFRANCO

THE town of Castelfranco is a short drive from Venice, four centuries ago a trip made easily by horse in a leisurely day. The landscape is somewhat monotonous, a flat plain laced by irrigation ditches, its roads lined by plane trees. The aspect of the town in Giorgione's day is not hard to imagine, because change has been gradual. The dusty road leads into Castelfranco, through the walls erected in the middle ages against the incursions of neighboring Cittadella. Within this girdle of walls, in the uninteresting neoclassical church of San Liberale, is one of the world's great pictures (Figs. 45 & 46).

Before this altarpiece thoughts articulate slowly. The painting seems to exist more as a state of mind than as an actual presence. We contemplate it at a distance, for the figures are withdrawn from the front plane of the canvas, and are seen from above, as if suspended in some sort of a vacuum. They are psychologically isolated from one another, and are but distantly in rapport with us. The child stares idly downward, while his mother is lost in thought. Two saints, Liberale and Francis, guard the holy mother and child, but their languid postures suggest that they are incapable of any physical action. They gaze dispassionately at us, and in their rapture do not meet our eyes, nor even realize our presence. They flank what appears to be a throne, whose dull colors are decked with stuffs of varied hues, the whole seen against a wall of deep velvety purple. But there is no way to ascend this throne, nor has it the appearance of furniture. Rather the base resembles an altar, on which rises a majestic foundation for the infant Christ and his mother. In place of the Host we have a vision of the Living Presence on the sacramental table.

It is a world of delicate lassitude, a subtle state of mind. The Madonna sits proudly, seen against a landscape whose greens and light browns fall back to a veiled lake, cerulean in color, and a sky whose glow casts a warm light over the land. In this landscape one experiences in purest essence the artist's feeling for form. All is blurred, edges and surfaces consumed in a diaphanous light. The light controls the appearance of everything it touches,

82

and determines the qualities of color and texture. Any detail—the trees to the right, the face of Francis, the drapery upon the Virgin's knee, is softened by this glow. We remember that Bellini's light cleansed and revealed forms in their pristine, cool clarity. This artist blurs forms, and touches them gently with the warm light of a failing sun. The *morbidezza* (softness) and *sfumatura* (smokiness) of the modeling melts tactile forms in favor of a lush optical impression. There is nothing quite like this golden light in Renaissance painting, and its reprise will await a Claude Lorrain in the next century.

The function of the landscape in relation to the figures is delicate and tender. The land lies by the shore of a lake, perhaps a memory of one of those numerous north Italian lakes which lie below the Alps. In a peaceful land rural buildings rise from the green meadow, and two knights rest by the wayside. The quietude echoes and magnifies the tranquility of the foreground figures, and shares with them the quality of a trance, glimpsed for a moment as if in a passing dream.

The *Castelfranco Madonna* was commissioned by a family of warriors, its serene calm in contrast to their violent lives. The picture was painted by Giorgio da Castelfranco, but we first encounter this attribution in 1648, almost a century and a half after the picture was painted. But at that we are fortunate, for as a historical figure Giorgione is an ill-defined shadow.[1]

Zorzi da Castelfranco the artist is called in those documents closest to his own lifetime. They are precious few, and later biographical testimony is confused and often contradictory. A short four decades after his death no one seemed quite sure who Giorgione was or what he had painted. Vasari is our chief source, but it is obvious that he had little direct experience of Giorgione's art. He probably serves us better on the main facts of the artist's life. He reports that Giorgione was the pupil of the brothers Bel-

[1] *Giorgione e i giorgioneschi*, ed. by P. Zampetti, 2nd ed., Venice, 1955. Opinions are given for all the paintings I discuss, the Dresden *Venus* excepted. One monograph bristles with every variety of factual information: G. M. Richter, *Giorgio da Castelfranco*, Chicago, 1937. A little-known but brilliant work on Giorgione's iconography: A. Ferriguto, *Attraverso i 'misteri' di Giorgione*, Castelfranco, 1933. While I cannot accept some of Ferriguto's major interpretations of pictures, throughout he offers fascinating material on Giorgione's patrons, some of which I have appropriated. His interpretation of the *Tempesta* seems to me the most reasonable so far proposed.

lini, that "he was schooled in Venice, and delighted continually in the pleasures of love, and he played the lute masterfully; so divinely did he play and sing in his time that his presence was often requested at various functions and musicals, and he was received by noble persons." Beyond this we know little more, except that Giorgione was a co-worker with Titian on the frescoes of the Fondaco dei Tedeschi, and that he died of the plague in 1510 at the age of about thirty-three.

Giorgione is a tantalizing mystery, but not solely because of the paucity of information about his life. Rather the mystery is two-fold, for we are uncertain what Giorgione painted, and when we are certain, know not what the pictures mean. The artist might well have remained a myth, were it not for a notebook kept by one Marcantonio Michiel.[2] In it he recorded the contents of various private collections seen by him during the 1520's and 1530's. Included in this list are three pictures by Giorgione which can be securely identified with extant paintings. To these three may be added the undoubted *Castelfranco Madonna,* and perhaps another pair of pictures whose documentary qualifications are in one way or another impeccable. About this hard core, like the ebb and flow of the tide, has attached anywhere from a handful to more than seventy pictures.

Even should the critic decide that he has defined the stylistic profile of Giorgione's oeuvre, the question of meaning remains. Before such haunting pictures as the *Tempesta* and the *Three Philosophers* (names suggested by Marcantonio's descriptions of these canvases) we remain intellectually baffled. The fact is that neither has received a convincing interpretation, and it is improbable that either will until relationships to cultural documents outside the pictures themselves can be established. Nor are we absolutely certain, though it is more than likely, that such pictures do possess a precise meaning.

Our task is difficult, and the results will be speculative, but I believe something of value will emerge if we focus upon two aspects of Giorgione the landscapist. The first is his relationship to Giovanni Bellini, not in a narrowly historical sense, but as another master of lyrical contemplation. The second concerns the

[2] T. Frimmel, *Der Anonimo Morelliano (Marcanton Michiel's Notizia d'opere del disegno)*, Vienna, 1888.

very end of Giorgione's short career, when he bequeathed to his followers an idea of landscape essentially alien to the old Bellini. I cannot pin down the elusive Giorgione, but I suggest that the more salient aspects of his landscape art are overlooked in the search for a skeleton key to his iconography.

In 1525 Marcantonio Michiel saw in the house of Taddeo Contarini a painting he described thus: "The canvas in oil of three philosophers in a landscape, two standing and one sitting, the latter who contemplates the sun's rays, with an excellently painted rock, begun by Giorgione and finished by Sebastiano Veneziano." Today the canvas is one of the treasures of the Kunsthistorisches Museum in Vienna (Fig. 48). If my private idea of Giorgione's evolution is sound, the canvas in the form we see it probably dates from about 1506 or 1507, and the alleged participation of Sebastiano, while not clearly distinguishable, is possible.

A seated youth, a middle-aged, turbaned man, and a bearded sage pause in an evening hour. The young man manipulates an astronomical instrument, his attention fixed on something beyond the boundary of the picture. The old man displays a sheet upon which are written symbols, but he, too, seems unaware of what he holds. The three men, so clearly of different generations, are thinkers, motionless in a silent landscape. Each is rapt in his own thoughts, bound in a captivating reverie that brooks no interruption.

In this landscape dusk is fast falling. A bluff to the left is already in shadow, the clinging plants of its slopes scarcely visible, and its summit just touched by a gentle light. This corner of nature is a study in contrasts. The bearded sage is garbed in rich yellow, the turbaned man in flaming scarlet, colors that complement the darkened trees, which stand in stark silhouette against the sky. Yet this strong and assertive pattern retreats under a glow of light. Fabrics are soft, and faces almost lost in shadow. The trees stand before a quiet evening sky, whose blue is varied by the soft grays of drifting clouds, and the orange disc of a sun that sinks below the distant hills. While the immediate foreground is boldly seen, beyond the landscape melts into an ineffable softness, the same play of golden light that is the wonder of the *Castelfranco Madonna*. It is as if this segment of humanity

85

were brought momentarily into sharp focus in a world otherwise engulfed in a thin haze.

As a study of figures in relation to a landscape, the *Three Philosophers* bears comparison with Giovanni Bellini. There are differences; Bellini's clean and precise world here has begun to shimmer behind a curtain of light, and Giorgione's ample, mature forms take leave of the more defined passages in a Bellini. And yet for both men a landscape is a place where nothing physical happens, where figures dwell in a contemplative communion with nature. The Frick *Saint Francis* is recalled, that ordered landscape where a saint breathes deeply of the morning air, and addresses his praises to the rising sun (Fig. 35). So in the Giorgione figures are at home in nature, and one, the seated youth, contemplates the light that bathes the top of the bluff. Marcantonio Michiel tells us that this is the light of the sun, but in this particular he is wrong, for the sun's rays die as it slips below the hills in the distance. So we are left with a mystery, an undefined light that may be the very protagonist of the picture.

The similarity between the two pictures carries further, for in both light enters from the left, and is contemplated by a human to the right. Both canvases are similar in format, and even allowing for modest trimming in each case, both are virtually the same size. It is then of more than passing interest to know that both pictures were in the Contarini Collection, the Bellini having passed there sometime before 1525, presumably from its original owner, one Zuan Michiel.

Could the two paintings be related, in the sense that Contarini commissioned Giorgione to paint a pendant for his newly-acquired Bellini? The question is tempting, but cannot be answered, for we would have to know the subject of the *Three Philosophers*. There have been interpretations, burdensome in their quantity and ingenuity, but none is wholly convincing.[8] X-rays reveal that

[8] The Bellini measures 124 x 137 cm. (Heinemann), the Giorgione 121 x 141.5 cm. (Zampetti). The dimensions in both cases are somewhat altered, but not substantially. If the Giorgione was in fact painted as a pendant to the Bellini, then one would expect an approximate match in size and format, which in fact there is. The problem of the meaning of the Giorgione should be left an open question pending the publication of Dr. Peter Meller's monograph on the painting, which if convincing will be a major contribution towards unraveling "the mystery" of Giorgione.

Giorgione felt his way to a finished picture, and in a first moment conceived a rather more Bellinesque image. They also show that the figure in red is painted over what originally was intended as a Moor or a Negro. Three sages, of whom one is dark-skinned: in Renaissance terms this is the iconography of the Adoration of the Magi, the subject which Giorgione may originally have had in mind.

An eighteenth century inventory gives the picture a poetic title: The Three Magi Who Await the Appearance of the Star. An old tradition is often right, and so would be explained the light which falls upon the bluff, for it can only be that of the miraculous star which shall guide the Wise Men on their way. Were this interpretation accepted, then the *Saint Francis* and the *Three Philosophers* would be closely bound in meaning. Both pictures by the agency of light would reveal to men the Divine Presence. As the source of life is revealed to Saint Francis, so the source of salvation guides the Wise Men.

I wish I could confidently offer this interpretation, far less fanciful than some which have been argued at great length, but it would be hardly honest. It is not obvious that the painting represents the Three Magi, and beyond the painting itself there are no reliable comparisons. Until such comparisons, written or visual, are found, the picture must remain a mystery.

But as landscape the mystery is less, for in confronting the *Three Philosophers* with the *Saint Francis,* we find an essential community of sentiment. Both artists are landscape poets, and both see landscape as a sympathetic place where the spirit may expand. Whatever the iconographers may still uncover, this essential bond between Bellini and Giorgione will remain. The form, but not the intent, has changed. Yet this judgment would probably be wrong if extended beyond this particular comparison to a general evaluation of Giorgione as related to his master. The famous picture in the Accademia at Venice should discourage any such oversimplification (Figs. 47 & 49).

"The little landscape on canvas, with the tempest and soldier and gypsy, by the hand of Giorgio da Castelfranco." So Marcantonio described the picture which he saw in 1530 in the house of Gabriel Vendramin, and which I believe was painted about 1502 or 1503. The painting is small, some two feet square, and in-

timate in feeling. We are tempted to simply call the picture a landscape, for the figures are small, and situated comfortably in surrounding nature. Indeed for Marcantonio the painting was first of all a landscape, a *paese,* a descriptive term which he had used as early as 1521. There is no reason to question the existence of a taste for landscape *per se* in the Veneto at an early date, and by many the *Tempesta* might have seemed little more than simply a landscape painting. However as the painting grows on the spectator, he realizes the importance of the figures, not as elements of a narrative but in their psychological interrelationship and their place within the landscape. Figures and setting fuse, and from this union arises the dominant mood of the canvas.

A moist landscape silently awaits a threatening storm. The atmosphere is brittle and charged, but at the same time there hovers a mood of languorous calm, shared by the landscape and the enigmatic figures who inhabit it. A nude woman nurses a child, a paganized Madonna of Humility whose impassive gaze suggests some instinctive attunement to the unseen forces about her. To the side stands a wayfarer, seemingly engrossed in the thought of a passing moment. He is physically apart, but one with the mother and child, partaking of the same bemused world of dreams. A village flanking a stream, the lightning and lowering clouds of an approaching storm, a few broken ruins—these complete the haunting image.

While this subject matter is enigmatic, its elevation to the level of evocative mystery is a question of technique and forms. As a builder of illusionistic space, Giorgione has been to school with Bellini. Despite the fact that there is a view up a valley, and so an invitation to a heavy-handed application of linear perspective, the space is partitioned by retreating planes which are parallel to the surface of the painting; the hillock and tree to the right, the tree and broken arcade on the left, the bridge and building behind. The scene is carefully framed by foliage, and the space closed by buildings in the distance. So this highly evocative picture rests upon a quite rationally calculated base.

The painting exudes humidity, wrought from textures, lights, and quiet colors. Here Giorgione leaves Bellini's example. Giovanni had painted those crystalline scenes where the air is rarefied and pure, fertile valleys in which the dust has settled, and the

moisture has been dried by the winds. A clean and tidy land is presented by the paradoxical means of precise generalizations of form. In Giorgione's art this moment of freshness has passed. The atmosphere has become laden with moisture, the foliage a fecund green. It requires more effort to breathe, and distant views are shrouded in haze. Bellini's land seems always upon the verge of aridity, while Giorgione's landscape is a place pregnant with the processes of growth. Growth suggests change, and it is the possibility of change behind ephemeral and shimmering mists that helps cast the ineffable mood of Giorgione's paintings.

Giorgione's moist and loaded atmosphere is partially the result of the manner in which the paint is applied. Bellini had demonstrated some of the possibilities of oil paint. His pictures often glisten, and at a distance appear to have the clear brilliance of enamel. Color areas are distinct, surfaces firm and unambiguous. Only on close examination does the velvety softness of some of Bellini's textures become apparent. Giorgione, like most of the other artists in the old Bellini's orbit, could hardly remain impervious to his example. But by the time of the *Tempesta* Giorgione had worked important changes. The paint has become thin and fluid, details such as the towers in the background but lightly washed onto the canvas. At the same time the brush is freer, and has moved carefully but rapidly. A thin bough of foliage in the upper left portion of the painting is evoked by a few spots flicked onto the canvas, while leaves of grass emerge from a glazed-over patch of blue-green. Giorgione suggests a variety of details, but they are rarely described with any thoroughness. Highlights, such as those that sparkle in the trees by the riverbank, break up the evenness of the picture's surface.

Seen from a distance, the *Tempesta* has a quality of color that could never be confused with a Bellini. Instead of clearly defined color areas, Giorgione has conceived the entire picture as a close blend of greens and blues. This chromatic homogeneity imposes a strongly unifying mood, for only with conscious effort may individual parts of the picture be seen in place of the whole. The brightest spots of color are the three figures, and the pair of truncated columns. Except for these light spots, the rest of the picture is a blend of earths, greens, and blues. The center of the painting is framed by a U of earth colors and olive-greens, formed

by the mound of earth with the tree and figure group on the right, and the ruins and trees on the left. Within this center one follows an inky blue stream back to the architecture, which is painted in grays touched here and there with pinks, and thence upward into the deep blue-gray of a stormy sky. The whole comes to life through variations of shade within the blues and greens, by highlights which dance off the buildings and trees by the stream. A flash of lightning emits a yellow glow, a suggestive source of sulphurous and eerie illumination.

Such are the ingredients of a compelling, ineffable mood poem. A nursing woman, a passer-by, a threatening storm which seems never to come—all combine in a spell of hallucinatory unreality. The mood is one of utter suspension, a quiet resolution that exists amidst apparent flux. The most remarkable quality of the painting, as Marcantonio realized, is the presence of a storm. Possibly its significance is narrowly iconographical, but in the way the artist has understood those rolling clouds, the storm becomes the most evocative aspect of the painting. In earlier Italian painting there is no such specific reference to an unusual condition of weather. Description of a time of day, of the seasons, of momentary phases of weather are rare, except in conventionalized form where the iconography demands it. The earlier landscapist reveals forms in their normative aspect, and tries to avoid the suggestive or the ambiguous. Giorgione overthrows this stability, and gives us a glimpse whose very essence suggests the fleeting passage of time. If one recalls Bellini's *Allegory of Justice and Mercy* (Fig. 42), the comparison of the two pictures mutely reveals everything one wishes to know. Formally Giorgione has worked a revolution, but as landscapes the two works are strangely similar. There is an utter calm, a lassitudinous relationship between passive figures and a silent landscape. But in Bellini contemplation is ultimately that of a Christian truth, of a benevolent mystery. A blade of grass or a pebble is honestly described, for it reflects in microcosm its Maker. Giorgione is equally a contemplative, but we no longer feel the artist's humility before the data of appearances. Why do these three sages contemplate a mysterious light, and why does a nude woman sit unmoved in the face of an approaching storm? While we know Bellini approached nature as the path to a higher truth, we intuit that

Giorgione contemplated the processes of life in their own right.

If we are to define Giorgione's attitude towards landscape, then we must understand the subject of this little picture. Sadly, the meaning remains a mystery, for no interpretation so far proposed is convincing. The elements are basic: three figures, readily interpreted as a family, who are in a stormy landscape. Perhaps it is an idyl, a *poesia*, just a *paese*, as Marcantonio called it. So believed Lionello Venturi early in our century, who wrote that "the subject is nature: man, woman and child are only elements, not the principals, of nature." But the Renaissance was not prone to such vagueness, and while our aesthetic sensibility remains with Venturi, our historical sense seeks a more precise explanation. Possibly this is a mythological scene (more than one has been suggested), or the illustration of a concept, such as the four elements. Any proposed interpretation is further confounded by X-rays, which show that originally Giorgione had conceived of a second nude woman instead of the wayfarer.

Let us be honest: we do not know the subject of the *Tempesta*, and have only an uncertain idea of that of the *Three Philosophers*.[4] Scholarship on Giorgione has always sought a key to the meaning of his art, at times in philosophy, at others in myth, or literature (such as the fabulous *Hypnerotomachia Poliphili* of Francesco Colonna), or finally in the proposition that his pictures are idyls without narrative meaning. The approach a critic takes must depend to some extent on his view of Giorgione's patrons. These patrons were young, well-educated, and scions of the ruling classes of Venice. There is every reason to assume that pictures painted for such men might possess a deep intellectual con-

[4] The quotation from Venturi and a summary of various interpretations of the *Tempesta* are given in Zampetti's catalogue. Ferriguto's interpretation, *op.cit.*, chs. v-vii seem to me entirely plausible but not demonstrable. For him the picture represents the forces of nature as embodied in the four elements. More recently a fascinating but unconvincing interpretation links the picture with the *Hypnerotomachia Poliphili* of Francisco Colonna, published in 1499: Luigi Stefanini, *Il Motivo della 'Tempesta' di Giorgione,* Padua, 1955 (originally proposed in 1941). As I say in the text, I regard the meaning of some of Giorgione's most central works a mystery. I assume that they do possess a definite and probably complex meaning, and in this the real Giorgione stands separate from the painters about him. To give but one example, the Compton Wynyates' *Idyl* (Zampetti, *op.cit.*, pp. 60-61) seems clearly to depend upon the *Tempesta,* but while in the latter one senses a mystery, in the former one suspects a composition has been adopted without knowledge of its real meaning.

tent. But such ideas would have filtered through the mind and hand of a poet, a musician, and person of grace who could make his way in aristocratic circles. Giorgione doubtless had a bright intelligence and high sensibility but little book learning. He was an artist, a man of sense impressions, and for this reason abstruse argument or precise concepts were probably of little interest to him. His ideas were rather distillations from the overabundant pedantry of the day.

The *Three Philosophers* and the *Tempesta* show us the essential Giorgione. The pictures reveal how formally Giorgione departed from Bellini, yet in the matter of landscape mood how he carried on his master's ideal. As landscapists, both men are lyric contemplatives almost without peers in the art of the West. Here the matter must rest, for much is still hidden concerning the meaning of this essential Giorgione. But if we move from the essential Giorgione to the master's late works, and on into that undefinable realm where Giorgione disappears and Titian finally emerges, a new problem is posed, the question of the pastoral sentiment in Venice.

There is a painting in Dresden, which Roger Fry thought might best exemplify the spirit of the Italian Renaissance (Fig. 50). Marcantonio saw it in 1525 in the house of Hieronimo Marcello at San Tomà: "Canvas of the nude Venus, who sleeps in a landscape, by the hand of Giorgio da Castelfranco, but the landscape and cupid were finished by Titian." The picture is surely the one described by Marcantonio, for the cupid that was subsequently painted out has been found by X-rays.[5]

The landscape is by Titian, but what is interesting is not so much its present form as the very idea of a sleeping Venus in a landscape. We may assume that Giorgione intended from the beginning to place his Venus in a landscape though we cannot tell how closely its appearance echoes the master's original idea. It is a hushed land, with those full cumulus clouds floating overhead that are to become one of the trademarks of Titian's manner. The rural buildings of a small settlement overlook a peaceful valley, and not a soul is seen abroad. The quiet hour is siesta, and the land is asleep.

[5] Hans Posse, "Die Rekonstruktion der Venus mit dem Cupido von Giorgione," *Jahrbuch der preussischen Kunstsammlungen*, LII (1931), pp. 29-35.

The picture is first of all a painter's delight. There is pleasure in the juxtaposition of colors and the manipulation of textures. The creamy skin of the recumbent form is bathed in a soothing light, its surface soft to the touch. Shadows slide gently into veiled smokiness, and there is little suggestion of bone or tendon, only the healthy porousness of living skin. The artist has delighted in the placement of a creamy white body upon a drapery of silvery gray. Their colors blend in a muted harmony, yet flesh and cloth are contrasted by means of the artist's superb feel for textures.

A sleeping nude in a pleasant landscape, one arm sensuously thrown back and a hand idly shading her private parts, such is an image which verbally described might seem sexually provocative. But nothing could be further from the truth. While physically real, Giorgione's Venus is seen from afar, a stately figure whom we contemplate without any full-blooded sense of empathy. The artist has kept us at a distance by means we realize only after reflection. To begin, one realizes that a nude asleep in a landscape is a common-sensical improbability, that this image is no counterfeit of reality, but an apparition of highest artifice. Venus is seen at a remove, not in bed as Titian will later paint her. Giorgione's figure is partially dematerialized, and seems to float with weightless, pneumatic ease, barely touching the garments beneath her. This effect is achieved partly by soft modeling, whose shadows are never deep enough to suggest weighty corporeality, and whose surfaces gloss over the articulation of the body. The only descriptive line is the outline of the body, a superb piece of abstraction. A finely attenuated profile runs without interruption from her right elbow to her knee, and the far side of the body is described in suave undulations echoed in the rolling forms of the landscape. Line describes a self-sufficient aesthetic reality rather than the mirror image of a flesh and blood model.

Above all, our rapport with the goddess can never be intimate, for she is asleep, impervious to those around her. Like Eve before the fall, she is unaware of her nakedness. One may wonder where Giorgione found this imagery, and even more, what the idea of sleep conveyed to him. The concept of a sleeping female nude was current in the fifteenth century, not as the image of Venus, but as the nymph of a fountain. Giorgione might have known

this iconography through a variety of channels, but most to the point is the *Hypnerotomachia Poliphili,* published in Venice in 1499, where the sleeping nymph is described with pictorial thoroughness. The description is close to Giorgione's Venus, and a glance at the woodcut which accompanies the description shows that from this somewhat wretched source the artist was able to spin consummate poetry (Fig. 51).[6]

While the source of Giorgione's imagery is probably explained, what it may have meant to him beyond a formal solution is not. "To sleep, perchance to dream . . . ," the nightmare fears of Hamlet were not those of Venice around 1500. In dreams were evocations, the presence of imaginative vistas, voyages beyond the self to rare lands. Already in the fourteenth century Petrarch had awakened in dreams to visions of the *Trionfi,* and Colonna's *Hypnerotomachia* is similarly a voyage in dreams to sights unknown and inaccessible to the world of consciousness. The dream was an avenue to precious insights, and such contemporary works as Bembo's *Asolani* and Sannazzaro's *L'Arcadia* cultivate the revelations of sleep. The sleeping Venus is touched by delightful uncertainties which only the spectator's imagination can probe. Hers is a world in pleasurable dormancy, "a green thought in a green shade."

The idyllic state of the sleeping Venus suggests a realm much desired and never achieved, the far-off land of Arcadia where babbling brooks traverse the verdant copses, their barks host to dallying nymphs and their swains. It is the land of milk and honey where love is perpetually pursued without regrets, and a Venus may bask in eternal sunshine. Marcello, the patron of the picture, traced his family lineage back to the goddess herself, so the picture is a sort of emblem of lineage. We might think that for a patrician of the lagoons, whose life was oriented towards the sea, Venus would be depicted riding the waves. But Marcello's Venus dwells not at Venice. Her abode is a rolling valley beneath the hills, perpetually in pleasant midsummer languor. It is, then, that *locus amoenus,* the pleasant place, of which the

[6] Ferriguto, *op.cit.,* ch. XIII, connects the picture to a woodcut in the *Hypnerotomachia.* On the nymph iconography: O. Kurz, "Huius nympha loci: a pseudoclassical inscription and a drawing by Dürer," *Journal of the Warburg and Courtauld Institutes,* XVI (1953), pp. 171-77.

Arcadian poets sang. Here one expects a vision of nude deities and semi-deities who breathe in rhythm with the landscape, and inhabit an enchanted world of escape where the longings of civilized men for natural simplicity find fulfillment in moments of reverie. So the Venus of Marcello, a man whose world was the sea, and just as soon forgotten.

It is pleasing to imagine Venus in Arcadia, yet this is only a loose analogy to evoke her untouchable world. There is, in fact, slight basis for any specifically Arcadian interpretation of the work. But the temptation remains to think of her in such terms, in no small part because of our knowledge of the Arcadian mood of Venice during the first decade of the sixteenth century. The dream of Arcadia, or more generally the pastoral ideal, had been revived already in the fourteenth century by Boccaccio. In fact, Tuscany would seem its proper home, for Florentine poets of the later fifteenth century give us pastoral imagery in some abundance. In the *Selve* Lorenzo il Magnifico sketched an elaborate picture of the Golden Age, and the plea of the shepherd Corinto is one of the loveliest pieces he wrote. In Florence, however, painters did not respond to these poetic suggestions. Rather at Venice an enthusiasm for pastoral poetry took hold, and eventually a visual equivalent. This was shortly after 1500, when a pirated edition of Jacopo Sannazzaro's *L'Arcadia* was printed in Venice.[7]

Sannazzaro's work runs well beyond a hundred pages, as one is painfully aware. This tapestry of interwoven prose and poetry is unevenly threaded, not always touched by the melodiousness that its subject matter would seem to demand. The book tells of the voyage of a disenchanted Neapolitan shepherd to the far-off realm of Arcadia. His name is Sincero, which suggests the frank honesty and simplicity that will attend his wanderings. Wander he does for many pages, living among the simple shepherds and sharing the unhurried tempo of their daily lives. With them he will hunt, pause to sing, offer sacrifices to the gods. All the while these events are interspersed with descriptions of landscape, and of the creatures that inhabit it. A dream of ill-omen puts an end to this idyllic sojourn, for Sincero hastens back to Naples to find

[7] Sannazzaro, *L'Arcadia*, ed. by A. Mauro, Bari, 1961. It first appeared in a pirated edition in 1502, then in a first edition of 1504.

that his loved one is dead. Such is this tale, more a delightfully mindless joining of pleasant images than a narrative with a plot.

L'Arcadia was born midst those villas on the bay of Naples, in the literary society of a Pontano and a Sannazzaro. It was eagerly received at Venice, where the ideals of escape from the city, of the salubrious ways of country life, were already strongly felt. Our best account of this is *Gli Asolani* of Pietro Bembo, published in 1505.[8] Here we find not a description of Arcadia, but a charming sketch of a society ripe for the Arcadian dream. *Gli Asolani* is set at Asolo, at the court of Caterina Cornaro, the ex-queen of Cyprus. On three successive afternoons six young men and women withdraw to a beautiful garden, and seated by a cooling fountain, discuss the qualities of love. As in Arcadia, so here conversation now and then stills for a song, and one feels the soothing presence of a *locus amoenus*. The piece ends in praise of divine love, a praise which became less sensuous and more Neoplatonic with subsequent editions of the work.

Gli Asolani is hardly important as a document of Renaissance ideas. Rather it reflects a style of living, the intercourse of noble minds in the pleasantest surroundings imaginable. Asolo is still an enchanting town. From its slopes the village offers a pleasant prospect across the flat plain where Castelfranco lies, onward to the distant Euganean Hills. In Bembo's day the town was the seat of a small but unique court, and it was this which gave rise to *Gli Asolani*.

In 1489 Venice received one of her distinguished daughters, Caterina Cornaro, brought home from Cyprus under thinly veiled duress. Through marriage Caterina had become queen of Cyprus, but on the death of her husband, the young widow was soon enmeshed in a web of politics beyond her control. The outcome was the acquisition of Cyprus by *La Serenissima,* but not without recompense to the queen. Caterina was given Asolo for the duration of her life, with a stipend to support her court. So the queen without a country found a home in one of the lovelier spots of north Italy, where she remained almost without interruption for the last two decades of her life.

The thought of the court at Asolo is touching, and tinged with

[8] *Prose e rima di Pietro Bembo,* ed. by C. Dionisotti, Torino, 1960. *Gli Asolani,* pp. 313-504.

sadness. It was an artificial creation, the by-product of a political transaction. It could have no mission except elegance in living, and was condemned at the death of its mistress. One likes to think of this court as a flourishing center of culture, a meeting ground of men such as Giorgione and Bembo, but there is little to suggest that Asolo was more than an artistic backwater. As in the days of Robert Browning, so several centuries earlier Asolo must have been a sleepy town, its life quickened only by the irregular visits of distinguished persons. Such a visitor was Pietro Bembo, who gave to the world the sketch of an ideal spot and an aristocratic way of life. Having read *Gli Asolani,* a Venetian of 1505 would have understood that beyond the lagoon lay a town which embodied in a small way a graciousness and leisure removed from his own hurried existence. Some painter, with an arid touch, attempted to catch the spirit that runs through Bembo's pages (Fig. 52). His stolidly pensive Caterina is surrounded by blank-looking courtiers, and intended poetry turns out to be flat prose. Nonetheless, the painter's message is unmistakable.

The fictional protagonists of *Gli Asolani* would have read Sannazzaro's *L'Arcadia* with pleasure, for their world was an embodied Arcadia, and lacked only the innocence of that far-off land. A Venetian of the time would not have missed the affinities between *Gli Asolani* and *L'Arcadia,* for they were merely different manifestations of the same taste. So in the first years of the century a new mood entered the Venetian literary scene, a concern for a simple life, for the goodness of love, for a return to an earthly paradise.

There is no doubt that this taste for the pastorale developed in literature before the visual arts, and a work such as *L'Arcadia* is strongly pictorial in effect. We may open at random to the beginning of the *Prosa quinta*: "It was already sunset, and all the west was adorned with a thousand varieties of clouds; among them violet, cerulean, some sanguine, others between yellow and black, and so shining from the reflection of the rays, that they appeared of fine and polished gold. . . ." It is all seen with a painter's eye, and quite consciously so, for in the *Prosa terza* is the famous description of the painted decorations of the Santo Tempio: ". . . we saw on its door some painted woods and beautiful hills, and

97

abundant, leafy trees, and a thousand varieties of flowers, among which one could see many flocks that were grazing and roaming the green valleys. . . ." Certain parts of *L'Arcadia*, like passages in Leonardo, are a virtual invitation to landscape painting.

The public that read Bembo and Sannazzaro would have appreciated Giorgione's pictures, for both literature and painting offer evocative images, suggestive notations rather than finished statements. The Venetian mood around 1500 is that of a fragile moment, in a rarefied environment where men sipped the pleasures of contemplative leisure. But one must ask whether it is justified to look at Giorgione through pastoral eyes.

Loosely speaking, yes. The mood of contemplative detachment, of sympathetic accord between figures and landscape, the unimportance of actual narrative, the vision of gods who rest in a peaceful landscape—all this is the stuff of pastoral poetry. But more precisely considered, that part of the Giorgionesque oeuvre closest to the master himself is not pastoral, for where are the shepherds, the shepherdesses, the nymphs, the flocks, the sacred shrines? And a painting such as the *Tempesta*, in spite of its shepherd-like figure, is far removed from the pastoral ideal. A storm threatens the land of eternal summer, and as any young parent knows too well, there can be no children in any Arcadia worthy of the name. The comparison of Giorgione and literature in the first decade of the century is a good one, provided that it is kept on a most general level. Here it would remain were it not for still another debated picture, the Louvre *Fête Champêtre* (Fig. 53).

This painting has had an uneasy history. The condition in which one sees it is quite new, as photographs of its former sadly ruined state reveal. Any judgments reached through style must then be most tentative. Partly because of this uncertainty, and partly because of a Victorian uneasiness towards the subject matter of the painting, it has had a long and varied history of attributions. It passed from Palma Vecchio to Giorgione, thence to an imitator of Sebastiano del Piombo to Sebastiano himself, then back to Giorgione where it received substantial support. Today opinion both published and unpublished veers strongly towards an attribution to the young Titian.

The elements of the painting are rather simple. The protago-

nists (if such idyllic figures can be called that) are four: two clothed youths and two nude maidens. Music is the pretext for their repose. As one of the men sounds a note upon the lute, the others listen pensively, one with flute in hand, the other idly pouring water into a well. The setting is pleasant and rural. Three of the figures sit upon the cushioned ground, while beyond a shepherd accompanies his flock. All is seen against a lush copse of trees, a distant view of buildings, and a misty plain.

These few facts are the raw materials of a haunting picture. There is the very improbability of the subject itself, a pair of clothed men with two nude women in an open landscape. These women are not undressed but nude, adorned with fine stuffs reminiscent of Greek sculpture. We find no picnic basket about, nor any fiasco of wine: no commonplace explanation of this gathering will do. These folk exist on an elevated plane of reality, divorced from our normal experiences. A note has been sounded, a word perhaps sung, and all pause, as if hypnotized in a momentary trance. The men regard one another with unspoken comprehension, while the standing figure pours water, her arm wonderfully expressive of the lassitude that permeates the picture. Her entire body is rhythmically focused upon the completion of this simple deed.

As in all the Giorgiones that we have seen, so here much of the ineffable quality lies in the ambiguous psychological relation of one figure to another. A woman stands apart, apparently divorced from the meditations of the other three. Yet we feel that she is not, that she is one with their thoughts. Whatever happens within the painting is a spiritual transaction, and is mutually understood without recourse to verbal communication.

While the picture is a piece for contemplation, it is also a most physical image, sensuous in its allure. These women are no longer the girls of fifteenth century art, but poised, mature women, instinctively proud of their bodies. They carry themselves well, and have an air of nobility about them. The amplitude of their bodies predicates the lushness of the painting as a whole. The soft and rounded forms of the seated nude are carried over into the abundant tree crowns behind, and one senses the rapport of porous flesh and living foliage.

The formal arrangement of the picture and its technique

strengthen the sensation of richness. The paint is fluid, applied with loose brushstrokes. Those surfaces that it models are velvety soft, and would seem to yield gently if touched. Colors discreetly bring attention to the figures. The foliage is various shades of muted olive, here and there brightened by patches of yellow-green. A steely blue plain stretches back to a lost horizon, while above the gray sky is occasionally broken by streaks of yellow and white. The general effect is quiet, indeed almost somber. Against it stands a mixture of creamy flesh and silvery draperies, and the deep reds and burgundies of the lute player's elegant garb. So the painting possesses not an impressive brightness, but a subdued vibrancy whose sensuosity grows upon one slowly.

This sonorous poem is laden with things unsaid, a mystery. We should like to know the import of the lutanist's song, and why this quartet is hushed in evocative reverie. One has the feeling that no set explanation will suffice, even if buttressed with the finest arguments. There are layers of meaning, the most important of which is a question of feeling rather than intellect, inexplicable through words.

We may accept this ineffable meaning, and grant that it lies at the heart of the painting. Still one desires to push on in search of shades of meaning that can be seized verbally. Within the painting are hints that invite interpretation. The most important is the unlikely juxtaposition of two nude women with two dressed men. Both men are clothed, but in quite different attire. The lute player is in elegant silks, expensive garments that have no place in a rural landscape, while his companion is dressed in rough cap and jerkin, dull in color and rude of manufacture. Surely a contrast is intended. The motif of a woman pouring water while highly evocative is also specific enough to beg interpretation. A small but possibly significant peculiarity is the architecture above the heads of the two youths. Over the dandy is a blurred glimpse of a stately villa, an oculus in its gable, its façade enlivened by columns or an arcade. Next to it, but closer by, is a bit of rustic architecture, a haphazard conglomeration of parts wrought in both wood and stone. Like the pair of men, these two structures are incongruent companions within the landscape.

Not long ago an interpretation of the canvas was offered

which unquestionably provides a strong clue to the meaning. A fifteenth century playing card shows a woman seated by a fountain, playing the flute with one hand and pouring water with the other. The figure is labeled *Poesia*. From this unpromising imagery would seem to spring the two nudes, and with them the basic meaning of the painting, something to do with poetry. This something may be explained by the contrast in dress between the two men, a difference between the elegant and simple, which is echoed in the architecture above their heads. It would not be too much, according to this interpretation, to regard the picture as divided into two halves. If these halves are associated with Aristotle's views on poetry, then a straightforward explanation of the picture emerges: it is an allegory of poetry which elucidates the Aristotelian split of this art into a higher and lower genre.[9]

This interpretation is argued with clear-headed concision, and there is nothing specifically to question or refute. But when one is done there is an empty feeling, as if only part of the story had been told. The picture may well be a rather simple allegory, but if so, how very casual is the painter's attitude towards it. The picture is not, in fact, clearly split in half, and the precise symbolism of the playing card has expanded into diffuse poetic imagery. Remembering that Giorgione's *Venus* seems to be taken from a nymph of the fountain, so here one wonders whether the meaning of the source has been taken over into the painting unaltered. The allegory, if there is one, has melted into warm sentiment and become unclear. But whatever one's doubts, a precious clue remains: the painting probably concerns the idea of poetry.

At this point one remembers the old name of the painting, *Pastorale*. Simply and obviously this is the right general title for the picture. We are in Arcadia, where music-making is the bread of daily life. Nude women loll about the clearing, only to be explained as the nymphs who populate the pages of Arcadian poetry. One of them stands by the familiar well, while the other holds a pipe, a standard piece of pastoral equipment. Even a shepherd and his flock are there to fill out the pastoral cast.

[9] P. Egan, "Poesia and the Fête Champêtre," *The Art Bulletin*, XLI (1959), pp. 303-13.

There is but one discordant note, the elegant young man whose overbred sophistication has no real place in Arcadia, and whose presence here is not easily explained.

This young man is the true protagonist of the painting. He has plucked a note, probably uttered a word, and his companions savor them with rapt attention. The seated nude lowers the pipe from her lips, seemingly entranced by what has just happened. It is he, the discordant element, who sets the psychological mood of the moment. Who, then, is this peaceful intruder in the land of Arcadia, and whence does he come?

The answer immediately suggests itself, but as with most interpretations of Giorgionesque paintings, is cheerfully devoid of factual substantiation. The young dandy would be the pastoral poet himself, the world-weary Italian of 1510 who through his art tries to enter the enchanted realm of a happier time and place. By melodious song he would escape his refined environment, but is unable to slough off completely the debilitating sophistication of his society. So he remains an inappropriately clothed stranger who tells his tale, accepted with benevolence and magnanimity by the languorous folk of Arcadia. In the far distance is the civilized architecture of the world from which he has come, shrouded in haze, but still in sight. The painting, then, would evoke Arcadia as it awakens in the imagination of a yearning artist.

Above all, the picture remains a state of mind. The young men seem strangely oblivious to the nudes before them, almost as if for their eyes these lovely apparitions did not exist. Perhaps the artist hints at different levels of existence, or suggests that this entire scene is an illusion evoked by the song of a young man who sits alone.[10] I suspect in truth that we shall never know. In its quality of a spiritual state rather than a physical fact this picture joins the ambiguous and evocative paintings already discussed. It is for this reason that I feel (for it is ultimately a matter of faith in these questions) that the picture is one of Giorgione's finest conceptions, left unfinished at his death. Its completion is owed to the freer hand and more sensuous temperament of the young Titian, perhaps as late as 1512. So Giorgione's vision extended beyond his lifetime, gradually to

[10] P. Fehl, "The Hidden Genre: A Study of the Concert Champêtre in the Louvre," *The Journal of Aesthetics and Art Criticism*, xvi (1957), pp. 153-68.

lose itself in a movement from ambiguous nuances to brash certainties, from a world in languid suspension to one throbbing with life.

The development of the pastoral as a popular mode reached its climax in the decade between 1510 and 1520. In the years between 1513 and 1517 alone several editions of both *Gli Asolani* and *L'Arcadia* were published, and another medium of popularization, the engraving, made pastoral imagery readily available.[11] Giulio Campagnola, the Paduan engraver who is recorded in Venice in 1507, did several pieces in a pastoral vein. His *Old Shepherd* is a patently Giorgionesque idea (Fig. 54), and the *Shepherds in a Landscape*, started by Giulio and finished by Domenico Campagnola after 1515, seems an uncomplicated reprise of the *Fête Champêtre* (Fig. 55). On the left one sees a group of music-makers in the shade of a grove, while to the right is a rustic village whose picturesque forms are enjoyed for their own sake. The engraving possesses a remarkable softness, achieved by a dot technique which captures in black and white the smoky suggestiveness of Giorgione's paintings. And then there are numerous paintings, a satyr who stalks a nymph, a shepherd with his flock, beautifully painted little pieces which drift anonymously amongst the followers of Giorgione (Figs. 56 & 57). They are minor poems in blues and greens, seen quickly as if through a misted glass, whose vague and idealized forms are a perfect complement to the make-believe literary world which inspired them.

I say inspired them, for ultimately we must see Pietro Bembo, author of *Gli Asolani* and promoter of pastoral drama, as the fountainhead of this taste at Venice. Giorgione's place as a pastoral painter remains uncertain. I might, as has been done, spin a web of relationships that would entwine Bembo, Giorgione, Giulio Campagnola, Caterina Cornaro, and others, but the web would have no historical substantiality, for too little is known. But in a wider sense Giorgione is indeed the pictorial fountainhead of pastoralism. In the *Tempesta* or *Three Philosophers*

[11] The wave of pastoral enthusiasm can be easily traced in the pages of the *Short Title Catalogue of Books Printed in Italy . . . from 1465 to 1600 Now in the British Museum*, London, 1958, where one sees that pastoral writing of antiquity was already published in Venice before the turn of the century.

Venetians saw a landscape of reflective silence, an ideal image which left behind the particularisms of Bellini. The question of how many strictly pastoral subjects are attributable to Giorgione loses its interest, for his contribution was an ineffable one, the creation of a landscape of mood whose meaning transfigures the particular subject matter. Only after this mood had been evoked, in Giorgione's last years or after his death, did the world of Arcadia become for painters the stuff that dreams are made of.

In these two essays I have put Bellini and Giorgione side by side, not in the spirit of historical juxtaposition, but as the distilled essence of their art appears to me. From this comparison certain generalities are hard to resist. Usually the differences between the two artists are stressed. While the formal and iconographic innovations of Giorgione are considerable, out of the contrast between the two men has grown an overly simplified view. Bellini is seen as a profoundly Christian artist, somewhat simple in outlook, naively fresh as a landscapist. But this image of Bellini then becomes a foil for Giorgione, first of the moderns, champion of art for art's sake, a soul sensuous and romantic. The idea of progress enters, and Giorgione the modern thinker and painter triumphs over Bellini, the slightly archaistic traditionalist.

Anyone who looks at the two men as landscapists would reach a different conclusion, and would stress their underlying similarity. For both men landscape is a silent place. The *Gethsemane,* the *Tempesta*; both are pictures that in their different ways suggest imminent change, but for the moment all is in a state of suspension, figures and landscape united in stillness. Nothing happens and nothing moves; only the spirits of men roam a quiet realm.

In the paintings of both artists the figures seem a natural emanation of the landscape itself, as much sons and daughters of the earth as the pebbles and flowers that cover it. Bellini's *Madonna of the Meadow* and Giorgione's *Sleeping Venus* are both improbable apparitions in a quiet landscape, yet one accepts their presence as simply another natural event among many. The reasons for their closeness to the earth are profoundly different, but in each case the effectiveness of the image depends

upon our understanding it as a fully natural relationship between figures and setting.

Finally, this quietude and peaceful union of men and nature is in both artists directed towards the same end, an invitation to reflection and contemplation. In both the *Allegory of Justice and Mercy* and the *Three Philosophers* figures muse and dream. It is as if some sort of specific action had died away, and the protagonists had given themselves over to reverie. The landscapes are the soft echoes of the figures' unarticulated thoughts. Through involvement with these contemplatives and their silent world, we too pause for thought.

For Bellini contemplation is directed towards a benevolent mystery. He trusts in the peacefulness of a finite world, secure in the belief that in its smallest detail it reflects without distortion the love and bountifulness of the Christian God. In the *Castelfranco Madonna* Giorgione perpetuates the essential interest of Bellini's pictures, but endows it with an ambiguous evocativeness that Bellini rarely possesses. In the *Tempesta* and *Three Philosophers* the mystery is no longer benevolent or comfortable. Because of our ignorance we know not its general limits, or even what segment of our being it affects. Giorgione's figures seem both physically and spiritually one with the landscape. The object of their contemplation, and hence that of the artist, seems to be nature herself, the face of the land which holds locked within it the secret of our being. Finally, if Giorgione becomes an Arcadian in his last pictures, nature is contemplated in the memory, as an analogy for mankind in a simpler and happier age. Nature is the solace of a weary spirit.[12]

Over a span of forty years Venice gave to the western world two of its true contemplatives. In their work we are asked for a moment to pause and reflect, for greater battles are won in contemplation than in action. Their vision is always honest and at

[12] My assertion that it is only the late or even "posthumous" Giorgione who paints pastoral subject matter should be qualified in two respects. We should know more about such lost works as the *Finding of Paris* and whether certain borderline pictures, such as *Paris Exposed* (Princeton University Art Museum, Princeton, New Jersey), are in fact by the master.

On the "pastoral Giorgione," see the recently published essay by R. Wittkower, "L'Arcadia e il Giorgionismo" in *Umanesimo europeo a umanesimo veneziano*, ed. by V. Branca, Firenze, 1964.

times a little sad. Perhaps like Bembo's hermit on the hill above Asolo they, too, realized that life is but a waking dream.[13]

[13] Probably Giorgione's oeuvre will never be defined stylistically to everyone's satisfaction. The mystery of his subject matter will only yield if additional exterior evidence can be brought to bear on the pictures. Perhaps the problem is only in our minds, for the critical comment of writers from Vasari through the seventeenth century dwells almost exclusively on Giorgione's amazing naturalism.

VI ❖ VENETIAN LANDSCAPES

TITIAN, nature's greatest confidant, is among landscapists the Homer."[1] Count Francesco Algarotti's words were published in 1756, and the sublime praise intended is unmistakable. Two centuries after his death Titian basked in the pleasantest part of the landscapists' Olympus.

This apotheosis had begun already in the Venetian's lifetime, for in 1548 the theoretician Paolo Pino compared him to the north Europeans, and observed that the latter were adept at landscape painting, ". . . because they imitate the landscapes in which they live, which on account of their wildness are pleasantly suited. . . ." However, ". . . we Italians are in the garden of the world, a thing more delightful to see than to paint, though I have seen miraculous landscapes by the hand of Titian, much more pleasing than those by the Flemings."[2]

On the basis of this and various other records, scholars have attempted to swell Titian's oeuvre to include pure, or nearly pure, landscapes. Probably such landscapes do not survive, and there is a question as to whether they were ever painted.[3] Critics from Aretino on acclaimed the landscape passages in Titian's canvases, not landscape paintings as such. A burst of sunlight in foliage, mountains shrouded in mist, billowing cumulus clouds—these were the glories of his art, and the basis of his fame as a landscapist.

To know Titian the landscapist is to grasp the essence of the Venetian experience of landscape during the sixteenth century. By 1515 Titian's attachment to the *poesia* of Giorgione faded, and with the Borghese *Sacred and Profane Love* the gently sounded music of a lyric moment gave way to the grander orchestration of Titian's early maturity (Figs. 58 & 59). Figures who are

[1] F. Algarotti, *Saggio sull'architettura e sulla pittura*, Milan, 1756, pp. 86-87.

[2] P. Pino, *Dialogo di pittura*, Venice, 1946, pp. 145-46.

[3] There is considerable literature on Titian as a painter of pure landscapes, but most of the pictures involved are questionable. On a picture at Buckingham Palace: H. Tietze, *Titian—The Paintings and Drawings*, London, 1950, p. 376. Another painting, which I have not seen but distrust on the basis of photographs, was published recently: "Un paesaggio di Tiziano," *Acropoli*, III (1963), pp. 232-36. For an interesting but for me unconvincing attempt to enlarge the horizons of Titian's landscape art: A. Morassi, "Esordi di Tiziano," *Arte Veneta*, VIII (1954), pp. 178-98.

perhaps twin Venuses bask in the fullness of womanhood. Bodies and draperies are ample, described in slow curves appropriate to rich textures and creamy carnations. Profane Venus (if so she be) is draped in pearly silver satin which billows about her arms and feet, while her sister's warm flesh is complemented by the translucent purples of fine wine. The moment seems imprecise, as it had been with Giorgione. Nude Venus raises her lamp, and casts an indulgent glance at her son, while her clothed counterpart gazes at the spectator with bemused disinterest. Both sisters seem to listen, perhaps to the ripples stirred by Cupid's play or to the clean trickle of water that issues from the golden drain of the sarcophagus. It is a moment of quietude, but one that stirs with physical palpitations. The nostalgia of Giorgione is replaced by a full-blooded glorification of life.

Landscape now assumes the role that it will maintain through most of Titian's career. It is background, carefully subordinated to the figures, but never a background chosen at random. In the Borghese picture landscape is a skillfully spun variation on the mood of the figures. The land is quiet at day's end. It is sundown, but not the hour of flaming skies. A warm glow appears over the shoulder of Profane Love, softly touching the buildings on the hill behind, and silhouetting the branches of a small tree. Most of the land is shadowed, bathed in deep browns and greens. To the right the failing light falls upon two riders, a shepherd and his flock, an embracing couple, while behind stretches the turquoise inlet, its shores ringed by the buildings of a village. A darkly forested hill runs to the edge of the town, only to disappear behind the nude. Beyond the land, the waters still receive the last rays of sunlight, earth and water blending where a small peninsula reaches out into the calm turquoise sea. Far away, two sails disappear towards the horizon. Over all spreads the evening blue sky, streaked with long fingers of cream and pale gold, a few fluffy cumulus clouds animating the stillness. Calm, silent, and suggestive of the earth's fecundity—such are the characteristics of Titian's landscape and of the twin Venuses who inhabit it.[4]

[4] Panofsky sees a *paysage moralisé*. Although this would be a proper complement to his interpretation, I do not see while standing before the painting that the landscape is thus divided. E. Panofsky, *Studies in Iconology*, New York,

If Titian seemed to dispel the golden lights and shimmering haze of Giorgione's world, still more important was his ability to endow the forms of nature with the vital juices that animated his figures. Physical dynamism and cosmic energy become one, the symbol of life itself. If generations of critics are heeded, then the highest example of this living landscape, achieved through new painterly means, was embodied in Titian's *Peter Martyr*.

The great altarpiece, tragically destroyed by fire in 1867, was delivered to the church of San Giovanni e Paolo in 1530. From Aretino and Vasari onward we are told insistently that this was Titian's finest painting. Of this one can hardly judge, but a fair idea of the altarpiece may be had via various copies, of which I reproduce an engraving by Martino Rota (Fig. 60). The murder takes place beneath a clump of trees, whose lush foliage fills the oval head of the altarpiece. Magnificent is the anatomy of the executioner, the gesture and expression of the martyred saint, the original invention of the fleeing brother. Untouched by innuendo or hesitancy, the figure group embodies all those qualities which a later age would declare the proper attributes of High Art. But even more striking must have been the color, the burst of light above from which issue the *angelini* who bear the palms of martyrdom, and the view of the Dolomites up a distant valley.

Both Aretino and Lomazzo admire that "grandissimo bosco" where the martyrdom occurs,[5] and Algarotti elaborates on the quality of Titian's foliage: ". . . and perhaps the most beautiful landscape ever painted is that of the *Peter Martyr,* where for the variety of trunks, of leaves, of the various bearings of the limbs one can discern the difference between one tree and another; where the land is so well partitioned and rolls on with such natural grace; where a botanist would go to gather plants."[6] Some idea of the verdant opulence in the lost altarpiece can be gleaned from a detail of the *Feast of Venus,* a picture done a decade earlier, but which nonetheless suggests what must have been the ripe lushness of those trees (Fig. 61). The sunlight plays

<hr>

1962, pp. 150-51. The actual subject matter of this picture is not surely known, and the picture has given rise to a number of interpretations.

[5] P. Aretino, *Le lettere di Pietro Aretino*, Paris, 1559, I, p. 171.

G. P. Lomazzo, *Trattato dell'arte della pittura scultura ed architettura*, Rome, 1844, II, p. 447.

[6] See note 1 above.

deep within the foliage, hollowing out pockets of air that fill the leafy boughs. Greens and yellows slide into one another, and the eye is led beyond them to a flash of sunlight on a distant building. No artist earlier had caught so well the cellular labyrinth of a forest crown, the paradoxical feeling of lightness in density that is offered by closely massed boughs. This detail suggests something of the effect that must have been produced by the *Peter Martyr*, though in the altarpiece it was on a vaster scale, doubtless worked with a freer brush. So Titian made palpable one of the most difficult objects that a landscapist faces, a leaf tree.

Shrewdly Lomazzo noted another novel quality of the altarpiece, the fact that figures and landscape elements are in a proper scale relationship.[7] One does not notice this at first, but it is so: the figures are in an absolutely just relationship to the trees that tower above them. The gesturing of human limbs is echoed in the boughs of the trees, and carried upward to the burst of light. Not only by scale, but by rhythmic movement the oneness of men and nature is suggested.

Light and color were the formal miracles of the *Peter Martyr*. Ridolfi, the seventeenth century Venetian biographer, captures some of this for us. ". . . the site is a grove, where on the distant mountain peaks (now that the white and vermilion dawn disappears) the sun slowly rises, streaking with gold the azure sky, the view being of the mountains of the Cenedese, which he saw from his own home."[8] We can only imagine the subtlety of this dawn sky, or find it in the sunsets in some of Titian's other canvases.

The penetrating intelligence of Eugène Delacroix saw the essential quality of Titian's genius as a landscapist: "One may regard him as the creator of landscape. He introduced in it that breadth with which he rendered his figures and draperies."[9] As is often so with Delacroix, the quintessential thought received no further elaboration, but we know full well what he meant if we look at a detail from the London *Madonna and Child with Saints Catherine and John*, a picture painted at about the same

[7] Lomazzo, *op.cit.*, pp. 446-47.
[8] C. Ridolfi, *Le Maraviglie dell'arte*, Venice, 1648, pp. 149 and 151.
[9] A. Joubin, *Journal de Eugène Delacroix*, Paris, 1932, III, p. 2.

time as the *Peter Martyr* (Fig. 62). With difficulty one makes out a meadow with grazing sheep, which leads to a wooded hillside. Beyond is a highlighted cluster of buildings, and blue hills in the distance. Lomazzo's story of Aurelio Luini in Titian's house comes to mind, the worthless daub of a picture which when viewed at a distance became a vision of light and pleasant vistas, and we immediately understand what Delacroix meant by breadth.[10] Titian's brushstroke becomes loose and impetuous in these years, an autonomous fact which exists virtually independent of the form that it describes. Networks of these strokes form a pattern whose meaning becomes clear only when viewed at an appropriate distance. This idea of an autonomous brushstroke cannot be too strongly emphasized, for formally it is Titian's fundamental contribution to the landscape painting of the West. Landscape is seen as a problem in paint, where conflicts between the general and particular are resolved, and a breadth of light and color is achieved which impressed critics from Aretino onward. In the *Peter Martyr* observers admired an amplitude of handling, the fullness of mature foliage, a sensuous play of light, the vital relation of figures and landscape forms. Titian filled the trees with the saps of life, and evoked a growing land through opulent pigments. His fiction of landscape was closer to the experience of the senses than any envisioned earlier.

The *Peter Martyr* marked a public and triumphant moment in Titian's career. But the great altarpiece was probably not among the most evocative of his landscapes. Rather his finest achievements were when he brought figures and their setting into a relationship whose implications transcended the physical, quieter canvases whose meaning is found in contemplation.

The Prado *Charles V on Horseback* was painted in 1548 to commemorate the emperor's great victory at Mühlberg the year before (Fig. 63). The commission offered Titian the occasion to paint a portrait of social status, of pomp and circumstance, but instead he chose a highly personal interpretation. This is not only a representative of the active life, but a fine mind and contemplative spirit. Few portraits probe more deeply the character of the great, the calm nobility of advancing years.

The time is twilight. The trees rise in darkened silence, un-

[10] Lomazzo, *op.cit.*, pp. 446-47.

touched by the glow of the setting sun, whose golden haze fuses the distant hills and clouds. Twilight, the hour of stillness; a day ends, and a human life ages in the wisdom and sadness of passing time. The mood of man and nature is one. The rider appears physically frail, tightly bound in gold and gray armor that catches the last rays of sunlight. Erect in the saddle Charles commands his mount, more by mind than movement. His chin juts forward, eyes heavy with the cast of melancholy thought. In the failing light is the sober mood of nightfall, and the regal purples of his trappings find complement in a steely sky streaked through with the faded pinks and yellows of sundown. The emperor rides in the company of his ineffable dreams. Petrarch, who wrote the lines that follow, would have understood the painting perfectly:

> No place and no time is indeed better adapted to the contemplation of a rustic solitude and of the tranquillity of a calmer life, than sundown, when youthful fervor has passed, and the hour of high noon, one might say, is left behind.[11]

These three paintings, *Sacred and Profane Love, Peter Martyr,* and *Charles V* suggest, but hardly define, the dimensions of Titian's landscape art. His world is more tangible than that of Giorgione, firmly muscular rather than softly floating. Yet he shares with Bellini and Giorgione the feeling that figures and landscape should comment significantly upon one another.

In sixteenth century Venice this attitude is pervasive, and the great painted landscapes have meaning insofar as they echo and magnify the actions and thoughts of their inhabitants. Nowhere is this clearer than in two broad categories of subject matter, the hermit saint in a landscape, and the varieties of pastoral. Naturally these were not the only concerns of the Venetian landscapist, but they best suggest his basic conception of painted landscape. These two themes embody two recurring concerns of the artist in the West: the search for an intersection of Time and Eternity in some quiet spot of God's creation, and the desire to discover in uncontaminated nature that innocence of body and spirit which man possessed for a brief moment at his birth.

[11] Francesco Petrarca, *Prose,* ed. by G. Martellotti et al., Milano/Napoli, 1955, p. 422 (from the *De Vita Solitaria*).

The subject of the hermit saint in a landscape yielded a distinguished series of interpretations during the Renaissance. A saint might be placed within a landscape with little thought as to whether the environment suited a fervid contemplative. But in the hands of a major artist the forms of the landscape became virtually an extension of the saint's quality of soul. No doubt the subject was a rich one for a sensitive interpreter, whose reflections might well have paralleled thoughts in Petrarch's *De Vita Solitaria*:

> Solitude is of three kinds, for him who would define it in its complexity: of place, which is the principal object of my discourse; of time, as at night, when even in the forum there is solitude and silence; of soul, as it is for those who, snatched from the light and crowding of the piazza by means of profound contemplation, ignore what happens there and, where and when they wish, are able to be alone.[12]

For Petrarch, Saint Francis was the great example of these three sorts of contemplation. We recall Bellini's interpretation of the saint, where the humble man with his beloved creatures inhabits a fully domesticated landscape (Fig. 35). The saint's removal from the world of facts is a purely spiritual one, for those very facts are transfigured before his eyes. Similar in style, but unlike in expression, is Bellini's fine *Saint Jerome,* in the Contini-Bonacossi Collection (Fig. 64). The subject is a theme that the Venetians will treat time and again, and Bellini's interpretations of it are the starting point for a long series of variations.

The geological world is much the same as that in the Frick *Saint Francis*, though even more brittle and arid. It is a silent landscape where the skies have remained clear for weeks, and the land has become burned and yellow under a relentless sun. A city appears in the background, an amalgam of Rimini and Ravenna whose crowded planes and sharp lines complement the intricate rigidity of the splintered cliff. The saint, who reads from a folio, is as gaunt as the landscape about him. His is an uncomfortable setting, with sharp pebbles underfoot, and lacerating edges exposed at every turn. Though his mental state is calmly

[12] *Ibid.*, p. 454.

reflective, everything within the landscape conspires to suggest the naked austerity of Jerome's life. As in the *Saint Francis,* so here the wilderness is adjacent to civilization. Through this architecture Bellini suggests a fundamental quality of contemplation, that it is more a state of mind than a question of a complete escape from civilization. One wonders whether Petrarch would have liked the emphasis of this interpretation.

Perhaps Lorenzo Lotto's woodland, probably painted in 1506, would have been more to his liking (Fig. 65). For a brief moment the saint escapes our gaze, until we find him seated upon the ground in rapt contemplation, cross and stone clutched in his hands. He seems minute beneath those rocks that rise in architectonic solemnity to the top of the picture. In spite of these sharp escarpments, here and there etched in brittle outline, this is an altogether gentler world than Bellini's. Foliage is soft and green, and the wood is permeated by a delicate light which smooths the textures of the rocks, and melts the forms in the distant background. This forest landscape is unique in Italian art of the early Cinquecento and recalls trans-Alpine painting. But in its mood of warm and quiet revery, Lotto's little picture is unmistakably a part of the idyllic Giorgionesque years. One reflects that Giorgione and his followers were uninterested in the theme of the hermit saint, a subject so well suited to their vision of landscape. It fell to a Cima and a Lotto to carry on the subject, which for a brief time must have seemed conservative to Giorgione's sophisticated patrons. But the theme of the hermit saint was to remain fascinating to Venetian artists, and as the sixteenth century unfolded, they brought forth ever new interpretations.

In Titian's hands the theme acquired a new intensity and heightened evocativeness, nowhere better seen than in the Louvre *Saint Jerome,* which I believe dates from the thirties (Fig. 66).[13] It is a canvas easily passed by, for it is small and dark. If one stops to look closely, he begins to see the picture and to appreciate its high quality. The darkness is not a question of age, for the artist has given us a haunting nocturne. The faint light picks up Jerome's roughened skin and describes the man who kneels with a robe of blue-gray pulled about him. With impassioned gesture

[13] For opinions on the date, H. Tietze, *Titian: The Paintings and Drawings,* London, 1950, p. 389.

he gazes fervently at a spot of light before him, the faintly but surely illumined outline of a tiny crucifix. All else is in shadow, his red hat, the all but invisible lion behind him. There is a soft glow about the picture, emanations of the light of the moon, which rises directly behind the tree. Its rays touch the distant wood with a silvery green, and here and there illumine the browns of the hillside. This soft light melts into the penumbral grayish blue of the night sky, and throws the large boughs of the tree into dramatic silhouette. This ghostly tree with the fervent contemplative beneath it endows the canvas with an ineffable sense of the fantastic.

The picture presents the contrast of hushed night to the turbulence of a spiritual experience. The theme of the nocturne is not uncommon in sixteenth century poetry and assumes in Titian's Venetian contemporary Bernardo Tasso a most pictorial treatment:

> Never from that day when eyes opened to admire the works of mortals did Heaven see a more tranquil and serene night: the air wrapped itself in so beautiful a mantle that the damp shadows could be seen but with difficulty; beneath its wing silence bore sweet sleep to the animals, and the shadowed horrors, fearing the light of the beautiful night, stayed concealed within the savage grottoes and did not wander forth, but only the pilgrim summer breezes played about the slopes and shores.[14]

With the poet we are in a mythological realm, and with the painter are engrossed in a spiritual happening. But for both the soft silver and unruffled silence of the night are the *locus* for an essay in landscape. Later Tasso, like Titian, would see Night as a cradle for turbulent spirits:

> If with your tranquil and gentle sleep you would close these infirm and sorrowing eyes which never gaze upon joyous or happy things.[15]

With Titian, the world of the hermit ceases to be a pleasant place within a stone's throw of civilization. Rather one enters

[14] L. Baldacci, *Lirici del cinquecento*, Florence, 1957, pp. 86-87.
[15] *Op.cit.*, p. 91.

the unkempt forest, a place of rushing waters and gnarled trees evoked by a detail from the painter's *John the Baptist,* done at mid-century (Fig. 67). For a brief moment the Italian artist set aside that domesticated landscape which had been groomed over the centuries, and ascended the forbidding hills above the plain.

We discover this same world in a remarkable drawing, done deep within a forest ravine (Fig. 68). The artist contemplates in solitude, and we feel his powerful aesthetic reaction to the woodland scene. He sees the effectiveness of a release from a dark pocket of space into an explosion of light, and takes joy in the web-like silhouette of trees against the sky. He explores an eroded landscape filled with pitfalls, its surface textured by crosshatching, quick parallel strokes, delicate curves, all interspersed with areas of blank paper. In the deepest shadow the darkness is broken only by specks of paper which show through the ink. To modern eyes the drawing is a study in tonalities, a patternistic design abstracted from a living landscape.

The author of the drawing is the Brescian artist Girolamo Muziano, who was born in 1532.[16] As we learn from a recently discovered life of the painter written by his confessor, Muziano was at Padua by the age of twelve, where he remained for three years. From there he moved to Venice, and finally on to Rome in the fall of 1549 where, as another biographer, Baglione, tells us, he was called "Il giovane dei paesi," the young landscapist. The artist's energy was at first devoted largely to landscape painting, a passion that his confessor describes vividly: He tells how the young Muziano was besieged by fever,

> . . . but it seemed to him that the sickness was something to profit by, because it was during the most raging fevers and greatest thirsts that he felt the fresh memory of limpid rivulets and vivacious fountains, and of flowering meadows and verdant landscapes that he had in fact seen in his travels, and with such vividness were they represented in his fantasy that even so ill, he could not keep himself from

[16] There is one monograph that is out of date: Ugo da Como, *Girolamo Muziano*, Bergamo, 1930. G. Baglione, *Le vite de' pittori scultori e architetti*, Rome, 1642, pp. 49-52. U. Procacci, "Una 'Vita' inedita del Muziano," *Arte Veneta*, VIII (1954), pp. 242-64. This newly discovered life is published here, along with a thorough commentary, in which the drawings are discussed.

putting these down in drawings, and so well did these turn out that he had the confidence to compare them with those of valiant men.

A second, large drawing by Muziano broadens our idea of his draughtsmanship (Fig. 69). The land is seen from a rise, while below the valley moves back along a languorous S curve, a space strengthened by scattered patches of dark foliage, densely cross-hatched areas that appear as blurs in the landscape. Muziano's firm touch and his concern with light and shadow are eloquently clear in the handling of the trees on the bluff. The artist sees this foliage with the eyes of a painter, and takes care to evoke strong contrasts of light and dark. But while the eye belongs to a painter, the hand is more that of an engraver. Any individual bow of foliage is formed by scallop-shaped strokes of the pen, which when viewed at a distance blend in a delicate softness. This is the essence of this style of drawing, which by means of a precise technique, paradoxically achieves full tonal contrasts and atmospheric effects.

In this drawing one part remains unfinished, significantly the figures, who seem to have been intended to be hermit saints. The figures were of least interest to the artist but in spite of the wild isolation of these woodland scenes, the drawings still seem accommodations for the free play of human thought. Some of the drawings are moody (Fig. 70). A note of ominousness hangs over the forest, for one's path leads to deeply shadowed caverns where the daylight has fled.

These ravines may be seen as places for retreat and contemplation, where the soul might pour forth its woes and receive a sympathetic hearing. As the poetess Veronica Gambara expressed the sentiment,

. . . hidden, reverend and holy groves, and solitary ways, to you weeping I have already told times over my woes. . . .[17]

Muziano may well have thought of his landscapes in much the same way, for between 1573 and 1576 drawings similar to the ones already discussed were used for a series of six prints of contemplative saints in landscapes, engraved by the northerner

[17] L. Baldacci, op.cit., p. 277.

Cornelis Cort.[18] One of the pieces, the *Saint Jerome*, compares closely to one of the drawings already examined (Figs. 71, 68). The wild landscape, which in the drawing is the pretext for an aesthetic tour de force, in the print becomes an untamed and almost savage complement to the high-keyed state of mind of the saint. This Jerome is more a tormented man than a contemplative. His muscular body is tensed, hands clasped in fervor, his face taut in rapt rapport with the image of the Crucified. The excitement that animates his body boils over into the surrounding landscape. The sharp and shadowed escarpment echoes the passionate sway of Jerome's body, while spiky and gnarled branches repeat the taut lines and knotted muscles of his limbs. Thanks to this figure the landscape possesses a layer of meaning which is missing in the drawings. And in these images of penitent saints, popularized through the medium of engraving, landscape comes as close as it ever will to being a weapon of the Catholic Reformation.

A final memorable variation on this seemingly inexhaustible theme came at the hands of Tintoretto, who had savored the accomplishments of his predecessors. The climax of his work as a landscapist is in two narrow panels, painted in the 1580's, at the end of each of the long walls in the downstairs *salone* at the Scuola di San Rocco. One represents Mary of Egypt in a landscape, the other a landscape with the Magdalene (Figs. 72 & 73). The landscape they contemplate is like nothing in earlier Italian painting. Mary of Egypt sits by a tumbling stream, and gazes out upon a moonlit landscape, a nocturnal harmony of browns, muted buffs, and oranges, with a phosphorescent web spun across its surface. Light flickers and darkens with ephemeral swiftness, and dissolves all signs of solidity. Light rather than the objects bathed in light is the painter's subject.

The flicker of moonlight in dark waters is given in short brushstrokes, which touch white flecks to the stream, and quickly describe the waterfall. To one side sits the saint, clothed in red and brownish-orange stuffs, and a palm tree rises on the other bank, its dark trunk highlighted in buff, formed by the rough brushstrokes that follow its rounded contours. The tree shoots

[18] J. Bierens de Haan, *L'Œuvre gravé de Cornelis Cort*, The Hague, 1948, pp. 121ff.

forth olive-green leaves, left by a rough and dry brush. Light then skips back into space, catching the tops of two logs fallen across the stream, and with spidery agility sketches a grove of trees. Moving always through gray and somber lands, one reaches a town, which lies wholly in the shadow of darkness. A hill rises behind, caught in a ghostly gray-cream light. Highlights begin to isolate a building, then slip off into the incompleted suggestion of scattered trees. Beyond lie dark, purplish mountains that prepare us for the sky, whose hue is a lighter variant tinged with orange. As one moves up from the horizon, these colors slowly deepen. Mary gazes upon this quiet scene, and watches the broken lines of moonlight that rim objects with a fluttering light.

The Magdalene landscape carries this vision to the point of total dissolution. We see the figure, clothed in pink, the light which catches her halo and the edge of her book. To one side the tree grows out of the darkness, its bark described in subtle tans and creams. The paint is laid on violently, and while this object has substance, it seems at the same time without real solidity, fashioned as it is of a spectral light. The water flickers for a moment at the saint's feet, while the gloomy landscape is rippled by eerie phosphorescent yellows, and the silhouette of a spindly tree. Above is that muted blend of purples, grays, and oranges which evokes the night sky.

Like the old Titian, Tintoretto's art had grown far more personal with the passing years. He surrendered the normative for the accidental, the intellectual for the sensuous. His landscape art suggests that reality is a momentary glimpse of a condition of light and atmosphere. On second thought, it is not so much this as a condition of the spirit, where sudden and inexplicable flashes illuminate for a moment the vast unknown.

While the theme of the hermit saint in a landscape gave rise to some of the best pictures of the century, it was a special mode, and not the broad stream of Venetian landscape experience. That description must be reserved for landscapes which, loosely speaking, are pastoral in sentiment. One of the earliest of these is the *Fête Champêtre*, which, as I recalled in an earlier essay, once bore the title *Pastorale*. Pastoral in this sense has a rather specific meaning, the literary definition exemplified by Sannazzaro's

L'Arcadia. The essential elements are, of course, shepherds, whose flocks are accompanied by the semi-deities of pleasant groves. Such a world is usually understood as a Golden Age, its locale a secular *Paradiso Terrestre*. Frequently, if one remembers that Vergil is a basic source of this genre, these simple pastoral beings are a masquerade for contemporary personages, so that, for instance, the shepherd Sincero of *L'Arcadia* is to be understood as Sannazzaro himself.

Sixteenth century Venetian art could be combed successfully for pastoral themes in this narrower sense of the word, but the search would be too limited. For in saying that the central stream of Venetian Renaissance landscape painting is the pastoral, I mean this in the much looser sense of pictures whose subject in one way or another treats the rural life. As we shall see, this pastoralism may range from the artificial sentiments of literary Arcadianism to unvarnished reports of actual peasant life. We seek, then, contrasts in the general idea of pastoralism rather than for any sort of oversimplified unity.

Though the choice is possibly arbitrary, Giovanni Bellini's *Madonna in the Meadow* might be called the first important Venetian pastoral (Fig. 43). This cool and sparse landscape, so exquisitely ordered, is the Virgin's garden become pastoral. Giorgione fully understood this lyric moment of his master's art, and the background of the *Castelfranco Madonna* presents a silent earth and golden light, a place of unending summer where haze shrouds a changeless sky (Fig. 46). This is a visual pastoralism, quite distinct from the pages of Theocritus, Vergil, or Sannazzaro. The visual and literary traditions were bound to meet, and as I suggested in the essay on Giorgione, this only happened in Giorgione's last years, or even after his death. Then the lyric contemplation of Giorgione embraced the pastoral cast of flocks, shepherds, and nymphs.

In Titian the pastoral landscape is present from the beginning, in the Dresden *Venus* which stands upon the borderline between Giorgione and his pupil, and in the *Sacred and Profane Love* where the pupil has declared his independence. This same pleasant land continues to adorn his canvases, both secular and religious. In the London *Madonna and Child with Saints Catherine and John,* the landscape is a view up an Alpine valley, described

with free brushstrokes (Fig. 74). Beyond the grazing flock stands a green ridge of trees, and the deep blue range of mountains that rise from the plain. Further on, the highest range is touched here and there by the sunlight and disappears in part behind agitated clouds driven by unpredictable Alpine currents. The canvas is pleasing as a sensuous manipulation of pigments, but beyond this, it is a fiction solidly grounded in fact. Titian has ascended to the place of his birth, those valleys of the Piave that stretch upward to Pieve di Cadore, and found there the memories of boyhood, essential to the pastoral vision.

Titian described one of his paintings as "The nude with the landscape and satyrs," in all probability the so-called *Pardo Venus,* today in the Louvre (Fig. 75).[19] Inevitably the Dresden Venus is recalled, that mood-laden idyl which Titian had brought to completion some twenty-five years before. Its private moment of dreams here becomes an energetic and noisy gathering in whose midst sleeps a beautiful nude woman. The scene is set in a woodland grove, where a warm light filters through the trees.

As often with Titian, color and light win us. Here some imagination is required, for the greens have changed to give the canvas an unpleasant olive-brown tonality. But one may still appreciate the artist's sensitivity for light and atmosphere. The hour is sundown; a golden haze touches the most distant peaks, and a warm, dust-filled light diffuses within the darkening wood. Enough light remains to bring the waters of the stream to life, and to warm the flesh of the reclining nude. Everything is rendered with a fluid brush, and only the foliage of the foreground is described in any detail. From the loose technique, however, emerges a fine sense of texture—the flesh of Venus, the bark of a tree, the fur of a hunting dog.

This is a most accessible moment in Titian's development as a landscapist. The sort of subject is immediately familiar to anyone who has sampled the numerous sixteenth century lyrics composed in the pastoral vein. Full-blooded, healthy figures dwell in a pleasant forest glade. Pictorially this woodland is developed by a few simple spatial principles. The visual short cuts to a sensuous *locus amoenus* have all been worked out: here a student

[19] H. Tietze, *Titian: The Paintings and Drawings,* London, 1950, pp. 389-90.

might learn how to paint a full-crowned tree, the glint of light off a waterfall, the expansive softness of a cumulus cloud. But more important than these conventions is the over-all vision of landscape elaborated by Titian. His is a fertile place in full bloom, blessed by running waters and the light of the sun. There is nothing ambiguous about it, no hint of infinite longings or unexplored wonders. In the freshness of the forest glade is found the natural equivalent of man's sense of physical well-being.

A more specifically pastoral concern is evinced by the minor masters who gathered about the great Venetians. These men were the painters of furniture panels, the draughtsmen and print-makers. Such a pastoral scene is the charming Titianesque idyl in the Barnes Collection, which for no good reason is titled *The Sleeping Endymion*,[20] or a myriad of drawings which belong to a tradition in which the central name is Domenico Campagnola. With this artist, born around 1500, is associated a large number of drawings and prints which can be neither dated nor attributed with much accuracy.[21] Domenico appears to have had his beginnings in association with Giulio Campagnola, that highly cultivated artist who died around 1515. But a short step from the *Rural Concert*, begun by Giulio and finished by Domenico, is a drawing surely attributable to Giulio (Fig. 76).[22] As in the

[20] I feel that Berenson's attribution to Titian himself is entirely too ambitious. B. Berenson, *Italian Painters of the Renaissance: Venetian School*, London, 1957, I, p. 188. However, the Titianesque qualities of the piece place it in Titian's orbit.

[21] To appreciate the complexities of sorting out sixteenth century landscape drawings one need only read the appropriate introductory essays to various artists in the Tietzes' catalogue, especially on Domenico Campagnola. H. Tietze and E. Tietze-Conrat, *The Drawings of the Venetian Painters*, New York, 1944. A specific example of the state of research will intimidate the bravest. The Tietzes attributed two drawings at Windsor Castle to Domenico, one of which is regarded as shop. Later Popham in his Windsor catalogue said "another twenty-seven . . . seem to me to have at least an equal claim to being regarded as authentic." A. E. Popham and J. Wilde, *The Italian Drawings of the XV and XVI Centuries in the Collection of His Majesty the King at Windsor Castle*, London, 1949, p. 201. The Tietze catalogue provides earlier bibliography (particularly their own various important articles in *The Print Collector's Quarterly*), and a good summary of what is known about most of these draughtsmen. See also A. Chatelet, "Les dessins et gravures de paysage de Domenico Campagnola," *Venezia e l'Europa—XVIII Congresso internazionale di storia dell'arte*, Venice, 1955, pp. 258-59. A. M. Hind, *Early Italian Engravings, Part II*, 3 vols., London, 1948. F. Mauroner, *Le incisioni di Tiziano*, Venice, 1941.

[22] Uffizi 463P. Tietze and Tietze-Conrat, *op.cit.*, p. 134, as G. Campagnola.

print, so here the artist has been fascinated by that same make-shift, patchwork architecture. To its sharp lights and angles he contrasts the leafy softness of a grove, and the irregularly rounded configurations of the terrain. The setting, fully rural and unspec-tacular in prospect, becomes the standard world of the graphic artist, to be repeated in endless drawings and a number of prints by various artists. These landscapes are frequently inhabited by shepherds and their flocks, who sleep beneath shaded trees, and roam the quiet gullies of a mountain valley (Fig. 77).[23] They are not the disguised, world-weary folk of pastoral poetry, nor are they acutely portrayed beings from real life. They exist at a dis-tance, the inevitable and necessary adornment of a bucolic land-scape.

The graphic genre became not only competent but highly popu-larized in the hands of Domenico Campagnola, who developed formulae that depended little upon the great painters. Among several woodcuts associated with his name is the *Landscape with a Wandering Family* (Fig. 80). As a landscape, this is a pastoral lyric. We find ourselves within a fertile valley fed by running waters, a land which supports a small village. A couple repose in a cool grove while their flock forages slowly along a dale. On the left a family passes on its way, bearing with them all of their possessions, including a cradle upon the mother's back. The goal of their journey is unknown, yet we are not curi-ous, for the land of the pastoral is replete with nomads and tenders of flocks.

As we have already seen, Venetian landscape at mid-century is richly forested. Like the hermit saint, the pastoral folk move in and out of moist and luxuriant woods. In Tintoretto's *Adam and Eve,* of the early 1550's, we are on the edge of this shaded region (Figs. 78 & 79). The canvas comes to life through clearly stated opposites: forest and river valley; a figure seen from the back against one seen from the front; a hard and muscular body against one that is smooth and soft; a gesture of withdrawal and one of advance; the play of highlight and deep shadow. The couple sit in a luxuriant paradise, an Eden painted with an aggressive bravura. This landscape is organized largely by the alternation of light and dark areas which lead into depth. Ob-

[23] Uffizi 502P. Anonymous Campagnolesque.

jects in the immediate foreground, the stone bench and the dark tree, are summarily painted. The foliage behind the couple is a deep but rich green, which stands out against light straw brown foliage. One moves back into the river valley, whose browns are enriched by the golden aura of the angel of the expulsion. As one probes deeper into this valley, the colors mingle in blues, browns and greens, bordered by the foliated darkness of the forest, touched here and there by highlights. Finally the blue hills are reached, white in the furthermost distance, silhouetted beneath a blue-gray sky which lightens at the horizon into hues of lavender and pink. All this a guided splash of paint, swiftly manipulated lights and darks whose alternation creates the space of the picture. The lushness of this leafy landscape finds no equal in the century, with the exception of Dosso Dossi, whose work we shall consider presently.

If Tintoretto's canvas is the Christian *locus amoenus*, the Garden of Eden, then its pagan counterpart is the large canvas of *Jupiter and Io,* done by the northerner Lambert Sustris in the later 1550's (Fig. 81).[24] The canvas shows with what willingness and masterful ability the artist from Amsterdam took to the Venetian manner. The surprised couple sit in one corner of the landscape beneath an abundant, sheltering tree. Beyond the foreground ridge opens a pastoral landscape on the edge of a forest, where we find the cool splash of a waterfall, grazing flocks, and the buildings of a mill. This stream valley is bounded by a dense forest, beyond which rise distant and barren peaks.

Apparently Sustris had been looking at everything Venetian, and in the process had become more Venetian than the Venetians themselves. The *Jupiter and Io* begs comparison with Titian's *Pardo Venus* (Fig. 75), for both are large mythological pictures, clearings within the forest. The place is much the same, a woodland glade enlivened by a sparkling waterfall, and closed in by low mountains, a setting for rustic love. In Titian's picture the figures are spread across the surface of the canvas, almost as relief sculptures before the landscape. Sustris moves them to one side, and by the diagonal layout of the topography invites us to take leave of these nudes and explore that verdant valley. The

[24] More recently on Lambert Sustris, see A. Ballarin, "Profilo di Lamberto d'Amsterdam (Lamberto Sustris)," *Arte Veneta*, XVI (1962), pp. 61-81.

differences between the two pictures are not simply those of two diverse artistic personalities, but also a difference of decades. From 1550 onward the landscape itself became increasingly interesting to the artist.

But the most important point of comparison is Tintoretto's *Adam and Eve*, freshly painted when Sustris undertook his large canvas (Fig. 78). Tintoretto's basic idea is taken up and expanded. Sustris retains the basic contrast of male and female, but it is rather more loosely presented. The figures are elongated, touched by the ideals of *la maniera,* and recoil together from the surprising apparition in the clouds. Tintoretto's alley of space, moving off on a diagonal with trees silhouetted against the sky, expands to become the main motif of Sustris' picture. In a sense the relative importance of figures to landscape has simply become reversed in the two pictures. Sustris absorbed the art of Tintoretto, and moved on to give landscape an importance that Tintoretto would accord it only later in his life.

By now one sees that the idea of pastoralism in Venetian painting is so broad that it escapes any exact definition. It involves either the pagan or the Christian, at home in bountiful land, blessed by the sun yet endowed with cool shade, a place that knows neither season nor weather. The trees of these landscapes bear sweet fruits, and the forest silence is broken by the tumble of small cascades.

However, as the sixteenth century progresses, the Venetian pastoral begins to divide into two distinct streams. On the one hand is the literary pastoral, a landscape either peopled with mythological beings, or the shepherds, nymphs, and fauns of Arcadia. On the other is the observed world of the Venetian mainland where dwells a hardy stock of peasants, people whom the artist records neither with scorn nor compassion. As subject matter the pastoral had first been glimpsed in the books of the ancients; with the passage of a few decades the subject was also found in contemporary rural life.

The literary pastoral lives on in two paintings in Berlin, which I believe to be the work of Sustris (Figs. 82 & 83).[25] One represents the *Hunt of Diana,* while the other is a *Pastoral with Nymphs and Fauns.* In these pendents we return to the specific

[25] Usually given to Paolo Fiammingo. See note 27.

world of the pastoral, the woodland haunts of gods and god-
desses, of nymphs and amorous fauns. These pictures were prob-
ably painted shortly before the appearance of Torquato Tasso's
pastoral drama *L'Aminta* in 1573, whose subtitle significantly is
a *Favola Boschereccia*. The landscape with fauns and nymphs is
the more engaging of the two canvases. The forms of the forest
border upon the fantastic but never quite depart from what one
might see in a forest grove. The bluff and the natural bridge are
dashingly painted with a constantly varied feel for textures and
the shift of light. From the bright crown of the bluff the light
fades into deep shadow on the right and below the bridge. The
painter loves to have us see through and under things, under
a natural bridge, or through a dramatically focused opening to
the sky beyond. As a whole the composition offers a space which
is blocked at the center, but with tangential alleys of space which
the eye can follow. The woodland seems fairly to squirm, for
the tucked-up limbs of the fauns and lithe-limbed nymphs offer a
contrast which is picked up in the trees of the wood. A loose
brush in alliance with a constantly shifting pattern of lights and
darks assure that the spectator's eye shall never come to rest.
Trees and soil alike seem to move in a lush mixture of greens,
grays, and browns. Movement is the hallmark of this picture,
a make-believe pastoral world endowed with a light, imagina-
tive touch.

The great range of concepts covered by the broad term "pas-
toral" is clear if one turns from these woodland scenes to a paint-
ing of rustic life done by Jacopo Bassano, probably shortly after
1560 (Fig. 84).[26] From delicate fiction we are suddenly trans-
ported to a vitally immediate apprehension. A peasant family
offers milk to the lambs and prepares its own repast, while behind
a sower hastens to finish his work. The light begins to fade as
the day nears its end, and the steely blue hills serve to enrich the
brown warmth of the autumnal foliage and the cow's hide. The
picture is painted with fat strokes, vigorously applied, a direct-
ness perfectly suited to the bluntly simple and humble subject
matter. Above all, these beings are real; a kneeling woman with
muscular forearms and calloused, begrimed feet; a lumpy woman
with her blouse in disarray; a hearty boy; a comfortably curled

[26] See *Jacopo Bassano—Catalogo della Mostra*, ed. by P. Zampetti, Venice, 1957.

mongrel dog. Small details ring unfailingly true, from the coarse bread upon the cloth to the sweaty sheen of a boy's hair. Bassano's art, like all art, is a reworking of reality, but in him the essence of an everyday reality is magnified.

We know relatively little of Jacopo Bassano, who spent his life by the banks of the Brenta in charge of a large studio which included four of his own children. Apparently the pupil of Bonifazio Veronese, this remarkable provincial maintained his contacts with Venetian art while looking with a highly sympathetic eye upon the peasant life around him. With Bassano, especially with a painting such as this, began a genre in Italian painting that was to enjoy great popularity through the following century. The mood is pastoral but hardly could be farther from the idyllic world of a Giorgione or a Sannazzaro. Peasant life is recorded by Bassano neither in a spirit of idealization nor as social criticism but because it was the dominant reality of the world in which he lived. In this interest in the simple life Bassano was preceded by the dramatist Angelo Beolco, called Il Ruzante. Protégé of the Paduan humanist Luigi Cornaro, Il Ruzante in his comedies explored the mentality and manners of the peasant, in a spirit of fun touched with genuine compassion.

Increasingly the Bassanesque view of rural life came to dominate the visual arts. His children, notably Francesco, took their father's idea of the pastoral and painted series of the months and the seasons. Even standard religious subjects were "pastoralized," as in Francesco's *Jacob at the Well* where the narrative crux of the picture is but an incident in a slumbering pastoral landscape (Fig. 85). In a picture by him at Modena the nominal subject of the Sacrifice of Isaac is almost lost in the distance. Eventually this sort of rural scene came to Venice itself. A·woodcut done by Boldrini on a design of Titian seems to reflect early drawings of the old master, but I believe it was not cut until the sixties and reflects the popularization of Bassano's art at *La Serenissima* (Fig. 86). A Giorgione and a Sannazzaro had found their popularity in a people still largely confined to the islands of the Lagoon. But by Bassano's day the movement of Venetians to villas on the terra firma was in its heyday, and with this new way of life came a direct contact with the country man and the

quirks of his psychology. The pastoral, at first an escape from real life of any sort, turned for a time to the realities of peasant existence.

The latter part of the century saw the arrival of two northerners who may be fairly described as landscape specialists, Paolo dei Franceschi, called Paolo Fiammingo, and Ludovico Toeput, Il Pozzoserrato.[27] The latter seems an outsider to the streams of landscape under discussion here, and in his taste he belongs more to trans-Alpine art. Paolo Fiammingo, like Sustris, became thoroughly Venetianized, and adopted the forest landscape of mid-century as his domain. Like Bassano, and quite possibly under Bassano's influence, Paolo's woodland landscapes are often peopled by convincingly real peasants and hunters. In a picture at Vicenza these people are at work in a forest, while in a small landscape in a private collection they pause for food during the hunt (Fig. 87). We find ourselves in a wood of deep greens, browns, and grays, and look through the foliage to a gray sky streaked through with pinks. This somber forest is enlivened by bright color spots of orange and red which suggest the leaves of the foreground limbs, and by a rough brushstroke that gives the landscape the quality of an oil sketch. The silhouette of the rocks follows a lively course, and the trees seem to wriggle. These people and their activity are perfectly plausible, but their animated world stems more from the imagination than the eye.

[27] A good summary and bibliography on northern landscapists in Italy is provided by G. J. Hoogewerff, *Het Landschap van Bosch tot Rubens*, Antwerp, 1954.

L. Menegazzi, "Ludovico Toeput (il Pozzoserrato)," *Saggi e memorie di storia dell'arte, I*, Venice, 1957, pp. 167-223. "Giunta a Ludovico Pozzoserrato," *Arte Veneta*, xv (1961), pp. 119-26 (the Praglia frescoes). The least well-defined of these figures is Paolo Fiammingo, for it is clear that a wide variety of only generically similar pictures are attributed to him. The pair of canvases in Berlin have at one time or another been attributed to Schiavone, Paolo Fiammingo, and Sustris. The first possibility is not to be taken seriously, but the choice between the other two names is difficult. A comparison of the Berlin pictures with the Paolo Fiammingo that I illustrate reveals immediately that the handling of foliage and the organization of space are closely similar. But the figure style of the Berlin picture corresponds to the Sustris *Jupiter and Io* in the Leningrad and is distinctly different from that in other pictures attributed to Paolo Fiammingo. If the two Berlin pictures are by Sustris, then they were painted in the fifties or sixties, and Sustris is an important source of Paolo Fiammingo's art. However, this should remain an open question until someone does an exhaustive study of Paolo Fiammingo's oeuvre.

While in Bassano the idyllic world of Sustris and much of earlier Venetian painting was recast in earthly terms, in Paolo Fiammingo the real people are retained, but their world becomes idealized once again. From the beginning, though, Paolo's outlook is typically Venetian, for he sees landscape as an arena for human activity. The little canvas we have looked at could just as well be described as a genre scene set within a landscape. From here it is but a short step to Annibale Carracci's landscapes in the Louvre (Figs. 131 & 132).

The Venetian experience of landscape during the sixteenth century was one in which figures and landscape were closely related both in form and meaning. Where we find pure landscape, it is almost always in a special context, such as the drawing, print, villa fresco, or easel pictures produced by foreigners resident in the Veneto. Rather, if my interpretation be just, Venetian landscape had its finest moments as an extension, or reflection of, human needs and aspirations. This landscape, an environment in which to contemplate or dream of a golden past, is seen most characteristically in the two themes touched upon here, the hermit saint in a landscape, and the pastoral landscape. What they share in common is the quality of a pleasant place, usually untouched by the savagery of nature and unravished by the hand of man. In a certain sense, then, this small picture painted by Jacopo Bassano and an assistant, exemplifies the Renaissance experience of landscape (Fig. 88). We are in the *Paradiso Terrestre,* whose amenities can still be imagined by a painter in the land east of Eden.

Finally, we might speculate as to why a strong genre of landscape painting *per se* did not flourish at Venice in the sixteenth century, that part of Italy which above all others might have produced genuine landscape painters. The answer is at once simple and most complex. A landscape painting *per se* held little interest for the Italian, for he expected landscape in a painting to be either a pleasantly incidental view, or to have rich human associations. As I shall stress when writing about the villa, he enjoyed nature most when it was controlled, when its accidents were purged by the order of Art. Moreover, the genre of landscape painting was held in low esteem, and as Paolo Pino's

129

words quoted at the beginning of this essay suggest, the genre was associated with journeymen artists from the north of Europe. When the Italian artist turned to pure landscape, it was usually in the drawing or print. The print seems to have been regarded from the beginning as a medium where a much larger range of subject matter was permissible than in the painting, as A. M. Hind's corpus of Italian engravings will reveal. The print was a popular art form, and as such might exploit subjects—among which, landscape—not considered sufficiently "serious" for the painter. As the century wore on, the subordinate position of the engraver became clear. Ever less frequently did he create independent compositions, but turned instead to the docile transcription of paintings and drawings by the great masters. He became an artisan of sorts whose craft, rather than ideas, was admired. The inference, then, is that the drawn and engraved landscape composition was considered a minor art, a popular genre that posed no threat to the Establishment of Painters.

If this explanation is correct, then there is a direct connection between a flowering tradition of landscape in graphics, and the appearance of small landscapes as subordinate parts of fresco cycles. This phenomenon becomes common from the 1540's onwards, for instance in Giorgio Vasari's house in Arezzo, in the Emilia in Niccolò dell'Abate's decoration of the Palazzo Poggi, in Rome in the decoration of the Villa Giulia and the Sala Ducale. By 1560 the art of landscape painting had been reduced to a popular and decorative status, and was hardly the proper vehicle for the exploration of major aesthetic problems. An original talent, Niccolò dell'Abate, had left Italy eight years before, the better northerners had not yet arrived, and Annibale Carracci, to become a fine landscapist, had just been born. One might say, stripped of the advantage of retrospect, that in 1560 the future of landscape painting as an important form of expression was in doubt.[28]

The fate of landscape painting conceived as an independent genre is best exemplified in a man who showed promise of becoming a fine landscapist, but renounced the possibility in order to achieve a modest place as a second-rate figure painter. I refer

[28] On the question of landscape as a genre in Renaissance Italy, see Ernst Gombrich's excellent article, listed in the bibliography.

to Girolamo Muziano, whose art we have already sampled. It is significant that upon reaching Rome Muziano broadened his horizons by turning from landscape to figure painting. The story is told by the biographer Baglione:

> But seeing that in order to become excellent in rendering figures he had need of great study and hard work, he resolved to become excellent in that genre, and applied himself to study with great fervor of soul and acuteness of mind the ancient things of Rome, as well as the good modern ones, and also nature. And in order to apply himself even more, because of what love affair I know not, he being young, one day he had shaved off not only his beard but all his hair so that he looked like a galley slave, and he decided not to emerge from his house until they had grown out again; and this he did to distract himself from love, and to concentrate more fully upon the study of painting. And at that time he painted the picture of the *Raising of Lazarus*, which is now at Santa Maria Maggiore, and he had it put in the Sala of the Palazzo di San Marco, so that it might be seen by all, and that he might acquire fame and recognition, and among those who saw it was Michelangelo Buonarroti the Florentine, excellent painter, sculptor and architect, and it pleased him so much that praising him he brought enough recognition to Muziano that through him Girolamo entered into the household of Cardinal d'Este as his painter, and made for him various large landscapes in the garden of Montecavallo, then belonging to this cardinal, and then he sent him to Tivoli to paint a few rooms in the palace built by the Este lords, where he acquired much recognition.[29]

The moral of the story is clear. For an artist who desired highest recognition, proficiency as a figure painter was an absolute prerequisite. Muziano did not give up landscape painting, as this passage and the Cort prints testify. But it did come to mean to him a form of mass decoration, of popularization. Significantly he did not produce landscape easel pictures, but went on to a brilliant career as a major artistic entrepreneur under Gregory XIII. He died in 1592, and left behind a house full of objects

[29] See note 16.

and books, but not a single landscape. With him died one of the more interesting developments of the Venetian landscape tradition, a development that probably did not fully realize its possibilities. One wonders whether Muziano did not have an inferiority complex about his finest natural gift. It is certain that his partial renunciation of this gift reflects the generally low esteem in which landscape painting as an independent genre was held during the later sixteenth century.

THE history of Italian art is the story of art in various independent cities, each of which has its own staunchly unique character. While terms such as "Italian" and "Renaissance" are convenient general labels, the path to deeper understanding is through a better knowledge of a given geographical region. Thus we speak confidently of Florentine, Sienese, or Venetian art, but once beyond these great centers, our understanding of the smaller ones becomes hazy.

So it is with Ferrara, that city of brick which lies midway between Bologna and Venice. Ferrara was one of the most important artistic centers of north Italy, yet Giorgio Vasari leaves an inadequate picture of her art, and even maligns the most distinguished among her sixteenth century painters. Ferrara had no real biographer of her artists until two centuries later, and so the main lineaments of her art were not defined by a man of letters until it had become a matter of academic interest.

Perhaps this is unimportant, for the bizarre quality of much of Ferrarese art assured that it would pass unnoticed during the centuries of classicism, which had been spawned in neighboring Bologna. But just this touch of the bizarre makes Ferrara one of the most fascinating Renaissance centers of landscape painting. Already in the fifteenth century her masters had dealt in fantastic worlds of brittle surfaces, natural bridges, and scorched rocks. Cosmè Tura's *Saint Anthony*, for example, presents a small but unforgettable bit of landscape (Fig. 89). The saint, whose throat and face seem moulded from rigid muscular tissue, looms in an archway, his body wrapped in metallic folds. At his feet spreads a seascape, bathed in the light of the setting sun. The sky is a fiery orange, and its rays spill over onto the polished sea, reaching to the gentle ripples that glide towards the saint's feet. Without exaggeration one may compare this flamboyant day's end to the canvases of Turner centuries later. To the right rise gray-green mountains, whose forms are streaked by an unreal light. The slopes rise, to culminate in a knobby and patently phallic form. Cosmè's vision of landscape is a personal fantasy, which encompasses some of his brightest moments as a painter.

Tura in any other center would have been a brilliant eccentric,

but in Ferrara his eccentricity comes close to the norm. This al-
lusion suggests that the fantastic landscapes of the sixteenth cen-
tury, so different from the Venetianism that directly precedes
them, are in fact the logical continuation of a firmly rooted local
tradition. That tradition flourished in an environment as much
northern European as Italian. Throughout the fifteenth and six-
teenth centuries Ferrara was host to many northerners, among
them artists, of whom one of the first and the most famous was
Roger van der Weyden. The taste for northern art was but aux-
iliary to a more general sympathy for things northern, which
reached a climax in the late 1520's and the 1530's, when Ferrara
acquired a French mistress, the Duchess Renée, and in a climate
of veiled Protestantism welcomed Clement Marot and John Cal-
vin as guests.

A small part of this northern taste expressed itself in an en-
thusiasm for landscape painting, which took a form distinct from
that in other regions of Italy. Our starting point shall be some-
what arbitrary, the earlier 1520's, with one of the most sumptuous
paintings in Italian art (Figs. 90 & 91).[1] In the Borghese Gallery
Dosso Dossi's canvas is called *Circe,* but as was long ago recog-
nized, this lady is Melissa, an enchantress of Ariosto's *Orlando
Furioso,* who undid the fatal spell of Alcina, the witch who had
turned proud men into plants and animals.[2] Rich in color and
pigmented texture, the painting invites intellectual surrender.
And what would be more appropriate for the magician whose
charms restored men to reason? She sits with head proudly erect,
potent instruments in each hand, sovereign over the obedient
creatures at her feet. Her face is flushed with the fullness of life
and framed by the golden fringe of a silk turban. The garments
befit a queen; a regal blue undergarment trimmed at the hem
and sleeves in gold, a burgundy shawl flecked with flashing high-
lights of gold. A drapery that seems at once of tapestry and velvet
lies over her knees; its hue the same deep burgundy, encrusted

[1] All the pictures here attributed to either brother are discussed in H. Mendel-
sohn, *Das Werk der Dossi,* Munich, 1914. A new monograph is being written
by Felton Gibbons of Princeton University.

[2] The probability that the lady is more Ariosto's Melissa than the Homeric
Circe was suggested by Julius von Schlosser, "Jupiter und die Tugend. Ein Ge-
mälde des Dosso Dossi," *Jahrbuch der preussischen Kunstsammlungen,* xxi
(1900), pp. 268-69.

with dense gold needlework, and fringed with gold strands. Folded back upon her right leg, the robe reveals its dark green lining. Deep reds, blues, greens—an opulently sensuous pattern colors the painting, the gold and precious jewels of royal and liturgical objects loomed into glowing fabrics. The enchantress has no eyes for us, but her all-too-human dog peers from behind the glistening armor that he once proudly wore. His gaze is deep and sad, neither a warning nor indication of curiosity, but simply the look of one to whom wisdom has come too late.

A lush landscape breathes the moisture of a rain climate. Rich browns, lighter gray-greens, creamy tans, and the steel blue of the sky meld in a sonorous pattern. The forest grove is evoked by Dosso's bold and well-loaded brush. Tree crowns of browns, green, and a dark straw yellow blend, brought to life by quickly worked highlights. Beyond the trees another grove is caught in a shaft of sunlight, and shines out in brilliant yellows. Three knights, who recall Giorgione's *Fête Champêtre*, converse in the background, the white and gold of their costumes as much a part of nature as the pink rose that blooms at Melissa's left hand. The land behind the figures is painted in a cream speckled by olive shadows, while all about the full tree crowns of brown and green billow out in rounded abundance. The town is rapidly brushed in lavenders, grays, and whites—colors which then mount to the hill behind. Overhead the sky is a diffuse blend of steel blues and grays that echo in a minor key the full brilliance of the enchantress' garment. The light greens of sun-filled trees and the forthright blue of a cloudless sky are avoided, for Dosso's world is one of damp fertility where the rain clouds hang heavy, and the shadowed foliage of growing things carpets the earth. A regal magician reigns in this land of metamorphosis.

This sensuous painting must be understood as an exaggeration of that full-blooded vitality that Titian had displayed in those canvases done for the Duke of Ferrara between 1518 and 1523. What in Titian is sheer animal ebullience here has gone a bit soft, a little sultry in its expectant sensuality. This fecund world is almost more tropical than Italian. In date we are probably between 1520 and 1525.

The picture reveals the hand of a master landscapist, if by that one means a man who uses his natural setting to comment

upon the mood of the figures. It comes as no surprise, then, to know that Dosso Dossi, court painter to the Duke of Ferrara, enjoyed a high reputation as a landscapist in his own century. Already in 1527 Paolo Giovio cites Dosso's work in *parerga*, small landscape pieces.[3] Despite his aversion for the brothers Dossi, Vasari echoes this praise,[4] and in the latter part of the century Lomazzo will include the brothers among the leading landscape painters of the age.[5]

There are more than words to support this tradition. The brothers worked at the Castello di Trento, and left there a series of lunettes which seem to be pure landscapes, though the recently uncovered frescoes are mere ghosts of their original state. A far more satisfying cycle is found in the frescoes of the Villa Imperiale at Pesaro, whose character as decoration is discussed later (ch. X). While there is the problem of dating, and of separating hands in these frescoes, one can say confidently that some of the landscapes are Dossesque in character.

The attraction of the North for Dosso Dossi is attested to by a picture in Moscow, *Saints in a Landscape* (Fig. 92).[6] I have not seen the canvas, but from a photograph I have no doubts about the justness of an attribution to Dosso Dossi. We find the same loose painting and moist atmosphere as in the Borghese *Melissa,* a figure style matched in other pictures, those same trees of the *Melissa,* where thin resilient trunks support full heads of foliage.

The painting is a collection of various saints—Jerome, Christopher, George, Catherine, Francis—gathered together in a fantastic landscape. Historically they cannot co-exist, and their juxtaposition is rendered plausible only by the essentially irrational character of the setting. The artist unifies incompatibles in the only way possible, the logic of dreams. The usually grim business of Christian didacticism is here an idyl, a romantic fantasy that distantly recalls Giorgione. The landscape is a subtle study in atmosphere, a place of flickering lights and shades. Hills rise unexpectedly, and mist-shrouded mountains and sea fade away

[3] *Dosso* and parerga cited by Gombrich, p. 346 (see bibliography).

[4] Vasari-Milanesi, v, 96 ff., vi, p. 319.

[5] G. P. Lomazzo, *Trattato dell'arte della pittura scultura ed architettura,* 2, Rome, 1844, p. 443.

[6] V. Lasareff, "A Dosso Problem," *Art in America,* xxix (1941), pp. 129-38.

into the distance. By analogy to other canvases by Dosso, one may imagine the yellow highlights in green foliage, the angry blue storm clouds that churn in from the side. This image of color and light can never have yielded potent religious instruction but must always have afforded ocular delight. Figures from Christian history are swallowed in the evocation of a fantastic and luxuriant environment.

Basically that environment is the creation of Flemish landscape painters, of whom the first in time was Joachim Patinir. This artist, who died in 1524, developed from the art of Gerard David, though a hypothetical trip to Italy may have been important in his formation.[7] He is remembered as the first man to turn out landscape panels *per se,* paintings which quickly found their way to Italy. If one places a typical Patinir beside the Moscow Dosso, then the affinities between them are clear (Fig. 93). Landscape is conceived not as an intimate glimpse at a corner of the world, but a sweeping vista rich in descriptive detail, typically up an estuary flanked by mountains, to a horizon placed high within the painting. Often one side of this vista will be blocked by a cliff, a device that forces the eye into the illusionistic space. From Patinir Dosso has borrowed the convention of storm clouds that roll in from one side of the picture. But having noted these similarities, one cannot fail to grasp that Dosso's picture is different. The Patinir has a slightly crabbed and dry air about it while the Moscow picture palpitates in moist sultriness. It is an oversimplification, but a valuable one, to say that Dosso has joined the northern structure of landscape to the Venetian feeling for pigments and lights.

The vogue for landscape *alla fiamminga* was not confined to Dosso Dossi, but was prevalent among the other painters of Ferrara, as may be seen in the following sketch of the contours of this taste, and a few speculations upon what motivated it. In a maze of undated pictures and uncertain attributions, it is a relief to find one canvas which does in fact carry a date, and which can be associated with a prominent Ferrarese master. Around this picture we can form a group, each canvas with its distinct character, but each bound to the others in a common spirit of fantasy.

[7] G. J. Hoogewerff, "Joachim Patinir en Italié," *La revue d'art*, XLV (1928), pp. 116-35.

The canvas is the *Landscape with a Magical Procession,* in the Galleria Borghese, Rome (Fig. 94).[8] There it is currently attributed to Girolamo da Carpi, though in the past it has variously been given to Niccolò dell'Abate, the Dossi, or an anonymous Fleming. Over the arch of the gatehouse to the right one can make out the date, 1525.

For a moment we stand before a world seen through the eyes of a dreamer. A parade of monsters moves slowly across a seacoast landscape, their forms born of memories of Bosch and the sixteenth century taste for the grotesque. They are kin of those strange figures that inhabit Alcina's island in Ariosto's *Orlando Furioso,* like them the children of minds fascinated by magic and sorcery. As in Ariosto, this canvas is a fantastic world, the place of a towering bluff abruptly pierced, of ice-blue mountains thrusting upward from low hills, of ominous clouds that roll in from the sea. If we turn for a moment back to Dosso's Moscow picture, we find the same view up an estuary to a raised horizon, the same irrational piling up on one side of the picture. And a glance back at the Patinir, or at a picture by his pupil Herri Met de Bles (Fig. 96), leaves little doubt as to the "northernness" of this point of view. Northern these pictures are, but the Borghese landscape possesses the geological morphology, the ice-blues, oranges, and sunset pinks, and the handling of foliage characteristic of Ferrarese art in these years. Even at a great distance one recognizes a canvas that belongs in the orbit of Ortolano, Garofalo, or Mazzolino.

Spatial structure is carefully worked out. The dark brown foreground is relieved only by the tan forms of a stag and a doe to the left, and a few bushes to the right. One's eye jumps from here to the magical procession, a fantastic line of light gray touched by pale greens, pinks, yellows, and paced by several accents in red. The weird group is bracketed on one side by a most northern-looking mill painted in soft grays, and on the other side by the grayish pink gatehouse. From the light area of the monsters there is a sudden transition to a dark horizontal band behind, and one begins to realize that the alternation of such light and dark areas is a powerful means of spatial evoca-

[8] My article, "Garofalo and a Capriccio alla Fiamminga," *Paragone,* 181, 1965, pp. 60-69.

138

tion. This dark band behind the procession is but the shadowed
extension of the sharply silhouetted bluff, and together they form
the major spatial division of the picture. The towering cliff defies
all gravitational logic. At its base opens a shallow tunnel, clean-
cut as if hewn by man. But how unstable a foundation this is
when one considers the load it carries. The hill suddenly thickens
as it rises, and bears upon the slope a small complex of build-
ings. The light brightens this upper slope, picking out the pink
and gray walls of the convent, the greens and yellows of the
trees. A road winds upward over the hill, and at the crest a small
figure is silhouetted against the blue-green sky, just as he is
about to pass over the summit into a limitless distance. The effect
is ambiguous and more than a little disturbing. Such details
as the minute, suspended terrace which juts from the cliff do
nothing to persuade us that this world is the product of reason.
Taken in certain individual parts the landscape is illusionistically
plausible, but seen as a whole it is fabulous artifice.

The dramatic silhouette of the cliff introduces the more distant
landscape. Behind the millstream a flat pea-green meadow
stretches to the sea, peopled by shepherds who tend their flocks,
and boatwrights who work on the far shore. From here space
develops by means of a continued alternation of lights and
darks, though more subtly stated than in the foreground. Finally
those mountains of blue ice are gained. The brushstrokes become
ever looser, and create a town at the base of the first mountain
whose walls of pink and gold creep up the slope. These strange
mountains seem half grown and half pulled from the earth,
jagged and striated as if malformed teeth. A disturbed sky lowers
over the land. Dirty gray storm clouds sweep in from the right,
their advance guard wind-whipped and whitened by the sun-
light. Before them lies a steely blue-green sky, which mellows
to faded pink and yellow lights at the horizon.

The canvas is a fantasy *alla fiamminga,* yet there is little in it
that cannot be explained within the context of Ferrarese tradi-
tions. One wonders what artist might have authored such a
picture. It is unlikely that an exact attribution can be shown,
but the proper milieu can be established. And when that is done,
the difficult problem of whether the picture is by an Italianized

Fleming, or conversely by an Italian working *alla fiamminga,* can be broached.

The closest parallel to the *Magical Procession* is a little picture by the Ferrarese Benvenuto Garofalo, in the Galleria Doria at Rome (Fig. 95). Here the figures and architecture bespeak an artist infatuated with the formal discoveries of Raphael's Renaissance. But beyond the parapet the measured decorum of classical order surrenders to a sparkling view of landscape. A dark strip leads to pea-green grass and some gray buildings. Across the water a town is sketched in swift highlights against the ice-blue mountains, which become objects faceted by light. Beyond, the pink and yellow streaked horizon rises to a gray sky.

This is exactly the color scheme of the *Magical Procession,* and the two pictures are no less alike in their spatial structure. In each the arm of a bay enters on the right, while mountains retreat into the picture on a diagonal from left to right. Strips of light and dark alternate, while clumps of highlighted trees help to strengthen spatial distinctions. Above is the same pink and yellow banded sky, with storm clouds that scud in from one side.

Still closer comparisons suggest not only a community of form between the two pictures, but an identity of the hands that painted them. There are the same ice-blue mountains, formed as if by a huge hand which had slowly pulled malleable material from the earth. Beneath the mountain is that same medieval town, with its rounded buildings topped by spires, wrought with the same soft and swift brush. In each picture the architecture is simple and rustic, with rounded arches and pitched roofs, all painted in gray. The roads which traverse these landscapes are peculiarly taut, as if their course had been laid out by some hard instrument. A small but important detail is this artist's predilection for a pair of conversing figures placed in middle distance, figures which are abstracted as attenuated straight lines topped by pin-like heads.

It seems likely that these two landscapes are by the same hand, and on the basis of the unproblematic figure style in the Doria picture, that hand should be Garofalo. But that would be too simple. Figures and landscape are clearly separated in the Doria picture, in such a manner that a collaboration is not only possible but would be almost impossible to detect. Further, a skeptic might

ask whether the Doria landscape is completely typical of Garofalo, and the answer would be no.

A large painting in London is a typical Garofalo, is dated 1526, and gives no hint of a collaboration (Fig. 97). When the *Pagan Sacrifice* is compared to the *Magical Procession,* our first reaction is to find them quite diverse. But in revealing details they are remarkably similar. The type of architecture and manner of handling clumps of trees (in middle distance in the Borghese picture, to the left of the nude's head in the other) is the same. Above the nude the pair of stick-like figures with pin heads makes its appearance. Less obvious but more important is the identical conception of geological morphology. The blue, light-faceted mountain to the right in the Borghese landscape appears in the same position in the London picture. Both the central mountain of the *Magical Procession* and the bluff of the London canvas have been pulled upward from the earth. The latter has been slightly twisted, and if one looks at the pierced cliff in the *Magical Procession,* he will discover the same effect. The rock is pulled up and over the tunnel from left to right, and then given a gentle twist towards the projecting terrace. In the one case the landscape is fantastic, with strange discrepancies in scale, in the other a largely believable view. Such is the difference between a landscape for a parade of monsters, and a landscape for a pagan sacrifice. But in basic concepts of form the landscapes are so alike that one must ask if they could not be by the same hand.

So an attribution is made, to an artist intimately bound to Garofalo, or even possibly to Garofalo himself. If the canvas is by a close follower, then there is every reason to believe that the follower was Italian, so impregnated is he with Garofalo's style. As the Moscow landscape is quite surely Dosso painting *alla fiamminga,* so this landscape would be Garofalo, or a Garofalesque in the same spirit. In venturing these opinions, I am assuming that just because Gothic buildings or a northern compositional scheme appear in a painting, this is not reason to think that a northerner did the picture. It is possible and reasonable to suppose that on occasion Italian artists chose to paint in what they considered a Flemish manner. If this is so, one must ask why. Before attempting an answer, we should expand our notion of the northern moment with two additional paintings.

One is the *Flight into Egypt*, at Coral Gables, Florida, a variant of a picture once in the Harck Collection at Seusslitz (Fig. 98).[9] The picture is currently attributed to Dosso Dossi, but I prefer to think of a possible collaboration between the two brothers, Battista responsible for the somewhat simplified and dryly drawn figures, and Dosso for the loosely painted stormy landscape, which is comparable to the background of Dosso's Moscow landscape (Fig. 92). Be this as it may, we again feel in the presence of a painting touched by northern ideals, both in composition and in details. These most Italian figures are backed by a dense forest, which spatially functions in the same way as the tall hills in the Moscow and Borghese landscapes. A view of a port opens on the right, its buildings roughly painted, and figures picked out by dabs of the brush. The mountains are pulled up, their peaks in high floodlight, and above hang thick and ugly storm clouds. Both in general concept and particulars this canvas is not far from the *Magical Procession*, but it is the work of a still freer hand who gives a more relaxed description of forms. There is in this picture some of the ominous threat of the *Tempesta,* a too rich foliage, a fantastic vision that seems to contradict the matter-of-fact foreground figures. How different this is from the peaceful and stable image of the same subject that Annibale Carracci painted at the beginning of the next century (Fig. 136).

The *Battle of Orlando and Rodomonte*, at Hartford, takes us to the festive world of Ariosto's great poem (Fig. 99). It is a place of flashing armor, brilliant banners, and caparisoned horses. The world is a brightly colored make-believe, whose veined stones are examined with a naive, archaizing precision, and where relationships of scale are playfully capricious. These colorful figures and improbable buildings are placed in a Flemish landscape, in spirit the just complement to the festive unreality of the foreground. A picturesque arch opens in the midst of a luxurious grove, and beyond lies a Gothic town, its spiky pinnacles utterly unlike the simpler rustic architecture of Garofalo. The town stretches to a seacoast, where small groups of people watch ships

[9] F. R. Shapely and W. Suida, *The Samuel H. Kress Collection: The Joe and Emily Lowe Art Gallery of the University of Miami*, Coral Gables, 1961. For the Seusslitz picture: H. Mendelsohn, *op.cit.*, pp. 134-35.

in the port. The whole is a pageant of sustained light-heartedness, in the spirit of Ariosto.

As picture-making the *Orlando and Rodomonte* is similar to the Borghese *Magical Procession*. The fantastic bluff of the latter has been replaced by architecture, but both serve the same compositional purpose. In each case middle distance is measured by a forest grove, and to the right the seacoast runs back to a high horizon (here evidently too high, for obviously the canvas has been cut at the top). And if one compares the picture to the Moscow *Saints* and Coral Gables *Flight,* he sees that in general inspiration they are of a family, even if they differ in particulars.

Superficially the canvas is the product of northern taste, but at heart it is fully Italian. While it is currently given to Dosso Dossi, in the past it was attributed to Battista. Its bright clarity and insistence upon simplified detail surely eliminate Dosso, whose world is inevitably more smoky and smouldering in color. But exactly this quality of simplified detail links the picture to the foreground of the *Flight into Egypt*, where one notes the same pools of shadow, the same inorganic relationship between trees and earth, the same frozen, linear drapery. One's thoughts must then run to Battista Dossi or a follower, with the possibility of collaboration in the more microscopic background.

Be the attribution right or wrong, the important point is that the picture is fully Ferrarese in all stylistic essentials, and so we return to the very question posed about the Borghese *Magical Procession*: why should an Italian artist have painted a picture so northern in general inspiration? A vague and easy answer would point to the growing popularity of Flemish art in north Italy during these years, and documents, such as the record that in 1535 the Duke of Mantua bought northern pictures in wholesale quantities, could be adduced.[10] More to the point, these were the years when small landscape panels began to arrive in Italy, the sort of painting done by Joachim Patinir and his many followers. In the Italian mind "a landscape painting" came to be identified as a product of northern taste, and both landscapes and those who painted them began to assume that low rank in the order of genres which later academic theory would explain all too thoroughly. When an Italian artist turned to landscape

[10] Cited by Gombrich, p. 339 (see bibliography).

painting, it was inevitable that he would begin to see through Flemish eyes.

Such a taste for Flemish landscape might explain the Borghese *Magical Procession* and Moscow *Saints*, but does not help us with the *Orlando and Rodomonte,* where landscape, while northernized, is rather incidental. For some reason here Battista, and Garofalo in the Borghese *Magical Procession* (for if it is not by him, it must issue from his studio), departed radically from their usual styles for a more Flemish point of view. One can only conclude that the subject matter in each case may have determined the stylistic mode in which the picture was painted. The *Orlando and Rodomonte* is a subject taken from Ariosto, and so a medieval subject whose setting is outside of Italy. Quite possibly, then, an artist normally Italianate in manner would have chosen what he understood as a medieval style in order to express a medieval subject. For an Italian this of course was not his tradition of Byzantine art, *la maniera greca*, but the tradition of Gothic art. Hence might be explained the background of the Hartford picture, an exercise *alla fiamminga* which was to be understood as Gothic art. In like manner, the Borghese *Magical Procession* presents Boschian imagery, and invites comparison to Ariosto, whose cantos thrive on magic and sorcery. This magical subject matter was probably understood as northern and medieval, and so the formal guise in which it is presented is possibly explained. Not improbably, then, a Flemish mode was meant to complement what was understood as an essentially medieval subject. The validity of this idea depends upon its extension to further pictures. For the time being, it is a possible approach to certain unique paintings which are surely not simply whims of taste.

This northern moment, which I have tried to characterize on the basis of a few pictures, is precariously centered upon the one date of 1525, though I think it likely that the four pictures I have discussed all date fairly close to that year. On the basis of what we know it is not possible to say when this *gusto fiammingo* began, or which Ferrarese (or northern) painters led the way. Nor is it easier to trace the evolution of this taste in the thirties and later. A large mythological picture, of Ferrarese origin, should date about 1540 (Fig. 100).[11] This nearly life-size figure is con-

[11] Ex-Robinson Collection, sold at Parke-Bernet, October 19, 1960. *Notable*

ceived in rounded, almost sculptural terms, and her body is sheathed in full, simple draperies. The husky cupid and laurel tree to one side are painted with the same firmness, and behind them carefully drawn boats float on a glassy sea. One discovers with surprise that the landscape is totally disjointed, for on the right the land drops away into a loosely painted valley, where processions of figures are half seen as they wind through an over-grown ravine. Water birds play in the foreground, while to the rear an exaggeratedly Gothic architectural complex is seen be-tween the trees, spread at the foot of a mountain. The entire passage is painted with a fluid and almost impressionistic brush, the very opposite of the firm control shown in the rest of the canvas. The hand which painted this landscape is thoroughly northernized, and surely different from the hand that did the figures and landscape to the left. It might be a northerner or an Italian, and we become intrigued by a notice given by a Fer-rarese writer of the seventeenth century who mentions in passing that "Il Civetta, famosissimo pittore" lies buried in a Ferrarese church.[12] "Il Civetta," the Owl, was the Italian nickname for Brueghel's great predecessor, Herri Met de Bles. His presence in Ferrara, perhaps from the later 1530's, might be hypothesized and would have sustained the taste for things northern that char-acterized this remarkable court.

The full flowering of this fantastic point of view comes not at Ferrara, but in Bologna, with the Modenese painter Niccolò dell'Abate.[13] He was born early in the century and raised in

Paintings by the Old Masters: Timkin, Robinson, Astor and other collections. Parke-Bernet Galleries, Oct. 19, 1960, p. 12. The subject appears to be an allegory, and in style the picture is close to Battista Dossi.

[12] M. Guarini, *Compendio historico dell'origine accrescimento e prerogative delle Chiese e luoghi pii delle citta e Diocesi di Ferrara,* Ferrara, 1621, p. 225.

[13] There is as yet no monograph on this fascinating artist. A basic bibliog-raphy is given at the beginning of the article by Enrico Bodmer, "Niccolò dell' Abate a Bologna," *Commune di Bologna,* 1934. Because this article is hard to come by, and the subsequent literature is in scattered articles, I give a selected bibliography. The Scandiano frescoes: W. Bombe, "Gli affreschi dell'Eneide di Niccolò dell'Abate nel Palazzo di Scandiano," *Bolletino d'Arte,* x (1931), pp. 529-53. R. Pallucchini, *I dipinti della Galleria Estense di Modena,* Rome, 1945, pp. 49-54. Bolognese frescoes: Bodmer's article and Buscaroli's book (bibliog-raphy). Easel pictures: for the Borghese landscape, C. Gamba, "Un ritratto e un paesaggio di Niccolò dell'Abate," *Cronache d'arte,* I (1924), pp. 77-89. For land-

Modena, where one might hope to find his beginnings as a painter by the earlier 1530's. But such is not the case, for he worked largely in the provinces until the later 1540's and many of his earlier works were painted house façades, now irretrievably lost. One would expect to find Niccolò's beginnings as a landscapist linked to the Ferrarese tradition, if indeed he had contact with such examples.

Our earliest certain idea of his landscapes is the small frescoed lunettes which once adorned a room in the Castello Boiardo at Scandiano, and which today are in the Galleria Estense at Modena. These lunettes were a minor part of an over-all decoration scheme, which included chiaroscuro battle scenes, episodes from the *Aeneid,* and portraits of music-makers upon the ceiling. Traditionally, but for no apparent reason, these frescoes are dated about 1540.

The first impression of these landscapes is doubtless the correct one, that they are well painted, interesting for their time, and on the whole aesthetically unremarkable. In all of them figures play a prominent part, and the series seems to illustrate the life of the countryside. We see a military procession, a fair, a hunting party, a man writing, etc., all set within landscapes. One lunette is an allegory (apparently of Peace) and is doubtless the clue to an iconographic program.

In one lunette a woman points out a castle upon a hill to a small boy (Fig. 101). The meaning escapes us, but it is likely that this is intended to be an accurate topographical representation. The foliage and hillside are executed in a pleasing gray-green, seen between slight trees which frame the figures and castle. The spatial structure could hardly be simpler. Beyond a pair of dis-

scapes in the Spada and Pallavicini galleries in Rome, see the respective catalogues by Federico Zeri. I regard the above three pictures as products of Niccolò's Italian period. For pictures in the Louvre and London National Gallery, Cecil Gould's catalogue of the latter. For landscapes in general, Bodmer's disappointingly general article, "Die Landschaften des Niccolò dell'Abate," *Zeitschrift für Kunst,* v (1950), pp. 105-15. Speculations on early Niccolò, R. Longhi, *Officina Ferrarese,* Firenze, 1956, p. 90. Niccolò in France: S. Béguin, "Niccolò dell'Abate en France," *Art de France,* ii (1962), pp. 113-44.

I must stress that the known facts of Niccolò's career are minimal, and that there is considerable doubt concerning attributions and dating. My pages are intended simply as an appreciative sketch.

coursing figures and a house rises a low and gradual slope whose form subtly echoes the curved format of the lunette, whose left side is fronted by the beginning of another hill and whose right is similarly backed by a more distant slope. Some alternation of light and dark areas and the spotting of clumps of foliage give variety and life to this otherwise simple scheme.

For those who know Niccolò the fantastic landscapist, these early lunettes are a revelation. They show an artist who in his beginnings is content with a rather factual and unimaginative approach to landscape, couched in the simple conventions of the landscape art. The landscape backgrounds of frescoes in the Casa Fiordibelli at Reggio Emilia and those of 1546 in the Palazzo Municipale at Modena support this impression.

The change in Niccolò's outlook as a landscapist apparently dates from his move to Bologna in 1547 or 1548. He had made his reputation with a picture done in the former year (in Dresden before the war), and according to one source, moved to Bologna as a result of Primaticcio's persuasions. Here he spent four years, and left a number of fresco cycles, both inside and on the façades of Bolognese palaces. At Via Galliera 4, one can see part of the decoration of a small room that was dedicated to scenes from Ariosto. Arcades open out upon a view of gallant knights and fair ladies, on an extravagance of elegant stuffs and wispy feathers that adorn them. Behind, a seacoast races away into the mist towards a raised horizon. There is lightness and ebullience, a bravura that seems to stem from slight hints in the Aeneid series at Scandiano. The provincial painter had flowered into an elegant, high-keyed dandy.

Niccolò's most important commission came from Cardinal Poggi, in whose palace (today the University Library) he and his assistants executed friezes in several rooms. Aula xv contains a notable set of landscapes by Niccolò himself, where the straightforward recorder of landscape becomes an interpreter of rare imagination. One of these landscapes shows an artist who has evolved radically since the Scandiano lunettes (Figs. 102 & 103). We stand upon a shaded hillside, whose slopes are covered with ruins, and gaze upon a mist-shrouded seacoast. On the right is the suggestion of a forest grove, whose trees are partly bowed by time, a natural analogy to the half-fallen buildings that lie

147

beyond. These ruins are almost living objects, caught as they are in an evocative light. To the right a wall throws brilliant reflections of sunlight through the trees, only to turn a corner and fall into deepest shadow, from which emerges a statue that seems for an instant a living person. To the left two white columns adorn a crumbling structure. A statue still tops this building, and luxuriant plant life eats away at the parting cracks. Further to the right a broken arch is silhouetted against the water, as if it were a great beak menacing the columned ruin.

One's first impression of these landscapes is that they are handled with impressive subtlety, and with a richness of color one does not expect in fresco. The dominant green foreground of the landscape gives way to the blues and lavenders of the background. The immediate foreground is a dark green, touched here and there with brown, and the small white flowers that grow near the twin trees. The sun breaks through to lighten the ground beneath the brown and fallen tree, while in front of the columned ruin the ground is a mottled spread of yellows, pinks, and tans. At the foot of the hill the water is blue, but as it glides past the shore this blue rapidly shifts to gray, which shimmers from the reflections cast by the buildings and mountains. These gray ranges are painted with a curiously dry brush, which leaves faceted rock surfaces, vaguely reminiscent of a Cézanne mountain. At the horizon sea and sky meet in a misty line.

In this landscape the fascination with ruins meets the fundamentally northern manner of structuring a landscape. One sees space blocked on one side, with a vista of great expanse upon the other. This basic scheme is punctuated by strong contrasts of light and shade, by the effective use of strong silhouettes and things seen through things. This is a landscape born of the imagination, and possesses a verve and rhythmic structure entirely its own.

The fresco serves as an introduction to Niccolò's landscapes in oil, his finest achievements in the genre. One of these easel pictures hangs as a pendant to the 1525 landscape in the Galleria Borghese (Fig. 104). The bond between these two landscapes is unmistakable, a broad view up a seacoast with far-off mountains that run to the horizon. The earlier landscape is inhabited by

nightmarish creatures, Niccolò's by colorfully dressed knights and ladies. Both pictures are fantasies, but somehow Niccolò's strikes one as even more artificial, a fabrication that bespeaks a highly refined and nervous sensibility.

The landscape possesses an ephemeral quality, evoked by color and light. Across the foreground are spotted brilliant patches of color. To the right an equestrian group watches the hunt which unfolds in the water below. But we readily see these figures simply as a color pattern, two spots of crimson which flank a soft lavender-white. One's eye glides over the gray-green foreground to another figure on horseback, seen from the rear. The animal is modeled in soft white, and the erect rider wears a crimson cape. The brilliant pattern is completed by touches of gold in the hat, cape and trappings of the horse. This radiance is complemented by the cavalier who stands beside a truncated tree, for he is attired in crimson from head to foot, with gold slashes on his pantaloons and gold worked upon his breastpiece. He speaks to three seated ladies, flowers of elegance garbed in costly silks. The colors become delicate, a gentle purple, a pastel yellow, a pale lavender. Be it the bright plumage of the male, or the soft pastels of the women, these colors are divorced from any everyday reality. In an entirely new idiom and context the frank pageantry of, say, a Paolo Uccello is given a sixteenth century dress. All these colors tend to fragment the picture, to stress decorativeness at the expense of illusion. And so we arrive at the essence of Niccolò's landscape art; it is illusion, but the illusion of a world of fable rather than of that which the eye sees in nature.

The colors of this landscape defy precise description. The contrasts are strong, ranging from the dark olive-gray of the foreground to the faded pinks and silvers of the far distance. There is none of the warm earthiness of the landscape dated 1525, for brown is virtually banished from Niccolò's palette. While the foreground is described in rather precise detail, the hills and sky are wrought in soft and filmy brushstrokes. The world dissolves in a pink mist, with a touch of ineffable enchantment that would have been understood later by Antoine Watteau.

Dark olive-gray frames three sides of the picture, the scraggily

tree to the left, a strip of foreground, and the shadow of the trunk on the right side of the canvas. The rest of the foreground is brushed in a light yellow-green, which contrasts strikingly with the deep gray-green, almost black water below. So begins that alternation of lights and darks that is Niccolò's device for carrying the eye into space. On the far shore dark gray-greens and light yellows are interwoven. Little else is on the palette, save the gray of the buildings, and the flaming pinks and reds of a conflagration whose ancestry goes back to the pictures by Bosch and Patinir. Behind the darkened trees the landscape brightens. A town is sketched in pinks and grays, and strange poles and towers rise from a pale hillside. A few rapidly brushed trees of blue-green and tan tower behind the buildings, fanning out like great ostrich plumes. Beyond forms dissolve in color. The hills become a light olive-gray, flecked here and there by highlights which describe a building or grove. And still beyond, as they skirt a haze-shrouded sea, the hills turn to silver. The sky is most exquisite, a soft blend of pinks and grays that floats in diaphanous layers above the landscape. But it is a momentary condition, for thick and sooty storm clouds blow in from the right, and will soon blacken the sky.

In this canvas the vision of an aristocratic world, already introduced in the elaborately garbed gentry of the Via Galliera, reaches a significant point. We immediately recognize this vision as a reprise of the fantastic landscapes cultivated at Ferrara during the twenties and thirties. Perhaps Niccolò encountered this taste in Bologna or in Ferrara itself, to which he might easily have traveled. Though I cannot demonstrate his historical contacts with this earlier northern moment, in spirit he surely continues it, bringing to it a complexity, a sophistication, and nuance of palette foreign to a Dosso or a Garofalo. The landscape is no longer inhabited by ecclesiastics, monsters, or figures from Christian history, but the denizens of an elegant society, those same aristocrats that Niccolò had depicted at their leisure in another frieze at the Palazzo Poggi. With poised gentility their games are played in a hothouse atmosphere.

It would seem that the vision of the Borghese landscape could not stand further development, yet Niccolò did just this in a pair

of canvases, one of which is in Paris and the other in London, probably painted between 1560 and 1570.

The London canvas, whose pretext is the story of Aristaeus, is a striking piece, about seven feet wide (Fig. 105). Before this picture subject matter is forgotten, and form captivates. The figures set the mood, pale and elongated bodies, their motions frozen in graceful rhythms, transparent gauzes flowing over long limbs and torsoes. To an eye attuned to the painting of our own time, the landscape is above all an exercise in pure paint. The fluid pigment was thinly applied, and has become even thinner with time. But in certain areas, a darkened grove of foliage, the paint suddenly thickens, worked in long brushstrokes that leave sharply raised edges.

Color more than anything sets the mood of the piece. With a perseverance that few landscapists before or after have observed, Niccolò has banished browns from his brush, to an even greater extent than in his Borghese landscape. The canvas is a dialogue between blues and greens, which meet when mixed with grays. The effect is an intense coolness, an icy richness, a dispassionate sensuality. From the greens of a leafy foreground one wanders back through an array of fantastic architecture flicked on the canvas by a hurried but controlled brush. On one goes, through a land whose creams and greens are those of tossed waves on an angry sea. The landscape is laced through with silvers, the distant mountains icebergs within whose hulks a pallid fluorescence glows. To the left they become a deep blue ink. A massive storm moves in from the left, and the gray overcast is relieved in spots by a hint of blue, and by the white of a nascent thunderhead. At the horizon a pale cream touched with pink slips into the blue-gray sea.

Dosso's *Melissa* shows a land of moist and breathing plants, of richly spun fabrics, of a pulsating body. It has the fullness of physical life. Niccolò's London picture is equally an orgy of pigments, but its richness wears a repressive intellectual bridle, so that its atmosphere is one of blue grass seen through a thin and clear sheet of ice. In it the caprices of Ferrarese painting of the twenties and thirties reach a degree of intolerably refined sophistication, of complex virtuosity. It would take an extravagant imagination to think or feel any further in this direction. Niccolò

151

dell'Abate was to be a dead issue as far as the future of Italian landscape painting was concerned. This ultimate thought of Niccolò, a northerner among northerners, was painted at the French court, where the artist had gone in 1552, never to return to his native Italy.

VIII ✧ IN RUINOUS PERFECTION

THE face of Rome is unique. Unlike the period museum that is Florence, Rome bears eloquent witness to the passing of the centuries. Layer after layer of architecture from all ages has increased the height of the city, filling in the valleys, so that to a visitor today "the hills of Rome" must seem a puzzling expression. If one were to choose the picture that most concisely evokes this landscape, he might well turn to Raphael. In the background of his little *Esterhazy Madonna* (Budapest) is a view of ruins (Fig. 106). The skeletal forms of broken colonnades frame a Romanesque campanile which rises from the fallen stones, the very symbol of Rome, a poignant juxtaposition of the ages that all who travel to the Eternal City carry away in their memories. The landscape of Rome is the encounter between architecture and the *campagna,* and for centuries artists have interpreted this theme.

San Silvestro al Quirinale is one of the less visited of Roman churches. Its façade was pushed back in the last century to widen the street, and today one must ring a bell and ascend a flight of stairs in order to reach the nave. Inside, in the first chapel to the left, two murals face one another, each of which measures about six by seven feet (Figs. 107-109). A glance reveals that they are landscapes, conceived with a breadth and heroic air that suggests the art of seventeenth century Rome.

The pictures are not seventeenth century, but were done about 1524 by the Lombard Polidoro da Caravaggio.[1] Commissioned by Fra Mariano Fetti, erstwhile barber to Lorenzo il Magnifico and favorite buffoon of Leo X, the young Lombard made a startling break with tradition by introducing landscape painting into the highly traditional decorative scheme of a Christian church. To be sure, landscape had been painted before, particularly in a secular context. But rarely had it achieved such monumental treatment, and never in so holy a place.

The two landscapes do have subject matter, scenes of the life of the Magdalene on one hand, and of Saint Catherine on the

[1] For a review of his career and works and full bibliography: E. Borea, "Vicenda di Polidoro da Caravaggio," *Arte antica e moderna,* Florence, 1961, pp. 211-27. In addition, my article, "Two Landscapes in Renaissance Rome," *Art Bulletin,* XLIII (1961), pp. 275-87.

other. Nominally, then, the pictures form a comfortable part of the over-all iconographic scheme of the chapel, and so in traditional terms their presence is justified. But these figure groups are minute and difficult to read, and it is ever so easy to consider the murals as landscapes *per se*. Thus their subject matter becomes irrelevant, for not figures, but the mood of noble nature pervades the pictures. Polidoro becomes an important harbinger of the great landscapists. He rejects the faded colors of fresco, and turns instead to a medium (oil and tempera or tempera) more suited to the chromatic richness of landscape painting.

One is attracted first to the Magdalene landscape (Fig. 107), by the nuances of a mist-filled atmosphere and the gentle distinction between textures of mountain, tree, and sky. The total coloristic effect is a quiet gray-green, highlighted by the whites of the waterfall. The water is enclosed by a rich brown tree on one side, and the dark gray outcrop of a hill on the other. The eye passes this shadowed foreground to focus upon the swift vertical flecks of white that evoke the falling water. A forest hugs the riverbank, and is depicted with all the sensuousness that one might first expect a century later (Fig. 108). Polidoro has succeeded in creating that mixture of sun-drenched foliage and deep shadow found only in the roof of the forest. The tree farthest to the right is a light green, and beside it the scorched frame of a dead trunk hangs over the water. From here the forest recedes into the shade. Farther to the left a luxuriant tree emerges from the shadows into the full sunlight. Spreading onward, the dense forest crown becomes a bright patchwork of gray-greens and autumnal orange-browns, and finally disappears behind the hill. The color of this lower right portion of the picture is balanced diagonally in the upper left by what was once the cerulean blue of the sky. The other two corners of the picture strike a similar balance, though a more somber one. The faded pink garments of Christ and the Magdalene stand out softly against the dark olive of the garden trellis, a wall of foliage which is brightened by white blossoms. Behind rises a hill covered with ancient buildings, described in subdued tones of brown and gray. This area is countered by the dominant element in the picture, the stark cliff behind the forest. The rock is a light gray, lost in murky

shadow on the right, and on the left darkened to stand out against the sky.

Light and atmosphere are the essence of good landscape painting, and Polidoro has understood this full well. His color not only describes a surface composition, but melts the solidity of objects, so that the veil of atmosphere is actually what we see. But if light and atmosphere be essential to good landscape painting, we have already seen that the rational structure of space is hardly less important.

Polidoro's method is best understood in the Magdalene landscape. He uses towering elements—the hill with its many buildings, the craggy cliff—to create a pleasing surface composition in which the horizon line is concealed and the sky area minimized. These large masses of land are placed parallel to the surface of the picture, and so perforce parallel to one another. There is no real suggestion of diagonals nor of that tunnel space so dear to the Tuscans of the previous century. Rather the progression into depth depends upon pockets of hidden space which lead the eye inward by power of suggestion. That which is not seen is all-important.

The tree on the right border of the Magdalene landscape is the visual introduction to the space of the picture. From here the eye may pass to the *Noli me tangere*, but will find the view blocked by the tall mound of buildings and ruins. Or one may look at the waterfall and the trees behind it, only to see that they vanish behind the hill with the columned porch upon it. So the unseen pocket of space behind the hill is emphasized. The cliff rises from the trees, again blocking the vista that lies behind. But there is little doubt that space sweeps away, for the deepest penetration in the very center of the picture is a distant mountain lost in haze. Ill-defined and without scale, it hints at an unseen vastness.

This somewhat lengthy formal description may suggest the power and resolution of these remarkable landscapes. Their stately mood partially results from their form, but their expansiveness and nobility is not thus wholly explained. There is something about them that foreshadows a Poussin or a Claude, the evocation of a solemn antique world, replete with temples, obelisks, and great columned porches. These artifacts are set within

an environment which is equally monumental, a landscape seen with a fresh eye. It is hardly the naive landscape nor trivial antique impediments of much of Quattrocento art. We breathe the air of another world, a world which recalls a proud past.

In order to see the character of these landscapes, one must ask from what they grew. As form, they seem almost a bolt from the blue, though their genesis from Polidoro's earlier work is demonstrable. Rather than dwell on this minor matter, one might better ask how and why this particular view of landscape and vision of antiquity came to be married. In order to appreciate Polidoro's interpretation, there is no better starting point than Rome at the dawn of the High Renaissance.

In the middle 1490's the bowels of Roman ruins revealed a new and fascinating source for painters, the so-called *grottesche*. Named for the grottoes where they were found, these examples of ancient painting showed curving, intertwining decorative patterns where fantastic monsters and vegetal forms are fused. The artists quickly recognized the suitability of these motifs for the decoration of such areas as vaults and spandrels, and in the 1490's one finds them a part of the Renaissance painter's repertoire. Thus is solidified an antiquarian attitude towards antiquity which had already formed part of the character of Andrea Mantegna.

But more than archaeology was required to feed the High Renaissance vision of antiquity. There would be also imagination and romance, the dreams of a glorious past. While the Umbrian Pintoricchio is a pioneer archaeologist in the *grottesche* of the Borgia Apartments, he lacks this quality of imaginative vision, as his fresco of the *Martyrdom of Saint Sebastian* reveals (Fig. 110). His landscape remains Umbrian, with its feathery trees, and view of the distant spreading hills. The battered remains of antiquity are inserted in the landscape like so many literal quotations. The saint is bound to a granite column which stands before a fantastic, moss-draped wall. This wobbly structure would seem to defy the laws of gravity. To the left lie some shattered columns of a capital and a fallen cornice, to the right a broken column with trophies carved upon the base. The round hulk of the Colosseum rises behind. But these are all scattered and unrelated details, intruders upon the peaceful calm of an Umbrian landscape. Pintoricchio has not felt the grandeur that was Rome, the

tons and tons of mortar and brick that with monolithic solemnity are rooted in the soil. Nor can we blame him. The Siena library is his testament.

Polidoro's landscapes presuppose a noble vision of antiquity. The first after Masaccio to grasp clearly the ancient world as a Noble Idea was Raphael. With exquisite sensibility and highest intelligence he evoked this classical past. The *School of Athens* presents a race of heroes, men of superior physical and mental stature who inhabit proud halls. Raphael, like Bramante, realized the scale and permanence of the Roman vision, and so he joins an ancient bath to Saint Peter's as yet unbuilt. He studied ancient statuary and incorporated it in his work, as in the *Parnassus*. But inevitably the model is transfigured and becomes flesh and blood. In the last analysis this is why Raphael is a classic.

Raphael's forms are the ultimate development of that grand style first proposed by Leonardo. Beyond this, one must remember that Raphael's environment was one of men of letters. His great patron, Leo X, saw art in two dimensions, as magnificent decoration. While Julius is the pope of a great architectural project, a staggering sculptural complex, a primordially forceful ceiling fresco, Leo is the pope of tapestries, manuscripts, painted façades, and stuccoed interiors. He was at heart a man of letters, and it is significant that in his instructions to Raphael, his Commissioner of Antiquities, he is especially concerned lest ancient inscriptions be destroyed.

Raphael bridged the gap between artists and literary men. He had Vitruvius translated, and took active part in an attempt to reconstruct the appearance of ancient Rome. He is also probably the author of a report on the antiquities of Rome made for Leo X, but written in the hand of Baldassare Castiglione. In these two men an artistic genius of little schooling and a cultivated scholar joined in devotion to a common intellectual pursuit. They were one in grief, for they "behold this noble city, which was queen of the world, so wretchedly wounded as to be almost a corpse." And they are united in the hope that with the support of his Holiness scholars and artists may recapture the face of a lost past. A Raphael and a Castiglione could both be archaeologists of exacting means, but they also had a broad vision, both aesthetic and political, of a great civilization that once had been.

It is this combination of intellect and emotion that is the immediate spiritual background for Polidoro's landscapes.[2]

The feeling for ruins in Raphael's Rome and the years that immediately followed his death is hard to recover, but we may set side by side a drawing and a poem which serve as a good barometer. The drawing is a landscape with ruins, its penumbral foreground relieved only by impressionistic dashes of white in the distance, where the buildings are dissolved in a capricious play of light (Fig. 111).[3] A lone figure sits beneath a darkened copse, wrapped in upon himself like Rodin's *Eve*. The light lacerates his form, picking it out in flakes and shreds. He would seem to sleep, but on second look appears a figure of despair whose tears flow upon his lap.

It is unlikely that we shall ever know exactly what the scene means, for its secret died with the draughtsman, Polidoro da Caravaggio. But how evocative it is to compare the drawing to a famous sonnet by Castiglione:

> Proud hills, and you, sacred ruins, who bear of Rome alone her name, ah, what miserable relics of so many lofty pilgrim souls! Colossi, arches, theaters, divine works, joyous and glorious triumphal pomp, in little time you are converted to ashes, and made in the end the vile laughing stock of the mob. Thus if on occasion famous works war against time, with slow step time casts works and names to earth. I shall live, then, content amongst my martyrs, for if time puts an end to earthly things, so perhaps shall it call an end to my torment.[4]

In spirit, Polidoro's weeping man is author of the sonnet, for both drawing and poem mourn the same cause.

The impact of these diverse archaeological studies upon landscape painting was swift, and is seen most clearly in a narrowly archaeological context. The Bath of Bibbiena and the Loggetta of Raphael in the Vatican are the purest examples of ancient

[2] On archaeology in Renaissance Rome, see the second chapter of E. Mandowsky and C. Mitchell, *Pirro Ligorio's Roman Antiquities*, London, 1963.

[3] A. Chatelet, "Two Landscape Drawings by Polidoro da Caravaggio," *Burlington Magazine*, xcvi (1954), pp. 181-82.

[4] *Baldassare Castiglione, Giovanni della Casa: Opere*, ed. by Giuseppe Prezzolini, Milan, 1937, p. 431.

painting reborn, for in them the decorative systems of the Domus Aurea of Nero are taken over with particular elegance. Raphael, the mind behind these decorations, saw the lesson of the ancient grottoes as a whole, not as a repository of individual motifs. The Loggia of Raphael, whose decoration was executed by his pupils between 1517 and 1519, is less pure, only because there is greater freedom in the decorative scheme, and a greater inventiveness *all'antica* in the individual motifs. Here the biblical scenes on the vaults were incorporated in illusionistic devices part ancient and part Renaissance, and the pilasters and arches richly decorated with stuccoes and frescoes. Amongst the latter are a series of lunettes painted upon the embrasures of the arched openings of the loggia. Almost all of them have been effaced by the weather, and with the exception of two ghost images, only one is well enough preserved to tell us that these lunettes were small landscapes.

The lunette is elaborately framed, and carried upon the heads of two harpies who flank an aedicula (Fig. 115).[5] Within the frame is a simple landscape, without apparent narrative significance. The decorative scheme shown in the photograph is strongly antique in flavor, and as much may be said for the landscape itself. That spindly ruin with its inadequate supports could stand only if carved from light wood. Born of fantasy rather than architectural logic, its forerunners are to be found in the so-called Fourth Pompeian Style of Roman painting, where the reasoned illusionism of earlier decades had given way to the imaginative structures of an anti-rational spirit. And it is just to this age of Roman painting that the *grottesche* belong. In detail the landscapist has tried to maintain this antique flavor, as in the figure with a staff on the left, whose swiftly brushed, summary form is strongly reminiscent of Roman practice. In spite of these characteristics, we would not for a moment mistake this little landscape for a Roman painting, for the organization of space is based firmly upon the assumptions of linear perspective. Yet the artist's antiquarian interest is abundantly clear, even to his choice of dull colors applied to a ground prepared of marble dust in the ancient manner.

[5] Not heavily repainted, according to restorers at the Vatican. The overdoor landscapes in this same loggia are considerably later in date.

As a work of art this weathered detail is little more than a daub, but it is of prime significance as an idea. It shows that the Renaissance artist knew what an ancient landscape looked like, and could produce a pseudo-antique variation if he so chose. Further, he saw that in antiquity landscape occurred in the context of wall decoration, a fact he had already read in Vitruvius. In spite of the subordinate position of landscape panels in the decorative scheme, it would have been but a short step to conceive of landscape as a distinct genre of painting, justified by the example of the ancients. Finally, the idea, this time based upon Pliny, of a specialist in landscape painting would have arisen.[6] Probably it is no coincidence that Vasari tells us that Raphael's shop included specialists; Polidoro in landscape, Giovanni da Udine in fruit and flowers, etc. So by 1519, in the very workshop where Polidoro learned his trade, the possibility of landscape painting *per se* was raised.

The backgrounds of paintings were equally affected by study of the antique, but in quite different ways. One manner is that of Giulio Romano, Raphael's prize pupil, who offers an archaeological reconstruction in the *Vision of Constantine*, in the Vatican Sala di Costantino (Fig. 112). Behind the gesticulating figures opens a view of the Tiber Valley. Light flashes down upon the Ponte Sant'Angelo, glistening off the statues that adorn it. On the near side of the bridge stands Giulio's reconstructed version of Hadrian's tomb, while opposite lies the tomb of Augustus, and behind a nontopographical collection of palace, obelisk, and triumphal column.

But Giulio's heart was not in it. A look at his various easel paintings of these years shows that his reaction to ruins in a landscape was unabashedly emotional. Rather his sympathies lay with the Polidoro drawing and the Castiglione sonnet. Among the first to feel ruins in this way was Raphael's arch rival, Sebastiano del Piombo. His *Raising of Lazarus* (begun in 1517) is indebted to Michelangelo, but when Sebastiano turned to the background, his memories went back to his Venetian beginnings (Fig. 113). A bridge spans a river, perhaps the Tiber. At one end is a ramshackle millhouse, with those overhanging, timber-buttressed rooms which appear in the rustic representa-

[6] See once again Gombrich's article, cited in the bibliography.

tions of the Giorgione-Campagnola circle. Through bridge and arch are seen closely ranked buildings that line the river's edge. Towers recede into the distance, as light flashes in the leaves of the trees. In this passage there is more than a faint echo of Giorgione's *Tempesta*. Venetian memories, yes, but the spell of Rome has come over Sebastiano. He has grasped the aesthetic possibilities of ruins, the play of mass and void, of light and dark. He has caught the age-old gravity of ruins as they emerge from the earth. Brick and mortar slowly crumble, while organic life clings to any available foothold. This is no longer the slight vision of a Pintoricchio, but the work of a man who had dwelt upon ruinous perfection.

A few years later the mood of Sebastiano's landscape was amplified in another painting, in Paris (Fig. 114).[7] The colors and particular handling of form speak for an attribution to one of Raphael's pupils, probably Penni, after the master's death in 1520. The picture is no more than two feet high, but most monumental in effect. It is of high quality, yet one feels that an ingenious concept has been somewhat bungled. There is little relationship between foreground and background, and the two parts of the picture compete for our attention. The amazing landscape wins us, for its grandeur bespeaks an awe in the face of ruination that exceeds even that of Sebastiano. We are led diagonally into space by an enormous foundation wall, whose clean surfaces are here and there nicked by the centuries. Plant life, caught in a flash of sunlight, sinks its roots into the parting fissures at one corner. The promise of titanic ruination is fulfilled in the background. With unerring play of line and plane, the artist pulls a hulking mass from out the earth. Its stones and bricks have conglomerated into looming monoliths whose forms slowly succumb to the ravages of time. The ruins are painted in grays tinged with browns, while the light-raked jamb of a huge archway is caught in a brilliant creamy hue. It is a picture of midday brilliance, conceived with a sensitive feeling for light and atmosphere. Air and light veil the buildings so that they are seen in their elemental monumentality, and the very moistness of the

[7] Raphael is usually thought to have done all or a part of the *Madonna of the Blue Diadem*, and because of its relation to the *Madonna del Velo*, it is dated 1510-12. A date before 1518 at the earliest is stylistically unacceptable.

blue landscape behind gives sustenance to the trees that slowly gnaw at the flaking stone. In this aging world man appears as a momentary visitor. Two tiny figures descend a long flight of stairs, while three others, highlighted in red against the sky, converse within the archway. Minute creatures venture upon a corpse of a fallen age, their brief span of life but naught before the ruins. The landscape is given a poignant interpretation, and a sense of the sublime that would seem to belong to a later century. This landscape is the brilliant invention of an unidentified hand, hardly the same one which executed the figures. Perhaps here the vision is Polidoro's, though I suspect we shall never know.

It is in the light of such images and feelings that the murals at San Silvestro must be assessed. We should realize first that the particular character of the landscapes at San Silvestro is a consciously cultivated artifice, and that Polidoro chose this particular convention in preference to others.

A sketch recently attributed to the artist leaves no doubt that for him a spontaneous reaction to nature was one thing, and a finished landscape painting quite another. This red chalk drawing, at Darmstadt, is unquestionably a study from life (Fig. 116).[8] Polidoro has mounted a low rise, and looks down upon a cluster of farm buildings. His sharpened chalk incisively catches the sloping lines of the buildings, and then is traded for a softer tip to describe the foliage. The chalk has moved quickly and surely, and has lingered over no detail. This shorthand, combined with an alternation of blank paper and heavily shaded areas, gives a vibrant sense of light and movement to this vignette. There is an unhesitant frankness about the drawing, untouched as it is by conventions of rendering. We are sure that this is what Polidoro saw, and wished to record in a quick sketch.

Only when one returns to the Uffizi drawing with a sorrowing man does he feel in the presence of a composition closely related to the San Silvestro murals (Fig. 111). The mood and compositional principles that underlie both are evident without description. This by choice was Polidoro's chosen vision of landscape, a dignified structure where a pleasing surface composition

 [8] J. A. Gere, "A Landscape Drawing by Polidoro da Caravaggio," *Master Drawings*, I, 1 (1963), pp. 43-45.

and a satisfactory structure of space are joined. These stately forms are the setting for a noble antique world, where man's proudest artifacts are cradled in the hills and forests of surrounding nature. At San Silvestro we see an early Christian century where buildings and ruins meet. It remains for us to to see more clearly the ingredients of this vision.

We should not be surprised to find in Polidoro the evocation of an antique world, for the artist was a Neoclassicist who thought in black and white, whose repertoire roamed the fields of Roman history and legend. His studies were transformed into innumerable chiaroscuro façade decorations, now recoverable only through engravings. Vasari's description of a young man who avidly drew every ancient fragment available to him is probably an exaggeration in the interests of truth. Polidoro was endowed with an archaeologist's mentality, and this leads one to ask in what manner ancient art may have affected his concept of landscape painting.

The decision to paint landscapes in a Christian chapel was surely a major innovation, but by no means a sign of secularization. Both patron and painter were probably well aware of the role of landscape in antique decorative schemes. They had read their Vitruvius and Pliny, had seen the grottoes, and the application of these lessons in the Vatican. The San Silvestro landscapes retain a traditional iconography, and are readily understood as subordinate parts of the over-all decoration of a chapel. Both in meaning and form they might have been defended in traditional terms, and their newness excused on the basis of solid precedent in Roman art and theory.

Knowing Polidoro's heavy debt to ancient art in his façade designs, we might suspect that his landscapes depend heavily upon the same source. Surprisingly enough, this seems not to be true. Polidoro's technique, some sort of tempera, or tempera and oil medium, may be an attempt to emulate the methods of the Romans. Or again in details, such as the background of the Saint Catherine landscape (Fig. 109), the impact of ancient painting is unmistakable. A long bridge is studded with small figures, a structure which resembles an aqueduct, and whose heavy arcades lead across the water to a tower at the far end. Above the tower a few buildings hug the hillside. The whole passage is bathed in

mist and executed in a summary fashion. The structure of the town is picked out by a few horizontal and vertical brushstrokes of white, the bridge but roughed in. The general effect is strikingly similar to the small landscapes of Roman antiquity, and Polidoro's technique leaves little doubt as to his source.

The specific debt to ancient painting is a matter of detail, and it contributes little to the general impression given by the landscapes. It is doubtful whether an extensive quantity of Roman frescoes was available in Polidoro's day. But that thorny problem aside, a comparison of Polidoro's murals to Roman frescoes now known yields no convincing comparisons. One might cite the famous Odyssey landscapes, discovered a century ago, but even here the fundamental concepts of composition and space are radically different. The great cliff of the Magdalene landscape, loosely comparable to the rock forms in the Odyssey frescoes, in fact derives in form and iconography from a Lucas van Leyden print of 1519, the *Dance of the Magdalene*.

But minimize as one will the actual influence of ancient frescoes upon Polidoro, it is certain that he wished his landscapes to recall ancient art, and this is the important point. What, then, is ancient about these murals? They suggest a sense of stateliness, a noble and well-ordered world, but these are classic qualities of the sort produced in various ages by grand spirits. In this respect it is the experience of the Stanza della Segnatura rather than of ancient art that has touched Polidoro. In details, such as the waterfall and moist forest above it, we discover a passion for sensuous appearances unknown in Roman mural painting.

By elimination one realizes that the architecture more than any other factor gives these murals their antique flavor. A mixture of ruins and reconstructed forms, this architecture evokes a nostalgic world where the events of Christianity take place in the shadow of fallen grandeur. A variety of architectural forms are packed tightly together, so that in the Magdalene fresco the effect is overly rich. A stately porch leads nowhere, and a roofed-over dome rises behind, so tightly cramped that it appears to be on top of the porch. To the left several columns carry a cornice, whose precise architectural logic is unclear. To one side is a small Roman temple. An obelisk stands out against the sky, and to the left sprawl brick ruins that recall the Palatine. Obelisk,

palace, ruin, temple, stately porch—the hillside displays the grander forms of ancient architecture. Similar structures adorn the Catherine landscape. The figures are placed in and before an Ionic portico, a sort of *scaenae frons*, or stage set, where disproportionately large actors play the scene. A pyramid, the arcaded bridge and a mausoleum are in the background, while a Romanesque campanile rises in the distance, an architectural waif in this world of classical forms.

The architecture of these landscapes is scholarly and romantic at the same time, a mixture reminiscent of Giulio Romano. At the basis of such an outlook is surely that inquiry into the appearance of ancient Rome, pursued by Raphael in his later years. It colors many works, such as the settings in Raphael's tapestries, or the architecture in Baldassare Peruzzi's *Presentation of the Virgin*, in Santa Maria della Pace (Fig. 117). Here the architecture seems to belong loosely to the same world of forms found in Polidoro's murals.

Still another activity may have colored Polidoro's architecture, the concern with the design of theater sets. Both Peruzzi and Raphael were innovators in this art, where the reconstruction of ancient buildings played an important role. Who is to say to what extent Peruzzi's *Presentation* or the Raphael tapestries are born of such designs? The most one can surmise is that the problems of the artist, scene designer, and archaeologist were peculiarly mixed at this particular moment, and the pursuit of one inevitably enriched the others. By Polidoro's time all these concerns lie behind the ancient world at San Silvestro.

Whatever the exact genesis of Polidoro's landscapes, they are highly cerebral creations, born of an intense desire to construct a believable space, and a plausible feeling for antiquity. But with all their high-mindedness, they smell not at all of dust or too much study. Paradoxically, their carefully deliberated framework is enlivened by direct observation. That passage with the waterfall and thick forest has a freshness that belongs to seventeenth century art. Polidoro is capable of close detail in leaves, or in a gnarled branch, but these details are absorbed in a soft over-all pattern of lights and darks, in the ever-present translucency of atmosphere. We see shifting lights in the foliage, and hear splash-

ing waters; by an impressionistic brush we are convinced that it is all true.

The landscapes may run the gamut from direct perception to studied artifice, but in a final assessment they belong to an ideal realm. They are ordered far beyond the happy accidents of nature, their stately architecture imparting a dignity that extends to the trees and mountains beyond. Thus is assured the lucidity and permanence of the world these landscapes describe.

Though touched by a warm feeling for nature, as the Darmstadt drawing reveals, Polidoro above all builds a landscape of the intellect. He must have looked fondly upon the diffused light of a Roman sunset, upon the rolling hills of the Roman Campagna, but they failed to find a place in his finished paintings. His public art is a product more of the mind than the eye, an appeal to our sense of order rather than to our less tangible emotions. Herein lies the divide between Polidoro and a landscapist like Giorgione. Giorgione's landscape is equally a matter of artifice, but we willingly accept it for its evocativeness, for the color and atmosphere which is its beginning and end. Polidoro's world is made of sterner stuff. Less immediately accessible, it nonetheless is the foundation of that durable order achieved a century later by Nicolas Poussin and Claude Lorrain.

For decades, however, this foundation was not built upon. The San Silvestro paintings stand alone, their example unheeded. The Sack of Rome in the spring of 1527 may partly explain this neglect, for Polidoro was one of many artists to flee the city. With these artist-emigrants Roman art spread the length of the peninsula, but with them also the threads of continuity were partially severed, including the possibilities suggested by the landscapes at San Silvestro. Polidoro was not among those who returned after the Sack, and without him the landscape art died among the Italians. Increasingly landscape became the preoccupation of foreign visitors, and a history of landscape painting in Rome from 1530 onward would have as many foreign names as Italian.

Landscape painting in Rome was above all a landscape of ruins, and Giulio and Polidoro are the founders of this mode, their noble vision worthy of *antichi romani*. But the foreigners from beyond the Alps saw the Eternal City in another light, nowhere better exemplified than in the work of Maarten van

Heemskerck, the Dutchman who painted the first significant landscape in Rome after Polidoro's departure.

Heemskerck is but one of a number of lowlanders who traveled to Italy in these years, in hope of refurbishing their art on the examples of the High Renaissance masters and the Antique. He arrived in Rome in 1532, doubtless inspired by the example of his master Jan van Scorel, who a decade earlier had been court painter to the maligned and short-lived Adrian VI. Heemskerck spent long hours doing topographically accurate sketches of the ruins of Rome. These drawings, varying in subject from panoramas of the city to detailed studies such as the head of the Laocoön, contain hardly a sheet which could be described as a landscape mood piece. Rather the studies of the city are mostly pure topography, accurate and devoid of imaginative interpretation. If Heemskerck shows plants growing from a crumbling ruin, it is because that is what he saw. He wished to capture the face of Rome as it looked, and most aesthetic considerations were subordinated to this desire. Precisely because of their objectivity, the Heemskerck sketchbooks are our best record of what Rome looked like in the earlier sixteenth century.

This is one side of Heemskerck's approach to antiquity; archaeological, empirical, essentially uncreative. But Heemskerck the artist had quite another side which links him to Giulio and Polidoro, the desire to reconstruct antiquity more by imaginative vigor than factual information. This vigor spills forth in one of the most grandiose and archaeologically unrestrained of paintings, the *Rape of Helen* (Figs. 118 & 119).[9] This huge painting (it is over twelve feet long) was done in 1535, and is the culmination of Heemskerck's Roman sojourn. It is as if in a burst of the imagination he had decided to purge himself of the long hours spent on those laboriously accurate drawings. The figure subject of the painting is engulfed in a wealth of panoramic detail, a broad coastal plain which reaches back to blue mountains whose veiled forms have the look of mammoth, eroded molars. Full clouds roll inland across a rainbow, and the land sweeps backward through a sequence of browns, greens and blues, the

[9] E. S. King, "A New Heemskerck," *The Journal of the Walters Art Gallery,* VII-VIII (1944-45), pp. 61-73.

almost invariable color formula of the northern painters from
Patinir onward.

The painting once bore the title, *Seven Wonders of the World,*
a mistaken identification that has more than a little poetic truth
to it. We are offered the various, the marvelous, the intriguingly
fantastic. Ruins and reconstruction lie one against the other, a
circular temple flanked by river gods, an arch which slowly
yields to the roots of clinging plants, an evocation of the Colossus
of Rhodes. Attempts to identify most of these buildings with
existing remains enjoy little success, but seen as an essay in re-
construction, the picture becomes in part an evocative image
of the city of Rome, which harks back to Giulio's Vatican fresco.
In the left background is the Tiber, spanned by the Ponte Sant'
Angelo, with the Tomb of Augustus on the right bank, and that
of Hadrian on the left. To one side is the Circus of Nero, with
the obelisk that a later pope would actually re-erect. Moving
across the landscape one sees other buildings which are either
the ruins or reconstructions of the Eternal City. But other de-
tails, such as the ruined circular building in the water, near the
ships, are wrought from the imagination. We leave Rome for a
realm found only in the inner eye.

Again, this picture must be understood as an outgrowth of
that attempt to reconstruct Rome made by Raphael and the
humanists about him, particularly Andrea Fulvio and Fabio
Calvo. The success of this undertaking was dampened by
Raphael's premature death in 1520 but still resulted in the pub-
lication of Fulvio's book, and a few engravings in care of Calvo,
in 1527. The seriousness and sobriety of this undertaking is not
to be questioned. One wonders how these scholars, or for that
matter Raphael himself, would have reacted to Heemskerck's
extravagant and imaginative abundance. The fantasy of this
great canvas has even gone beyond Giulio and Polidoro to par-
take of the fairytale land of the *Hypnerotomachia.* Yet this is not
really so, for this unique painting is simply the logical continua-
tion of the landscape of the twenties. In Heemskerck, the for-
eigner, is focused sharply that dual attitude towards antiquity
which had existed already in Mantegna, the science of archae-
ology on the one hand and nostalgia for a distant civilization
on the other. Heemskerck's canvas is prophetic of later land-

scape painting in Rome. With scant exception, for more than half a century artists were to turn their backs upon the architectonic dignity of Polidoro's landscape, and dream of a Rome wrapped in fantasy. Polidoro's heroic mode was replaced by one where nostalgia for the fragility of civilization is joined to a taste for the picturesque.

The sensibility of Heemskerck is echoed in the prints produced at mid-century. Hieronymus Cock, one of the leading publishers of his day, issued a series of prints in 1551 which reproduce the more famous ruins of Rome (Fig. 120). One is immediately reminded of Heemskerck's drawings, and realizes that like them these prints satisfy a need today met by photography. These accurate depictions were to serve not only the curious and the pilgrims, but were also a source book for artists and architects, particularly those who could not personally undertake the trip to Rome. Quite diverse in intent is a print done a decade later by the Vincentino Battista Pittoni (Fig. 121).[10] A city goes up in flames, perhaps Troy or Nero's Rome, a fantastic conglomeration of intact buildings and ruins. The artist evokes a distant past, but a past he conceives as always having been in a state of ruin. The print is a painterly tour de force, whose character is summarized by that tunnel of space in the center of the sheet, a space that rushes through cutting contrasts of white and black towards an explosion of light about a tiny group of figures. The artist is pleased with this giddy flight of space, for he repeats it in a valley to the right, and in a line of buildings that runs towards the flames. He uses every opportunity to set highlights against deep shadow, which results in an almost stridently dramatic effect. But bound to light is an expressive use of line, whose taut impressions describe the holocaust of flame and scorching smoke, and a seething sky whose striated texture predicts the wood cuts of an Edward Munch centuries later. Trees grow from crumbling brick, and architectural juxtapositions have only picturesqueness as their *raison d'être*. Nostalgia and a fantastic sentiment blend on an archaeologist's holiday.

In painting, this sort of fantasy is the rule, though we may first consider a noble exception. Between 1552 and 1555 some small landscapes were frescoed in the new Roman villa of

[10] See the notes to Ch. x.

Julius III.[11] We shall return to this decoration later and look here at one landscape, a view of the Palatine (Fig. 122). It is by a distinguished landscapist (I believe Matteo da Siena), the first man to grasp the principles of Polidoro's art. Ruins are no longer elaborate artifice, but believable relics set in a mountain landscape. The manner in which the figures and distant architecture to the left are painted suggests that the artist hoped to evoke the character of ancient painting, just as Polidoro had done nearly thirty years earlier. The space of the landscape is built about an imposing central mass, the ruin-strewn Palatine Hill. To the left one's eye follows a valley, with its sketchy architecture, while to the right a more complicated spatial avenue leaves Romulus and Remus, to flow via the Tiber around the hill and out of sight. The substantiality of this hill is described by the path that winds up it, while a far-off range of mountains carries the space into the far distance. In the vigor of the spatial structure the little fresco recalls Polidoro, but is equally a harbinger of Annibale Carracci's *Flight into Egypt* (Fig. 136). It is a convincing vision of antiquity for much the same reasons as the landscapes at San Silvestro: to a believable antique architecture is wed a stately and ordered spatial structure, and an invocation of the technique of ancient mural painting.

The spirit of these little landscapes, and of the villa in which they appear, is also that of a visitor to Rome in these same years, the French poet Joachim du Bellay. As the frescoist of the Villa Giulia looked back upon Polidoro, so Du Bellay absorbed Castiglione's sonnet into his own longer work, *Les Antiquitez de Rome,* and leaves us an impassioned hymn to antiquity, here given in Spenser's version:

> O that I had the Thracian Poets harpe,
> For to awake out of th' infernall shade
> Those antique Caesars, sleeping long in darke,
> The which this ancient Citie whilsome made:
> Or that I had Amphions instrument,
> To quicken with his vitall notes accord,
> The stonie ioynts of these old walls now rent,
> By which th' Ausonian light might be restor'd:
> Or that at least I could with pencill fine

[11] See the notes to Ch. x.

Fashion the pourtraicts of these Palacis,
By paterne of great Virgils spirit divine;
I would assay with that which in me is,
 To builde with levell of my loftie style,
 That which no hands can evermore compyle.[12]

It is sad to think of the author of the Villa Giulia frescoes, a man of no small originality, whose efforts were devoted to the minor parts of a frieze placed so high that one cannot truly see his achievement. He was appreciated as a decorator, and little more. Such was the fate of the landscapist in Rome, whose stature steadily diminished until he became virtually an anonymous journeyman.

A more accurate picture of the landscape art in Rome in the decades after 1550 is offered by the frescoes in the Vatican loggia directly over that of Raphael, done for Pius IV between 1560 and 1564.[13] The walls are covered by painted maps of various parts of the world, and over each map is a long rectangular landscape, a topographical illustration of the part of the world charted beneath it. Highly eclectic, these frescoes are a delightfully undisciplined hodgepodge of forms and little ideas.

The portrait of Greece is a representative example (Fig. 123). Various elements are spread across a broad panorama, a sequence of events read in time rather than as a tightly unified composition. Other panels, such as that of France (Fig. 124) and Asia Minor (Fig. 125) flank a central spatial opening with rudimentary stage wings. But in spite of this order, one still tends to move from anecdote to anecdote.

The fanciful and haphazard layout of these compositions prepares the discursive and irrational flavor of their mood. The panel of Greece overwhelms the spectator by its sheer overabundance of illogically joined architectural forms. In extrava-

[12] Joachim du Bellay, Les antiquitez de Rome e les Regrets, intro. E. Droz, Paris/Geneva, 1960.

[13] Dated 1560-64. Documentation: R. Almagià, Le pitture geografiche murali della Terza Loggia e di altre sale vaticane, Vatican City, 1954, pp. 1-4. The important name associated with the project is Giovanni da Udine, said by Vasari (Vasari-Milanesi, VI, 567) to have died in 1564. He in fact is dead by August 18, 1561 (A. Bertolotti, Artisti veneti in Roma nei secoli XV XVI e XVII, Venice, 1884, p. 18), and "Saboath pittore" (ibid., pp. 19-20) was probably the director of the work.

gant outlook it belongs with a set of prints done by Battista Pittoni in 1561 (Fig. 121), while all in turn are ultimately descendants of Maarten van Heemskerck's large canvas (Figs. 118 & 119). But in the fresco Heemskerck's articulate and sustained vision has crumbled. A truncated column, a ship in a cove, a pair of horsemen—all assume an equal value, and float in ambiguous scale relationships. Our instinct is to flee this random foreground, and with a magnifying glass examine the jumble of a Baroque city in the background.

The panel which represents France yields a better insight into the frescoist's view of the relationship of ruins and landscape (Fig. 124). A sylvan clearing and a ruin claim equal notice. This ruin, conceived in a true affection for decay, seems an improbable apparition where elegant folk are intent upon music-making near a busy inlet. A relic of antiquity seems a requisite complement to a refined society and a land which lays claim to a venerable historical tradition. The ruin is as *à la mode* a feature of the landscape as the elegant costume of the people in its shadow.

The view of Asia Minor shows the artist an incurable romantic, who weaves his fantasy from foliage, ruins, and running waters (Fig. 125). A river splits the panel as it courses past a broken bridge to disappear behind the ruins. Its sounds are echoed by a high waterfall in the background and cascades which tumble from a massive ruin on the left. The ruins of men's finest buildings seem menaced by the elements of nature, for the central ruin is prey on one side to corrosion by water, and on the other to the advance of a luxuriant forest. The feeling of spatial discomfort is here heightened. The forest seems hard upon us, while the ruin, at a strangely tilted angle in relation to the topography, is unnaturally far removed. Objects begin to float in a mirage-like environment.

Yet it is easy for a critic to turn hesitancies and inconsistencies on the artist's part into positive expressive virtues. The Terza Loggia frescoes are interesting but hardly of high quality, the anecdotal product of small ideas and limited talents. These landscapes, like most in Rome at the time, were minor elements in major decorative schemes, painted by men who had the misfortune not to be trained as figure painters. Usually these painters

were northerners, or provincial Italians. So with the landscapist(s) of the Terza Loggia, who remains anonymous but whose work is strongly colored by Flemish tendencies. For instance, the town and round keep in the water in the panel of France can be found in Patiniresque landscapes, while the spatial disjuncture of some of the panels was propagated by landscape prints issued by the firm of Hieronymus Cock in the 1550's. Also the ruins in these landscapes are paralleled in contemporary prints. Their peculiar charm lies in what might be regarded as negative qualities, namely their chronic discursiveness and failure to achieve a personal synthesis.

Such landscapes continued to be painted after the 1560's, finally to be displaced by the work of the brothers Bril, active in Rome from the 1580's. Matthew died in 1584, but his brother Paul was to live nearly half a century longer, and in the last decades of the Cinquecento was the most popular landscapist in Rome. In the early 1580's the Vatican Torre de'Venti was frescoed under the direction of Matthew Bril, and is the largest and one of the least known of Renaissance landscape cycles.[14] One of these frescoes will summarize, fairly I feel, the somewhat shallow interpretation of antiquity promulgated by the Brils and their numerous followers (Fig. 126). The quality simply as painting is an improvement over what had gone earlier, but one still feels in the presence of superficial anecdote. A colonnade is perched improbably atop a hill, which is in fact an island between streams. This artificial device suggests the calculated quality of this rustic scene, an additive composition where a variety of angular relationships are offered as an end in themselves, where objects are seen through apertures as a stock pictorial stunt, and where contrasts of light and dark are cultivated more as a dramatic device than as a deeply felt aesthetic expression. It is a convention, albeit a pleasing one, capable of endless variations which in fact it received in these very rooms.

We close on a note of anticlimax, in Rome of the 1580's where landscape was valued as decoration but hardly as a serious genre of painting. Yet all this was to change with the advent of Anni-

[14] J. Orbaan, "Onbekende Frescoes van Mattheus Bril in het Vaticaan," *Onze Kunst*, XLIV (1926), pp. 77-80. M. Vaes, "Matthieu Bril," *Bulletin de l'Institut historique belge de Rome*, VIII (1928), pp. 283-331, especially pp. 315 ff.

bale Carracci, who brought the lessons of Venice to Rome, and developed a landscape art worthy of Polidoro's precocious suggestions. The Eternal City has always found her champions, who in Edmund Spenser's words seek

> Olde Rome out of her ashes to revive,
> And give a second life to dead decayes. . . .

IX ✧ ANNIBALE CARRACCI

OCCASIONALLY an artist appears who passionately absorbs the art of the past, and with astute circumspection builds upon the accomplishments of his forerunners. He works with a largely unfailing taste, and takes his place as at once a traditionalist and an innovator. Such was the Bolognese Annibale Carracci, to whose lot it fell to cull the best from the landscape traditions of the sixteenth century, and to consolidate a mode of seeing and a tenor of feeling for the generations that followed. Annibale was no genius but a superb professional, and his products were at all times reasoned and understandable.[1]

He was born in Bologna in 1560, and with his brothers Ludovico and Agostino was to become the guiding force of Bolognese painting in the latter part of the century. Almost from the first Annibale seems to have been interested in landscape, an interest which might be traced across his drawings, now Campagnolesque, then touched by Tintoretto, again of fresh originality. Rather than examine this mine of material, however, I shall recall the landscape experiences available to Annibale, starting with the elegantly aristocratic landscape friezes by Niccolò dell'Abate in the Palazzo Poggi. Had these seemed tasteless, by 1580 a wealth of prints were available: Campagnola, prints after Muziano, Fontana, Pittoni, and hosts of northerners. Annibale's first trip to Venice seems to have been in the later 1580's, but we cannot doubt that some Venetian painting was known to him. The sources, in short, from which a landscapist might learn were abundant by 1580.

The key to Annibale's taste is already offered in a picture painted about 1585, the *Vision of Saint Eustace*, at Capodimonte, Naples (Fig. 127). The saint has dropped to one knee in a lush, water-nurtured vale. His still wonderment is broken only by a

[1] For all the paintings discussed here, plus biography and bibliography, see G. Cavalli, C. Gnudi, et al., *Mostra dei Carracci*, Bologna, 1956. Also D. Mahon, *Mostra dei Carracci: Disegni*, Bologna, 1956. Anyone interested in finer questions of chronology would do well to peruse the various reviews of the show, especially Denis Mahon's, which appeared in the *Gazette des beaux-arts* the following year. For Annibale as landscapist and for the aftermath, F. Arcangeli et al., *L'Ideale classico del seicento in Italia e la pittura di paesaggio*, Bologna, 1962.

tumbling stream, which splashes among the cool rocks and protective shade of the surrounding forest. A miraculous vision is cradled in a moment of religious silence.

One immediately perceives that there is nothing here of Niccolò dell'Abate of the northerners, or of the naive vision of Pisanello (Fig. 2). The canvas is most Venetian, sensuous and yet reasoned in its quest for a lucid structure of space. The saint kneels, arms spread in rapt awe, and gazes across the gully at a motionless stag. Between the animal's antlers glows the apparition of the crucified Christ, glimpsed during a chance encounter in a wild ravine. A valley broken by jagged escarpments gradually opens upon a distant spreading plain, its floor eroded through time by a small stream. The entire left side of the picture is flanked by these knife-edged formations, which offer meager foothold to a few trees. The right side of the scene is less craggy. The stag is silently poised on a rounded outcrop, only, we may imagine, to disappear in the forest a moment later. This rocky setting frames the scene on three sides, and trees lean in at the top of the picture from right and left, embracing with their subdued greens the deep blue of the sky. Annibale has plotted the surface composition of the canvas carefully, and completes it with two silhouetted trees placed in middle distance. They lock the two-dimensional pattern of color in place, and at the same time slow the eye's progress into space. The eye is drawn towards the sky through the tortuous space of the ravine, whose walls are harsh rock formations, spatially stage wings that withdraw into depth by parallel ranks. The length of this valley is transversed visually by a zigzag course that moves from the dogs in the left foreground to the saint, tó the stag, the horse, the trees in middle distance, and finally on into the far distance. Spatially the canvas boldly foreshadows the later popular device of suggesting a continuation of the painted environment beyond the confines of the picture frame, for the two rushing rivulets must converge a short distance below the lower edge of the painting. Yet none of these considered devices determines the success of Annibale's canvas. Rather its brilliance lies in the poetic mood that is evoked during a pause in a lonely valley, where for a brief moment the paths of Time and Eternity intersect. The world for an instant is hushed, and only the sound

of falling water suggests that here, as in Venice of three-quarters of a century earlier, "life itself is conceived as a sort of listening."

The forest world envisioned by Annibale is loosely akin to the vision of such men as Tintoretto, Sustris, and Paolo Fiammingo, but by 1585 he probably had not yet encountered their work. His own Bologna offered little, and he was too much a man of his time to take direct lessons from nature. But there were other possibilities whereby the heritage of earlier art became the intermediary between nature and Annibale's own ideas.

For a young painter, Albrecht Dürer's famous print of the *Vision of Saint Eustace* would have served as a starting point for a new interpretation of the scene (Fig. 130). Eustace, his hounds and horse, and the stag fill the foreground of Dürer's print. The forested slope cuts off any extensive vista, and our attention is brought instead to the grouping of man and animals. We discover with delight Dürer's caprice of placing saint and stag among the trees behind the domestic animals, for the apparent unimportance of the principal scene stresses its quality as a miracle which unfolds almost unnoticed in the most ordinary of circumstances. From the figures one passes in depth to a steep hill topped by a small village, and one sees that this is a domesticated setting where wood and town are but a short footbridge apart.

Dürer was held in high esteem in Italy, and Annibale consulted him, only to find the German's concept a bit old-fashioned. Perhaps Dürer's fairytale lacked the authentic ring of a woodland miracle, such as one might imagine it in the nearby Apennines. Unable to accept Dürer's idea of landscape, Annibale nonetheless felt obliged to do him homage. The small dog who quizzically regards the saint in Annibale's painting is borrowed directly from the hound in the lower right corner of Dürer's print. His respects paid, Annibale looked elsewhere for a more fruitful model.

He found this model in the sumptuous prints done after drawings by Muziano, some of which we have already examined. One of these prints represents the *Vision of Saint Eustace*, and a glance reveals its affinities to Annibale's painting (Fig. 129). Both scenes are set in a rocky gorge which opens upon a distant view, a gorge carved by a small stream and flanked by trees. In each

case saint and stag are separated by the ravine, the saint kneeling to the left, the stag statuesquely posed on an outcrop to the right. The feeling for space in each representation is similarly evoked by a central alley flanked by parallel wings that move into depth. But there are no specific correspondences between the two scenes. There is no furtive stealing here but rather an open embrace of a kindred spirit, for Annibale has absorbed the basic form and mood of Muziano's prints.

In Annibale's composition a ragged rim of rock lines the left edge of the canvas. This rim both frames the picture and serves as a *repoussoir* device, and it introduces immediately the rugged topography that will be encountered in the picture. Again this happy solution finds precedent in art rather than nature. Another from Muziano's series of prints is the *Saint Jerome in a Landscape* (Fig. 71), where the right side of the print is bounded dramatically by a sharp rock formation, carved by the same erosive forces that have left their mark on Annibale's landscape. By searching Annibale's landscape, one may discover even more specific debts to Muziano. The two trees silhouetted in the center of the painting derive from the *Saint Jerome*, and the shattered tree trunk above the two dogs compares to the stump in the lower left corner of the print. Annibale's debt is obvious, but the question remains as to why his borrowing is of more than casual interest.

Annibale faced a problem. He doubtless possessed a feeling for the landscape about him, but lacked examples which might help him to articulate this feeling in paint. The pressing question was how to arrive at a visually believable formula for the construction of space, one that would evoke not fantasies but the world as it looks to the observer. Annibale's requirements were satisfied in Muziano's art, where the emotionally evocative and intellectually reasonable met in a happy union. Only in Venice had this particular blend been preserved. A framing of the lateral boundaries of the composition, a measurable progression into space by parallel elements, a reconciliation of surface composition and depth composition—these were the essential qualities which attracted Annibale to Muziano's prints. While the borrowing itself is of passing interest, it appears in retrospect an

important early choice in Annibale's search for a tangible order behind surface appearances.

A few years after the *Saint Eustace* was painted, Annibale undertook a pair of large paintings, the Louvre *Hunting* and *Fishing* (Figs. 131 & 132). The canvases are full of anecdote, and one cannot resist scrutinizing them for their subjects. The pieces show neither the peasant world of Bassano, nor the overbred beings of Niccolò dell'Abate, but a socially mixed world caught in a moment of rather matter-of-fact bucolicism. In the *Fishing* some peasants are at work in a boat, while others pull a net through shallow waters. To the left two men discuss the catch, and behind a boy fishes from the opposite bank. To the right the principal anecdote introduces one to the picture. An elegantly dressed lady has arrived with her son, and chooses fish from a string held up by a corpulent, unattractive man. The *Hunting* again shows prosperous people, a couple who arrive on the left, the man with a falcon upon his gloved hand. Scattered through the landscape are beaters, and men who carry the game already killed. The woman points ahead, and to the right we see the object of her attention, servants who prepare a *signorile* luncheon *al fresco*. While in each picture the subject is ostensibly the chase, we see that in fact the quarry is highly important. The *Hunting* offers us sport, but the *Fishing* is concerned simply with the procurement of food. Thoughts of the pastoral or bucolic begin to drift away, and we realize that these landscapes should be labeled genre pieces. They even possess a touch of humor, as in the passage in the *Fishing* where a little boy clutches two slimy fish with grim determination while his mother chooses larger specimens. Important people enjoy the out-of-doors, mixing with benevolent condescension among their beloved inferiors. One may imagine these paintings in the house of an important patron, most probably in a well-used dining room.

Formally, the step from the *Saint Eustace* to the *Hunting* is not long, for in spite of a different format Annibale arrives at a similar solution. Each end of the picture is framed by large trees, between which the eye follows a series of rolling hillocks into space. The topography of the *Saint Eustace* has been softened, and a spatial device introduced which will reappear often, the foreground ledge, or stage, which drops away into the space

of the picture. We recall that Niccolò dell'Abate cultivated just such a device, but for entirely different ends. What for him was an element of fantasy is understood by Annibale as a rationally ordered way to introduce the space of the picture. Once into this space, the hillocks roll on a gradual diagonal from right to left, their extent measured by a careful spacing of trees.

Color is more important in this environment than any linear indications of space. The canvas richly blends browns and greens, earth colors which roll into depth, topped by lighter shades of greens. Through the brownish trees one sees the deep blue-gray valley of the middle distance, where the waters of a stream are just distinguishable. There a shepherd tends his flock, and beyond lies a clump of deep blue-green foliage on the far bank, a note of color that pulls one further into space. Finally the distant mountains are gained, whose gray walls match the lowering sky. With no bright sky to distract us, we remain among the quiet colors of the wood.

Where Annibale places an intense color, it is for a purpose. The scarlet jacket of the peasant on the left compels us to enter the picture at that point, and having done so, we discover the couple on horseback. They are garbed in whites, purples, yellows, and blacks, and the light catches the plumes of their hats and the woman's extended arm. We follow her gesture, and arrive at the picnic, and hence at the completed subject of the picture. Lest we miss the arriving couple, and so the meaning, Annibale has placed a simply dressed figure in the center who points at his *signori,* and links them to the right side of the canvas.

The *Hunting* is an eminently agreeable picture. If one compares it to the *Pardo Venus* (Fig. 75) and the Sustris in Berlin (Fig. 82), he sees that Annibale's landscape maintains a stoutly independent character. A mythological landscape has become a genre scene, and the conception of the forest lies between Titian's ideal, unchanging world, and the imaginative extravagances of Sustris. The scene is far more genre-like in flavor than any of the Venetian paintings that we have considered, and one rather should see it in the light of a man such as the Bolognese Passarotti, an innovator in still life passages and genre scenes. Equally to the point, though less definable, is the importance of Jacopo Bassano's conception of peasant life to Annibale. Such

Bassanesque memories occur in the group to the right. It is unimportant to arrive at precise sources for the picture if one realizes its general significance. While one might describe the picture as a landscape painting, this would be too simple. Annibale is interested in his figure subject, and landscape is but a part of a general broadening of his subject matter to encompass diverse aspects of daily life. Seen in this light, the *Hunting* joins the remarkable *Bean Eater*, Annibale's painting of a peasant at his table, which is startlingly modern in its directness.

Both in form and subject matter the companion picture, the *Fishing*, shares many of the qualities of the *Hunting*. The genre aspect is even stronger, and stock motifs begin to appear, such as the boat which had been favored by Campagnola, and which will reappear in Carracci. The landscape is lighter in tone than the *Hunting*, and shows a verve in brushwork, particularly in the white-flecked water and the creamy strokes that form the hill behind the second canal. The brush moves quickly over the buildings and foliage, and leaves little more than sketches, perhaps best savored in the left background. At times, as in the sky above the man with the net, the pigment is richly swirled.

The structure of the painting is neither simple nor, perhaps, entirely successful. A foreground ledge is used once again, its ends closed by the figures. Behind those to the right rise dark trees, which make this the "strong" side of the canvas. Beyond the ledge is a body of water, a motif that Annibale will repeat, and which will become a stock prop of the classical landscape. Moving into depth, one reaches a bank, beyond which is seen a canal. All of this constitutes the lower half of the picture, a fact that is too evident when one views the canvas from a distance. This clear division of the two-dimensional composition of the picture may also be read in depth as highly compartmentalized space. The far bank of the canal impedes passage into space, for up until that point the picture is quite dark, the land a somber brown, and the water gray. Once beyond this bank, the color scheme shifts to lighter hues of grays, blues, creams, and greens. This division of space is stressed by the dark green hedgerow on the left, and the olive-green and orange-

brown trees that rise in the center of the picture. It is as if two unrelated spaces exist, the closed and rather specific foreground, and the light, vaguely sketched lands beyond the canal. Considered by an eye attuned to the later Carracci, or to the Italians and Frenchmen who followed him, this dichotomy may seem aesthetically unsatisfying. But as we have already seen in the *Hunting*, the figure subject was most important to Annibale, and in order to hold attention within the foreground, he may have ruptured the space intentionally. This possibility brings us back to ponder the meaning of these pictures: perhaps rather than landscapes with genre elements, they are genre scenes with landscape elements. In this important distinction there is more than a rearrangement of words.

Judging the picture on formal grounds, one may find it a qualified success. The brushwork and feeling for textures and pigment are superb, and Annibale will rarely again allow himself such freedom in a landscape. But when viewed from a distance, the balance of colors is not wholly satisfactory. The landscape is quietly sober, a brown land over which hangs a gray sky, whose clouds shield the sun to the right. The unity of this subdued key is jarred by the overly strong color spots of the figures, who are not absorbed into the quieter mood of their environment. Over the whole plays a light which functions neither logically nor poetically, for it touches objects at random, its force too strong for the gray of a cloudy day. The painting, then, is still one that gropes for solutions rather than perfecting them.

It might be argued that by the time of these two pictures Annibale had not painted a landscape painting. His interests had run to genre, or to special categories such as the contemplative saint in a landscape, to which the *Saint Eustace* belongs. But whatever his intent, formally these early pictures were a necessary prelude to Annibale's landscape art, and they predict absolutely the course of his development.

The *River Landscape*, in Berlin, might be called Annibale's first landscape painting, for human activity has become purely secondary (Fig. 128). The picture may be dated in the early nineties, and is one of Annibale's most accomplished efforts. No longer does one feel that the structure of space is hesitant, nor

that the picture is essentially a genre piece. This is landscape, a study in space and light whose aim is the evocation of a tranquil and noble mood.

Annibale offers a view of ruins in a river landscape. On the near shore an elegant couple serenade one another, while on the water the boats of both peasants and *signori* ply their way. Past the ruin lies a peaceful plain, which reaches toward a lost horizon. Annibale still loves social distinctions, of a young fop on the shore and a beefy drinker in a boat nearby, but the meaning of the picture no longer rests with these figures. They have become adornments, and we take leave of them to contemplate the landscape itself.

The structure of space is a perfectly predictable continuation of Annibale's earlier experiments. The foreground ledge with water beyond reappears, its ends carefully framed by clumps of trees. This ledge is no longer abrupt, but extends into space, its bank marked by two small trees near the center of the canvas. In this foreground the colors are subtly varied, so that the area shall not go dead. Across this foreground grow three pairs of trees, carefully distinguished as to size, foliage, and form of their limbs. We begin to see that the artist consciously seeks contrast and variety within a harmony.

Once beyond this dark introduction of earth and trees, one's eye drops to the glassy surface of the river, and is led upstream by a calculated spacing of boats. The dominant feature of the landscape is reached, the hulking Roman masonry on top of which rise lighter buildings. Memories of the old are evoked in a dignified union of artifacts and nature. Those buildings, the great block to the left and the bridge, are all wrought in simple geometry, their massiveness and solidity stressed. These qualities are clairvoyant harbingers of Poussin's feeling for the relation of architecture and nature.

Formally, the architectural complex becomes the spatial hub of the picture. As in the *Fishing*, so here Annibale has desired some sort of definition of middle distance, but in that picture the definition was excessively planar, and broke the continuity of spatial flow. Here the object in middle distance succeeds in defining space without fragmenting it. To the right is a glimpse

of shimmering waters and loosely painted trees, one of Annibale's most successful landscape passages. And on the left one may follow the way pointed by two small figures, and find himself in the broad and light-soaked spaces of the distant plain. So by a continuous flow, as it were, the ground plain established in the foreground is reaffirmed and carried back to those hazy mountains in the distance. Here the carefully made structure dissolves in the atmosphere.

One may wonder where Annibale derived the elements of his landscape. Had he gazed upon such a scene, or was this an imagined image, perhaps the distillation of some matter-of-fact print? The answer is ultimately unimportant, for Annibale's vision is unequivocally ideal. His is a normative world, a place of unchanging seasons where the sun always shines, and where the lucid definition of relationships is far more important than the suggestiveness of things unseen. One may say that such a landscape is the triumph of Titian's vision. The great Venetian had crystallized the suggestions made by Bellini and Giorgione before him, and presented a landscape where forms were broadly handled, space clearly structured by elements placed parallel to the picture plane, and light was full and generalized. As the setting for either religious episodes or secular events, this landscape is a pleasant place, smiling and void of danger. Now Carracci took this landscape, and extended its finite confines towards the suggestiveness of infinite horizons.

In the mid-1590's Annibale went to Rome, not as a wide-eyed student, but as an established artist under high patronage. In the unending palaces, walled gardens, and churches of Rome he would have seen landscapes in wholesale abundance, for the most part done by northerners, or under northern inspiration. What is remarkable is Annibale's imperviousness to these examples, and his fidelity to his basically Venetian beginnings.

Sometime in the later 1590's Annibale painted his most brilliant landscape, the Louvre *Sacrifice of Isaac* (Fig. 133). The scene is as Genesis would have it, Abraham and Isaac upon a height, with the servants and ass below in the valley. The topography offers steep bluffs that rise from the plain, a wild but not desolate land. Although the painting is on copper, only about

a foot and a half tall, it is monumental, carried out with a confident looseness that reveals none of the miniaturist's technique so often encountered in copper panels. The picture is richly colored, and alive with vibrant lights. Browns and grays of the cliff stand forcefully against the light-drenched blues and greens of the valley, and the verdant silhouette of the great tree vibrates against the cerulean sky. These colors are unforgettable, a proper setting for the pink and yellow color spots of the figures. Once we have apprehended the subject matter, we are quite willing to forget it, and enjoy the pleasures of pure landscape.

The landscape is a lucid, effective structure: we pass two precipitous bluffs, cross a valley, and ascend again to lower hills wreathed in mist. The scheme is old and tried, but the effect quite new. The artist has cut the scene at the edges with a calculated arbitrariness, leaving us in doubt as to where we stand in relation to the space of the picture. We must imagine that the precipice to the lower left bends around to accommodate us, for a small truncated tree juts through the lower edge of the picture. Literal-mindedness will not serve us, however, for the effect of giddy perilousness cannot be rationalized away. At the same time we look up at the scene of sacrifice and down upon the valley, a broad view that suggests the vastness and feeling of movement produced by a wide-angle photographic lens. One may speak of structure as he will, but it is nothing without the flood of light, which endows the solids with life. It flows in from the left, its source hidden from view. The foreground cliff is thrown into strong relief, but the drama of light, which might so easily be carried throughout the painting with persistent obviousness, immediately melts in the background into softly differentiated colors and luminosities. The servants rest in a plain of creams and greens, which moves into some dark trees enlivened by a few highlights. Past a gray hill lie the dark blue-green trees of a shadowed valley which opens upon a further plain whose color is a sea green. All these colors flow imperceptibly one into the other, saturated with the intense yet soft light from the left.

Bound to this light is a flawless feeling for atmosphere. Beyond the valley rises a low gray hill, tinged with white, and above a blue forest climbs to a higher hill, in turn enlivened

by highlights. Beyond, the soft graying hills roll onward to melt into the sky. Annibale deals not in form but tonality, wielding a loose and soft brush. The absolute rightness of the picture lies in his ability to control the advance and retreat of different areas of color, and there are few landscapes where colors hold so well their proper distance in space. Not only is this true in deeper space, where the relative similarity of tones makes this control easier, but is firmly observed up to the very surface of the painting.

The large tree is a fine summary of Annibale's dexterous and tasteful accomplishment as a landscapist. It is soaked in light, the trunk dark gray in the shadows, bright and mottled where the sunlight breaks through. The foliage is a rich green, dark within the crown, and lightening towards yellow as the boughs catch the sun. Simple, bowed horizontal strokes render the leaves, lovely where they become almost transparent and glow against the sky. The tree lives through unexpected pictorial accents, the strong flash of light on top of a shattered stump, the autumnal orange of nearby branches from which the life slowly ebbs.

This is an exhilarating landscape, a painter's picture of lights and colors. We need bring to it only a sympathetic eye, for in the best Venetian tradition the painter has attended first to feelings, and only later to cerebration. Still one will ask whether the picture is Annibale's free invention, or a synthesis of earlier suggestions. Doubtless it is fully both of these. The tree recalls the *Peter Martyr*, that bravado of lights and brushwork. Perhaps the bluff with the tree jutting out of it. shows that Annibale had studied Polidoro at San Silvestro. Or again, the raised point of view is ultimately northern, as a generic comparison to an engraved roundel by Hans Bol makes clear (Fig. 134).[2] Annibale had consulted his heritage, and produced a picture whose spatial implications and sensitivity for light are his alone and look forward to the artistic and intellectual challenges of a new century.

Though I consider the *Abraham and Isaac* Annibale's most brilliant essay in landscape, it was hardly the most typical or influential. That description must be saved for the famous Doria

[2] F. Hollstein, *Dutch and Flemish Etchings, Engravings, and Woodcuts*, III, pp. 36-37.

Flight into Egypt, one of a set of six New Testament scenes in oil done for the private chapel of the Aldobrandini family about 1604 (Fig. 136).[3] In this picture Annibale summarizes his point of view, for the sequence begun by the *Fishing* and continued by the *River Landscape* is there completed.

Superficially Annibale is in debt to another, Paul Bril, who had come to Rome in the 1580's, and who more than anyone had popularized the genre of landscape painting. In matters of form Annibale owes nothing important to him (significant influence, in fact, passed the other way), but the lunette format of the Aldobrandini Chapel is one that Paul Bril had already used for landscapes in several decorative schemes. This borrowing is in itself of no profound interest, but it provides a comparison between the art of Carracci and Bril where both were concerned with similar compositional problems. Annibale certainly studied the leading Roman landscapist of the day, and resolutely rejected his solution. The comparison is worth our while, for in showing us what Annibale was not, we may have a better idea of his uniqueness.

The Bril landscape is one of a series of lunette frescoes in a loggia on the *piano nobile* of the Lateran Palace (Fig. 137).[4] Placed below ceiling decorations which illustrate the Book of Genesis, the landscapes apparently have no narrative significance. Bril chose to have this particular scene engraved, for it is one of the most interesting of the set. Travelers cross a coastal landscape, high above a small but busy port. The landscape was swiftly carried out in light greens, yellows, blues and soft grays, rather pastel-like in effect. Mushrooming cumulus clouds fill a blue sky, touched here and there with lavender.

One's immediate impression is of the similarity between the two landscapes. In both a small group of figures, one an equestrian, are placed on a rising ledge in the foreground. This foreground drops off to a river or an inlet, where birds fly above drifting boats. In the middle distance one encounters architec-

[3] H. Hibbard, "The Date of the Aldobrandini Lunettes," *Burlington Magazine*, CVI (1964), pp. 183-84.

[4] On the lunettes and on Bril in general, R. Baer, *Paul Bril*, Munich, 1930. A good book which rightly de-emphasizes the importance of Bril to the development of more progressive figures.

ture, and finally glimpses a further expanse of water. Perhaps Annibale felt the comparison that we are about to make, for his canvas is an almost point by point refutation of Bril's conception of landscape.

Annibale's landscape has a clear focus and is simple, while Bril's is panoramic and laden with discursive anecdote. In the Bril space rushes precipitously from the ledge into the deepest distance. With nothing to impede the eye, the sails on the horizon are seen immediately. In the Carracci the central spatial fact is a mass rather than a cavernous void. The strict parallelism of the landscape elements, and the placement of such objects as the trees on the left and the central hill slow one's progress into space, and assure that this space shall be experienced in consecutive units as well as a whole. This difference in the time required to travel from the foreground to the horizon is one of the basic distinctions between the landscapes. And though this movement is slower in the Carracci, the sense of space is greater, partly because of Annibale's superior feeling for light and atmosphere, qualities difficult to achieve in fresco. But more important is the stress Annibale laid upon surface pattern, which in turn evokes depth, for the foreground ledge and the tree upon the left are objects which one is compelled to see through and beyond. Bril's space opens more freely, but a myriad of detail brings the eye back to the surface of the fresco. Those too agitated clouds, the large birds, the bunched sails on the horizon; all tend to advance and to be read as elements in a pattern rather than objects in depth. Not anchored to any dominant structural scheme, they seem to float in an undefined vacuum. A final important difference between the works is the adaptation of each composition to the peculiar format. One instinctively recognizes Annibale's polished adaptation of his landscape to a lunette. Bril's, on the other hand, could as easily occupy a rectangular field, as indeed it does in the engraving already mentioned. Rather than press this comparison further and begin to confuse distinctions of form with distinctions of quality, we may look more closely at Annibale's canvas in isolation.

Annibale's figures are small, but important. They are the protagonists of the landscape, though no complex or untraditional

meaning attaches to them. The whole composition revolves around them, spotted as they are in bright primary colors. They stand against an unchanging landscape, whose central fact is the weighty hulk of the castle which presses against the flanks of the hill. It is light that gives life to this solemn solidity, a translucent layer that lies over the bones of the earth and human artifacts.

The strongest light falls fully upon the head of Mary and upon the Child, and so creates a principal point of focus. At the feet of the Holy Family the water becomes suddenly and inexplicably bright, as if footlights to illuminate the figures. The sharply outlined bank rises against the water, and the figures move slowly but steadily on this flight from danger. The composition is impregnated with a gentle sense of urgency, for the movement from right to left is given staccato emphasis by the white birds that soar over the steely-gray waters, leading us towards the darkness of the trees on the left side of the picture. Both because of the curved frame and distant light, one's eye follows them upward and back towards the spatial center of the picture. Passing through the warm browns and grays of the castle, one reaches the weathered autumnal browns of the tree to the right. One follows it downward, to catch the strong highlights of a shepherd and his flock, aligned so that they will guide the eye once again to the Holy Family. Subtle in the extreme is this slow-moving oval described upon the surface of the painting. Rather than imposing awkward problems, the unusual format of the composition is exploited to suggest the slow deliberateness of a flight from death.

The development of space is equally refined. The foreground and trees are dark, and only the translucent foliage shows gray-green against the sky. The water is the color of steel, not significantly lighter than the foreground, and one leisurely passes it by to reach the large land mass in middle distance. Here quiet variations of gray, dark green and olive gray blend in a subdued pattern. The scene is pastoral, but dominated by the fortress-castle, which is solidly built in shades of brown and gray, with warming touches of pink. Lovely is the contrast between the full greens of foliage and the faded hues of weathered masonry.

To the right two mountains are suggested in blues and lavender-grays, and to the left a grove of green trees rises above the gray sea. Gray equally are the mountains that line the far shore, ranges that retreat until their crests blend with the sky, a cerulean expanse tufted with light wisps of wind-blown clouds. At the horizon pink and yellow lights glow softly.

This silent world is a measured blend of eternal stability and momentary elusiveness, a happy compromise between reason and the senses. The picture is probably Annibale's most representative achievement, and its complete reasonableness almost carries it toward dullness. The *Flight* is the perfect summary of Annibale's outlook, and qualitatively it is one of his best pictures. But Annibale still had several years to live, and near the end painted a picture that suggests his particular character as a landscapist. It is a beautifully painted piece, but as an idea is unsatisfactory. And in this limitation lies the clue to Annibale's historical position.

The painting is *Magdalene in a Landscape*, also in the Galleria Doria (Fig. 135). The picture is small, some two feet wide, its intimacy appropriate to the theme of contemplation. The Magdalene sits in the foreground, her body caressed by brown strands of hair, and covered by a light blue robe. She gazes heavenward, her attitude betraying no particular emotion. Only the skull beneath her elbow reminds us of the object of her thoughtful reverie. She is Giorgione's Venus awakened in a world where the spirit finds little rest.

The Magdalene is not in the landscape, but before it. She occupies a corner in front of a thicket, almost as if she had been added to a pure landscape as an after-thought. The ineffable union of nature and the human spirit achieved by Giorgione is lost here, for the figure completely dominates the composition. She is the strongest area of color, and our attention is drawn both to her physical massiveness and her pose as a thinker. The landscape stretches behind as a peaceful setting for a drama of the soul, much the same watered valley that Titian or Sustris had painted earlier. Annibale even in his last years is solidly within the Venetian tradition.

The structure of the picture is unfailingly sure. A bit of sun-

light strikes the left foreground; otherwise the sides and bottom of the painting are framed in darkness. The flanking trees are dense and shadowed, lighter only where the long boughs reach out against the sky. A large tree catches our attention in middle distance, its dark green crown sparkling in the sun at the top, and passing to a withered brown on the left side. Sunlight plays over the stream bed at the base, while dark waters flow to the left. Beyond the water the landscape again falls into shadow, and an abrupt hill rises from the darkened grove, its upper slopes touched by the light of the sun. This is that massive element in middle distance which had become increasingly important in Annibale's landscapes. In pleasant contrast to the darkness is the feathery tree which occupies the center of the canvas, its light greens silhouetted against a brilliant cerulean sky. This sky towers over the olive tones of the plain, and the blue-gray hills that rim the distant horizon. Full cumulus clouds push slowly across the landscape, their soft rounded forms echoing the languid body of the Magdalene.

The picture is beautifully painted, the quiet and full poetry of Annibale in one of his more private moments. But that said, I must confess that I find the poetry not particularly appropriate. This puffy-limbed and blank-faced sinner will not gain our compassion, for her soul is neither heroic nor pitiable. And what does this landscape, whose very essence is freedom from care, have to do with that soul? There is no essential relationship between the figure and landscape. We may appreciate one or the other, or both, but it is not clear how they touch each other in terms of meaning. The sensitivity to the interaction of man and nature that marks Giorgione's *Three Philosophers* or Titian's *Charles V* was a closed book to Annibale. Rather his greatest moments were when he was painting landscape *per se*, and thinking of it as a genre. For him, as my descriptions have suggested, landscape was a problem in spatial structure and light. Unbothered by complexities of subject matter, he might devote himself wholly to this formal task. His message as a landscapist is surely limited, but dignified. He suggests the sublimity of calm, permanence, and civilized nature, all presented through the hand of a fine painter. As a great eclectic, he distilled from the sixteenth cen-

191

tury experiences of landscape some of its finest thoughts. When Annibale's vision of permanence would be joined to the evocation of a grand historical past, such as Polidoro had glimpsed for a brief moment, landscape painting would achieve a noble plateau. This was to happen in the art of Nicolas Poussin.

X ✦ VILLA

Di giugno dòvi una montagnetta
coverta di bellissimi arboscelli
con trenta ville e dodici castelli
che siano entorno ad una cittadetta...

<div align="right">FOLGORE DA SAN GIMIGNANO (13TH C.)</div>

T HE rise of landscape painting accompanied the flower-
ing of city life, for only with the development of a com-
plex money economy did the great landscapists appear.
Their art brought an illusion of the country into the city at the
very moment when city dwellers began to seek pleasure in the
villa. Outside the walls a city man might enrich his artificial
existence with the pleasanter pace of country life, enjoying rural
amenities without the loss of urban comforts. At times his villa
was adorned with landscape paintings and so became a place
where Nature and Art met, often with fresh results. A look at
this meeting yields thoughts on a vague subject, the Italian's
reaction to nature, and the place of landscape in this experience.

The phrases "feeling for nature," or "response to nature" are
peculiarly unsatisfying, for there is an infinity of ways to feel,
and no end of definitions of the word "nature." But if all that is
meant is the uncomplicated aesthetic response to the sights,
sounds, and smells of the open countryside, then from the point
of view of art there is no problem. The song of a sparrow, the
scent of newly opened flowers, the blue profile of distant moun-
tains, surely all such experiences have lifted spirits through the
ages. But the important question is how, if at all, does a so-
phisticated mind convert these uncomplicated reactions into
thoughtful artistic expression. A simple truism bears repeating,
that a direct response to nature and the interpretation of nature
in art have little to do with one another and should not be con-
fused. One recalls the ancient Greeks, dwellers in one of the most
beautiful of countries, who banished landscape from their art.
They were sensitive to the world around them, but their concept
of the visual arts simply did not encompass the emotions aroused
by beautiful scenery.

<div align="center">193</div>

One's "response to nature" is absorbed rapidly by what might be called a style of life. Direct reactions are tempered by fundamental assumptions concerning the manner in which the good man should comport himself in his day-to-day existence. These assumptions are discussed in Renaissance literature, for example in Cristoforo Landino's *Disputationes camaldulenses,* where the respective virtues of the active and contemplative lives are debated, or in Lorenzo de' Medici's *Altercazioni,* which begins with a meeting between city dweller and peasant, each of whom envies the other's way of life.

Yet theory is far less interesting than the manner in which real men actually composed their lives. For instance, Petrarch retreated to the country whenever possible, and found there a *locus amoenus,* beautiful to look at, but more important, suitable to live in.[1] Throughout his correspondence and writings recurs the idea that the solitude of nature gives rise to thoughts, and is a setting for contemplation and inspiration. He will write, "Le città son nemiche, amici i boschi a' miei pensier . . ." (Cities are the enemies, woods the friends to my thoughts . . .), and his descriptions of nature are always bound to the peace or agitation of his own soul at a particular moment. At one moment this land is completely idealized, a place of "chiare, fresche e dolci acque," while at the next it is pelted by a nocturnal storm. For Petrarch response to nature and the intellectual life were intertwined, and proper nourishment of the intellect was the key to a fruitful existence.

If Petrarch's scholarly temperament exemplifies the life of contemplation, then the turbulent career of Niccolò Machiavelli is wed to the active life. Yet we have his famous letter of 1513 to Francesco Vettori, written from exile in Sant'Andrea in Percussina, a document which shows that for this very different temperament nature was likewise inseparable from the measured

[1] For Petrarch's feelings towards landscape, see particularly *De Vita Solitaria,* in Francesco Petrarca, *Prosa,* ed. by G. Martellotti et al., Milano/Napoli, 1955. Also in this same edition, the famous letter on the ascent of Mont Ventoux (p. 831), and a letter which describes his rural and solitary life (p. 969). In Francesco Petrarca, *Rime trionfi e poesia latina,* ed. by di F. Neri et al., Milano/Napoli, 1951, see the following pages: 93; 175 ("chiare fresche e dolci acque"); 178; 189 ("ogni abitato loco è nemico mortal degli occhi miei . . ."); 242; 310 ("Le città son nemiche . . ."); 333; 378; 396; 409; 462; 613.

composure of daily life.[2] Machiavelli rises with the sun and goes to see the woodcutters in one of his groves. He discusses their troubles with them and then moves on to tend his bird traps. He may pause to read in those woods, pages from one of the revered Tuscans, or from an ancient Roman. But at the next moment he is gaming at the tavern, involved in unending petty squabbles, well aware that he is marking time among men who have little to offer him. At last evening falls, when in fresh clothes he retires to his study, and enters "the courts of the ancients, where fondly welcomed by them, I partake of the food that is mine alone, and for which I was born. . . ." A country day comes to an end, and a noble soul has been nourished by a fastidious combination of sense impressions and grand ideas.

Petrarch and Machiavelli are different men of different eras, yet they are one in their self-conscious awareness of the properly composed life. Nature is an arena for contemplation, for cerebral activity, and offers a just balance to city existence. Men such as these were well aware that the ancients had pondered the relative advantages of city and country life, and when Renaissance men gazed upon nature, it was partially through eyes attuned to history.

The responses of a Petrarch or a Machiavelli were to some extent those of the typical owner of a country villa. He did not look upon his country house as simply a retreat from the city, but as an alternative and complementary way of life which had its own style. The Renaissance concept of the villa was heavily influenced by ancient writers, Horace, Cicero, Pliny the Younger, Cato, Varro, Vitruvius, and others.[3] The Renaissance scholar realized that the villa was a country house with an agricultural function, that in fact it had begun as a farm building, and only later evolved into a pleasure house. The ancients told further how the villa should be situated, how its plan might be arranged, with the proper orientation and proportion of the various apart-

[2] To Francesco Vettori, December 10, 1513. Niccolò Machiavelli, *Opere*, ed. by A. Panella, Milano/Roma, 1938, pp. 916-20.

[3] For a general outline of ancient thought on the villa, see G. Mansuelli, *Le ville del mondo romano*, Milan, 1958. Also G. Becatti, *Arte e gusto negli scrittori latini*, Florence, 1951. For specific citations in ancient authors apropos of the villa: see *Dictionnaire des antiquités grecques et romaines*, v, Paris, 1909, pp. 870-91, "Villa."

ments. We hear much about agriculture, but also about the villa as seat of the Good Life, where solitude may be sipped, and the fruits of contemplation harvested. To this end the villa might be furnished with books, statues, and portraits, and its walls adorned with illusionistic landscapes and feigned birds fluttering among arbors. Different villas had different purposes, some being primarily agricultural, others more for pleasure. The man of means might have several, from which he could choose according to his mood and the season.

Already in the Quattrocento Leon Battista Alberti, both in his *De Re Architectura* and *Villa*, leaves no doubt that ancient ideas about the villa were well understood. However, instead of examining Alberti's ideas or those of sixteenth century theorists, one might do better to see what a villa owner says in passing about his possessions. One such owner was Luigi Cornaro, that long-lived and depressingly abstemious Venetian who wrote a treatise on the art of living long. He describes his town house,

> the like of which is no longer built in our day. It is so arranged that in one part of it I am protected against the extreme cold of winter; for I built the house according to the principles of architecture, which teach us how that should be done. In addition to the mansion, I enjoy my various gardens, beautiful by running streams—retreats wherein I always find some pleasant occupation for my time.
>
> I have, besides this, another mode of recreating myself. Every year, in April and May, as well as in September and October, I spend a few days at a country seat of mine, situated in the most desirable part of the Euganean Hills. It is adorned with beautiful gardens and fountains, and I especially delight in its extremely comfortable and fine dwelling. In this spot I also take part at times in some easy and pleasant hunting, such as is suited to my age.
>
> For as many days again, I enjoy my villa in the plain. It is very beautiful, both on account of its fine streets converging into a large and handsome square—in the center of which stands the church, a structure well befitting the place and much honored—and also because it is divided by a large and rapid branch of the river Brenta, on either side

of which spread large tracts of land all laid out in fertile and carefully cultivated fields. This is now—God be praised! —exceedingly well populated; for it is, indeed, a very different place from what it was formerly, having once been marshy and of unwholesome atmosphere—a home fit rather for snakes than for human beings. But, after I had drained off the waters, the air became healthful and people flocked thither from every direction; the number of the inhabitants began to multiply exceedingly; and the country was brought to the perfect condition in which it is today. Hence I can say, with truth, that in this place I have given to God an altar, a temple and souls to adore Him. All these are things which afford me infinite pleasure, solace, and contentment every time I return thither to see and enjoy them.[4]

Cornaro considered his two villas as distinct from one another in use. His seat in the hills was a realized *locus amoenus*, a place of gardens and fountains devoted to the pursuit of pleasure. His villa in the plain, on the other hand, was an agricultural community, wrested from previously uninhabitable land. In the one he might read the *canzonieri* of Petrarch, while at the other he would discuss the plight of the peasant with his problem-conscious protégé, the dramatist Il Ruzante. But in at least one respect Cornaro looked upon both his villas in the same way. Though the estates of hill and plain were very different from one another, they were alike in that in each the environment was carefully controlled and domesticated, and the accidents of untended nature systematically eliminated. As a generalization, the same may be said for most Renaissance villas, be they Venetian villas with their emphasis upon agriculture, or Roman villas, given over almost completely to elaborate gardens and the play of water. The villa and its grounds were a thoroughly civilized precinct, where Nature was garbed in the vestments of Art, and wild nature, like a background in a painting, remained a distant detail.

It seems almost paradoxical that the villa, usually located on a fine site, should frequently be decorated with painted land-

[4] I have used W. F. Butler's edition, *The Art of Living Long,* Milwaukee, 1913. The edition contains a revised version of "The Villas erected by Luigi Cornaro," by E. Lovarini, which originally appeared in *L'Arte,* II (1899).

scapes. Nature and Art at first glance appear engaged in competition, where comparisons could not fail to be invidious. Yet the actual setting of the villa and the landscape paintings within it were generally dissimilar in appearance. Instead the painted landscapes in the villa served two distinct functions. The first was to indicate the geographical location of the villa, or to boast of the lands possessed by the owner. Not only was the geography described, but often its venerability was suggested. The second and more complex function of landscape was as part of an illusionistic scheme whereby the walls of the building appear to be rent in order to provide a view of a make-believe world.

The desire to suggest a specific topography partially explains much of Renaissance landscape painting. This uncomplicated use of landscape is easily grasped in the decoration of the Roman villa of Julius III, carried out in 1552-55.[5] The landscapes are all but absorbed in a complex decorative scheme that includes illusionistic scenography, feigned statues and elaborate strapwork frames (Fig. 138). In the center room of the *piano nobile* the hills of Rome are represented in a series of landscapes, of which I have already considered the scene of the Palatine Hill (Fig. 122). The frescoes seem simply to allude to the city of Rome, at least until the two additional panels are considered. One shows the Villa Giulia with its fountain, a suggestion that as a site it deserves to rank with these other notable wonders of Rome. But this claim requires an antique pedigree, provided by the second panel, which depicts the discovery of the Acqua Vergine (Fig. 139). According to the Roman writer Frontinus, the aqueduct "was called Virgo, because a young girl pointed out certain springs to some soldiers hunting for water, and when they followed these up and dug, they found a copious supply. A small temple, situated near the spring, contains a painting which illustrates the origin of the aqueduct."[6] This spring, bearer of the lifeblood of Rome, supplied the fountain of the Villa Giulia and gave the property an impressive an-

[5] For the decoration, A. Venturi, *Storia dell'arte italiana*, ix, 5, Milan, 1932, pp. 851 ff. I believe that the landscapes of the Seasons at the Villa Giulia are by Matteo da Siena on the basis of a visual comparison with his documented frescoes in the Sala Ducale of the Vatican.

[6] M. Bafile, *Villa Giulia*, Rome, 1948, especially pp. 31-32. Frontinus, *Aqueducts of Rome*, tr. C. Bennet, London/New York, 1925, p. 351.

cestry. The decoration taken as a whole suggests further that the Villa Giulia is an ancient Roman villa reborn, an idea strengthened by the artist's effort to paint in a style *all'antica*. The sketchy temple and tower with its ibis and goats could well be passages lifted almost directly from Roman painting.

The landscapes in the next room depict the Four Seasons, a subject well-suited to the villa, whose manner of life is more attuned to the seasons than that of the town house. These little landscapes, as an examination of the scene of Summer will confirm (Fig. 140), are the most remarkable produced in Rome in these decades, both in the sophistication of their spatial structure and subtlety of execution. A glance at the figures leaves little doubt of their antique inspiration, and one wonders whether the whole idea here is not more indebted to ancient ideas than to the sporadic earlier appearance of the Seasons in Italian art. Be that as it may, through landscapes the geography of the villa and its existence through the unending cycle of the seasons is elegantly suggested.

Landscape painting is used in much the same way at the Palazzo Farnese in Caprarola, decorated a few years after the Villa Giulia.[7] This huge palazzo may be called a villa only by virtue of its rural location, yet its decorative scheme, an elaboration of the active and contemplative lives, is particularly appropriate to a country seat. The principal room on the front of the *piano nobile* is the Sala Regia, or Sala d'Ercole, from whose loggia opens a broad vista over the town of Caprarola to the plain that spreads towards Rome (Fig. 141). Once more the decoration is meant to point out the ancient renown of the land where the villa is found, and to boast of the landlord's possessions. The villa lies near the Lago di Vico, a magnificent crater lake which even today preserves an air of quiet isolation. Here, according to legend, Hercules drove his club into the ground, and when he finally dislodged it in a show of strength, a geyser issued from the cavity and formed the lake. This tale is rather comically told in the large ceiling fresco, which is

[7] For landscapes at Caprarola not discussed by me, and earlier bibliography, H. Hahn, "Paul Bril in Caprarola," *Miscellanea Bibliothecae Hertzianae* (*Römische Forschungen-Band XVI*), Munich, 1961, pp. 308-23. The topographical scenes of the Sala d'Ercole are given to Paul Bril and his shop.

VILLA

surrounded by small landscape panels that illustrate the Deeds of Hercules (Fig. 142). Mythology here is practically absorbed in a landscape vision.

Dryly topographical landscape panels are on three walls of the room, and each is carefully labeled. These show the possessions of the Farnese, owners of Caprarola, holdings that vary in importance from towns such as Piacenza and Parma to small villages and castles. This direct reference to lands possessed is analogous to the portraiture of these years, where the social status and profession of the sitter are stressed through emphasis on clothing and unequivocal attributes. Both portraiture and landscape are concerned primarily with outward signs of status rather than with more personal or intangible qualities. This propagandistic function of landscape goes back at least to Simone Martini's *Guidoriccio da Fogliano* and might be traced right through the Renaissance in a great variety of paintings to find a logical conclusion in the courtyard of the Palazzo Vecchio in Florence, where the frescoes of the possessions of the house of Austria might better be described as aerial maps than as landscapes.

One of the frankest essays in landscape propaganda is the elegant Loggia Gambara, at the Villa Lante in Bagnaia (Fig. 143).[8] From the end of the fifteenth century this land near Viterbo had been a modest park, and its extensive elaboration only came at the hands of Giovan Francesco Gambara, who took possession of the property in 1566. The young cardinal, onetime secretary to Julius III, must have had earlier villas in mind when he laid out the Villa Lante, in particular the Villa Giulia. While the latter is a garden space enclosed by architecture, the Villa Lante is mainly a garden whose two pavilions serve as accent marks in a large spatial composition. The garden grows increasingly complex as it descends from terrace to terrace and is animated by waters that now bounce vivaciously in a liquid chain, and then lie still in deeper pools. The outside world is shut off, while within all is painstakingly groomed.

The landscapes within the Loggia Gambara in no way compete with the real scenery outside, for like the garden itself, they are works of art which have a specific purpose. We recog-

[8] A. Cantoni, et al., *La Villa Lante di Bagnaia*, Milano, 1961.

nize the Villa Lante frescoed upon one wall, and on another the
town of Bagnaia that lies at the foot of the villa grounds. Prop-
erly oriented as to the local geography, the spectator is then
given a Social Register of Italian villas, for other panels depict
the Villa d'Este at Tivoli, and nearby Caprarola (Fig. 144). All
these frescoes taken as a series represent the Idea of the villa,
and by implication, the good life and good society of which
the villa is an outward sign. With no concealed modesty the
Villa Lante is included in this proud company, and no less a
critic than Montaigne in fact judged the place superior to the
Villa d'Este, and Pratolino, outside of Florence.[9]

The villa landscapes that denoted ownership and topographical
location were not meant to be seen as individual works of art,
but as parts of a series which illustrates an idea. If they possess
a mood or any particular formal excellence, this was because the
artist rose above the demands of the humble task allotted to
him. Typically, as at Caprarola, the quality of the decoration
is most charitably described as indifferent. On rare occasions, as
at the Villa Giulia, these landscapes individually are of high
quality, and deserve to be admired independently of the decora-
tion to which they are subordinated. Decoration for the most
part, good art rarely, this sort of villa landscape was not pri-
marily illusionistic in intent, and so did not pose the question of
the spectator's relationship to the real scenery outside of the villa.

This question is the essence of the second mode of villa land-
scape, that which appears as a part of an illusionistic scheme.
The first fine example is in the Villa Farnesina in Rome, built
by Baldassare Peruzzi for the Sienese banker Agostino Chigi in
the first decade of the sixteenth century.[10] The salone of the
piano nobile, frescoed by Peruzzi a few years later, poses prob-
lems that were to be explored for decades (Figs. 145 & 146). The
sumptuousness of the inlaid floor and carved ceiling permeates
the walls, whose illusionistic columns and veneers are richly
grained marble. The wall is opened at intervals so that one ap-
pears to see through deep porches to the world outside. The

[9] *Journal de voyage en Italie*, Paris, 1932, p. 288.
[10] C. Frommel, *Die Farnesina und Peruzzis architektonisches Frühwerk*, Ber-
lin, 1961. Full bibliography. A sketch of Chigi's festive and cultural activities
may be found in L. Pastor, *History of the Popes*, viii, London, 1913.

effect is solemn and dignified, with none of the ambiguities and precious conceits which are so often a part of illusionistic decoration. Only the figures over the doors and in the niches introduce a note of uncertainty, for we wonder momentarily whether they might be alive.

The landscape that lies beyond the fictional balustrade is Rome, not the legendary and historical Rome that Julius III was to have painted in his villa forty years later, but Rome as it looked in Peruzzi's day. Various familiar landmarks appear, including the Farnesina itself, so one has the sensation that the walls open out upon the actual scenery that lies beyond the grounds of the villa. To fully appreciate the effect, one should move to a point near the wall, directly opposite the fireplace. In theory this feast for the eyes is laid out for one man, the *padrone di casa* who would receive guests in this, his throne room.

One wonders why artist and patron indulged in this sort of a fiction, especially in a room which even in an unadorned state was spacious and adequately lighted. Perhaps the illusionistic urge was simply a part of Peruzzi's concern with theater and architecture; in any event he practised it on the ceiling of the Stanza d'Eliodoro in the Vatican, and if a most plausible attribution is correct, on some of the bays in the Loggia of Raphael. But this explanation is too simple, for one of the underlying principles of the decoration of the Farnesina is illusionism. In the bedroom next to the salone Sodoma set up an illusionistic balustrade before the space of the fresco, and in the main loggia Raphael illusionistically opened the ceiling out into the sky. The vault is laced with a fictitious arbor, between whose strands float healthy putti and ample semi-deities. Across the top of the vault spread two large scenes of Olympian deities, a fiction woven upon illusionistic tapestries. So the arbors of the real garden are illusionistically continued in the building itself, with decorative cloths stretched above in order to protect this cool place from the imagined sun.

In fact, the entire villa, although imposing in mass and proportions, is in a certain sense an ephemeral garden pavilion. Two loggie on the ground floor permitted a free flow between house and garden, while the devices of the illusionistic painter

expanded the rooms within. The outer surface of the villa was adorned with façade paintings, which certainly gave a more vivacious and less architectural effect than that which we see today.

With all this in mind, the illusionistic conceits of Peruzzi's Sala delle Prospettive are understandable. The entire villa is a dialogue between fiction and reality, a visual game appropriate to a pleasure palace. Perhaps such illusionistic decoration has its roots in ancient painting, though theater design and the extravagant decoration invented for triumphal entries were probably more important. Above all, the artists wished to project the villa into the surrounding garden. Not by chance does a poem of eulogy written at the completion of the villa have Venus, who is on a sort of mythological Grand Tour, choose the Villa Farnesina as her preferred *locus amoenus*. The choice is fitting, for the goddess of love, under whose patronage nearly all the painting in the villa falls, was also goddess of the garden.

An anecdote explains better than any rationalization the taste which lay behind the decoration. Chigi gave an elaborate banquet for the great of Rome in a large hall hung with elegant tapestries. At the end of the meal the hangings were suddenly removed, and the bewildered guests found themselves in the bleak interior of Chigi's stables. Evidently the man had an almost child-like fascination for the dialogue between fiction and reality, for the unexpected surprise. His pleasure dome is a monument to an extravagantly playful taste, a gay pendant to the regal boldness of Raphael and Michelangelo in the Vatican.

The example of the Farnesina was soon heeded at Mantua, and a little later on the Adriatic shore. There, in the hills just above Pesaro, is the Villa Monte Imperiale.[11] It is in two parts,

[11] H. Thode, "Ein fürstlicher Sommeraufenhalt in der Zeit der Hochrenaissance: Die Villa Monte Imperiale bei Pesaro," *Jahrbuch der Königlich preussischen Kunstsammlungen,* IX (1888), pp. 161-84. B. Patzak, *Die Villa Imperiale in Pesaro,* Leipzig, 1908. H. Mendelsohn, *Das Werk der Dossi,* Munich, 1914, pp. 178-83. The landscape frescoes, which appear to be by various hands, have recently been restored. This work has yielded interesting results in the Sala del Giuramento, where a few of the original frescoes have emerged from the nineteenth century repaint, showing that the decorative scheme, if not the present surface, is original. The restored state of the Sala dei Cariatidi allows a reevaluation of Dosso's part in the decoration. Finally, the Sala Grande ap-

the older a Quattrocento block begun in 1469 by the Sforza, and acquired later by the Duke of Urbino. This spot, with its panoramic view of the hills that roll towards Urbino on one side, and the crest of a hill leading to a view of the Adriatic but a short distance away on the other, became a favorite summer retreat of the court of Urbino. This old palace must have been inadequate, for about 1530 the Duchess began as a gift for her husband a new villa connected to the old, a fabric in the best Roman Renaissance manner. The man in charge of this new building was a long-time servant of the court, the architect and painter Girolamo Genga.

In these same years the Duchess Eleonara had Genga direct a group of painters in the decoration of a suite of rooms in the old palace. The decoration narrates the principal events of Duke Francesco Maria's military and political life, as yet without that overlay of pomp and allegory so characteristic of such decorative schemes later in the century. The narrative part of the frescoes is confined to the ceilings, leaving the walls free for illusionistic devices and landscape vistas. It is more for this decoration than for the figure scenes that the old Sforza villa is memorable.

Both as an architect and a decorator Genga was oriented towards Rome, so the memories of the Farnesina at Pesaro are not surprising. His boldest illusionistic experiment is in the Sala del Giuramento, where the wall is opened out upon a rolling landscape whose pleasures are revealed by putti who lift billowing curtains. We may imagine this landscape as the broad valley which actually lies below the castle, and in one panel Genga's new villa appears under construction. The whole effect is more informal than in Peruzzi's Sala delle Prospettive, and Genga may have felt this appropriate for a rural, as versus a suburban, villa. The painted result is a fresh and cool room, where the imaginary breezes may pass uninterrupted.

The small Camera dei Semibusti also is illusionistic in intent, and its lunette and ceiling decoration give the whole an antique flavor (Fig. 147). Loosely speaking, it is a Renaissance equiva-

pears to be wholly modern in date. Professor Craig Hugh Smyth is preparing a study of the decoration of the villa.

lent of the so-called Second Pompeian Style, where the wall was usually painted away to show a landscape or fictional architecture. The illusion is forceful, abetted by the swags which provide a *repoussoir*, and the full modeling of the niches overhead. If this room displays a vague parallel with ancient painting, the decoration of the Camera delle forze d'Ercole suggests a direct relationship with Roman art (Fig. 148). The particular combination of a feigned easel picture on a wall next to an illusionistic landscape recalls the Third Pompeian Style, where the same unusual juxtaposition occurs, and certain colors, such as the deep brick red, are unmistakably ancient in origin. But most remarkable is the absence of any heavy-handed archaeology in the decoration. The artist probably knew well what the ancients said about wall painting, and consulted the few remains available to him, but his intent was to recreate ancient decoration in a modern mode rather than to copy.

The illusionism in the decoration of the Villa Imperiale needs no complicated explanation. Instead of providing an artificial substitute for real nature, the frescoes are meant to force out the walls of the building into the surrounding countryside. The villa, after all, still had the character of a closed and fortified country estate, quite in contrast to the Cinquecento taste for a more open building. Genga's decoration is no more than a light-hearted attempt to modernize the villa by giving it a fictional airiness which in reality it did not possess.

Illusionistic landscape decoration reached its finest development in the Veneto, in one of the loveliest of sixteenth century villas, the Villa Barbaro, built by Palladio for the Barbaro family in the early 1560's (Fig. 149).[12] The brothers Barbaro, with the

[12] Vasari-Milanesi, VI, p. 376; VII, p. 530. A. Palladio, *I quattro libri dell'architettura*, Venice, 1570, Bk. II, p. 51. On the general intellectual climate from which the villa comes: C. Yriarte, *La vie d'un patricien de Venise au seizième siècle*, Paris, 1874, and R. Wittkower, *Architectural Principles in the Age of Humanism*, London, 1949. The most complete description and illustration of the villa: P. Ojetti et al., *Palladio Veronese e Vittoria a Maser*, Milan, 1960. For a general account of the decoration of related villas: L. Crosato, *Gli affreschi nelle ville venete del cinquecento*, Treviso, 1962. On dates and hands in the frescoes: G. Fiocco, *Paolo Veronese*, Bologna, 1928, pp. 69 ff. feels the frescoes date shortly after 1560, a dating which has never been challenged seriously. L. Coletti, "Paesi di Paolo Veronese," *Dedalo*, VI, 1925, pp. 377-410, considers the question of hands, and tentatively considers the possibility that Lodovico Poz-

artists Palladio, Veronese, and Vittoria, constitute one of the more remarkable patron-artist teams in the history of Renaissance art. Daniele was both a contemplative and man of action who traced his descent through a distinguished family of intellectual patricians. Venetian ambassador to England, avid student of mathematics, philosophy, and botany, not the least of all he was a dilettante of architecture. Already in 1556 he had brought out an annotated translation of Vitruvius, an edition illustrated by Palladio, who himself had issued a guide to the antiquities of Rome two years earlier. When Daniele took holy orders, the patrimony passed to his younger brother Marcantonio, a leading diplomat whose career took him from France to Turkey. Like his brother, Marcantonio was interested in art and had tried his hand at sculpture.

This formidable combination of patrons and architect could only result in a villa conceived *all'antica*, but ancient in spirit rather than pedantic detail. In broad outlines the advice of the ancient authors was followed, especially as it had filtered through Alberti's treatise, which Daniele openly relied upon in his own commentary on Vitruvius. Barbaro knew that the town house should be rather soberly decorated, while the villa might be given over to "allegrezza e piacevolezza." It should be located at the foot of the hills, and oriented southward. In plan it should have a portion for the servants, and for the *padrone*; in short provision for both utility and delight of the soul. The instructions of the ancients are followed loosely at Maser, and the quest for unity assured by an elaborate system of harmonic proportions maintained throughout the edifice.

The interior of the villa was frescoed by Paolo Veronese and his assistants, probably in 1561-62. The ceilings consist mainly of allegorical figures, while the walls are opened by various illusionistic devices. There are magnificent portraits, fictional people who step through doors, a dog, solemn architecture. But

zoserrato might be responsible for the landscapes. This suggestion has received undue attention subsequently, for it seems clear that the landscapes are an integral part of a completely unified decorative scheme, and that Pozzoserrato, who is first active in the Veneto more than fifteen years later, can have had no part in it. The supposed resemblance to Pozzoserrato is rather a resemblance to the engraver Pittoni, discussed below.

the true leitmotif is the landscapes, which fill room after room in the villa (Fig. 150). Their source is ultimately the Farnesina, more directly the Villa Imperiale, but most closely the decoration of the Odeon of Luigi Cornaro at Padua (Fig. 151), where about 1530 Cornaro and his architect Gian Maria Falconetto must have enjoyed the same relationship of deep mutual respect felt by the Barbaro and Palladio.[13] But the search for Veronese's sources is only of passing interest, for whatever his models, his solution is a personal synthesis. As at the Sala delle Prospettive, so here the illusionism reaffirms the structural solidity of the architecture. Throughout, the illusion is meant to evoke probabilities, not fantasies, and in this Barbaro remained faithful to Vitruvius' feeling that painting should represent things as they are.

The general inspiration for these illusionistic landscapes and for their predecessors may well have come from ancient writers. The Renaissance knew through Pliny that a certain Tadius (or Studius or Ludius, depending upon the reading) painted "walls with pictures of country houses and porticoes and landscape gardens, groves, woods, hills . . . ," and through Vitruvius that architectural features were illusionistically represented and covered promenades adorned with, "varieties of landscape gardening, harbors, headlands, shores, rivers, springs, straits, temples, groves, cattle, hills and shepherds." This list sounds much like a description of the landscapes at Maser, and it is not fanciful to imagine these illusionistic landscapes as the sort of view one would have from a real balcony or portico.[14]

The landscapes seem unrelated in meaning to the representations above them, and have no precise meaning of their own. This absence of high purpose was justified by Alberti, who speaks of our pleasure in seeing "delightful landscapes, ports, fishing, hunting, shepherds, flowering things, branches." For

[13] On Cornaro's building activity at Padua, see the good articles by W. Wolters "Tiziano Minio als Stukkator im Odeo Cornaro zu Padua" (I) and (II), *Pantheon*, XXI (1963), pp. 20-28, pp. 222-30. Wolters considers this building with its decoration to be an important early phase of Venetian villa decoration. He believes the landscapes date about 1530-33, and are by Falconetto.

[14] Vitruvius' remarks on wall painting are found in *On Architecture*, Bk. VII, Ch. v. Pliny's remarks on Tadius as a landscape painter are in his *Natural History*, Bk. XXXV, pp. 116-17. (In both cases I have used the translation in the editions of the Loeb Classical Library.)

Alberti, landscape offers delectation rather than instruction, and is a mode of wall decoration rather than an independent genre of easel painting. He even suggests that walls decorated with fountains or rivers will soothe those who suffer from fevers or insomnia. Landscape, then, is buoyant, a life-enhancing boost to the spirits.[15]

But this said, we realize that the landscapes at Maser have a meaning beyond simple decorativeness. In general, their topography loosely evokes the landscape of the Dolomites (Fig. 152). However, the fact that the Villa Barbaro itself appears above a bay in one of the frescoes discourages any efforts to discover a realistic topography in the landscapes. It is an idealized realm, but one that remains consistently plausible.

The landscapes share one characteristic, for almost all of them are the setting for ancient ruins. These are not fantastic, but, on the contrary, in certain scenes appear to be archaeologically accurate. One is aware of being within a villa, classical in style and worthy of proud comparison with ancient buildings, and of gazing on the ruins of a civilization upon whose legacy the present is built. Given the taste of both patrons and architect, this concern with ancient ruins is completely understandable, and Veronese's trip to Rome in 1560 must have prepared him well for the commission which lay ahead. It is fascinating to see how the frescoes came into being, for the process has implications both for the meaning of the decoration and the state of the genre of landscape painting about 1560.

In 1551 Hieronymus Cock issued a series of engravings of Roman ruins, intended as trustworthy records of remains rather than as interpretive essays.[16] Veronese possessed these prints, and used three of them quite closely for frescoes in the Villa Barbaro. A typical comparison shows that the frescoist adopted the same viewpoint as the engraver, but took the liberty of making certain transformations (Figs. 153 & 154). The sense of space is greater in the fresco, both because obstacles have been laid in the

[15] "Villa," in L. B. Alberti, *Opere volgari,* ed. by C. Grayson, I, Bari, 1960. L. B Alberti, *De Re Architectura,* Florence, 1485. On the villa, see especially Bk. v, Chs. xiv, xv, xvii, xviii. On landscape painting in the context of interior decoration, Bk. ix, Ch. ii.

[16] For the Cock prints of 1551: F. Hollstein, *Dutch and Flemish Etchings, Engravings, and Woodcuts,* iv, Amsterdam, n.d. pp. 180-83.

foreground, and the ruin is seen from a more distant point. The ruined building is proportionately taller, the bridge more arching and graceful, and the colonnade to the left noticeably lighter, with wider intercolumniations. Veronese had to adapt the print to a slender vertical format, but beyond this he reveals a taste for the graceful and elegant which begins to border on the nonarchitectural.

While Veronese used but three out of Cock's set of twenty-five prints, for the majority of the remaining landscapes a second source was employed, a series of prints issued by the Vicentino Battista Pittoni in 1561.[17] The true genesis of the frescoes lies in this borrowing, for Veronese sought not only the models for ruins but his concept of landscape itself. In many cases words are not needed to show the close relationship between print and fresco (Figs. 155 & 156). A coastal landscape is seen from a fairly high point that offers a panoramic view. Once again the frescoist desired a powerful spatial effect, and so put a solid pyramid in the foreground in place of the figures who appear in the print. In particulars print and fresco are close, though the artist suppressed detail in favor of an atmospheric effect, and in passages such as the city to the right took considerable liberties with the model.

While the two frescoes just discussed are probably by Veronese's assistants, a final comparison reveals the master's hand, and his innate elegance and instinct for fine composition (Figs. 157 & 158). The print suffers from a superabundance of ruins, somewhat randomly juxtaposed in an undistinguished pictorial composition. Veronese immediately set about to simplify the model. With a sure sense of rhythm, he created a visual decrescendo that passes from the ruin on the left to the curved arcade, through the pyramid and finally down to the water. The triangular area so formed is complemented by the triangle of land which is the far shore, and the diagonal line of the branch that

[17] For the little-known Battista Pittoni: Vasari-Milanesi, v, p. 423 and note 3. G. Nagler, *Neues allegemeines Künstler-Lexicon*, II, Munich, 1841, p. 397. The set of prints at the Uffizi which I have used does not have the full frontispiece as given by Nagler, but simply the date 1561. A. De Witt, *La collezione delle stampe R. Galleria degli Uffizi*, Rome, 1938, p. 73. As a resident of Vicenza, Pittoni doubtless knew Palladio, and one may speculate as to whether these prints were done on the order of Palladio, Veronese, or the Barbaro.

enters on the right side of the fresco. The basic elements of the print are present, but by elimination, rearrangement, and adjustments of scale they are reborn in a sensitive relationship. Moreover, certain banal facts in the prints become suggestive possibilities in Veronese's hands. In the print (Fig. 158) Pittoni looks through an archway to the curved arcade beyond, and to the right glimpses the sky through the second story of columns. For the painter this hint of things seen through things became a matter of high aesthetic possibility. We see through the arch to the arcade, and in turn through this arcade to the expanse of the sky. Characteristically, the upper story of this arcade has been conceived in more open terms than in the print. We see through it, and appreciate the light that plays within it, and upon the ground floor. Finally as one's eye drifts down to the sea, a portion of water is framed through a colonnade. Veronese delights in silhouette, in contrasts of light and dark, in the game of seeing things through other things. In his hands a printmaker's unrealized suggestions become a painter's guiding principles.[18]

These few frescoes give a good idea of the landscapes at the Villa Barbaro, and of their origins.[19] But we should go beyond

[18] Since Pittoni's prints were issued in 1561, and the frescoes at the Villa Barbaro are undated, a skeptic might well ask why it is not possible that the prints were done after the frescoes, a sequence that from the point of view of quality might seem more logical. Three reasons speak against this. The fact that Veronese used the 1551 Cock prints for his frescoes makes it likely that Pittoni's set of 1561 was a second model. Secondly and more persuasively, the frescoes differ from both the 1551 and 1561 sets in the same way: ruins are lightened and made more graceful, and there is an attempt to suggest a greater expanse of space. Finally, a comparison of one of the frescoes (*Ojetti, op.cit.*, p. 131) with the print from which it is closely derived leaves no doubt as to the proper sequence. Across an arm of water lies an elaborate landing stage, a central block flanked by two towers. The façade of the central building is clearly defined in the print, and its source is the Arch of Constantine. The building in the fresco is more elegant and complex, more vertical in feeling, and lacks any clear definition of the manner in which architectural members are related. While one can perfectly well imagine that a painter took in hand the logical, architecturally conceived building of the print, and proceeded to lighten it and strip it of its simple logic, the relationship in reverse will not do. One cannot suppose that Pittoni took Veronese's blurred and suggestive building, and then soberly converted it into a rational image based upon careful archaeological thinking.

[19] A later fresco complex at Sabbioneta, near Mantua exemplifies several of

this to speculate upon the meaning of these frescoes, and what is implied by their genesis.

At first it seems surprising that an important part of a major commission by a leading artist should derive from such a humble source as prints. But in historical context this is quite understandable. By 1560 the genre of landscape painting was either the domain of foreigners, or else of draughtsmen and printmakers. So in the Veneto we find the variegated graphic production that clusters around the name of Campagnola, and the easel pictures done by Venetianized foreigners such as Lambert Sustris, Ludovico Pozzoserrato, and Paolo Fiammingo. For Paolo Veronese incidental landscape backgrounds and landscape *per se* were not the same thing. While he could paint pure landscapes (and I believe did in certain instances at Maser), he was quite content to let this special mode of painting be done either by specialists, or be based on the work of a specialist, in this case an engraver. Involved was the prejudice that the landscapist was a somewhat humble creature, on call for the artist or decorator who had more important things on his mind. It is difficult to speak of Veronese's conception of landscape, for the use of Pittoni's prints at Maser raises the question as to whether he had any. He may well have, but it was not a problem that interested him. For a number of the landscape panels at Maser he was happy to allow his assistants to follow the models of little-known graphic artists. Where he himself took these models in hand, we see eloquent proof that a variation may be of much higher quality than the original theme.

But more is involved in the adaptation of the Cock and Pittoni prints than a simple desire to provide models for frescoists. Doubtless on instruction from the patron, Veronese painted a series of landscapes with ruins, including a landscape with the Villa Barbaro itself. Perhaps the theme of ruins is nothing more than a decorative caprice, appropriate for a patron with antiquarian tastes. But even if this be essentially correct, the collection of ruins at Maser has a seriousness and evocativeness far removed from frivolous decoration. Can it be that Barbaro's villa was considered Rome recaptured, that the many ruins are

the trends discussed in this chapter: *Sabbioneta*, ed. by Alfredo Puerari, Milan, 1955.

reminders of a mighty civilization, which Venice fancied herself to be equaling, and perhaps surpassing? The landscapes are not simply an illusionistic game, but an evocation of grand historical memories. The spectator is invited for a moment to contemplate these past glories, and to enjoy the noble specimen of architecture, painting, and sculpture which is a bit of Rome reborn.

One might say that the landscapes of the Villa Barbaro summarize in microcosm the landscape experience of the Italian Renaissance. Like most landscapes of the day they, too, were first adornment, a means of delectation rather than of instruction. As such, they offer to us a *locus amoenus*, where the weather is fair and the landscape friendly. We find no deceptive substitute for what the eye sees, but an idealized realm where one may find peace and well-being. Wild and savage places, such as those celebrated by the Neapolitan poet Luigi Tansillo, are with rare exceptions foreign to the landscape painter's experience.

The Renaissance landscape is a place for contemplation, not only because of its amenity and quietude, but because frequently it suggests thoughts of the past. At times this evocation was gained through ruins, as with Polidoro, or Veronese at Maser. Or again the pastoral landscape is but another variation on this feeling for history, the dream that a simpler age once offered a more direct and sincere mode of life. Yet even that coin had its reverse, as the strange and morbidly fascinating world of Piero di Cosimo has shown us.

Through these diverse ideas runs a common thread, that landscape is not seen for itself, but as a commentary upon the human condition, as a speculation upon the tension between order and disorder in the world. But no matter how broad or limited the Italian experience of landscape during these years, the Renaissance artist like Dante before him (*Purg.* x, 31) knew that Nature had been put to shame by Art, and that the business of landscape painting was to evoke a moment of contemplation, wherein a man might discover his just relationship to an often tumultuous world.

Rezio Buscaroli, *La pittura del paesaggio in Italia*, Bologna, 1935.

Kenneth Clark, *Landscape into Art*, London, 1949. The best introduction to the subject.

Max J. Friedländer, *Essays über die Landschaftsmalerei und andere Bildgattungen*, The Hague, 1947. Excellent. Available in English.

Kurt Gerstenberg, *Die ideale Landschaftsmalerei; ihre Begründung und Vollendung in Rom*, Halle, 1923.

Josiah Gilbert, *Landscape in Art Before Claude and Salvator*, London, 1885.

Ernst Gombrich, "Renaissance Theory and the Development of Landscape Painting," *Gazette des beaux-arts*, XLI (1953), pp. 335-60. Excellent on the theoretical side of the rise of the genre.

Lorenzo Gori-Montanelli, *Architettura e paesaggio nella pittura toscana. Dagli inizi alla metà del Quattrocento*, Florence, 1953.

Joseph Gramm, *Die ideale Landschaft. Ihre Entstehung und Entwicklung*, 2 vols., Freiburg, 1912.

Johannes Guthmann, *Die Landschaftsmalerei der toskanischen und umbrischen kunst von Giotto bis Rafael*, Leipzig, 1902.

Wolfgang Kallab, "Die toscanische Landschaftsmalerei im XIV und XV Jahrhundert. Ihre Entstehung und Entwicklung," *Jahrbuch der kunsthistorischen Sammlungen des allerhöchsten kaiserhauses*, XXI (1900), pp. 1-90.

Hanna Kiel and Dario Neri, *Paesaggi inattesi nella pittura del Rinascimento*, Florence, 1952.

Friderike Klauner, "Venezianische Landschaftsdarstellung von Jacopo Bellini bis Tizian," *Jahrbuch der kunsthistorischen Sammlungen in Wien*, LIV N.F., XVIII (1958), pp. 121-50.

Ernst Zimmerman, *Die Landschaft in der venezianischer Malerei bis zum Tode Tizians*, Leipzig, 1893.

INDEX

PLATES

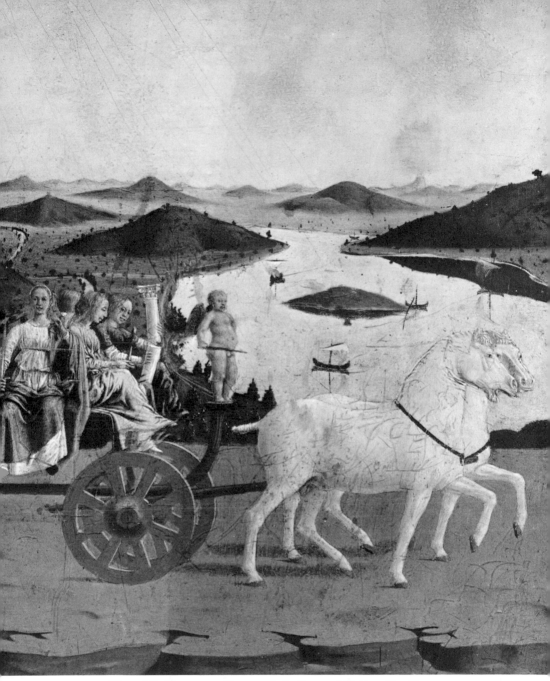

1. Piero della Francesca, *Allegory of the Count of Urbino* (detail)
Florence, Uffizi

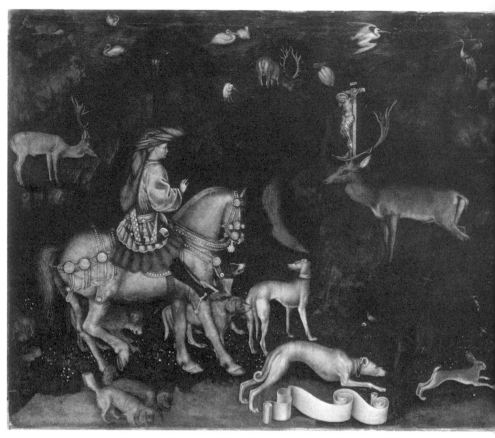

2. Pisanello, *Vision of Saint Eustace,* London, National Gallery

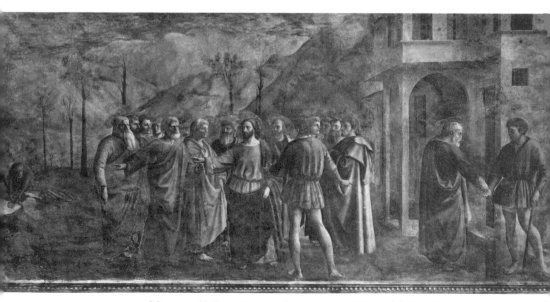

3. Masaccio, *Tribute Money,* Florence, Santa Maria del Carmine

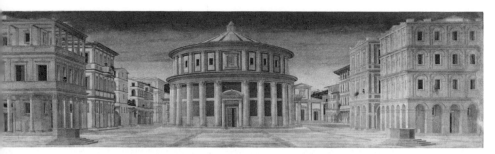

4. Anonymous, *Ideal Cityscape,* Urbino, Palazzo Ducale

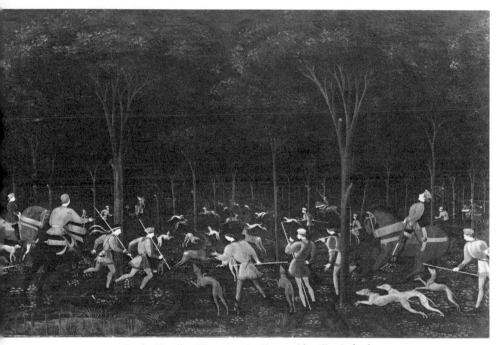

5. Paolo Uccello, *Hunt in the Forest* (detail), Oxford,

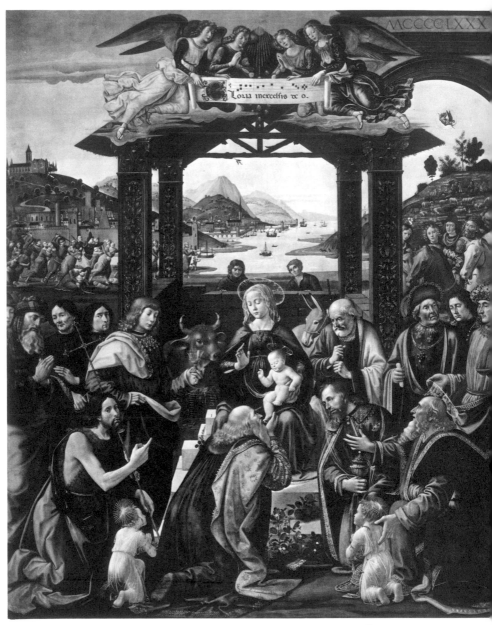

6. Domenico Ghirlandaio, *Adoration of the Magi*, Florence,
Spedale degli Innocenti

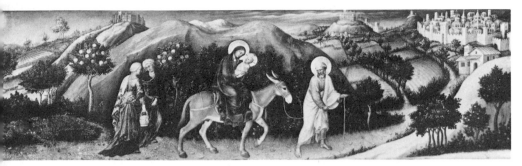

7. Gentile da Fabriano, *Flight into Egypt,* Florence, Uffizi

8. Fra Angelico, *Deposition* (detail), Florence, Museo di San Marco

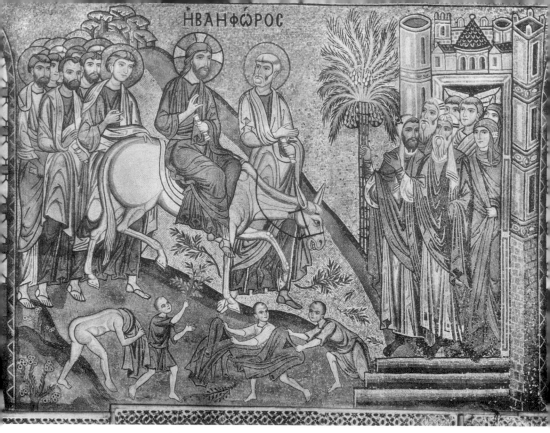

9. *Entry into Jerusalem,* Palermo, Cappella Palatina

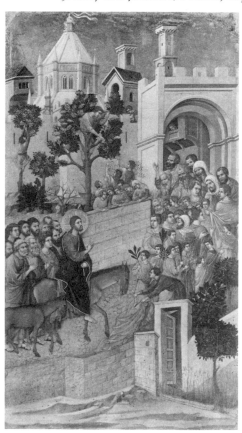

10. Duccio di Buoninsegna, *Entry into Jerusalem,* Siena, Opera del Duomo

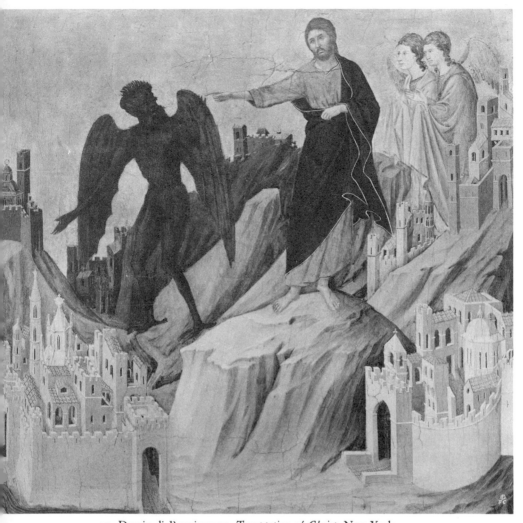

11. Duccio di Buoninsegna, *Temptation of Christ*, New York, Frick Collection

12. Simone Martini, *Guidoriccio da Fogliano*, Siena, Palazzo Pubblico

13. Ambrogio Lorenzetti, *Good Government in the Country,*
Siena, Palazzo Pubblico

14. Alesso Baldovinetti, *Adoration of the Child* (detail),
Florence, Annunziata

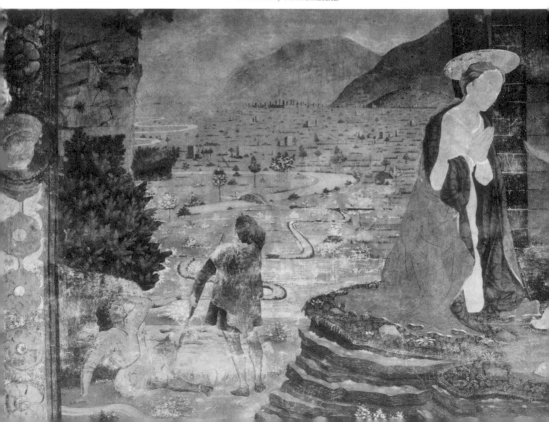

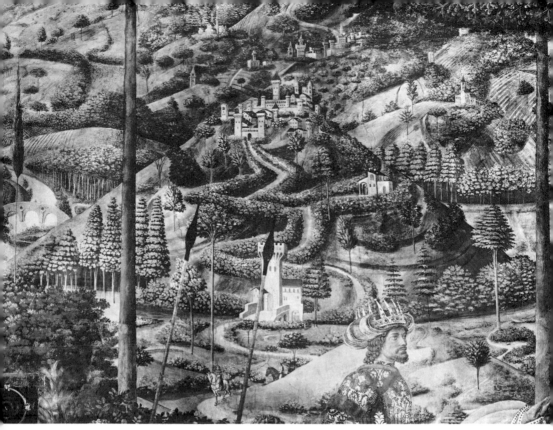

15. Benozzo Gozzoli, *Procession of the Magi* (detail),
Florence, Palazzo Medici

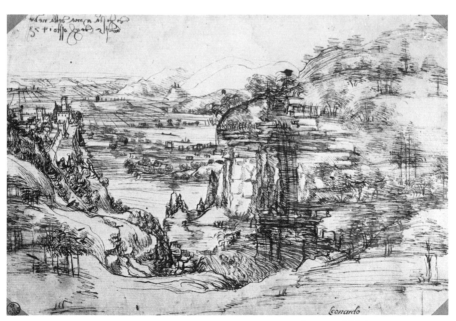

16. Leonardo da Vinci, *Landscape of 1473*, Florence, Uffizi

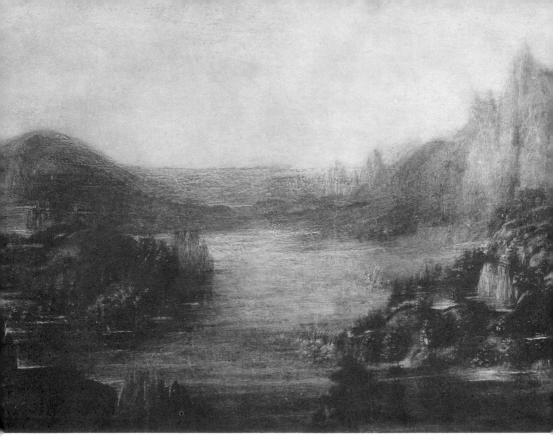

17. Andrea del Verrocchio and Leonardo da Vinci, *Baptism* (detail),
Florence, Uffizi

18. Leonardo da Vinci, *Annunciation* (detail), Florence, Uffizi

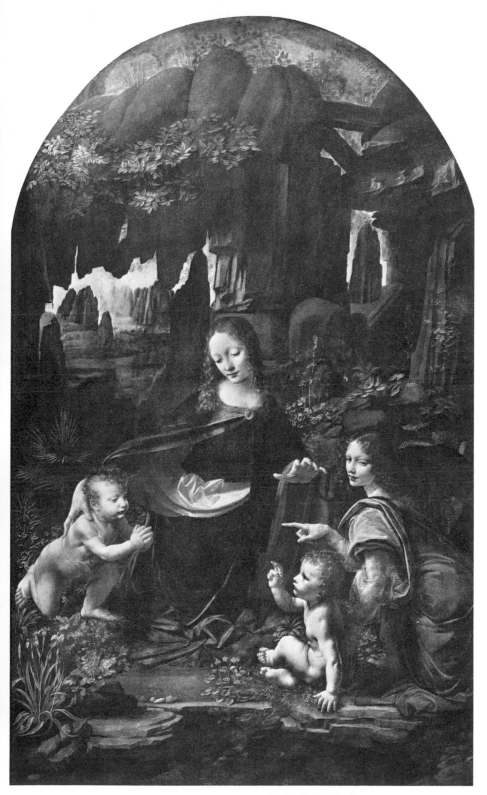

19. Leonardo da Vinci, *Virgin of the Rocks,* Paris, Louvre

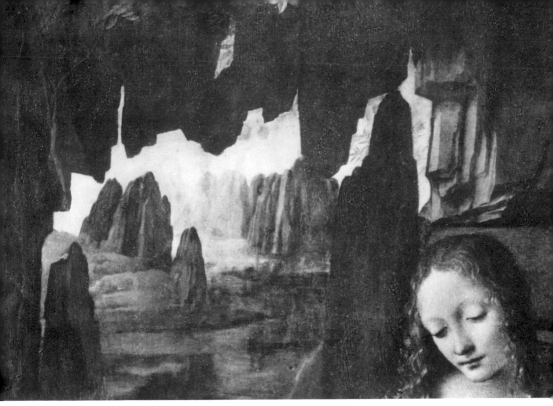

20. Leonardo da Vinci, *Virgin of the Rocks* (detail), Paris, Louvre

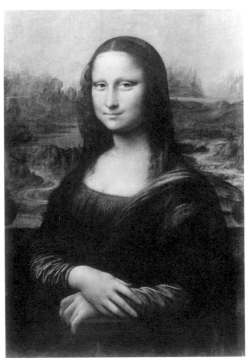

21. Leonardo da Vinci, *Mona Lisa*,
Paris, Louvre

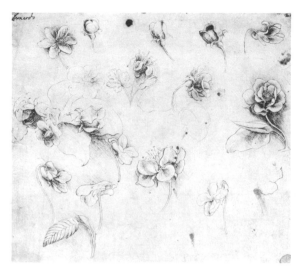

22. Leonardo da Vinci, *Study of Flowers,*
Venice, Accademia

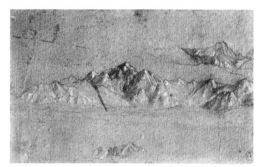

23. Leonardo da Vinci, *Mountain Range,*
Windsor, Windsor Castle

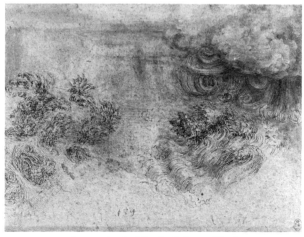

24. Leonardo da Vinci, *Deluge,* Windsor,
Windsor Castle

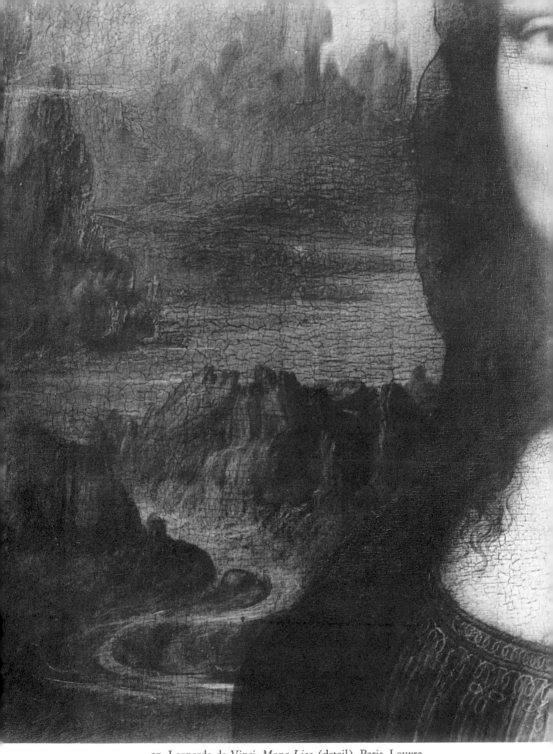

25. Leonardo da Vinci, *Mona Lisa* (detail), Paris, Louvre

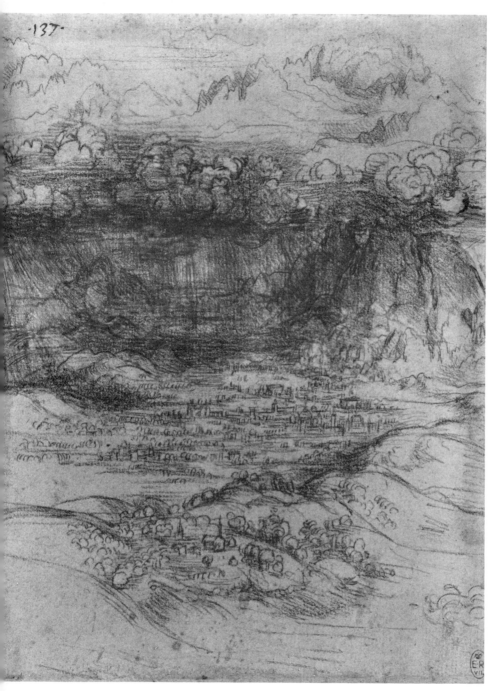

·137·

26. Leonardo da Vinci, *Storm in the Alps,* Windsor, Windsor Castle

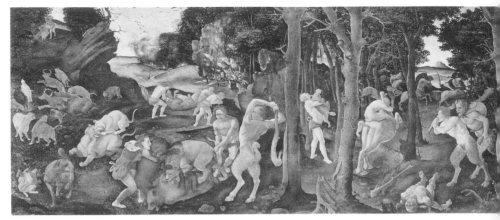

27. Piero di Cosimo, *Hunt*, New York, Metropolitan Museum

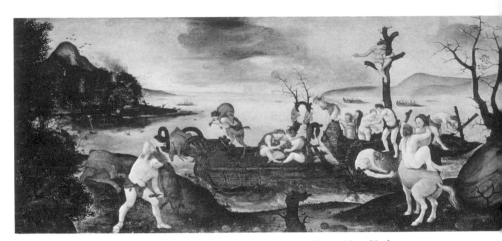

28. Piero di Cosimo, *Return from the Hunt*, New York,
Metropolitan Museum

29. Piero di Cosimo, *Forest Fire*, Oxford, Ashmolean Museum

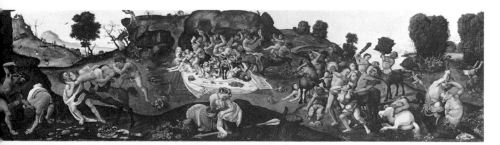

30. Piero di Cosimo, *Battle of the Lapiths and Centaurs,*
London, National Gallery

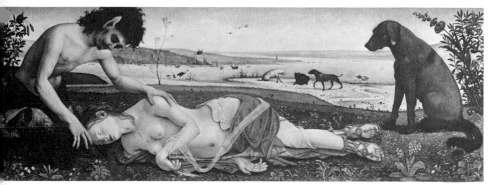

31. Piero di Cosimo, *Mythological Scene* (?),
London, National Gallery

32. Piero di Cosimo, *Perseus and Andromeda,* Florence, Uffizi

33. Sandro Botticelli, *Primavera*, Florence, Uffizi

34. Vittore Carpaccio, *Miracle of the Cross*, Venice, Accademia

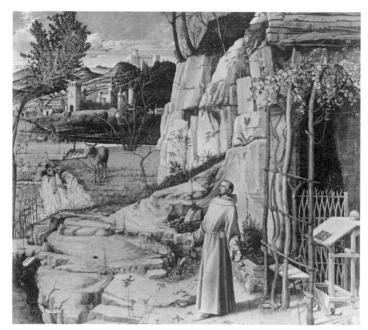

35-36. Giovanni Bellini, *Saint Francis in Ecstasy*,
New York, Frick Collection

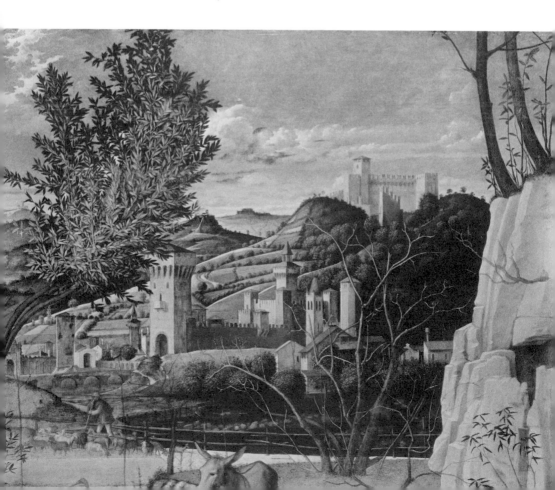

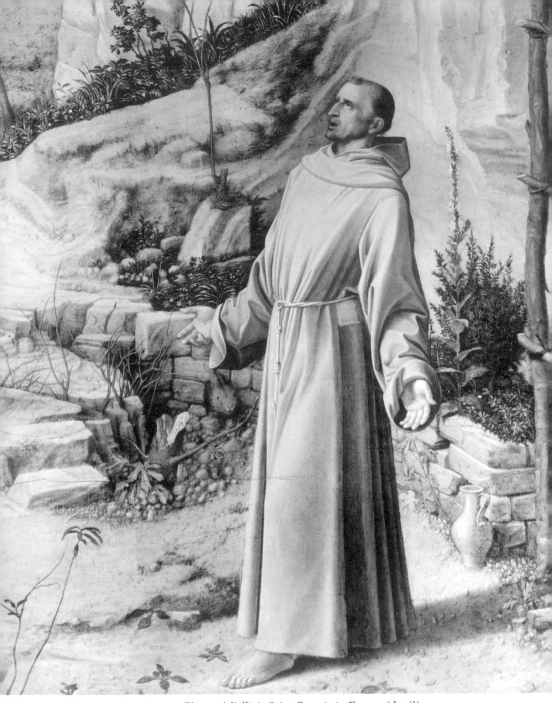

37. Giovanni Bellini, *Saint Francis in Ecstasy* (detail),
New York, Frick Collection

38. Giovanni Bellini, *Transfiguration*, Naples, Capodimonte

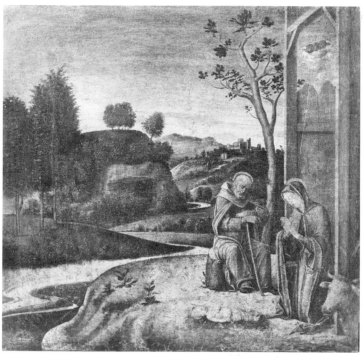

39. Giovanni Bellini, *Adoration of the Child*,
Pesaro, Museo Civico

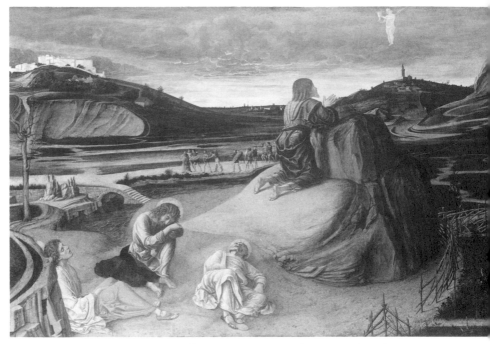

40. Giovanni Bellini, *Gethsemane*, London, National Gallery

41. Andrea Mantegna, *Gethsemane*, London, National Gallery

42. Giovanni Bellini, *Allegory of Justice and Mercy*, Florence, Uffizi

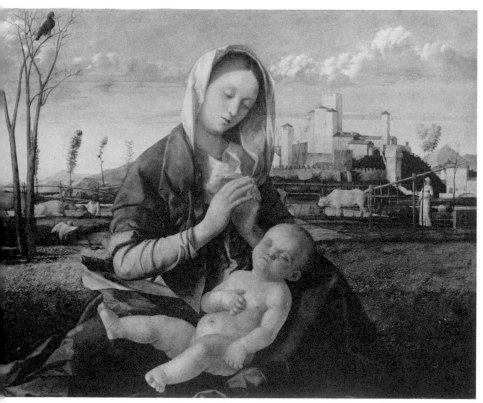

43. Giovanni Bellini, *Madonna of the Meadow*,
London, National Gallery

44. Giovanni Bellini, *Madonna of the Meadow* (detail),
London, National Gallery

45-46. Giorgione, *Castelfranco Altarpiece*, Castelfranco, San Liberale

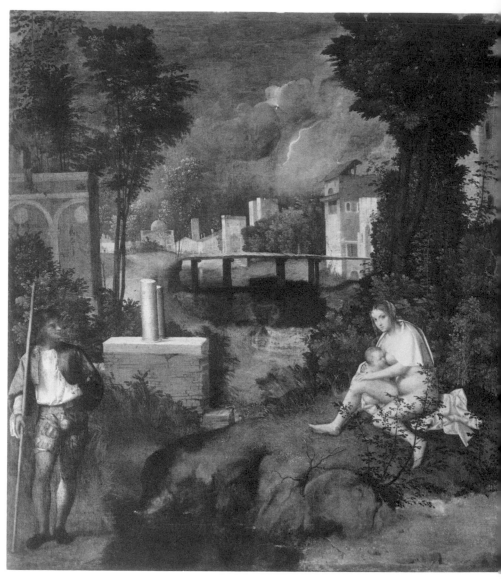

47. Giorgione, *La Tempesta,* Venice, Accademia

48. Giorgione, *Three Philosophers*, Vienna, Kunsthistorisches Museum

49. Giorgione, *La Tempesta* (detail), Venice, Accademia

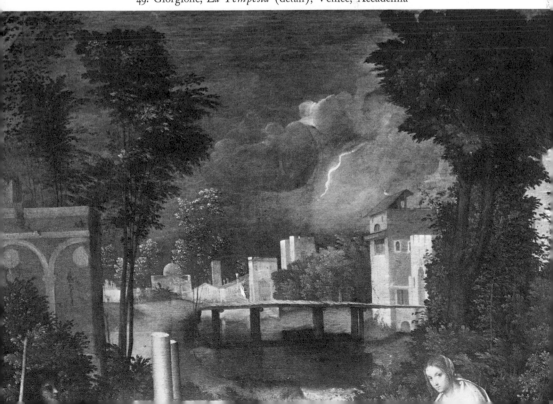

50. Giorgione, *Sleeping Venus*, Dresden, Gemäldegalerie

51. Woodcut from the *Hypnerotomachia Poliphili*

52. Anonymous, *Court of Caterina Cornaro*, Private Collection

53. Giorgione, completed by Titian (?), *Fête Champêtre*,
Paris, Louvre

54. Giulio Campagnola, *Old Shepherd*, New York,
Metropolitan Museum

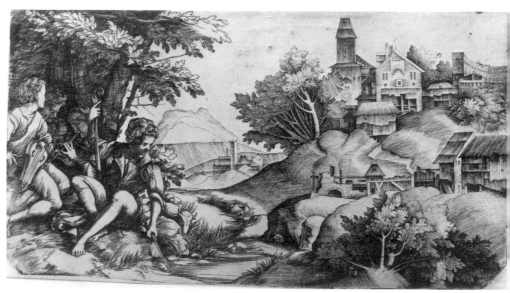

55. Giulio and Domenico Campagnola, *Shepherds in a Landscape*,

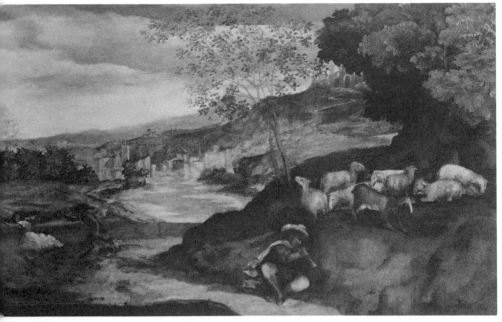

56. Anonymous, *Shepherd and Flock*, Private Collection

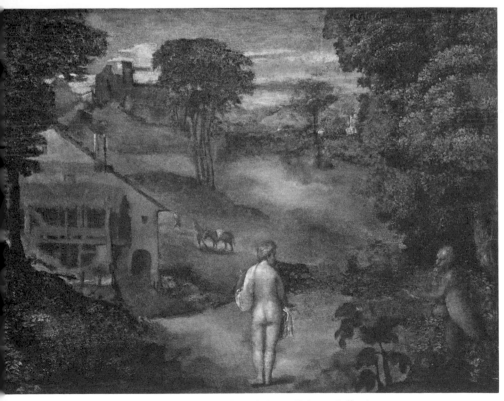

57. Anonymous, *Nymph and Satyr*, Private Collection

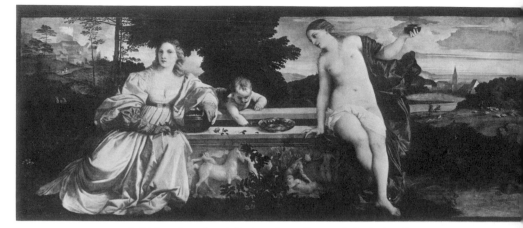

58. Titian, *Sacred and Profane Love,* Rome, Galleria Borghese

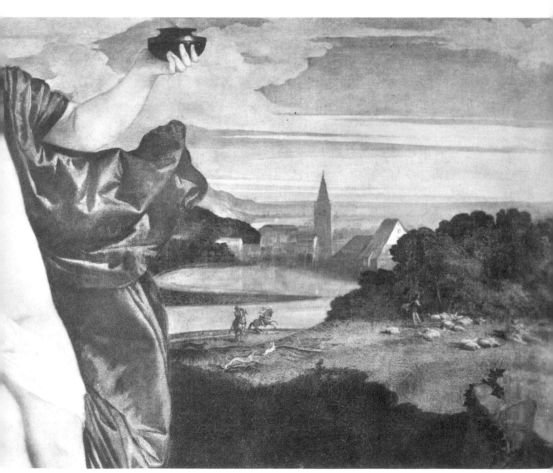

59. Titian, *Sacred and Profane Love* (detail), Rome,
Galleria Borghese

60. Martino Rota after Titian, *Peter Martyr,* Vienna, Albertina

61. Titian, *Feast of Venus* (detail), Madrid, Prado

62. Titian (assisted), *Madonna and Child with Saints Catherine and John* (detail), London, National Gallery

63. Titian, *Charles V on Horseback*, Madrid, Prado

64. Giovanni Bellini (assisted), *Saint Jerome*, Florence,
Contini-Bonacossi Collection

65. Lorenzo Lotto, *Saint Jerome,* Paris, Louvre

66. Titian, *Saint Jerome,* Paris, Louvre

67. Titian, *John the Baptist* (detail), Venice, Accademia

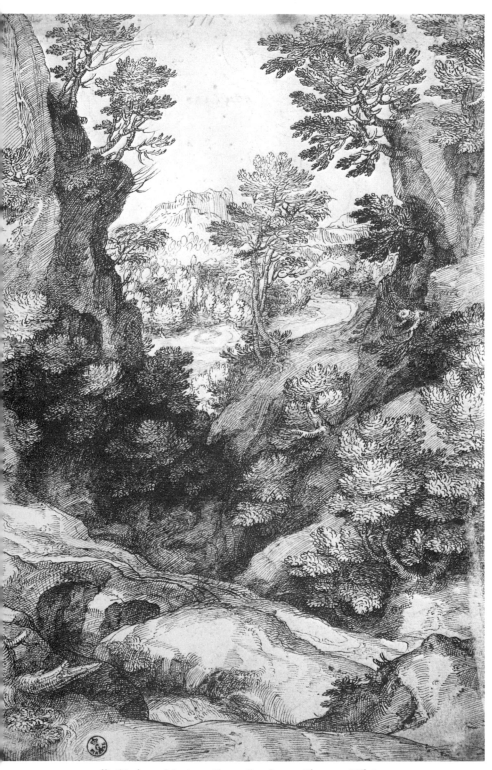

68. Girolamo Muziano, *Forest Landscape*, Florence, Uffizi

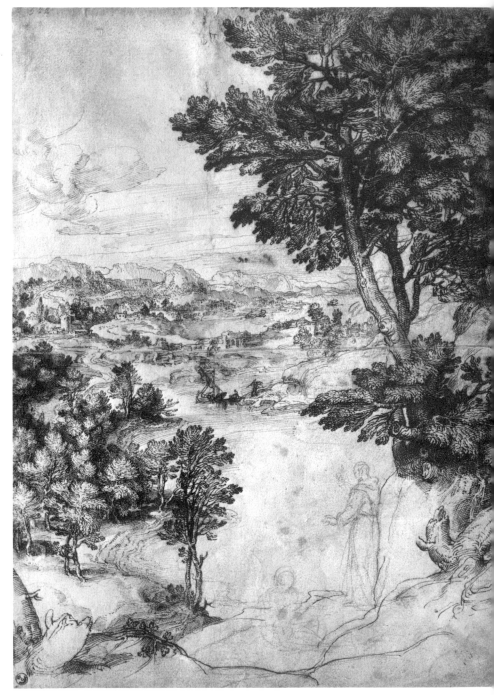

69. Girolamo Muziano, *Landscape*, Florence, Uffizi

70. Girolamo Muziano, *Forest Landscape,* Florence, Uffizi

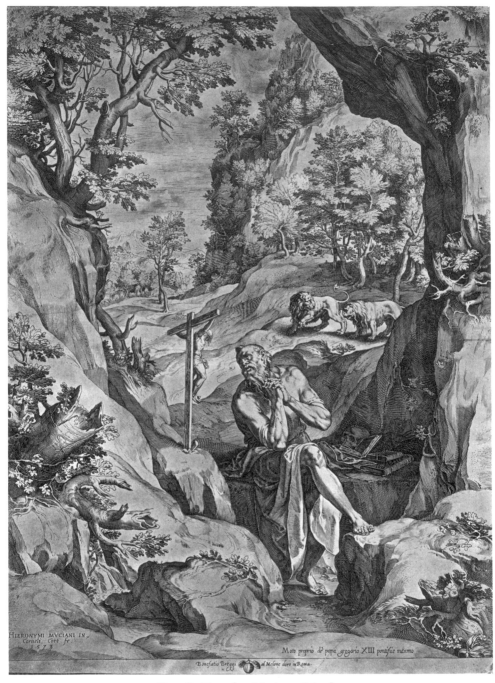

Within the image, engraved text:

HIERONYMI MVCIANI IN.
Cornelis Cort fc.
1 5 7 3

Mato proprio de papa gregorio XIII pontifice máximo

Bonefatiu Bregi al Melone dero in Roma.

71. Cornelis Cort after Muziano, *Saint Jerome*,
London, British Museum

72. Jacopo Tintoretto, *Saint Mary of Egypt,* Venice,
Scuola di San Rocco

73. Jacopo Tintoretto, *Mary Magdalene*, Venice,
Scuola di San Rocco

74. Titian (assisted), *Madonna and Child with Saints Catherine and John,* London, National Gallery

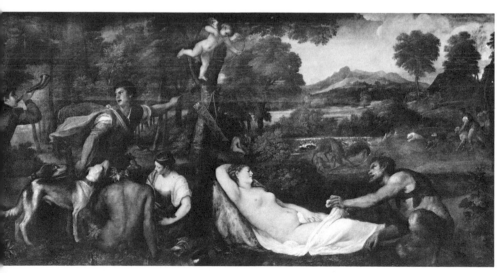

75. Titian, *Pardo Venus,* Paris, Louvre

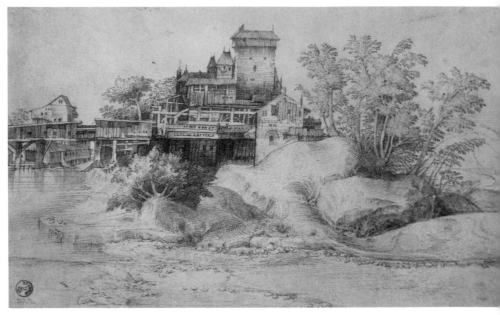

76. Giulio Campagnola, *Rustic Buildings,* Florence, Uffizi

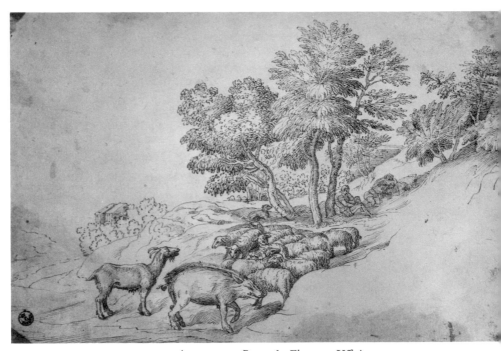

77. Anonymous, *Pastorale,* Florence, Uffizi

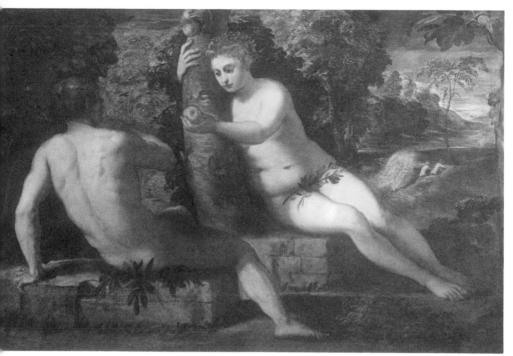

78. Jacopo Tintoretto, *Adam and Eve*, Venice, Accademia

79. Jacopo Tintoretto, *Adam and Eve* (detail),
Venice, Accademia

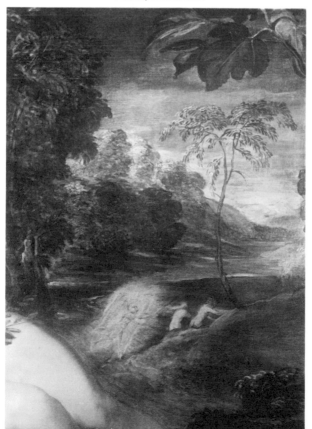

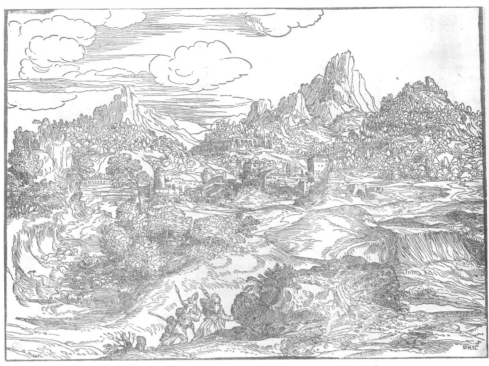

80. Domenico Campagnola, *Landscape with a Wandering Family,* Florence, Uffizi

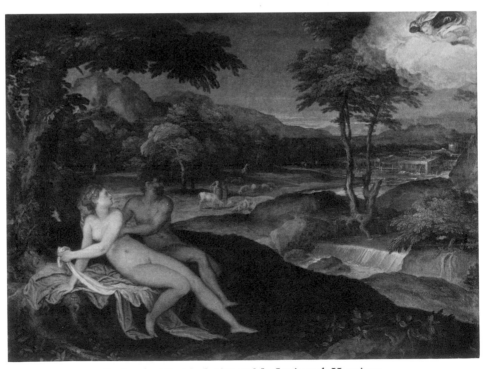

81. Lambert Sustris, *Jupiter and Io,* Leningrad, Hermitage

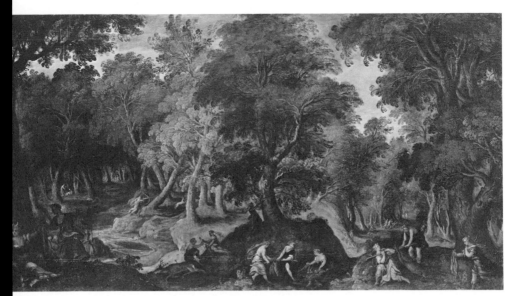

82. Lambert Sustris (?), *Hunt of Diana*,
Berlin-Dahlem Gemäldegalerie

83. Lambert Sustris (?), *Pastoral with Nymphs and Fauns,*
Berlin-Dahlem, Gemäldegalerie

84. Jacopo Bassano, *Peasant Family,* Lugano, Thyssen Collection

85. Francesco Bassano, *Jacob at the Well*, Vienna,
Kunsthistorisches Museum

86. Niccolò Boldrini after Titian, *Milkmaid in a Landscape*,
Florence, Uffizi

87. Paolo Fiammingo, *Hunt*, Private Collection

88. Jacopo Bassano (assisted), *The Earthly Paradise,*
Rome, Galleria Doria

89. Cosmè Tura, *Saint Anthony*, Modena, Galleria Estense

90. Dosso Dossi, *Melissa,* Rome, Galleria Borghese

91. Dosso Dossi, *Melissa* (detail), Rome, Galleria Borghese

92. Dosso Dossi, *Saints in a Landscape,* Moscow,
Pushkin Museum of Fine Arts

93. Joachim Patinir, *Saint Jerome in a Landscape,* Madrid, Prado

94. Garofalo (?), *Landscape with a Magical Procession,*
Rome, Galleria Borghese

95. Benvenuto Garofalo, *Holy Family,* Rome, Galleria Doria

96. Herri Met de Bles, *Landscape with the Good Samaritan*,
Vienna, Kunsthistorisches Museum

97. Benvenuto Garofalo, *Pagan Sacrifice*, London,
National Gallery

98. Battista Dossi (assisted), *Flight into Egypt,* Coral Gables,
Joe and Emily Lowe Art Gallery

99. Battista Dossi (?), *Battle of Orlando and Rodomonte,*
Hartford, Wadsworth Atheneum

100. Anonymous Ferrarese, *Mythological Scene,* formerly
Beverly Hills, Robinson Collection

101. Niccolò dell'Abate, *Landscape,* Modena, Galleria Estense

102. Niccolò dell'Abate, *Landscape,* Bologna, Biblioteca dell'Università

103. Niccolò dell'Abate, *Landscape* (detail), Bologna,
Biblioteca dell'Università

104. Niccolò dell'Abate, *Fantastic Landscape,* Rome, Galleria Borghese

105. Niccolò dell'Abate, *Mythological Landscape,*
London, National Gallery

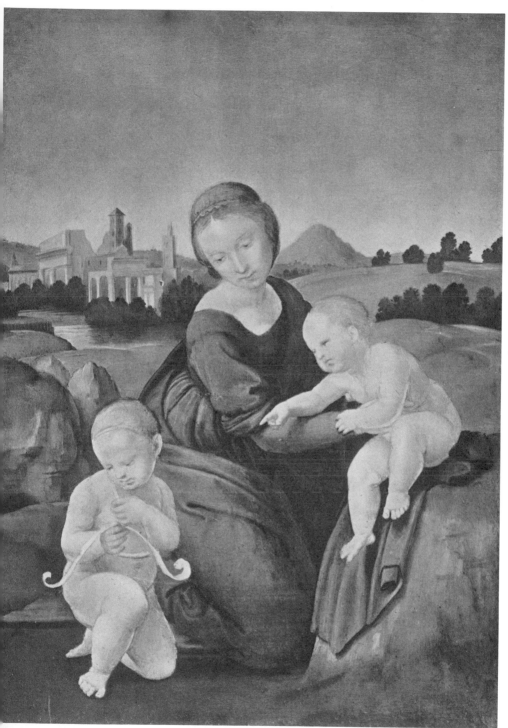

106. Raphael, *Esterhazy Madonna*, Budapest, Museum of Fine Arts

107. Polidoro da Caravaggio, *Landscape with Scenes from the Life of the Magdalene,* Rome, San Silvestro al Quirinale

108. Polidoro da Caravaggio, *Landscape with Scenes from the Life of the Magdalene* (detail), Rome, San Silvestro al Quirinale

109. Polidoro da Caravaggio, *Landscape with Scenes from the Life of Saint Catherine*, Rome, San Silvestro al Quirinale

110. Bernardino Pintoricchio, *Martyrdom of Saint Sebastian*, Vatican, Appartamenti Borgia

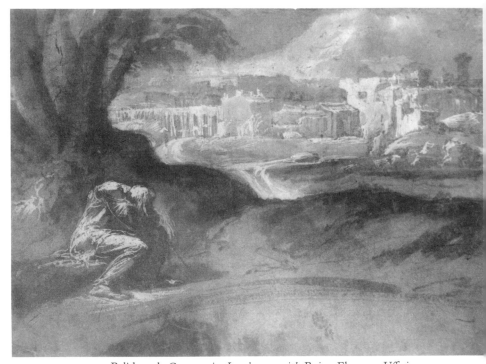

111. Polidoro da Caravaggio, *Landscape with Ruins,* Florence, Uffizi

112. Giulio Romano, *Vision of Constantine* (detail),
Vatican, Sala di Costantino

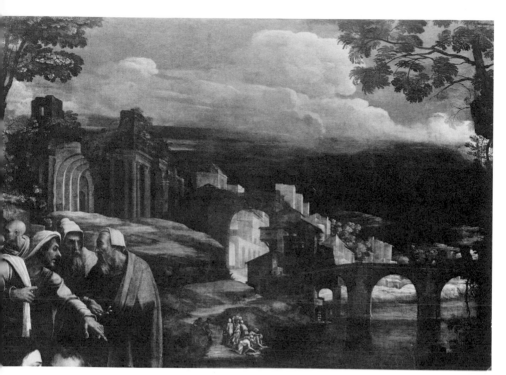

113. Sebastiano del Piombo, *Raising of Lazarus* (detail),
London, National Gallery

114. Follower of Raphael, *Madonna of the Blue Diadem* (detail),
Paris, Louvre

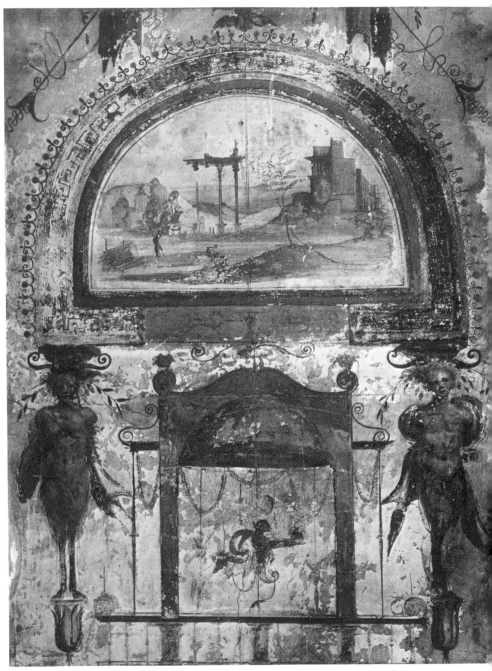

115. Anonymous, *Landscape all'antica,* Vatican, Loggia di Raffaello

116. Polidoro da Caravaggio, *Landscape*, Darmstadt,
Hessisches Landesmuseum

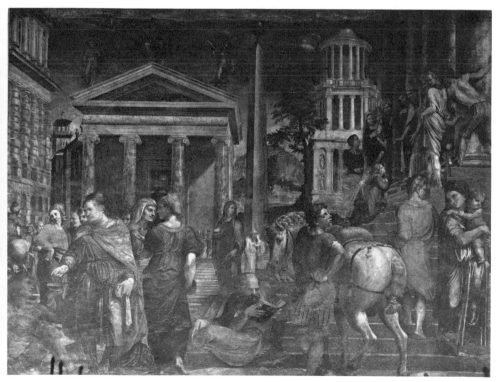

117. Baldassare Peruzzi, *Presentation of the Virgin*, Rome,
Santa Maria della Pace

118. Maarten van Heemskerck, *Landscape with the Rape of Helen*,
Baltimore, Walters Art Gallery

119. Maarten van Heemskerck, *Landscape with the Rape of
Helen* (detail), Baltimore, Walters Art Gallery

120. Hieronymus Cock, *View of Rome,* Vienna, Albertina

121. Battista Pittoni, *Fantastic Landscape,* Florence, Uffizi

122. Matteo da Siena (?), *The Palatine,* Rome, Villa Giulia

123. Anonymous, *View of Greece,* Vatican, Terza Loggia

124. Anonymous, *View of France,* Vatican, Terza Loggia

125. Anonymous, *View of Asia Minor,* Vatican, Terza Loggia

126. Matthew Bril, *Landscape,* Vatican, Torre de' Venti

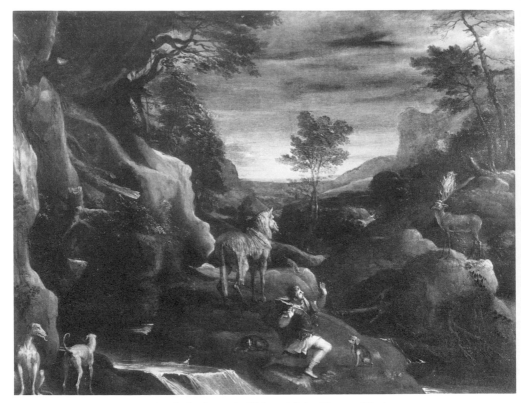

127. Annibale Carracci, *Vision of Saint Eustace*, Naples, Capodimonte

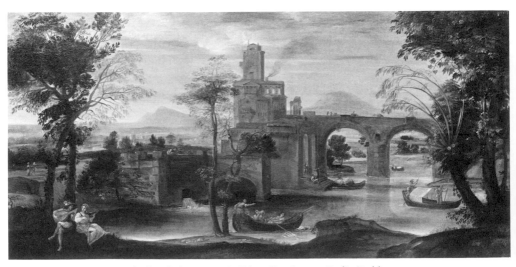

128. Annibale Carracci, *River Landscape,* Berlin-Dahlem, Gemäldegalerie

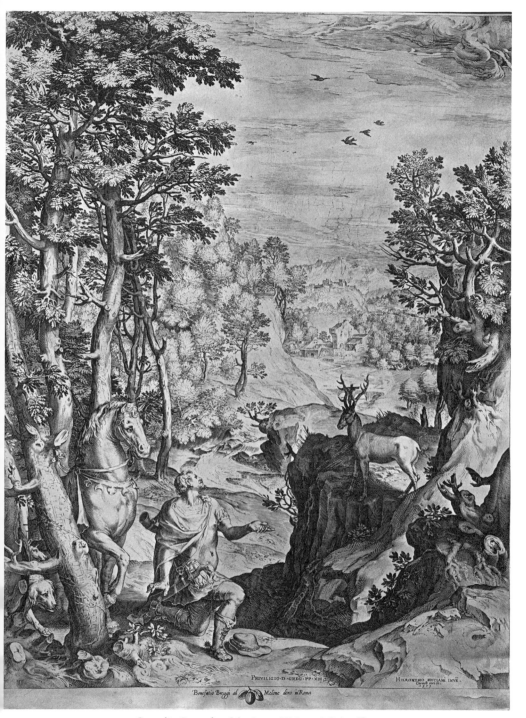

129. Cornelis Cort after Muziano, *Vision of Saint Eustace,*
London, British Museum

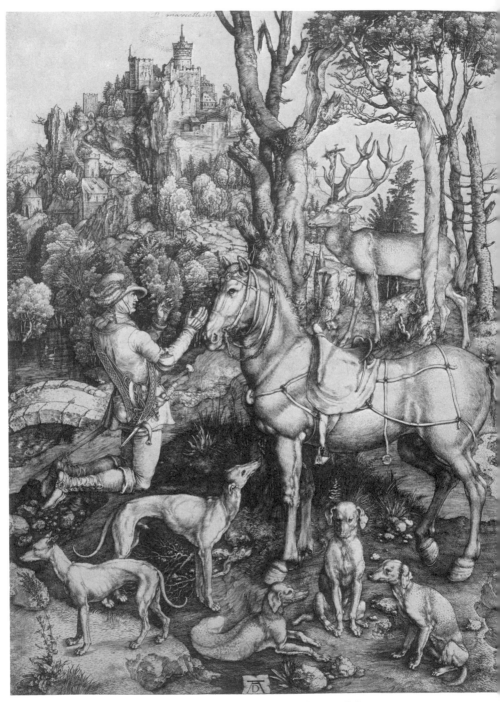

130. Albrecht Dürer, *Vision of Saint Eustace*, Princeton,
Princeton University Art Museum

131. Annibale Carracci, *Hunting,* Paris, Louvre

132. Annibale Carracci, *Fishing,* Paris, Louvre

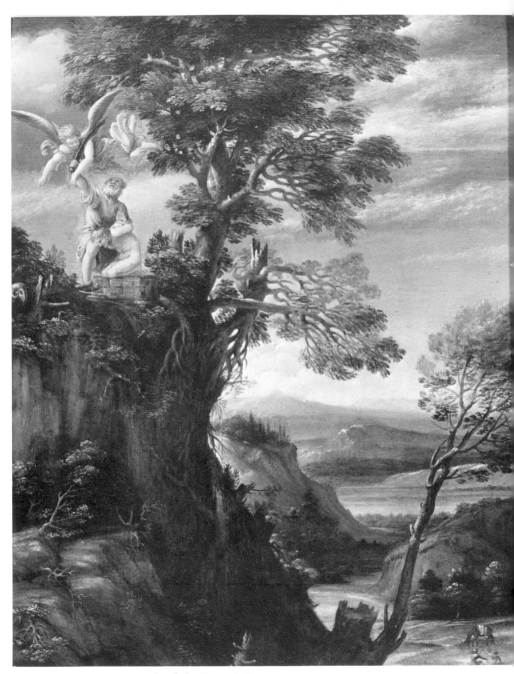

133. Annibale Carracci, *Sacrifice of Isaac*, Paris, Louvre

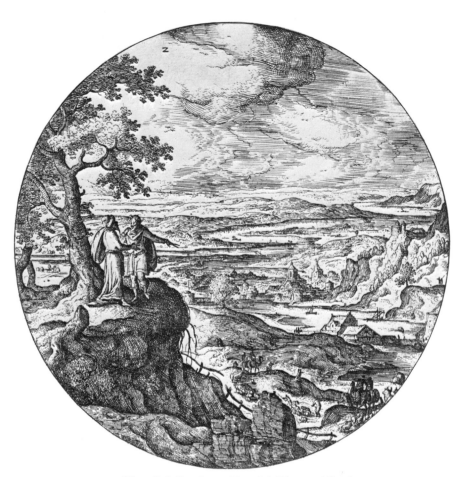

134. Hans Bol, *Landscape Roundel,* Vienna, Albertina

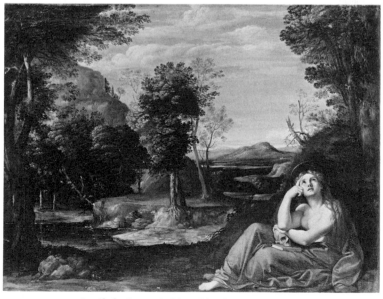

135. Annibale Carracci, *Mary Magdalene in a Landscape,*
Rome, Galleria Doria

136. Annibale Carracci, *Flight into Egypt,* Rome, Galleria Doria

137. Paul Bril, *Landscape,* Rome, Lateran

138. Taddeo Zuccaro et al., *Decorative frieze* (detail),
Rome, Villa Giulia

139. Matteo da Siena (?), *Acqua Vergine,* Rome, Villa Giulia

140. Matteo da Siena (?), *Summer,* Rome, Villa Giulia

141. Federigo Zuccaro et al., *Sala d'Ercole,*
Caprarola, Palazzo Farnese

142. Anonymous, *Landscape,* Caprarola, Palazzo Farnese

143. Anonymous, *Loggia Decoration,* Bagnaia, Villa Lante

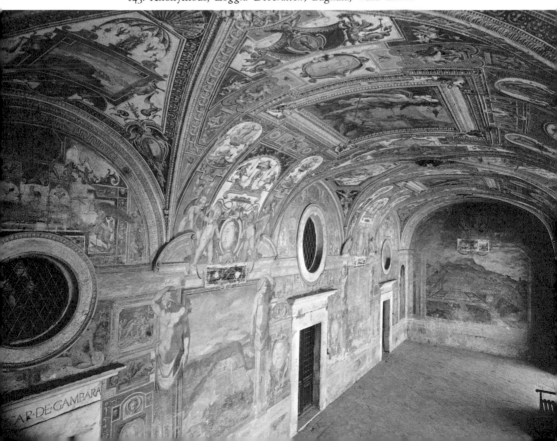

144. Anonymous, *View of Caprarola,* Bagnaia, Villa Lante

145. Baldassare Peruzzi, *Sala delle Prospettive*,
Rome, Villa Farnesina

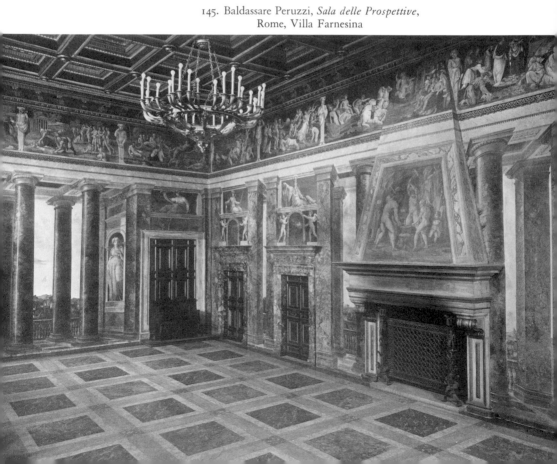

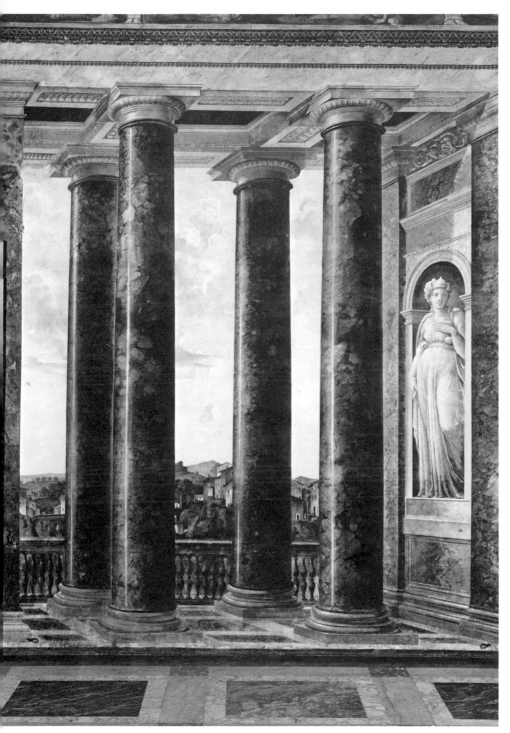

146. Baldassare Peruzzi, *Sala delle Prospettive* (detail),
Rome, Villa Farnesina

147. Girolamo Genga et al., *Camera dei Semibusti*, Pesaro,
Villa Imperiale

148. Girolamo Genga et al., *Camera delle forze d'Ercole*
(detail), Pesaro, Villa Imperiale

149. Andrea Palladio, Maser, *Villa Barbaro*

150. Paolo Veronese, *Illusionistic Decoration,*
Maser, Villa Barbaro

151. Gian Maria Falconetto, *Illusionistic Decoration*,
Padua, Odeon Cornaro

152. Paolo Veronese et al., *Landscape,* Maser, Villa Barbaro

153. Paolo Veronese et al., *Landscape with Ruin*,
Maser, Villa Barbaro

154. Hieronymus Cock, *Landscape with Ruin*, Vienna, Albertina

155. Paolo Veronese et al., *Seascape,* Maser, Villa Barbaro

156. Battista Pittoni, *Seascape,* Florence, Uffizi

157. Paolo Veronese et al., *Landscape,* Maser, Villa Barbaro